# COLLECTING NATIVE AMERICA

## 1870–1960

### EDITED BY SHEPARD KRECH III
### AND BARBARA A. HAIL

SMITHSONIAN INSTITUTION PRESS
WASHINGTON AND LONDON

Copy editor: Jan McInroy
Production editor: Robert A. Poarch
Designer: Janice Wheeler

Library of Congress Cataloging-in-Publication Data

Collecting native America, 1870–1960 / edited by Shepard Krech III and
    Barbara A. Hail.
        p.   cm.
    Includes bibliographical references and index.
    ISBN 1-56098-815-0 (alk. paper)
        1. Indians of North America—Museums—History.   2. Indians of
North America—Material culture—Collectors and collecting.
    3. Indian art—North America—Collectors and collecting.   I. Krech,
Shepard, 1944–  .   II. Hail, Barbara A.
E76.85.C65   1999
970.004'97'0075—dc21                                              99-39620

British Library Cataloguing-in-Publication Data available

Manufactured in the United States of America
05  04  03  02  01  00  99    5  4  3  2  1

⊗The paper used in this publication meets the minimum requirements of the
American National Standard for Information Sciences—Permanence of Paper for
Printed Library Materials ANSI Z39.48-1984.

# CONTENTS

WILLIAM C. STURTEVANT

# FOREWORD

Publications on museum history have often stressed the early history of European museums, of cabinets of curiosity. This volume examines an important aspect of museum history that has been largely unstudied: the roles of private collectors in the foundation of North American public museums of American Indian materials, from about 1870 to 1960.

Most of the major North American museums of natural history were founded ten or twenty years earlier than 1870. Their anthropological collections (emphasizing North American materials) gradually differentiated from their collections of natural history. As anthropology became established as a recognized scholarly discipline, at first in museums and a little later in universities, these museum departments entered a period of very energetic and systematic collecting of American Indian materials, an activity that lasted some forty years, until the 1920s. The purposes of these collections and the accompanying exhibitions were (and still are) mixed: scientific, historical, educational, entertaining, monumental or commemorative.

Most of the collectors discussed here seem to have viewed their activities as the accumulation and preservation of a material record of the romantic past of the Indian peoples they believed to be vanishing. Indian people and their cultures of course have not vanished, but they have changed, and the mostly traditional sorts of artifacts and works of art that are now in museums are indeed an important record of the past of the cultures and arts of North American Indian peoples.

A remarkable array of individuals is surveyed in these essays, people with different motives, from different backgrounds, showing interests in different sorts of materials. This is a story about (usually) wealthy individual collectors, amateurs (in the classical sense of that word), most of whom altruistically arranged for their private collections to become public museums.

Hardly any museums of this type have arisen recently. Auction house catalogs of the last twenty-five years or so show that similar collections are now usually dispersed via the art and antiquities market rather than preserved in public museums, in part probably because of the steep rise in monetary value of these materials, which can be seen as one consequence of the collecting activities described here. Another factor must be the need for a large endowment to support any public museum.

The history of these collections is part of the history of anthropology, and of the history of art collecting and art appreciation (because Native American materials are now widely recognized as real or high art). The period is largely a world of the past, which we need to understand in order to appreciate and use effectively the legacy that these collectors have left us, whether we be anthropologists, Native people, art historians, or other museum visitors and museum users.

The kind of information presented in the essays in this volume is needed before proper use can be made of the now public collections that resulted from the obsessions of their founders. We need to know the contexts for the accumulating—the aims and purposes of the collectors, and especially how the objects were acquired. How close to the original makers and users were the donors or sellers of the objects? How well documented is the history of each object before it was acquired by the founding collector? Put another way, the usefulness of each object is heavily dependent on what we can know of its various past contexts, of its taphonomy.

Rather surprisingly, information of this kind is not easy to find in the catalog and accession records available in most museums. Even in the case of museum collections made by professional anthropologists, the field catalogs are rarely as detailed as we would like, and even more rarely are they adequately copied into the museum's working catalogs. In order to fill out the usual museum records, one must turn to printed, manuscript, and oral sources on the collectors and their collections—exactly the kind of evidence cited and analyzed by the authors of the following essays.

These studies provide a model for examining the history of other museums, both smaller ones that are similar to those treated here and the large, long-public museums with collections of art and artifacts originating in American Indian, First Nations, and other non-Western societies.

SHEPARD KRECH III

# INTRODUCTION

Over the last fifteen years, many scholars have mined the intersection of collecting, museums, and the artifacts of indigenous people. They have explored the processes through which the original owners gave up, willingly and legally or not, their possession of artifacts, which subsequently flowed into the West, in many cases eventually to reside in large repositories. Exposing and postulating a range of unstated assumptions that underlie museums and exhibitions, they have plumbed imperialist histories, colonialism, subversive market relations, inequities of power, the violence of collecting, and the more recent return of patrimony and control over interpretation. The themes resonate in our postmodern and postcolonial time, when the public is widely aware of the illegal traffic in antiquities and the looting of archaeological sites as both historical issues and urgent contemporary problems the world over. They fit an era in which nations, tribes, and individuals are demanding restitution of property confiscated in war or during punitive expeditions or stolen from its original site. And they suit a day when museums in the United States are under federal mandate to determine, with American Indians, the legal basis of their Native North American collections and to return—to repatriate—funerary, sacred, and patrimonial objects, as well as human remains, to the new owners under law.[1]

As important as these works are, conspicuously absent in them is the collector who amassed artifacts and housed them in his or her own museum. Biographical studies of individuals who accumulated private collections of

painting and sculpture, and occasionally built museums, may be common, but the sustained analysis of the processes whereby collections and museums of indigenous artifacts took shape is not. Seldom is the focus on men and women whose collections consisted mainly of the artifacts and imagery of Native people of North America.[2]

Moreover, when collectors are painted into the picture, the strokes are sometimes presentist, which while fitting the intellectual ferment of our day nevertheless only obscures their conscious intentions and therefore the full dimensions of collection- and museum-building processes. While we are not unsympathetic to the critical positions taken by our colleagues in recent years, our concerns lie principally elsewhere. We are far less interested than others in postulating a link between collecting and licentiousness, damning collectors for methods inappropriate in our own day, viewing collecting as disinheritance in some dark colonial period, or reading exhibits as systems of enforced meaning.[3] Rather, our approach parallels that of historians who argue that it is insufficient and misleading to explain the turn-of-the-twentieth-century culture of consumption in terms of externally imposed power or hegemony alone, while ignoring the intentions, motivations, and actions of people at the time.[4] One of our principal goals here is to return collectors and museum founders to their day, with the intent of comprehending anew their motivations and actions. Along the way we hope to avoid anachronisms in the delicate dance of writing history at a time when we are all fully aware of its perspectival and contested nature.

The idea for this volume and the symposium that preceded it developed from an exhibition and catalog that scrutinized Rudolf F. Haffenreffer's collecting and his private museum, the King Philip Museum, in Bristol, Rhode Island.[5] Titled *Passionate Hobby: Rudolf F. Haffenreffer and the King Philip Museum,* the exhibition and the catalog were intended to address these lacunae through one person's thoughts and actions. Our goals were to explain Haffenreffer's fascination for Native America, to determine his collection-formation processes, to place his museum interests in the context of his life, and to shed light on his thoughts about and interactions with the indigenous people whose artifacts he owned.[6]

Similar interests drive the essays in this current collection. In remarks on almost a dozen individuals, we seek mainly to account for why they developed and acted on their interest in Native America by amassing ethnographic and archaeological collections and, in most cases, planning or building museums. We speak about collecting and museum building from

the 1870s through the 1950s, an eighty-year period, the beginning of which overlapped with the era when major national, regional, and university museums of anthropology and natural history formed and engaged in an intense global competition for artifacts.[7] As several scholars have shown, patronage and the convertible nature of artifacts fueled the worldwide quest for objects during this time. Collectors and museums commodified and pursued artifacts as never before. The market spawned innovations, which fast became traditions, and altered indigenous art styles, economies, and systems of ethics. As traditional objects assumed fresh shapes and entered new markets, the boundaries of the genuine or authentic artifact stretched and blurred. After collectors and dealers had alienated the bulk of collectible material culture from Native communities (and the occasional Indian voice rose in protest), the new owners fit their new possessions into private settings or public spaces in museums where these artifacts acquired a range of new meanings.

On a stage that was dominated by major museums and involved collectors, dealers, and massive quantities of artifacts, legions of individuals also managed to get in the act. Most were bit players compared with the large institutions. A very few were not—George Heye, who amassed between one million and three million objects, is the most obvious example. Men and women both, these individuals hold our attention in this book. Some started to accumulate objects during their youth. Some, interested in American Indians, began their collections with arrowheads and stone tools turned over in the plowed fields where they lived. Throughout the nineteenth century, local archaeologists, antiquarians, and relic collectors were enjoying their long heyday. Many were intrigued by the questions of who the ancestors of Native Americans were and where they came from, and some accepted the theory that the Mound Builders, whose prominent sites could be found throughout the Midwest and South, could not have been the ancestors of Indians then living in the same regions, who seemed incapable of such works, but must have been people from elsewhere—Phoenicians, Hittites, or the Welsh, perhaps.[8]

Our goals are to put our subjects into the context of their time as fully as our data allow; to understand the major aspects of their biography that influenced their collecting and thinking about Native people; and to comprehend how they assembled their collections. We stay close to our sources—written, visual, artifactual, and oral—as we set about trying to account for what motivated people to collect artifacts and then—in many cases—build museums. Among the questions we consider are the following: Did these

collectors and museum founders share certain understandings and motivations or were they a varied lot? Did they assume with others of their day that real Indians had already disappeared or soon would if reformists were correct in their assumption that civilization and assimilation were inevitable? Did they harbor sentimental thoughts about a lost time when Indians were noble, and did they therefore collect in order to salvage what was left? How keen was their acquisitive drive or how obsessive their search for objects? Did they oversee their collecting and museum-building enterprise personally or were their lives so busy in other ways that they delegated these tasks to others? Was information on original ownership, provenance, or cultural meaning important to people who collected for themselves rather than for major museums (which preferred objects with context)? And how did they think about and interact with the indigenous people whose objects they collected and displayed? With these questions we join the multidisciplinary debate about how best to imagine the history of collection and display and how best to speak sensibly of the actions of museum founders, many of whom belonged to the economic elite and collected the artifacts of people distant from themselves in economic and cultural terms.

The collectors and museum founders on whom we focus were born between 1834 and 1902 and died between 1909 and 1982. Their involvement with Native American artifacts stretched over nine decades. Some of their names are familiar, especially in regions where they made a mark: Sheldon Jackson, Ernest Thompson Seton, David Ross McCord, Phoebe Hearst, George Heye, Charles Lummis, Mary Cabot Wheelwright, Rudolf Haffenreffer, Clara Endicott Sears, and Francis and Mary Crane. One, Sheldon Jackson, began to collect American Indian artifacts in the 1870s, before any of the others considered here. The others were especially active in the four decades from the 1890s through the 1920s. Heye, Hearst, and Seton started collecting in the 1890s, Lummis and Haffenreffer in the first years of the twentieth century, and Wheelwright and Sears in the 1920s. Several remained active in the 1940s, and while most had died by the 1950s, when the Cranes collected and built their museum, Haffenreffer, Wheelwright, and Sears all still retained control over their institutions during that decade.

Almost all these individuals shared a connection to the Northeast—Heye, Haffenreffer, McCord, and Sears lived there, and Jackson, Seton, Wheelwright, Lummis, and the Cranes all moved west, south, or north from the East. Hearst was born in the Midwest. In the late nineteenth century, Indians were to a great degree invisible in the Northeast, and the re-

gion had become a center of support for Pan-Indian causes and organizations. Support was drawn especially from the middle and upper classes—a socioeconomic status shared to a great degree by individuals who also required capital to found museums—for whom the now distant and often idealized Indian past assumed a new and safe appeal.

Aside from shared geography and—to an extent—socioeconomic means, the cast of characters is quite diverse. Three (Jackson, Lummis, and Seton) actually had more modest backgrounds. Sheldon Jackson (1834–1909), for one, did not fit the mold. As Molly Lee describes in "Zest or Zeal? Sheldon Jackson and the Commodification of Alaska Native Art," his parents were converts to Presbyterianism, and they guided their son toward a career in the church. After a dramatic religious experience, Jackson entered seminary and in time became a Presbyterian missionary to Alaskan Natives. Nor was Charles Lummis (1859–1928) typical. As Thomas H. Wilson and Cheri Falkenstien-Doyle show in "Charles Fletcher Lummis and the Origins of the Southwest Museum," he was born to modest circumstances, yet went to Harvard. But then he dropped out and headed west, where for a time he tried to live by the wits of his pen as a writer and editor of the *Los Angeles Times*. Ernest Thompson Seton (1860–1946) was also responsible for his own fortunes as a writer, artist, and popularizer, as Nancy J. Parezo and Karl A. Hoerig describe in "Collecting to Educate: Ernest Thompson Seton and Mary Cabot Wheelwright," an essay that compares two of many Easterners who moved to Santa Fe after the Atchison, Topeka, and Santa Fe railway made it easily accessible to artists, writers, and tourists.

But others were born to economic or social position—sometimes both—and some had active and successful (if brief) business careers. David Ross McCord (1844–1930), as Moira T. McCaffrey states in "Rononshonni—The Builder: David Ross McCord's Ethnographic Collection," was born into a family of lawyers, merchants, and landowners. He entered the law, eventually becoming a Queens counsel in the 1890s. George Heye (1874–1956), as Clara Sue Kidwell shows in "Every Last Dishcloth: The Prodigious Collecting of George Gustav Heye," embarked on careers as an engineer and an investment banker, but when in 1915 he inherited considerable wealth, he turned full bore to his collecting and museum project. Rudolf Haffenreffer (1874–1955), as described in "Rudolf F. Haffenreffer and the King Philip Museum" (for which I am responsible), was the son of a German immigrant and successful brewer and became an industrialist and brewer of note in his own right, eventually serving as president and chair-

man of the board of Narragansett, one of the largest breweries in the nation.

Others supported themselves and their passions with inheritances from their parents or a spouse, or through marriage to a spouse with a successful career. Two women born in Boston, neither of whom married, are prime examples of collectors and museum founders with familial inheritances. Clara Sears (1863–1960), a descendant of John Endicott, the first governor of the Massachusetts Bay Colony, was, as Barbara A. Hail details in "Museums as Inspiration: Clara Endicott Sears and the Fruitlands Museums," the beneficiary of two China trade fortunes. And Mary Cabot Wheelwright (1878–1958), like Sears a Boston Brahmin and, as Parezo and Hoerig describe in their comparative essay, a determined, independent Victorian who traveled widely until her mother's death in 1923, settled near Santa Fe and started to lead an even more unconventional life after she was able to draw income from a trust fund. Mary Crane (1902–82) was also born to wealth or position, as was her husband, Francis Crane (1902–68), which made possible, as Joyce Herold relates in "Grand Amateur Collecting in the Mid-Twentieth Century: The Mary W. A. and Francis V. Crane American Indian Collection," their leisure activity, including collecting and museum building. Phoebe Apperson Hearst's (1842–1919) collecting interests flowered after marriage. She was born into a prosperous farming family, but—as Ira Jacknis details in "Patrons, Potters, and Painters: Phoebe Hearst's Collections from the American Southwest"—she lacked substantial personal wealth and social position until she married a successful mining entrepreneur and moved to San Francisco, after which she devoted herself to travel, the arts, anthropology, and public philanthropy.

Given the overlap in their ages, socioeconomic status, and interest in indigenous artifacts, it is not entirely surprising that some of these individuals knew, or had dealings with, or competed with, each other. Heye and Haffenreffer, linked by their interest in artifacts and in German American culture (and beer), as well as by exchanges in which artifacts and cash formed the transaction, knew each other for decades and were on a first-name basis. Sears and Haffenreffer knew each other largely by reputation: both sought an artifact known as King Philip's Club (it supposedly belonged to that seventeenth-century Indian leader) that they considered vital to their collections and museums. Many of these museum builders were probably aware of others, either by reputation or when they traveled to the region where their contemporaries were active.

Most of the individuals of whom we write had been exposed to collecting or American Indians, or both, during their youth, when interests brought to fruition later in their lives probably formed. For example, McCord was no doubt influenced by his parents, who were interested in collecting, Indian affairs, and natural history and science; by his visits to natural history societies and exhibitions; by his parents' friends who had interest in aboriginal affairs or artifacts; and by attendance at lectures. Others, during their youth, had similar, if not as extensive, exposure and experiences or displayed curiosity about collecting or indigenous people. Jackson collected botanical specimens (and was interested in ethnography) when he was young. At an early age Ernest Thompson Seton was intensely curious about Canada's aboriginal people, and he later drew on childhood experiences in Ontario woods and fields as he formed youth clubs based on his perception of traditional American Indian lives. The parents or grandparents of both Mary and Francis Crane had ethnographic and archaeological collections that included Native American baskets and lithics; the Cranes later inherited them. Lummis collected in college. Mary Wheelwright and Clara Sears grew up in circles where painting and sculpture and museums were privileged—even if American Indians were not. Haffenreffer and Heye might have been influenced during boyhood by school texts placing Native people in a romantic past, by Buffalo Bill traveling shows, or by German interests in American Indians. But for both, as for Phoebe Hearst, events that occurred when they were near or in adulthood seemed more important as catalysts for their growing status as collectors of indigenous artifacts and (eventual) founders of museums: for Heye it was work in Arizona and contact with Navajo men; for Haffenreffer, purchase of the land where King Philip lost his life in 1676 and his subsequent find of local archaeological artifacts; and for Hearst, a dedication to education that first became evident during her late teens when she was a schoolteacher in rural Missouri.

Collectors often appear or are cast as eccentric, and some contribute to the perception that they can be seen in no other way. Robert Opie, for example, the collector who has amassed the packaging of hundreds of thousands, if not well over one million, consumer products, seems driven crazy, even to himself, by his seemingly universal collecting habits, which he confesses run his life. He may define the extreme, yet others are also so focused on their collecting projects that they call down on all collectors the label "hopelessly eccentric," and they spawn theories ranging from collecting

and sexual activity as mutually exclusive to (more reasonably) collecting as rooted in (and reflecting) longing, memories, and experiences of the collector.[9]

For some of the individuals considered in this book, collecting was in fact a major preoccupation. Lummis, McCord, Heye, and others were driven to possess artifacts from Indian Country. Lummis started collecting during his college days but always in a small way, since he lacked resources. He claimed to have stolen signs advertising Cambridge business firms, which he and a friend then displayed in their rooms. His friend, Lummis complained, "hadn't a touch of the Collector's Fever," but Lummis exuberantly admitted to making up for any deficit: "I had the Fever on both sides." He represented collecting as an affliction, a kind of disease. After dropping out of Harvard, Lummis drifted west to Ohio and then to Santa Fe, which he found difficult to leave, but he did—for Los Angeles, where he became a writer and editor of the *Los Angeles Times.* Then followed a stroke and return to the Southwest to Isleta Pueblo, photography, books, marriage (his second) to a schoolteacher at Isleta, and a trip to South American archaeological excavations with the historian-anthropologist Adolph Bandelier. In 1893 he returned to Los Angeles and continued to write about the virtues of that city, American Indian rights, private museums, and other topics. He also built his own home with imported Isletan labor and displayed a collection of artifacts in a front room that he called the *museo.* Throughout his travels he collected artifacts. An unsystematic collector, he picked up many objects for pecuniary reasons, buying and selling them in order to finance his meandering, and for the remainder he reserved personal stories rather than narratives about science or provenance.

McCord also seemed especially driven. In the late 1870s he started to amass paintings, manuscripts, a library of eight thousand volumes, and furniture; after fifteen years or so, he added Indian artifacts. He housed them all at home. After the turn of the century his collecting continued apace. He acquired most of his ethnographic artifacts by post—and seems to have been largely responsible for the depletion of his substantial resources by the end of his life.

But Heye was most extreme. Bitten by what he called "the collecting bug," after which "I was lost," he started modestly enough, purchasing a Navajo man's shirt when he was working in Arizona before the turn of the century. By 1906 he possessed more than 30,000 objects. After he inherited from his family in 1915, he turned full bore to collecting and when he stopped he had well over one million objects. In his heyday he traveled to

reservations, where, as one associate said, he would "be fretful and hard to live with until he'd bought every last dirty dishcloth and discarded shirt." In an understatement, Marshall Saville, professor of archaeology at Columbia University and employee at Heye's Museum of the American Indian, remarked that his employer had "valuable magpie tendencies." Others have called him obsessive.

But not all the collectors and museum founders considered here were as fixated on artifacts as McCord or Lummis—or Heye. As in other ways, they were a diverse lot, and in their collecting they varied in intentions and acquisitive drive. For some, collecting was overshadowed by an active business life or other interests. Haffenreffer, for example, dedicated most of his time to the business of business even though he was greatly interested in his numerous cigar-store Indians (which *Time* considered his "passionate hobby") and other representations of Native North Americans and in his archaeological and ethnographic collections. Other businessmen for whom collecting was an avocation were Rowland G. Hazard II, president of a Rhode Island textile mill, and Louis Warren Hill Sr., president of the Great Northern Railway; no matter how much passion they and others like them expressed for American Indian artifacts or prehistory (and it could be considerable), collecting was a hobby to be pursued on time taken from running a railroad, a mill, or a brewery; cataloging and other tasks—sometimes even the collecting itself—were delegated to employees.[10]

Sheldon Jackson saw artifacts not as an end in themselves but as a means to accomplish what was always most important to him: the conversion of Native people to Christianity. He had secondary interests in tourism and Native educational and political causes. Early in his career he bought and sold, or gave away, Indian art and artifacts, both popularizing them for the consuming middle-class masses interested in nostalgia and funding his proselytizing efforts. In Alaska he was appointed general agent for education, a position he used to obtain space on boats for himself and his collections. An eclectic collector who got off the beaten track and had access to a variety of artifacts—in both respects he was unlike the typical tourist on an Inside Passage trip during his day—he had an apparent predilection for sacred artifacts. His tactics could be controversial in their time; once his Native guide rebuked him for suggesting that a totem pole be cut down and removed from a deserted village. Jackson installed a curio cabinet at Princeton Theological Seminary, where he had trained years before; then founded the Sitka Industrial and Training School in Sitka, Alaska, where students trained in a number of vocational arts, including the manufacture

of curios for the burgeoning tourist trade along the Inside Passage; and finally established the Sheldon Jackson Museum and Library for a separate collection. His goals remained all along to convert Natives, teach them useful skills, and induce patrons to support them (and his mission).

Ernest Thompson Seton at first collected artifacts out of a deep interest in Native Americans, but very soon his collecting and his use of the artifacts were intended for a very specific purpose: the education of scouts in the woodcraft skills of traditional Indians modeled on James Fenimore Cooper's Pawnees (or Mohicans or Delawares), which were thoroughly romantic portrayals. Seton collected Indian artifacts as early as the 1890s, when he was on the Crow Reservation—he subsequently published on sign language—and continued when he undertook a trip into the central Canadian Arctic in 1907, but not until he moved to Santa Fe in the early 1930s did he put the objects on display—in a compound where he lived alongside an institute and college for students interested in Indian clothing and culture. People came to know his collections through his heavily illustrated publications. Seton's audience was vast—he reached millions through books, essays, speeches, and youth organizations. Much that he wrote and published was illustrated with American Indian objects in part modeled closely on authentic artifacts and in part invented. Long after his death, the remainder of his unsystematically acquired collections was donated to the Boy Scouts of America in Cimarron, New Mexico.

Most of the collectors considered here founded museums, and (as with Heye or Jackson) it is difficult to separate what drove them to collect from what propelled them to build museums; indeed, after a certain point they collected to fill their museums. Jackson, McCord, Heye, Haffenreffer, Hearst, Wheelwright, Lummis, Sears, the Cranes—all were directly responsible for museums that housed their collections. They were unusual compared to thousands of individual collectors who collected art and artifacts of Native America on a small or large scale and merely put them on display in their homes, in curio corners and settings influenced by Arts and Crafts sensibility.[11]

The stories of the formation of their museums are richly varied and detailed. Like other museums that took shape during the nineteenth and twentieth centuries and acquired the artifacts of the world's indigenous people, theirs were large and small, metropolitan and rural. They were located in a variety of settings: New York; Los Angeles; Montreal; Berkeley, California; Santa Fe, New Mexico; Sitka, Alaska; Bristol, Rhode Island;

Harvard, Massachusetts; and Marathon, Florida. Some were accessible to the public during regular open hours, and others were private and inaccessible except by arrangement with the owner. Some were dedicated to the artifacts of indigenous people, and others held collections relating to far more—from natural history to national history.

All possessed—in the name of founders, trustees, or the public—artifacts housed within their walls. Appropriated, these objects were literally taken over by museums as their own. Museum architecture and interpretative schemes framed the artifacts and brought them under the museums' authoritative mantle. In large urban museums, the framing was monumental, the structure often classical, the authority absolute. The architecture of museums founded by the individuals we consider here varied greatly, from classical and monumental buildings to a low cement building at the heart of a dairy farm, from a mid-nineteenth-century schoolhouse to a structure in the shape of a Navajo hogan. In no museum was power absent, but there was great variation in how people deployed and perceived power. Most of the museum founders discussed here retained control as long as they could—some until they died. Displays within their museums were indeed undergirded by tacit assumptions about culture, nature, evolution, gender, science, race, and authenticity, which indelibly influenced educational agendas. Most often they arranged artifacts taxonomically, by category—such as baskets, arrowheads, pestles and mortars, and so on, or by tribe, perhaps on and around life-size mannequins in "realistic" tribal-based settings.[12]

The museums considered in the essays that follow embodied not just educational goals but fundamental understandings about Native people that drove their founders to amass collections and interests in certain classes of objects. The museum founders shared certain broad educational goals, one of the most important of which was to preserve for and present to the public the artifacts of what they thought was a doomed race and to use their museums to educate or instruct the public. Many assumed that the real Indian had already disappeared or soon would if the reformists were correct—as most believed they were—in their assumption that civilization and assimilation were inevitable. Some collected to salvage what was left. As they did, they not uncommonly harbored sentimental views about a lost time when Indians were as noble as James Fenimore Cooper's textual representations of Delawares and Pawnees or Edward Curtis's manipulations for the camera.[13]

David Ross McCord was a perfect example. After the turn of the century, by which time he had accumulated large and varied collections, he gave up the law in order to attain his goal of a museum that would instruct the public about Canadian history, in which Indian lives played a significant part. The task, he felt, was urgent. Indians were doomed. Their past was noble and virtuous—in sharp contrast to their present-day circumstances. His museum, he hoped, would be unrivaled as a monument to aboriginal skill and industry, and so he appealed widely by mail to missionaries, government agents, and others resident in Indian Country to purchase and send a wide range of traditional objects, for which he promised prime prices. McGill University in Montreal deliberated for a full decade before accepting McCord's offer of his collections, which by 1919 numbered more than 15,000 objects, including 3,500 artifacts relating to the Indian past in Canada, many with documentation on ethnicity and provenance. In 1921 the McCord National Museum opened, with rooms devoted to the French in Canada, Protestants, Jesuits, the War of 1812, and other topical subjects. Two rooms were dedicated to Indians of Canada and organized by people (e.g., Haida) and category of object (e.g., baskets, pipes). But McCord had run through all his money—and his health—and left his wife virtually penniless upon his death.

McCord's was a national educational project in which Native Americans—more precisely, the Canadian Indian past—played only one part. Charles Lummis had a similar aim, but for one region rather than an entire nation. When Lummis decided to build a public museum, in order for it to happen, he needed to persuade influential friends from all quarters of Los Angeles to support the effort. He had been interested in such a project since the mid-1890s, and it was clear that he saw it as a way to put Southern California on the global map—and score points against the Eastern establishment. In the eleven years it took the museum to rise, Lummis arranged for the support of an archaeological research program, the purchase of collections of artifacts, paintings, and books, and the donation of his own collections. He wrote with missionary zeal that he was building a structure "to outlast the Parthenon," a "Temple of History, Science, and Art." The Southwest Museum opened in 1914 with displays of shells, ornithology, ethnography, art, and so on—reflecting Lummis's catholic and often unfocused interests. Soon intractable problems emerged, including priorities and finances. Most serious was Lummis's temperament—his children later labeled him "reckless and pugnacious"—and finally the board removed him as a trustee.

Like McCord and others, Rudolf Haffenreffer had explicitly didactic interests. After he bought a country estate that was also a working farm in Bristol, Rhode Island—property that increasingly became the focus of his life—he found archaeological artifacts on the land, became interested in King Philip, whose history was intertwined with that of his property, and hatched the idea of a museum, which grew at the heart of the farm. His museum collections expanded after personal trips to the West—where he had mines—and after he employed an archaeologist to collect for him, and his museum took on a reputation as a sanctuary where others placed heirlooms. Like Heye, Haffenreffer sponsored excavations, hired an agent to collect for him, possessed rare books and manuscripts, and emphasized the serious study of artifacts—but the scale of Haffenreffer's operations was very different from that of Heye's. The interior spaces of his King Philip Museum were increasingly taken over by sofas, tables, and other furnishings—and late in its history, by cigar-store Indians—but through artifacts placed densely in glass cases, documents, a card catalog, and books, Haffenreffer was able to convey a concern for authenticity and context. He opened his museum for his friends, and for the public, and wished especially to educate students about practical aspects of Indian life and to encourage youth to write essays on the history of the Wampanoag and Narragansett people. His property became an important meeting ground for Boy Scouts, whose outdoor skills agenda—a lifelong interest of his contemporary Ernest Thompson Seton—Haffenreffer supported.

Francis and Mary Crane also had educational goals. Their earlier avocations had been breeding Guernsey cows and Great Pyrenees dogs on their Massachusetts farm, and they did not collect American Indian artifacts in earnest until poor health forced Francis Crane's retirement in the early 1950s, at which time they moved to eighty acres in the Florida Keys. Like many, they were drawn to the pastoral life, and their land, like Haffenreffer's property, contained archaeological remains (of the Calusa). Evidently moved by the wild nature of their property and interested in a retirement educational project relating to people who lived in nature and appropriate to their own social responsibility, the Cranes immediately planned to build a museum—the Southeast Museum of the American Indian—and collected the first of more than 11,000 artifacts, in part through extended buying trips to the West. Their collecting was compressed into several years, and at its height they spent seven months of one year on the road, seeking out and purchasing an extraordinary variety of objects both old and new, mostly from inexpensive, local sources. They were most inter-

ested in objects reflecting traditional—or as Francis Crane put it, "true, unaffected"—lives of American Indians, and when their museum opened, its displays were organized by topic and by culture area (e.g., Northwest Coast ceremony), were often crowded, and revealed the Cranes' limited knowledge of both authentic artifacts and accurate interpretation. Their museum was open for one decade. They were unable to attract school-children and tourists who came to the Keys for outdoor recreation. More-over, health problems again loomed as a concern for Francis Crane. Conse-quently the couple gave their collection to the Denver Museum of Natural History after the assistant director (whom they had met) assured them that it would be the centerpiece of his museum's ethnology collections and exhi-bitions.

When George Heye decided in 1916 to found his own museum in New York to preserve everything pertaining to our American tribes, he, too, seemed motivated by educational goals: he said that he wished to provide an avenue for men like himself—businessmen interested in training in ele-mentary anthropology. Franz Boas and other anthropologists at Columbia University, the University of Pennsylvania, and the American Museum of Natural History, hoping to benefit further from Heye's largesse—he had subsidized anthropological training at the two universities and was a sig-nificant benefactor of the University Museum of the University of Pennsyl-vania—were chagrined but helpless to influence him. Heye's motivations were probably far more complex—for one thing, he also wanted control, which he obtained by appointing friends as trustees. Archaeology was his passion, and he hired and bankrolled his own archaeologists. He sponsored expeditions, purchased items from anthropologists like Boas and museums like the University Museum, and collected with abandon. Heye understood the importance of systematic collecting and recording and hired people to carry out these tasks professionally, although he never met his own stan-dards. The Museum of the American Indian opened its exhibits to the pub-lic in 1922, and Heye's staff got on with the important business of research and scholarship. The late 1910s and 1920s were the museum's heyday, with widespread expeditions, archaeology and ethnographic work, but by this time Heye's enterprise had become heavily dependent on the generosity of trustees. After financial reversals and the death of several benefactors in 1928–29, he was forced to trim his sails.[14]

By the time Phoebe Hearst decided to underwrite the cost of a museum of anthropology, she had been broadly interested in European paintings and

sculpture for several decades. She had traveled extensively, taken the Grand Tour in Europe, and supported the arts in Washington, D.C., when her husband was in the U.S. Senate. But anthropology was evidently her favorite subject, and after she became the benefactor of a number of initiatives of the University of California she offered financial support to help underwrite both a museum—today's Phoebe Hearst Museum at the University of California, Berkeley—and a department of anthropology. With her economic power, archaeology as a passion within anthropology, and subventions of institutional research, she resembled Heye. But her interest in antiquities was much broader—she supported collections not just from the Southwest, California, and Peru but also from Egypt, Greece, and Rome. She did virtually no direct collecting herself, and her personal professional connections—indeed, friendships—were with women like Zelia Nuttall and Alice Fletcher, anthropologists associated with Harvard and the University of Pennsylvania. Jacknis uses Phoebe Hearst's acquisitions from the southwestern United States to exemplify the processes by which objects came into her collections. Hearst amassed (through intermediaries) a range of materials bearing on Native Americans from that region: utilitarian and ceremonial objects, artifacts made for domestic consumption and for sale to tourists, archaeological and ethnographic objects, and photographs, manuscripts, and paintings relating to Native people and landscapes. She was filling the Museum of Anthropology, which opened to the public in 1911—and as she did, she tried to exert some control over how artifacts were displayed within it, which produced tension between the aims of the patron and the state institution, as Jacknis describes.

Phoebe Hearst, who was raised a Presbyterian, was attracted to metaphysical texts, pantheism, and especially the Baha'i faith, and she was taken by romantic paintings of American Indians, which, she thought, revealed the soul—and which hung above displays of her artifacts. Two other museum founders considered here shared Hearst's interest in the religious or spiritual aspects of Indian life: Clara Endicott Sears and Mary Cabot Wheelwright.[15]

Sears's Peabody relatives were well-known transcendentalists, and she tended early on to spiritual and ecumenical religious interests. They intensified after 1913, when she purchased land thirty miles west of Boston that had been the site of Bronson Alcott's brief mid-nineteenth-century utopian experiment. Here Sears began a pastoral life on a dairy farm and gathered—in her own home and a nearby cloisters—antiquities, a Byzan-

tine colonnade from a Venice monastery, and marble busts of thinkers from Socrates to Thoreau. She settled in, eventually to write some fourteen books. And she built three museums. One housed nineteenth-century paintings; another, Harvard Shaker artifacts; and the third, the American Indian Museum, the artifacts of Native America. Her utopian, transcendental, and ecumenical leanings led her to sympathetic portraits of King Philip. After she moved a mid-nineteenth-century schoolhouse to her property, she collected Indian objects over a two-year period, 1927–29, amassed anthropological texts in a two-thousand-volume library, lined up consultants to whom she had ready access through familial contacts, and opened the American Indian Museum. Her collecting project was almost over: in 1934, she ceased collecting Native American artifacts.

The American Indian Museum celebrated the romantic and ethnographic past of the American Indian and was intended, on one level, to be a memorial to King Philip. Even though Sears was interested in New England archaeology and history, King Philip and the iconic King Philip's Club, and tribal elections in the contemporary Massachusetts Native scene, she was like many in seeking Indianness in the West. The Plains region figured prominently in exhibited materials (and was reflected in her small bronze of Cyrus Dallin's *Appeal to the Great Spirit*), which included both dioramas and displays of life-size figures with faces modeled from living Indians, clothed in both authentic (Plains) and inventive (Northeast) garb. Contemporary Native people from the Northeast were largely invisible. With the single exception of a Mohegan, who was active in the Boy Scouts, they did not figure alongside living Sioux and San Ildefonso men in celebrations and pageants enacted around the museum's opening and the unveiling of large bronze statues depicting spiritual and contemplative Noble Indians.

Sears hoped to inspire awe and beauty in the visitors to her museum, which stood on a manicured green with only romantic sculptures of the American Indian to interrupt one's gaze to trees and horizon. In uncluttered central spaces and spiritual interpretations of Algonquian petroglyph designs engraved on the floor, she celebrated a romantic conception of the Indian, which reportedly interested her even more than historical accuracy. In the end, Sears's primary interest lay in creating a mystical aura around the American Indian.[16]

In Santa Fe, Mary Cabot Wheelwright found simplicity and adventure— her escape from stultifying Boston convention. At the same time that she rejected the institutionalized Christianity of her childhood, Wheelwright, a mystic, found enlightenment in Eastern religions and Navajo spirituality.

She established a close relationship with the Navajo Hosteen Klah, a well-known weaver of tapestries using designs derived from sandpaintings and foremost singer of the Nightway chant. Klah believed that at some future time the world would be destroyed, that White people would carry knowledge into the next world, and that it was his duty to teach them about Navajo belief and ritual. In 1927 he and Wheelwright embarked on a project whose goal was the preservation of Navajo philosophy and religion. Their relationship was not merely that of patron and client. Instead, as Parezo and Hoerig argue, they were intellectual equals, each respecting the other. As the sandpainting reproductions, sandpainting tapestries, songs and prayers on tape, and field notes mounted, Klah urged that a permanent home be built. Wheelwright agreed, and after a friend gave her land near Santa Fe, she built the Museum of Navajo Ceremonial Art (Navajos called it the House of Sandpaintings) in the shape of a hogan. It opened in 1937, and Wheelwright was its director and principal benefactor for the next twenty years. Before her death in 1958, the Navajos thanked her for "building the things of the spirit into visible and physical form."

All these collectors and museum founders devoted part of their lives to the material culture of American Indians. But there was great variation in what they thought or wrote about Native people, and even greater difference in their contact with them. For most, contact was extremely limited and consistent with the great social differences at the time between people of different classes (and races). Phoebe Hearst, for example, had very little contact—and she seemed not the least bit interested in contemporary California Indian lives. George Heye was also uninterested in contemporary Indian lives and cultures—eschewing ethnographic information on ritual and languages, for example. Not only did his opportunistic collecting run afoul of ethical issues raised at the time, but when the Hidatsa requested that he return to them a medicine bundle known as the Water Buster during a severe drought, Heye restituted instead some bogus artifacts (after which rain fell). After this, he must have been even further removed from Indian worlds. Years later, the Cranes sometimes purchased directly from Native people and developed an exchange relationship with an Assiniboine-Sioux family, but for them that seemed to be the extent of the contact.

For others it was different. Haffenreffer, for example, might not have had much contact with Native people except for one in his employ and the occasional support of local Pan-Indian organizations, but he showed deep concern for the local history of Wampanoag and Narragansett Indians, es-

pecially the people who had made their home at Mount Hope, his Bristol property. Haffenreffer was passionate about the importance of Native perspectives on history, and in one local speech and publication, he refashioned seventeenth-century history in a sympathetic reading that owed nothing to his Puritan neighbors and everything to more romantic and revisionist sources.

McCord, Lummis, Jackson, Seton, Sears, and Wheelwright had even more contact with Native people. McCord was sympathetic to Indian causes, and the Six Nations Confederacy gave him a name that meant "A Builder," probably for legal advice regarding land claims. McCord tried to use these connections to his advantage when he wrote letters to Indians soliciting artifacts for his collections, but he was not always successful. Lummis also was interested in issues affecting contemporary Indian lives. After he dropped out of Harvard, he went west and discovered people of Spanish and Indian descent in Santa Fe, and then after an interlude in California he settled in Isleta Pueblo, where he became involved in highly contentious political issues about the removal of Isletan children for boarding school. Lummis took a stand on behalf of parents who wanted their children to remain at Isleta, and he wrote about this and other issues. In the 1890s Lummis continued to take on the cause of American Indian rights, and in Los Angeles he built a home with imported Isletan labor. As a missionary, Jackson was with Native people constantly and interested in Native causes if they were not in conflict with the agenda of assimilation, conversion, and education. Seton's times with Native people were very different and highly impressionable—they consisted principally of outdoors activity, including a lengthy trip into the Canadian Subarctic and Arctic. Finally, as detailed by Parezo and Hoerig, Wheelwright—of all the collectors and museum founders considered here—developed the most lengthy and nuanced relationship with a Native person, Hosteen Klah.

These collectors and museum founders left a substantial legacy. One consequence of their activity was support for the discipline of anthropology. Phoebe Hearst's donation of collections and a museum to the University of California, and her financial involvement with the museum and with anthropology and the gift by Rudolf Haffenreffer's heirs of his King Philip Museum both ushered in anthropology (ultimately, departments) at the University of California, Berkeley and at Brown University, respectively. In an earlier day, George Peabody's gift of endowment to Harvard University, which was used to found the Peabody Museum of Archaeology and Eth-

nology, after which curatorial and professorial positions were sought for anthropology, had a similar impact.[17]

Another part of the legacy is in the public and private institutions where formerly private collections can be found today. The most conspicuous example is the National Museum of the American Indian, formerly the Museum of the American Indian, Heye Foundation, which is due to rise on the Mall in Washington, D.C., in 2001 (its New York branch is now at the United States Custom House). The McCord Museum in Montreal, the Southwest Museum in Los Angeles, the Phoebe Hearst Museum at the University of California, Berkeley, the Haffenreffer Museum of Anthropology, Brown University, the Wheelwright Museum in Santa Fe, and the Fruitlands Museums in Harvard, Massachusetts, Seton's collections in Cimarron, New Mexico, and the Cranes' at the Denver Museum of Natural History are visible reminders of what these men and women managed to bring into existence.

But the most important legacy consists of the artifacts themselves. They number well over one million objects. While no one knows what their fate might have been in the absence of these collectors and museum founders, and while the methods employed to collect some of the objects would be shunned today, many friable and vulnerable objects have undeniably been saved from decay or destruction. Fortunately, the great bulk of materials has been preserved. Today these collections form a material basis for knowledge of the Indian past. They comprise a record through which scholars, the public, and Native people themselves can gain access to the Native past. American Indians have used these collections not only to unlock their pasts but to revive and celebrate their artistic expressions.

Finally, as legislation has paved the way for the repatriation of human remains, funerary and sacred objects, and items of cultural patrimony to Native communities, the new rightful owners—individuals, families, descent groups, tribes—are making their own decisions concerning preservation, conservation, storage, and display of objects to which they have regained title. They determine the fate of restituted objects, which clearly contain the potential to revitalize old and new traditions, to generate strong and sometimes contradictory emotions, and to reinscribe ethnic identity, and which are so obviously a concrete reflection of indigenous power.

### Acknowledgments

Barbara Hail and I wish to acknowledge the support of the Haffenreffer Family Fund at several stages of this project, including editorial preparation; Edward C.

Rafferty for his editorial work and perseverance through a computer virus; and Brown University graduate students Natalie Moyer and Donald Holly for their copyediting assistance. We are also grateful to Haffenreffer Museum staff members Christopher Gunn, Kathleen Luke, and Janet Tanner for their technical and administrative assistance.

## Notes

1. See especially George Stocking Jr., ed., *Objects and Others: Essays on Museums and Material Culture* (Madison: University of Wisconsin Press, 1985); James Clifford, *The Predicament of Culture: Twentieth-Century Ethnography, Literature, and Art* (Cambridge: Cambridge University Press, 1988); Susan Pearce, ed., *Museum Studies in Material Culture* (Leicester: Leicester University Press, 1989); Sally Price, *Primitive Art in Civilized Places* (Chicago: University of Chicago Press, 1989); Ivan Karp and Steven Lavine, eds., *Exhibiting Cultures: The Poetics and Politics of Museum Display* (Washington, D.C.: Smithsonian Institution Press, 1991); Peter Vergo, ed., *The New Museology* (London: Reaktion Books, 1991); Janet Berlo, ed., *The Early Years of Native American Art History* (Seattle: University of Washington Press, 1992); Eilean Hooper-Greenhill, *Museums and the Shaping of Knowledge* (London: Routledge, 1992); Michael M. Ames, *Cannibal Tours and Glass Boxes: The Anthropology of Museums* (Vancouver: University of British Columbia Press, 1992); Ivan Karp, Christine Mullen Kreamer, and Steven Lavine, eds., *Museums and Communities: The Politics of Public Culture* (Washington, D.C.: Smithsonian Institution Press, 1992); Annie E. Coombes, *Reinventing Africa: Museums, Material Culture, and Popular Imagination* (New Haven: Yale University Press, 1994); Daniel J. Sherman and Irit Rogoff, eds., *Museum Culture: Histories, Discourses, Spectacles* (Minneapolis: University of Minnesota Press, 1994); John Elsner and Roger Cardinal, eds., *The Cultures of Collecting* (Cambridge: Harvard University Press, 1994); Moira G. Simpson, *Making Representations: Museums in the Post-Colonial World* (London: Routledge, 1996); *Curatorship: Indigenous Perspectives in Post-Colonial Societies,* Proceedings, Mercury Series, Directorate Paper no. 8 (Hull, Quebec: Canadian Museum of Civilization, 1996); Jeremy Clancy, ed., *Contesting Art: Art, Politics, and Identity in the Modern World* (Oxford: Berg, 1997).

2. The major exceptions are Berlo, *Early Years,* and Elizabeth Hill Boone, ed., *Collecting the Pre-Columbian Past* (Washington, D.C.: Dumbarton Oaks, 1993). For two recent biographical studies of a collector of "folk art" and a collector of painting and sculpture who opened his private gallery to the public, see Lynda Roscoe Hartigan, "Collecting the Lone and Forgotten," in *Made with Passion* (Washington, D.C.: Smithsonian Institution Press, 1990), 1–81; and Jane Hancock, Sheila ffolliott, and Thomas O'Sullivan, *Homecoming: The Art Collection of James J. Hill* (St. Paul: Minnesota Historical Society Press, 1991).

3. Nicholas Thomas, "Licensed Curiosity: Cook's Pacific Voyages," in Elsner and Cardinal, *The Cultures of Collecting,* 116–36; Simpson, *Making Representations,* 192; *Curatorship,* 59, 81 ("dark colonial period"); Donna Har-

away, "Teddy Bear Patriarchy: Taxidermy in the Garden of Eden, New York City, 1908–1936," in Haraway, *Primate Visions: Gender, Race, and Nature in the World of Modern Science* (New York: Routledge, 1989), 26–58.

4. For the debate, see T. J. Jackson Lears, *No Place of Grace: Antimodernism and the Transformation of American Culture* (New York: Pantheon Books, 1981); Richard Wrightman Fox and T. J. Jackson Lears, eds., *The Culture of Consumption: Critical Essays in American History 1880–1980* (New York: Pantheon, 1983); Warren J. Susman, *Culture as History: The Transformation of American Society in the Twentieth Century* (New York: Pantheon, 1984); Simon J. Bronner, ed., *Consuming Visions: Accumulation and Display of Goods in America, 1880–1920* (New York: Norton, 1989).

5. The symposium, "Collectors/Museum Founders and American Indians," organized by the editors of this volume and sponsored by the Council for Museum Anthropology, was held at the annual meeting of the American Anthropological Association in Washington, D.C., in the fall of 1995. Except for Moira McCaffrey's essay, which was later added, the chapters in this volume were presented at that symposium.

6. I wish to thank my students and colleagues for their collaboration on *Passionate Hobby: Rudolf F. Haffenreffer and the King Philip Museum* (the exhibition and catalog). Ann McMullen, then in the midst of doctoral work in Brown University's Department of Anthropology and now curator at the Milwaukee Public Museum, and David W. Gregg, a doctoral student in anthropology and curator-in-charge of the exhibition (and now associate curator and move manager, Haffenreffer Museum of Anthropology), were responsible for major projects systematizing and inventorying archives and archaeological materials in the Haffenreffer Museum. They, Barbara Hail, the deputy director and curator of the Haffenreffer Museum, and I engaged in lengthy discussions on the processes whereby collectors and museum founders become interested in indigenous people and their artifacts. In this way, both the documentary and the artifactual basis for a sustained focus on Rudolf Haffenreffer and context for analysis took shape.

7. For the Museum Period in anthropology (1840s–1890s), see William C. Sturtevant, "Does Anthropology Need Museums?" in *Proceedings of the Biological Society of Washington* 82 (1969): 619–50: "This periodization—Museum Period 1840–1890, Museum-University Period 1890–1920, University Period 1920 to date—is developed from that implied by Collier and Tschopik (1954). While it reflects primarily the United States situation, a similar sequence obtains in other parts of the world. The second period probably began two or three decades earlier in France and Germany, and lasted three or four decades longer there and elsewhere in Europe" (p. 622). See Donald Collier and Harry Tschopik Jr., "The Role of Museums in American Anthropology," *American Anthropologist* 56, no. 5 (1954): 768–79.

8. Douglas Cole, *Captured Heritage: The Scramble for Northwest Coast Artifacts* (Seattle: University of Washington Press, 1985), and Curtis Hinsley, *Savages and Scientists: The Smithsonian Institution and the Development of American Anthropology, 1846–1910* (Washington, D.C.: Smithsonian Insti-

tution Press, 1981); J. C. H. King, "Tradition in Native American Art," in *The Arts of the North American Indian: Native Traditions in Evolution,* ed. Edwin Wade (New York: Hudson Hills, 1986), 65–92; Charles L. Briggs, "The Role of Mexicano Artists and the Anglo Elite in the Emergence of a Contemporary Folk Art," in *Folk Art and Art Worlds,* ed. John Michael Vlach and Simon Bronner (Ann Arbor: UMI Research Press, 1986), 195–224; Nancy J. Parezo, "The Formation of Ethnographic Collections: The Smithsonian Institution in the American Southwest," *Advances in Archaeological Method and Theory* 10 (1987): 1–47; Beverly Gordon with Melanie Herzog, *American Indian Art: The Collecting Experience* (Madison: University of Wisconsin, Elvehjem Museum of Art, 1988); Berlo, ed., *Early Years;* Barbara A. Hail, "The Ethnographic Collection," in *Passionate Hobby,* 91–134 (three million).

9. Jean Baudrillard, "The System of Collecting," in Elsner and Cardinal, *The Cultures of Collecting,* 7–24; Robert Opie, "Unless you do those crazy things . . . ," in ibid., 25–48; Susan Stewart, *On Longing* (Baltimore: Johns Hopkins University Press, 1984), 132–73; Edwin L. Wade, Carol Haralson, and Rennard Strickland, *As in a Vision: Masterworks of American Indian Art* (Norman: University of Oklahoma Press, 1983), 13 (on collectors as eccentric).

10. Ann T. Walton, John C. Ewers, and Royal Hassrick, *After the Buffalo Were Gone: The Louis Warren Hill, Sr., Collection of Indian Art* (St. Paul: Northwest Area Foundation, 1985); Sarah Peabody Turnbaugh and William A. Turnbaugh, *The Nineteenth-Century American Collector: A Rhode Island Perspective* (Peace Dale, R.I.: Museum of Primitive Art and Culture, 1991).

11. Most collectors, including Milford Chandler, Stewart Culin, Rowland G. Hazard II, and Louis Warren Hill, did not found museums; see Diana Fane, Ira Jacknis, and Lise Breen, *Objects of Myth and Memory* (New York: Brooklyn Museum, 1991); Walton, Ewers, and Hassrick, *After the Buffalo Were Gone;* Turnbaugh and Turnbaugh, *The Nineteenth-Century American Collector;* also Berlo, *Early Years,* on patrons of Native artisans or other collectors in the late nineteenth and early twentieth centuries. For others who did found museums, see John C. Ewers, "William Clark's Indian Museum in St. Louis 1816–1838," in *A Cabinet of Curiosities: Five Episodes in the Evolution of American Museums,* ed. Whitfield Bell et al. (Charlottesville: University of Virginia Press, 1977), 49–72; David Penney, *Art of the American Indian Frontier* (Seattle: University of Washington Press, 1992).

12. On issues in the last two paragraphs, see especially Donna Haraway, "Teddy Bear Patriarchy"; Simon J. Bronner, "Object Lessons: The Work of Ethnological Museums and Collections," in Bronner, *Consuming Visions,* 217–54; Jay Mechling, "The Collecting Self and American Youth Movements," in Bronner, *Consuming Visions,* 255–85; Ames, *Cannibal Tours and Glass Boxes;* James Clifford, "On Collecting Art and Culture," in Clifford, *The Predicament of Culture,* 215–51; Clifford, "Four Northwest Coast Museums: Travel Reflections," in Karp and Lavine, *Exhibiting Cultures,* 212–54; Clifford, "Objects and Selves—An Afterword," in Stocking, *Objects and Others,* 236–

46; Charles Suamarez Smith, "Museums, Artefacts, and Meanings," in Vergo, *The New Museology,* 6–21; Brian Durrans, "The Future of the Other: Changing Cultures on Display in Ethnographic Museums," in *The Museum Time Machine,* ed. Robert Lumley (London: Comedia/Routledge, 1988), 144–69; Nicholas Thomas, "The European Appropriation of Indigenous Things," in Thomas, *Entangled Objects: Exchange, Material Culture, and Colonialism in the Pacific* (Cambridge: Harvard University Press, 1991), 125–84; Hooper-Greenhill, *Museums and the Shaping of Knowledge;* James A. Boon, "Why Museums Make Me Sad," in Karp and Lavine, *Exhibiting Cultures,* 255–77; Curtis M. Hinsley, "Collecting Cultures and Cultures of Collecting: The Lure of the American Southwest, 1880–1915," *Museum Anthropology* 15, no. 1 (1992): 12–20.

13. Even collectors with relatively modest financial reserves, like Milford Chandler, were "driven"—his word—to collect Native American artifacts in order to preserve objects before they disappeared. "He believed that these things were national treasures and it was his mission to help preserve them," Richard Pohrt said of Chandler. See Richard A. Pohrt, "A Collector's Life: A Memoir of the Chandler-Pohrt Collection," in Penney, *Art of the American Indian Frontier,* 299–322, 301.

14. In addition to Clara Kidwell's essay in this volume, see F. W. Hodge, ed., *Aims and Objects of the Museum of the American Indian Heye Foundation,* Indian Notes and Monographs 33 (New York: Museum of the American Indian, Heye Foundation, 1922); *The History of the Museum,* Indian Notes and Monographs 55 (New York: Museum of the American Indian, Heye Foundation, 1956); S. K. Lothrop, "George Gustav Heye—1874–1956," *American Antiquity* 23 (1957): 66–67; Kevin Wallace, "Slim-Shin's Monument," *New Yorker,* September 19, 1960; Barbara Braun, "Cowboys and Indians: The History and Fate of the Museum of the American Indian," *Village Voice* 31 (April 8, 1986): 31–34, 36, 38–40. The quotations in the text are from Wallace, "Slim-Shin's Monument."

15. As Molly Lee suggests when she discusses Jackson's predilection for sacred objects, it would be interesting to explore the connections between occupation (missionary) and collections, and—as suggested by the major interests of Hearst, Sears, and Wheelwright in their museum projects—the link between gender and collecting and museum projects. See also Shepard Krech III, *A Victorian Earl in the Arctic: The Travels and Collections of the Fifth Earl of Lonsdale, 1888–9* (London and Seattle: British Museum Publications/University of Washington Press, 1989); Shepard Krech III and Barbara Hail, eds., *Art and Material Culture of the North American Subarctic and Adjacent Regions,* Special Issue, *Arctic Anthropology* 28, no. 1 (1991): 1–149.

16. See Barbara A. Hail's essay in this volume; also Harriet E. O'Brien, *Lost Utopias* (Harvard, Mass.: Fruitlands and the Wayside Museums, 1947); and Cynthia H. Barton, *History's Daughter: The Life of Clara Endicott Sears Founder of Fruitlands Museums* (Harvard, Mass.: Fruitlands Museums, 1988). Like Haffenreffer, Sears wrote an essay on the seventeenth-century Indians of Southern New England; her more poetic work, which compares fa-

vorably with Haffenreffer's, was called *The Great Powwow: The Story of the Nashaway Valley in King Philip's War* (Boston: Houghton Mifflin, 1934).

17. Curtis Hinsley, "From Shell-Heaps to Stelae: Early Anthropology at the Peabody Museum," in Stocking, *Objects and Others,* 49–74; "Historical Introduction," in Phoebe Apperson Hearst Memorial Volume, *University of California Publications in American Archaeology and Ethnology* 20, ed. A. L. Kroeber (Berkeley: University of California Press, 1923); T. H. Thoresen, "Paying the Piper and Calling the Tune: The Beginnings of Academic Anthropology in California," *Journal of the History of the Behavioral Sciences* 11 (1975): 257–75; Winifred Black Bonfils, *The Life and Personality of Phoebe Apperson Hearst* (San Francisco: John Henry Nash, 1928).

# 1

# ZEST OR ZEAL?

## Sheldon Jackson and the Commodification of Alaska Native Art

Many nineteenth-century Christian missionaries shared an interest in collecting Native artifacts. If the prevalence of such collections is any indication, objects of Native manufacture—especially those associated with sacred realms—were powerful magnets for the very men whose purpose it was to exterminate the religious practices from which these objects derived. In this essay I will account for this contradiction as it played itself out in the career of Sheldon Jackson (fig. 1.1). I will argue that it can be resolved by placing missionary collecting squarely within the matrix of nineteenth-century ideas about science and progress. At the same time, the career of Sheldon Jackson, Alaska's best-known missionary collector, provides a case study in which to consider the attraction that collecting held for the American middle class during the latter half of the nineteenth century and the forces at work in the transition of Native art collections from the private to the public sphere. Further, following Richard Eves,[1] I will argue that, for missionaries, the acquisition of material culture, far from being a benign activity, played a key role in the colonialist project that Jackson and his peers advanced.

### RESIDENT/RETURNEE COLLECTORS

Western culture's penchant for the exotic has had far-reaching effects on the study of Native artifact collecting. Whereas research about the producers

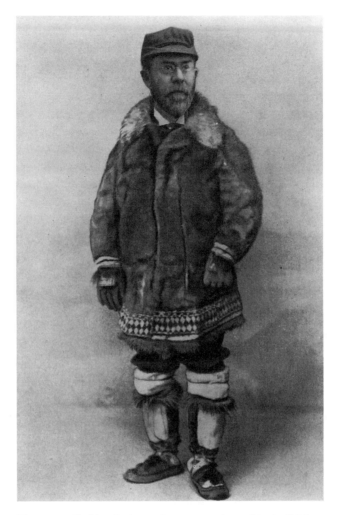

Figure 1.1. Sheldon Jackson about 1890, dressed in the Eskimo garb he wore when making fund-raising speeches. Department of History and Records Management Services, Presbyterian Church (U.S.A.).

of Native art is abundant, inquiries into the preferences, socioeconomic status, and mind-set of its Western consumers are few and far between. Those that do exist, furthermore, tend to concentrate on the high end of the spectrum, focusing on the spectacular activities of world-class collectors[2] and ignoring the rank-and-file middle-class variety who constitute the ma-

jority. Analysis of middle-class collectors of turn-of-the-century Alaska Native art shows that they fall into three distinct subgroups.[3] Most were tourists who acquired a few souvenirs of their trips up the Inside Passage; a few were serious basket collectors; the rest were those I have called resident/returnee collectors, some of whom were missionaries.

As a group, resident/returnee collectors showed several hallmarks. First, unlike the other types, they were usually male. Second, they went north either on a regular basis—like the sailors on the U.S. revenue cutters that patrolled the Arctic waters annually—or they remained in Alaska for extended periods, as did military personnel, teachers, and missionaries. Third, not only did resident/returnee collectors have more time in which to gather Native art, they frequently traveled to parts of Alaska that were off the beaten path. This meant that the array of objects offered them was wider and more closely connected to indigenous ways of life than those found along the tourist route. Fourth, male resident/returnee collectors had access to domains of culture—the sacred, for example—that would have been off-limits to their female counterparts.[4] Finally, resident/returnees often felt compelled to cloak their acquisitiveness in the legitimating mantle of science. Following the dominant paradigm of the time, their common rationale was that Native art collections could illuminate earlier stages of human culture.[5]

## MISSIONARIES AS A SUBSET OF RESIDENT/RETURNEE COLLECTORS

Missionary collectors constituted a special category of resident/returnees. Heeding the call to go forth and convert the world's heathen was not an insignificant assignment. It required both dismantling the existing value system of a culture and structuring a substitute based on nineteenth-century Christian values. Daunting as it may seem today, this task posed fewer obstacles in the nineteenth century, before the concept of ethnocentrism had been problematized and when faith in progress and Western supremacy was absolute.

Christian missionaries seem to have considered the artifacts of Native peoples as metonyms for the indigenous cultures in which they originated, and they used them for an array of religious, economic, and political purposes. They exhibited them to Native people so those people could reflect on the distance they had put between themselves and the old ways and,

sometimes, so they could be reminded of earlier aesthetic standards. Missionaries sent Native artifacts home to sell, thereby to obtain financing for their operations, and they exhibited them at home as proof of Christianity's triumph over primitive religion. Finally, missionaries used Native artifacts to support the hierarchy of social Darwinism in its claims of Western superiority. Whatever the purpose, Protestant missionaries were major players in the appropriation and recontextualization of Native art and artifacts in the West.

## THE DEVELOPMENT OF JACKSON'S INTEREST IN NATIVE ARTIFACT COLLECTING

Presbyterian missionary Sheldon Jackson was the quintessential collector. He was born in upstate New York in 1834, and his parents, who had recently converted to Presbyterianism, pledged on the occasion of his baptism that their son would dedicate his life to the church. Among the seminal experiences of Jackson's youth that propelled him toward mission work were church lectures by missionaries on furlough about their work among the Native peoples of Africa and Asia. His interest in mission work was also fostered by several years' residence with a missionary family while he attended preparatory school in Ohio.

In 1853, at the age of nineteen, Jackson, then a student at Union College in Schenectady, New York, publicly proclaimed his faith and his chosen calling as a missionary. Upon his graduation from Union, Jackson was admitted to Princeton Theological Seminary, known as a fertile training ground for missionaries.[6] At Princeton, his high intelligence, curiosity about the natural world, fascination with other cultures, and passion for collecting matured alongside his missionary calling. As a teenager he had amassed collections of botanical specimens and compiled detailed notes on different ethnic groups. While he was at Princeton, a chance encounter with a missionary collection of artifacts from Thailand opened his eyes to the possibilities of using such objects to further his Christian ends. Initially, he saw their potential as a lure for recruiting seminary students to the missionary calling, though later he found them useful for other purposes as well.[7]

It was not until 1876 that Jackson had the chance to find other, wider uses for material culture in his quest for the souls of Native people. After tours of duty in the Midwest and the Plains, Jackson, whose formidable energy and genuine interest in the cultures of his largely Native American flock

were matched by his silver-tongued oratory and enthusiasm for spreading the Christian message, was reassigned to the sparsely settled Southwest. A skilled and imaginative fund-raiser since his days as a door-to-door salesman of religious books while at Princeton, Jackson soon realized that Native artifacts could be used to finance his ambitious plans to missionize the Far West,[8] where in 1869 he had been appointed mission superintendent for the Synod of Iowa. In addition to Iowa, the territory included the modern-day Dakotas, Idaho, Montana, Nebraska, Utah, and Wyoming. Over the next decade, Jackson lived mainly in Denver but traveled 29,000 miles around his territory, founding twenty-two churches. At the same time, he summarily added the territories of Arizona, New Mexico, Washington, and, finally, Alaska to his turf.[9]

## THE MULTIPLE ROLES OF NATIVE ARTIFACTS IN JACKSON'S MISSIONARY PROJECT

Exactly when Jackson began making use of Native American artifacts is unclear, but the first recorded instance of his collecting was in 1870, when he noted in a letter to his newsletter, the *Rocky Mountain Presbyterian,* that he had found a basket, a stone artifact, and a Pima pot during his travels around the Southwest.[10] By the late 1870s his collecting activities had mushroomed, attracting the attention of such nationally prominent institutions as the Smithsonian, to which he sometimes contributed specimens and with which he sometimes competed for them.[11]

Jackson seems to have been fully aware that Native artifacts held a growing fascination for middle-class Americans. That such would be the case in a culture repressed by the inhibitions of Victorianism is not surprising. The stereotype of so-called primitive peoples as idol-worshipers given to orgies and cannibalism was yet to be vanquished, and Native artifacts made tangible these associations.

In addition to the allure of the exotic, Native-made objects also appealed to a streak of nostalgia in the American public. In the increasingly urbanized and industrialized nation, yearnings for rapidly disappearing rural life nourished a romanticized vision of untouched Native culture and an appetite for its material artifacts.[12] Between about 1880 and 1910 it was fashionable to collect Native American art and to display it in curio cabinets, cozy corners, and other architecturally devised spaces.[13]

Jackson was not the first missionary to capitalize on this attraction, but

he was certainly among its most dedicated adherents. Throughout his long career he devised innumerable uses for Native artifacts in raising money for his mission work. He often reciprocated for the many favors he asked in the course of his projects with raven rattles and other artifacts as gifts. Before his shift of focus to Alaska in the late 1870s, he offered artifacts as premiums to those who donated fifty dollars or more to the *Rocky Mountain Presbyterian*.[14] Jackson also gave Native artifacts as gifts to those who had been helpful in his fund-raising campaigns, and they were sometimes shipped east to sell at church bazaars.[15] Thus Jackson was among the most ardent of the early commoditizers of Native American material culture, and as such, he played a major role in popularizing Native art among the American middle class.

## SHELDON JACKSON AND ALASKA NATIVE ART

In 1877 the ever-restless Jackson made his first trip to Alaska. Overlooking the century of Russian Orthodox missionization that had preceded the 1867 Alaska Purchase, he portrayed Alaska as virgin territory in which he would vie for the souls of the heathen aboriginal population. For instance, in his 1880 *Alaska and Missions on the North Pacific Coast,* Jackson writes: "When in 1867 this vast territory, with a population of from 30,000 to 50,000 souls, was turned over to the United States, the call of God's providence came to the American church to enter in and possess the land for Christ."[16]

On returning from his first trip to Alaska, the diminutive minister, with characteristic aplomb, annexed the American North to his territory, which already included most of the sparsely settled Far West, without bothering to obtain advance permission from church authorities. From 1870 to 1890, his professional life was increasingly tied up with converting, educating, and acculturating Alaska's Native peoples[17] and with the lobbying necessary to realize his ambitions. Jackson sincerely believed that he was rescuing the people from "heathenish rites and devil worship."[18] "God is placing Alaska at the feet of our beloved church," he wrote. "Let us take possession in the name of the Lord."[19]

In Alaska more than in Jackson's earlier tours of duty, Native artifacts played a pivotal role in his nationwide fund-raising program. Dressed in an Eskimo parka and fur boots and armed with an extra parka for audiences to try on, he crisscrossed the country, marshaling financial and moral sup-

port for his campaign to bring Alaska's Native peoples into the Christian fold. Between 1877 and 1883 alone, he is estimated to have delivered more than nine hundred speeches about America's farthest-north territory.[20] In addition to public appearances, he set about publicizing the plight of Native Alaskans through a dizzying array of lectures, as well as mainly repetitive articles in the popular press and seemingly ceaseless lobbying in Congress, where he even went so far as to put an Eskimo parka on exhibit to attract attention to his cause.[21] In Congress, in the pulpit, and behind the lectern, his persistence paid off. Over two decades, he garnered enough support for Alaska to found and staff churches, establish schools across the territory, and launch a reindeer-herding program among the Eskimos of the Arctic coast.[22]

Jackson acquired Native material by several different methods. First, he himself collected enthusiastically whenever possible. During his annual inspection trips, first to southeastern Alaska and later among the Alaskan Eskimos, he never missed a chance to trade for artifacts as he moved from village to village. Adopting what Rosemary Carlton calls a "vacuum cleaner" approach to the task,[23] he amassed thousands of Native artifacts over the years. One considerable boon to his activities was his federal appointment in 1855 as general agent of education for Alaska during his campaign to establish schools in the North. Whether in fact or by Jackson's interpretation, the title—one that he apparently made up and used well in advance of obtaining his appointment—carried with it the power to commandeer space on government vessels and the services of their personnel, privileges that he used to advantage in his collecting activities, especially after he began to travel to Arctic Alaska.[24]

As his reputation grew, benefactors and audiences were not the only ones to profit from his collecting. Both individuals and museums, such as the Field Museum of Natural History and the Peabody Museum of Archaeology and Ethnology at Harvard, sometimes asked him to search for a particular piece or to gather Alaskan material to bolster their inventories.[25] Jackson by no means gathered every artifact later attributed to him, however. The second means by which he obtained artifacts was through field collectors. Missionaries, teachers, prospectors, and other inhabitants of the remote outposts under his command were entreated to send him all the specimens of local manufacture that they could gather. Such documentation as survives suggests that his requests often met with success.[26]

Jackson also served the cause of popularizing Native artifacts through his role as an early advocate of Alaska tourism. During his tenure in the

Southwest he had hit upon the idea of escorting parties of educators, congressmen, and other influential persons to view for themselves the plight of Native Americans. The junkets also offered Easterners the chance to buy Native American artifacts.[27] During the 1880s Jackson extended the practice to Alaska, often bringing groups of church dignitaries or educators to Sitka on his annual tour of duty. Thus he also boosted the artifact trade through his role as tour organizer. It was not long afterward that tourism became the major outlet for Alaska Native arts and crafts.

## THE FOUNDING OF THE SHELDON JACKSON MUSEUM

Native artifacts were also essential to a second component of Jackson's campaign for the souls of Alaska's Native people. The idea of founding a museum for the display of such material was one that he had been exploring for some time. In 1879 he had had what he referred to as a "cabinet" of Native art installed at Princeton Theological Seminary. Harking back to the impression that the missionary artifact collection from Thailand had made on him as a Princeton student, he hoped that a comparable collection of Native American material would attract students to the missionary profession by acquainting them with the primitive state of far-off indigenous cultures. But the Sheldon Jackson Home Mission Collection, as he named it, also served as a means of publicizing his missionary efforts and as a monument to his robust ego. Though it never reached the size of his later collection in Sitka, beginning in 1879 he nonetheless sent to Princeton hundreds of pieces of southwestern pottery, a Tlingit totem pole, and other Alaska Native art over the years. After two years, he had added so much to the collection that it outgrew its home and funding in the theological school and was transferred to the Princeton University Natural History Museum.

But Jackson's ambitions as a collector and exhibitor of Native art did not stop at the gates of his alma mater. In the early 1880s, recognizing the Native Alaskans' need to enter the money economy, he founded the Sitka Industrial and Training School, whose curriculum included a carving and weaving program. There, students turned out replica artifacts to sell to the sightseers who flocked ashore from the summer tour ships. At the school, he also began a second collection of artifacts that was far more extensive than the first.

About the same time, Jackson, with the encouragement of some visiting educators and the enthusiasm of locals with natural history and ethnology

interests, founded an organization dedicated to the collection, preservation, and publication of Alaskan natural history and anthropology. Called variously the Alaskan Society of Sitka and the Museum of Natural History and Ethnology, it was loosely connected to the staff at the Sitka Industrial and Training School. The group was charged with collecting objects that would inspire students to work in the same vein as their forebears. Meeting irregularly until 1911, the society sponsored evening talks on topics of interest and promoted the cause of science and the collecting of Native artifacts.[28]

As usual, Jackson's motives in founding the society and the museum were multiple. His stated purpose was to acquaint students with the quality of their artistic heritage and to encourage them in marketable skills such as vocational arts. At the same time, however, he saw the collection and display

Figure 1.2. The first Sheldon Jackson Museum and Library. Finished in 1889, the structure was built to resemble a Northwest Coast community house. The designs were painted by Edward Marsden, a Tsimshian student at the Sitka Industrial and Training School, who later became the first ordained Northwest Coast Indian Presbyterian minister. Early Prints Collection, Alaska State Library, Juneau, PCA 01-517.

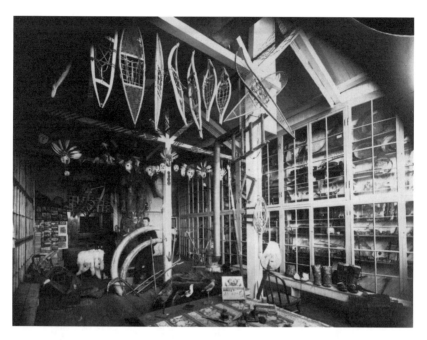

Figure 1.3. Interior of the original Sheldon Jackson Museum and Library, around 1894. Many of the wooden cases were moved from the original building and are still in use today. Case and Draper Collection, Alaska State Library, Juneau, PCA 39-193.

of traditional artifacts as a way of demonstrating to Tlingit and tourist alike how far Native people had progressed out of the heathen darkness, thanks to the benefits of Christian education.

Altruism was not the only motive for the founding of the Sitka museum, however. In this, as in most of Jackson's activities, egotism and acquisitiveness also played a part. By 1889 the collection, first called the Sheldon Jackson Museum and Library, had outgrown its home in the school's chapel and was moved to a new frame building financed by Jackson (figs. 1.2 and 1.3). In 1897 the collection was again reinstalled, this time in its present home, an octagonal concrete building designed by a Boston architect, the first fireproof structure to be built in Alaska. Jackson, who also paid for the new building, let it be known that he would not object to having his name above the door (fig. 1.4).

In the early years of its existence the Sheldon Jackson Museum and Li-

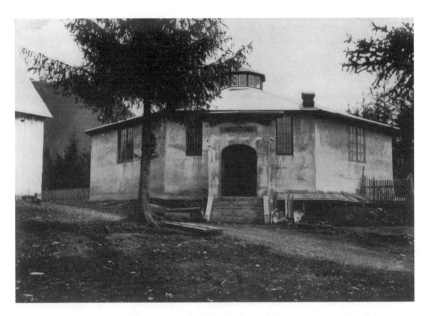

Figure 1.4. Exterior of the present Sheldon Jackson Museum. Completed in 1897, the octagonal concrete building was the first fireproof structure in Alaska. Department of History and Records Management Services, Presbyterian Church (U.S.A.).

brary received donations from many sources, such as revenue cutter personnel, Moravian missionaries, and Alaska Commercial Company traders. But the lion's share of the collection came from Jackson himself. At first, the bulk of the material was gathered from the nearby Northwest Coast (primarily Tlingit) Indians, but by 1890 increasing competition from other collectors drove the prices beyond Jackson's reach. In response, he turned his attention to the North, where artifacts were still plentiful among the more remote Yup'ik and Inupiaq Eskimos. For example, from his 1892 Arctic tour Jackson donated about 1,500 Eskimo objects, and the following year he contributed 3,000 more from the same source.[29]

The museum was not the only part of Jackson's domain to profit from his collecting. He also supplied the museum's store, which mainly sold products from the training school, with duplicate artifacts acquired on the trips north. The store's inventory was substantial enough that two museums at major universities now hold northern materials from this source.[30]

As the century drew to a close, however, Jackson became increasingly

committed to developing an even wider public forum in which artifacts were used to woo the general public into supporting his schemes. Beginning with the 1893 World's Columbian Exposition in Chicago, he mounted at least four different artifact exhibits and displays of training school handiwork at world's fairs and expositions across the nation. As he became increasingly absorbed by expositions, his commitment to filling the shelves of the Sheldon Jackson Museum diminished. Even so, by the time of his death in 1909, Jackson had contributed more than two-thirds of the museum's total inventory.[31]

## NATIVE REACTIONS TO JACKSON'S COLLECTING PRACTICES

The question of how Alaska Natives perceived Jackson's collecting program is tantalizing; on this issue the literature is frustratingly silent. Whereas reactions to the establishment of formal schooling among Alaska Natives are legion, local responses to Jackson's artifact collecting are rarely mentioned. For instance, a biography of Edward Marsden, the Tsimshian student at the training school who was responsible for the Northwest Coast designs on the second museum building, makes no mention of Jackson's second vocation.[32] The most likely explanation is that curios and the collecting of them were too little valued at the time to arouse comment.

That the Tlingit were not completely supportive of his methods, however, is suggested by an incident witnessed by John Muir early in Jackson's Alaska tenure. When Jackson ordered a totem pole to be felled for removal from a deserted village, he was rebuked by his Native guide, who asked how Jackson would respond if a Native person removed a gravestone from his family plot. The incident seems to have affected Jackson, who thereafter became more cautious about unethical practices.[33]

Another, more indirect line of evidence suggests that Jackson's collecting methods were unpopular among his Native constituents. According to Sergei Kan, there was a dramatic rise in Tlingit conversion to Russian Orthodoxy during the 1880s, after Jackson founded Presbyterian missions in Sitka and Wrangell and well after the withdrawal of the Russians from this same region.[34] Kan argues that the conversions can be attributed to the relentless missionizing of the Presbyterians and their insistence that the Tlingit converts renounce traditional practices such as the potlatch. The Russian Orthodox Church was more tolerant of traditional practices among Native people than were the Protestant sects. Kan was told by his infor-

mants that Tlingit families often went so far as to hide potlatch artifacts from the Presbyterians, but Carlton was able to find no evidence that Jackson or any other Presbyterian missionary confiscated artifacts or forced Native people to relinquish them as part of the conversion process.[35]

## CONCLUSIONS

What light does the career of Sheldon Jackson shed on missionary collecting in general and on the contradictions inherent in such collections in particular? Furthermore, what does Jackson's exhibiting of Native art tell us about the nature of Native artifact collecting at the turn of the century?

First, it is apparent that Jackson's collecting of artifacts, like his founding of the museum that housed them, was undertaken to further his ultimate goal of converting Alaska Natives to Christianity. In his book, his articles, and still more in his public lectures and lobbying, Jackson fabricated a missionary discourse in which he called on Native artifacts to provide the contrastive unit against which to construct the enlightened Christian path to eternal salvation.[36] His works are studded with descriptions of Tlingit dance performances in which horrible masked figures representing the devil danced around with hideous rattles, then made speeches in which they reaffirmed their Christian faith by relinquishing their musical instruments.[37] Exaggerated as this now seems, it is important to remember that such missionary discourse constituted the earliest experiences that several generations of Americans had with indigenous people.

Nineteenth-century missionary collecting was an epiphenomenon of the voracious appetite for non-Western material culture that took hold during that time. And Christian missionaries apparently did not see any inconsistency in their acquisition of Native art with one hand and their destruction of the institutions from which it sprang with the other. Products of their time and culture, Protestant missionaries embraced the scientific law of survival of the fittest; the ethnocentric assumption that Western culture stood at the pinnacle of the hierarchy enabled them to view the demise of the less-fit small-scale societies as inevitable.[38] As Jackson pointed out: "I have seen these people come up step by step from . . . heathen degradation . . . into the light of Christian civilization."[39]

That the biological model of evolution pertained equally to the realm of culture was a given in the nineteenth century, so if Native culture was doomed to extinction, missionaries saw it as their moral duty to replace its

institutions with their own. Conviction of the righteousness of their task blinded men of God to their central role in the destruction of the small-scale societies that were on the losing end of the power equation. Missionaries like Jackson sincerely believed in exhibiting Native material culture as evidence of primitive peoples' progress up the evolutionary ladder, and in warehousing these same artifacts for the benefit of science.

As Nicholas Thomas rightly argues—and as Jackson's collection corroborates—missionaries were especially attracted to sacred artifacts.[40] And well they might be. For one thing, whether or not missionaries such as Jackson acknowledged it, the appropriation of Native artifacts—many of which had ritual purposes—removed them, at least symbolically, from circulation and made it incrementally more difficult for Native people to practice the beliefs associated with them. For another, the act of appropriation altered the meaning of such objects. On the symbolic level, a mask that had once brought life to a religious ceremony repudiated that ceremony once it was recontextualized in a missionary's exhibit. And when such a mask was collected, so, implicitly, was the ceremony attending it. Detaching an artifact from its ambient effectively neutralized the practice as well as the object that spoke for it.[41]

Without doubt, Jackson's conviction—and that of his counterparts in Africa and Oceania—that substituting Christianity for indigenous religion would benefit the peoples in question was genuine, and the founding of schools in rural Alaska fed into this deeper purpose. If Native Alaskans were better off for knowing how to read or write, however, it was with the ulterior motive of providing access to the Christian Bible. The link between religion and education under Jackson's regime is corroborated by the record. Teachers in the village schools in southeastern Alaska were expected to take an active role in conversion. According to William Du Puy: "In the [Alaska] native villages it is but natural that the teacher . . . should organize Sunday-schools. . . . In this way he . . . readily becomes the wise man of the community, replacing the medicine man."[42]

A century after Jackson's Alaska years, when the pervasive mores and values support ethnic plurality rather than assimilation, it is easy to cast aspersion on his career. To do so, however, is to judge him unfairly. Jackson's dedication to the cause of converting Alaska Natives is but one isolated instance of a worldwide missionary crusade, one carried out with the absolute conviction that Western culture stood at the pinnacle of the evolutionary chain of being. Jackson's aim to save the souls of every man, woman, and child in Alaska was informed by this assumption.

At the same time, Jackson's project was reinforced by the federal government's ongoing neglect of its responsibilities for Alaska and its Native people. By appointing Jackson to the position of general agent of education for Alaska, the government granted him the authority to staff the Alaska schools with missionaries and design the educational curriculum to include a strong component of Christian doctrine. Whether or not we find the underlying assumption unpalatable, the separation between church and state was less clearly defined a century ago, and wholesale condemnation of this, or the racism inherent in the idea of the "Great Chain of Being" that informed it, amounts to a form of presentism.

Jackson also founded the Society of Alaska Natural History and Ethnology to further his agenda. In 1893, for example, the society published a circular letter requesting information about "totemism," which read in part:

> There are certain questions related to Totemism and Family Descent which can only be settled by carefully questioning the elder natives. In other words, [what is] the bearing of totemism on marriage and on the inheritance of property?[43]

It is less likely that the query[44] was motivated by scientific curiosity than by the need to explain the social system in order to dismantle it. Missionaries' aversion to communal living is at least as well documented as their determination to do away with such systems in favor of the Western model of nuclear families with bilateral kinship organization.

What can the career of Sheldon Jackson tell us about the nature of nineteenth-century Native artifact collecting in general? For one thing, Jackson's professional life is a case study of a trend widespread in Euro-American culture at that time. The latter half of the nineteenth century witnessed a dramatic change in the practices associated with public exhibition. It was the time when the more elitist cabinets of curiosity were being replaced by the great museums as larger numbers of people moved to the city. And in Jackson's collecting patterns we see a clear example of the shift. In 1879 he used the very term "cabinet of curiosity"[45] to describe the collection that he established at Princeton, and indeed it was such: a modest, unsystematic collection housed in the rarefied atmosphere of a university campus, whose intended audience was small and select. Twenty years later, when he founded his museum in Sitka, and still later in his exhibitions at world's fairs and expositions, we see his increasing alignment with the democratizing spirit of the age. As Carol Duncan reminds us, the princely cabinet of the eighteenth century, which was tied to developing concepts of na-

tionalism after the French Revolution, was the antecedent of the public museum.[46] Duncan goes on to argue that the public museum was a safe vehicle for disseminating the political propaganda of nationhood to a recently empowered middle class without running the risk of redistributing any real power.[47]

Jackson moved Native art into the mainstream in yet another way. Though his educational tours undoubtedly furthered the cause, it was through his entrepreneurial schemes of shipping artifacts off to benefactors that he had his greatest impact. In his long career, Jackson was responsible for moving many thousands of Native American objects across the cultural divide. His pioneering efforts were a force in building consumer interest and providing an avenue for disseminating Native artifacts throughout the middle class. Jackson was by no means alone in this endeavor; missionaries across Alaska—and, indeed, all over the world—sent back Native artifacts, though perhaps no one made a more determined effort over a longer period of time than he. To the American middle class, these artifacts were tangible representations of the far-off Native Americans who made them. For more than thirty years Sheldon Jackson made sure that such reminders were theirs for the asking.

## Notes

1. Richard Eves, "Missionary or Collector: The Case of George Brown," *Museum Anthropology* 22, no. 1 (1998): 49–60.
2. See, for example, Douglas Cole, *Captured Heritage* (Seattle: University of Washington Press, 1982).
3. Molly Lee, "Appropriating the Primitive: Turn-of-the-Century Collection and Display of Native Alaskan Art," *Arctic Anthropology* 28, no. 1 (1991): 6–15.
4. Jehanne Teilhet, "The Equivocal Role of Women Artists in Non-literate Cultures," *Heresies* 4 (1977): 96–102.
5. Lee, "Appropriating the Primitive"; see also Molly Lee, "Tourists and Taste Cultures," in *Unpacking Culture,* ed. Ruth B. Phillips and Christopher B. Steiner (Berkeley: University of California Press, 1999), 267–81.
6. Rosemary Carlton, "Sheldon Jackson, the Collector" (master's thesis, University of Oklahoma, 1992), 20–24.
7. Ibid., 24.
8. Ibid., 24–36.
9. Ibid., 35, 40.
10. Ibid., 48.
11. Ibid., 49.
12. Lee, "Tourists and Taste Cultures."
13. Lee, "Appropriating the Primitive."
14. Theodore C. Hinckley, "The Alaska Labors of Sheldon Jackson, 1877–1890" (Ph.D. diss., Indiana University, 1961), 101–2.

15. Carlton, "Sheldon Jackson," 47.
16. Sheldon Jackson, *Alaska and Missions on the North Pacific Coast* (New York: Dodd, Mead, 1880), 129.
17. Carlton, "Sheldon Jackson," 64–82.
18. Sheldon Jackson Scrapbooks, Microfilm Collection 33, roll 1, frame 42 (Philadelphia, Presbyterian Historical Society), Alaska and Polar Regions Collection, Elmer E. Rasmuson Library, University of Alaska, Fairbanks.
19. Sheldon Jackson Scrapbooks, 33, 1, 50.
20. Hinckley, "The Alaska Labors," 101–2.
21. Sheldon Jackson Papers, Microfilm Collection 191.
22. Carlton, "Sheldon Jackson," 89–116.
23. Ibid., 104.
24. Ibid., 50–51.
25. Ibid., 94.
26. Ibid., 57, 70.
27. Ibid., 46.
28. Ibid., 137–42.
29. Ibid., 185.
30. University of Michigan Museum of Anthropology and the Haffenreffer Museum of Anthropology, Brown University; Carlton, "Sheldon Jackson," 178–80.
31. R. N. Dearmond, "The History of the Sheldon Jackson Museum," in *Faces, Voices, and Dreams*, ed. Peter L. Corey (Juneau: Alaska State Museum, 1987), 3–19.
32. William G. Beattie, *Marsden of Alaska* (New York: Vantage, 1955).
33. Carlton, "Sheldon Jackson," 77–78.
34. Sergei Kan, "Russian Orthodox Brotherhoods among the Tlingit: Missionary Goals and Native Response," *Ethnohistory* 32, no. 3: 196–222.
35. Carlton, "Sheldon Jackson," 80.
36. Nicholas Thomas, "Colonial Conversions: Difference, Hierarchy, and History in Early Twentieth-Century Evangelical Propaganda," *Comparative Studies in Society and History* 34 (1992): 366–89.
37. See, for example, Jackson, *Alaska and Missions,* 104 and 178.
38. It would have been instructive to know if the artifacts in the museum were arranged so as to reflect the evolutionary model. Unfortunately, this information was not recorded (Rosemary Carlton, telephone interview, September 4, 1998).
39. Sheldon Jackson Papers, Microfilm Collection 191, 7, 102.
40. Nicholas Thomas, *Entangled Objects* (Cambridge: Harvard University Press, 1991), 168.
41. Ibid., 156.
42. William A. Du Puy, "The Awakening of the Alaskan," *American Review of Reviews* (n.d.), 179; undated copy in the Sheldon Jackson Collection, Collections of the Department of History, Presbyterian Church, Philadelphia.
43. Dearmond, "History of the Sheldon Jackson Museum," 12.
44. The same circular carries the implication of White ownership of Tlingit culture: "As citizens of the United States, it is a matter of importance that the

credit for such work [obtaining information about totemism and descent] shall not fall to foreigners, as it will unless forestalled." The xenophobia was probably brought on by the presence in Alaska of Ariel and Adrian Krause, a pair of German ethnographer brothers, though whether the Americans had any more right than the Germans to the information is open to question.

45. Carlton, "Sheldon Jackson," 24.
46. Carol Duncan, "Art Museums and the Ritual of Citizenship," in *Exhibiting Cultures*, ed. Ivan Karp and Steven D. Lavine (Washington, D.C.: Smithsonian Institution Press, 1991), 88–99.
47. Ibid., 92–94.

MOIRA T. McCAFFREY

# 2
# RONONSHONNI—THE BUILDER

## David Ross McCord's Ethnographic Collection

Years ago at a Council of the Six Nations at Brantford this name [Rononshonni] was conferred upon me. There was something most prophetic in it which now impresses me as I near the end of my earthly term. . . . I always thought it meant a member of the Iroquois Confederacy . . . but it was much more in fact and [in] light of my life-work . . . this National Museum—and the part the Indian section of it plays—I do not know what the Council saw in me—but the name means *a builder.*[1]

David Ross McCord wrote these words in 1916, twenty-six years after the ceremony in which he was given an Iroquois name by representatives of the Six Nations Confederacy. He probably received this honor primarily in recognition of legal advice he had provided regarding treaties and land claims, since at the time of the ceremony he had not yet begun to collect ethnographic artifacts systematically.[2] Nevertheless, he recalled the ceremony with drama and emotion as he savored the newly discovered significance of his honorary name (fig. 2.1).

The McCord National Museum, the crowning achievement of David Ross McCord's lifelong collecting activities, officially opened in downtown Montreal on October 13, 1921. It exhibited one of the largest and most diversified Canadian historical collections of the time. From 15,000 to

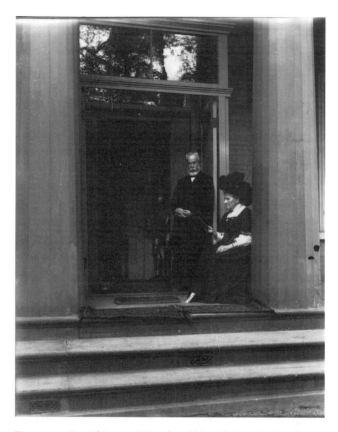

Figure 2.1. David Ross McCord and his wife, Letitia Caroline
Chambers, at Temple Grove, ca. 1910. Notman Photographic
Archives, McCord Museum of Canadian History, Mp2135(7).

20,000 artifacts were presented in thematic displays on such topics as aboriginal people, exploration and the fur trade, missionaries, New France,
the Seven Years' War, and the history of Montreal. McCord's motto for the
museum and the leitmotiv for his collecting activities was, "When there is
no vision, the people perish."[3]

Collecting ethnographic material played a predominant part in McCord's
self-proclaimed mission. The goal of this essay is to understand why and
how McCord collected aboriginal artifacts, and the place they occupied in
his national museum. To determine the genesis of McCord's attitudes about
Native people, I begin by reconstructing his childhood and education.
Next, I explore the historical context in which McCord set out to build his

collection and the specific factors that shaped his views and assumptions. I describe the methods he used to acquire artifacts from across Canada and examine the types of displays he designed, both within his home and for his eventual museum. In conclusion, I explore McCord's legacy by evaluating the collection's relevance and the significance that his work holds today.

The insights presented here are based to a large extent on the exceptionally rich corpus of documents that comprises the McCord Family Papers.[4] The papers include David Ross McCord's correspondence with aboriginal leaders, dealers and middlemen, government agents, missionaries, other collectors, supporters, and professional archaeologists and anthropologists working in both Canadian and American institutions. Also preserved are receipts and research notes prepared by McCord for most of the objects he purchased or received as donations, as well as his historical notebooks— five slim volumes containing his thoughts and comments on a range of topics, including aboriginal people.

## FAMILY BACKGROUND

David Ross McCord (1844–1930) was born into a well-established family of merchants, lawyers, and landowners. In 1760, John McCord, his great-grandfather, left Ireland for Quebec City as a provisioner for the conquering British army. He quickly set up shop, offering a variety of goods mainly imported from England, including haberdashery, groceries (sugar, tea, rum, spices), and hardware. Thomas McCord, one of John's sons and David Ross McCord's grandfather, was also a merchant; however, he gradually began to play an active role in judicial matters, a situation not uncommon at the time for merchants of high standing. In 1788 Thomas became a justice of the peace for Montreal, and in the 1790s he was appointed a municipal court judge.[5]

McCord's parents played a critical role in shaping his interests, personality, and passion for collecting. His father, John Samuel McCord (1801–65), was a prominent member of the Montreal Bar Association and served as a circuit court judge throughout the Eastern Townships and the Ottawa Valley. His mother, Anne Ross (1807–70), came from a family of leading Montreal lawyers. She married John Samuel in 1832 and had six children over the next twelve years. By all accounts, the McCord household was a happy and privileged environment, where the children's lives were guided by intellectual pursuits of all kinds.

Anne Ross was known for her intelligence and her forceful personality. As a teenager, she assembled a small museum of curiosities, and she presumably encouraged her children to follow similar pursuits. In addition to serving as secretary of the Montreal Orphan Asylum, she was an accomplished amateur watercolor artist who specialized in meticulously rendered depictions of flowers.[6] John Samuel McCord was a deeply religious man who was actively involved in Montreal's Christ Church Cathedral. In addition to his duties as a circuit court judge, a lawyer, and a landowner, he was a Mason, a lieutenant colonel in the militia, an elected member of the first council of the Art Association of Montreal, and an accomplished amateur scientist. John Samuel's principal scientific interest was meteorology. He pursued his studies with passion, keeping detailed meteorological journals and exchanging information with some of the leading scientists of the day.[7]

## DAVID ROSS McCORD'S UPBRINGING AND EDUCATION

McCord grew up at Temple Grove, an imposing neoclassical structure that had once been the family's summer refuge. The home, on the slopes of Mount Royal, had a commanding view of Montreal that swept across the old city to the St. Lawrence River. With the help of servants, the McCords nurtured extensive gardens, often experimenting with new species of flowers and shrubs. The large library at Temple Grove was filled with erudite volumes, while the walls were covered with watercolor views of Montreal commissioned from the prominent Montreal artist James Duncan over a period of twenty years.[8] Temple Grove was the scene of many intimate family events, such as Christmas of 1854, when the children recited new pieces of poetry following a formal dinner.[9] On occasion, the house and gardens served as a backdrop for elaborate dinner parties at which the McCords entertained up to eighty guests, including many social and intellectual luminaries of the time.

John Samuel McCord's diaries provide a glimpse of the cultural and intellectual currents that shaped David's interests from a very early age. When he was only four years old, David and his siblings were taken to cultural events such as the "Diorama of Winter." At seven he went to the circus, and by nine he attended lectures on topics such as literature, religion, science, Greek tragedy, and Canadian history.[10] While still in his early teens, he often went to meetings of the Natural History Society of Montreal.[11] A particular treat for the McCord children was accompanying their

father on his travels as a circuit court judge. Thus, in 1862, David traveled to Waterloo, Ontario, with his father to undertake a "botanical excursion": while John Samuel was in court, David was "in the woods."[12] Two years later he shared the results of his research with members of the Natural History Society of Montreal in a paper titled "On Canadian Ferns, Their Varieties and Habitat."[13]

The McCords insisted on a broad classical education for their children that included fluency in the French language. After completing primary school, David attended Montreal High School, where he greatly pleased his parents by winning prizes in classics, geography, and history.[14] He went on to McGill University, where he completed his B.A. in 1863, and his M.A. and B.C.L. (law degree) in 1867. After graduation McCord successfully clerked with the Montreal legal firm of Leblanc, Cassidy, and Leblanc, and became an advocate in 1868 and a Queens counsel in 1895.[15]

## "WELL POSTED IN THE INDIAN MATTERS": McCORD AND ABORIGINAL PEOPLE[16]

David Ross McCord's interest in aboriginal people and issues may have been sparked at a very early age through conversations with his parents. His mother, Anne Ross, had a close friend whose son, the sheriff of Montreal, was married to an aboriginal woman. Later in life, McCord wrote about this woman in very respectful terms in his historical notebooks.[17] Also, John Samuel occasionally passed through the Mohawk community of Kahnawake, located near Montreal, in his professional travels. A diary entry dated November 1853 indicates that he had a three-hour stopover at the "Indian village terminus" and spent this time "among the Indians by learning the correct names of several places." In his typically laconic manner, John Samuel also noted: "The [I]ndians when talking of the [S]cotch [*sic*] call them dung, excrement from the shape of their flat projecting bonnets which look like cakes of cow dung."[18]

Perhaps David Ross McCord's earliest firsthand encounter with aboriginal people took place in Montreal at the 1850 Provincial Industrial Exhibition when he was six years old. His father was greatly involved in the event, which included "Indian Games."[19] David may also have been present at the 1860 festivities linked to the completion of the Victoria Bridge and the visit to Montreal by the Prince of Wales. One event involved a flotilla of nine Hudson Bay cargo canoes manned by one hundred Iroquois from Kah-

Figure 2.2. Headdress, Iroquois (Mohawk), 1860. Cotton, glass beads, silk. Worn on August 29, 1860, at the festivities linked to the completion of the Victoria Bridge. Length 30 cm. McCord Museum of Canadian History, M1085.

nawake and the "Lake of Two Mountains" (the present-day community of Kanehsatà:ke). The paddlers wore specially made costumes that included beaded and feathered headdresses and scarlet cloth leggings. Decades later McCord collected a headdress and a pair of leggings worn at this portentous event for his fledgling museum (fig. 2.2).[20]

At the age of fourteen, David had an experience that may have marked his life forever. As a reward for good conduct and prizes obtained in school, he was invited to accompany his father on a steamer trip to Ottawa. While there, they visited John Samuel's schoolmate Dr. Edward Van Cortlandt.

He showed them "his cabinet," which was crammed with archaeological artifacts from the Ottawa region, and promised to aid David in his geological studies.[21] While in Ottawa, John Samuel often dined with another close friend, William Foster Coffin. A lawyer and retired sheriff of the District of Montreal, Coffin had investigated "problems" at Kahnawake in the 1840s.[22]

As a young man, McCord had an active law practice representing the City of Montreal, as well as important industrial and institutional clients. He also appears to have provided legal counsel to a number of aboriginal communities. Unfortunately, the records from McCord's legal practice were destroyed in a fire, and little is known of his involvement with the Iroquois prior to 1890, the year in which he received his honorary name. From 1893 to 1895, McCord carried on a correspondence with Jeremiah Hill of Six Nations pertaining to treaties and land rights. The following excerpt from a letter written by Hill on November 13, 1893, leaves little doubt that McCord was openly supportive of aboriginal causes. "If you really desire to help us Indians to be freed from the apparatus of the Government towards their Indian fellow subjects . . . I wish the Great Spirit would bless you and give you long live [sic], I presume it was through him that caused for you to sympathize the Indians."[23]

Two years later, in 1895, McCord visited the Huron community of Lorette, situated close to Quebec City. The exact purpose of the trip is not known, but his notes show that while there he interviewed a number of individuals about wampum, a subject that fascinated McCord throughout his life. He spoke to Chief Maurice Bastien, as well as to Gaspard Picard, Philip Vincent, and Paul Picard—who showed him some wampum belts. McCord drew meticulous illustrations of the belts and took notes on their possible age, method of manufacture, and meaning.[24]

## McCORD THE COLLECTOR

David Ross McCord appears to have begun collecting seriously around the time of his marriage in 1878. He had precipitated a family row when he began courting Letitia Chambers (1841?–1928), who had emigrated from Ireland and was matron of the Montreal Smallpox Hospital. The problem was, her family's financial and social background did not meet with the approval of McCord's sisters. Revealing a streak of fierce independence that characterized him throughout his life, McCord ignored his sisters' admoni-

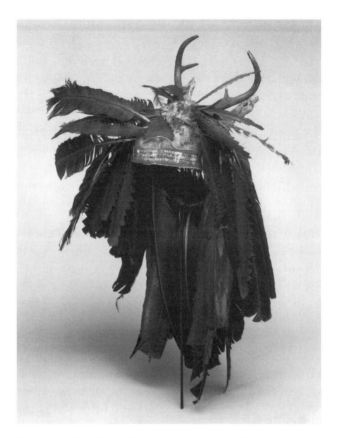

Figure 2.3. Headdress, Iroquoian type, late eighteenth century. Deer-head skin with antlers, tanned hide, porcupine quills, red stround, cloth, wool padding, eagle feathers, downy feathers, thongs, vegetable fiber, red ochre. Height 54 cm. McCord Museum of Canadian History, M182.

tions, married Letitia, and promptly took over Temple Grove with his new bride, forcing his sisters to find lodging elsewhere. The couple remained childless, and there are indications that McCord was not an easy man to live with.[25] Nevertheless, it is clear that in Letitia he found a partner to share his vision and support his obsessive collecting activities. In one of his catalogs, McCord inscribed the following dedication:

A word regarding my dear wife. Without her sympathy and cooperation I never could have succeeded . . . she appreciated history and the humble work in which I was engaged—an attempt to save the historical land marks. Her serious habits

permitted me, while occupied with a profession, to keep up the knowledge, without which I could never have accomplished what little I have done. She has been my constant companion and patient sympathetic & keen assistant in the field and in our visits to many quarters and many people for facts and *vestigia*.[26]

McCord's earliest acquisitions were in keeping with his father's interests. He commissioned a well-known painter, Henry Bunnett, to document the rapidly changing landscape of Montreal. He also amassed an impressive library of more than eight thousand books, journals, and pamphlets, including many volumes about aboriginal people.[27] McCord's first ethnographic acquisitions were related to the theme of warfare. He obtained a remarkable Iroquois headdress, believing it to have been worn by the famous Shawnee leader Tecumseh (fig. 2.3). He also sought out tomahawks, scalps, and other mementoes of famous warriors. Soon after the turn of the century, however, McCord became obsessed with building a museum-quality collection to document Canadian history. He relinquished his law practice and, living largely off rentier income, decided to devote all his energies to collecting.

## McCORD'S COLLECTING INFLUENCES

David Ross McCord was certainly not alone in his quest to collect ethnographic artifacts. At the close of the nineteenth century, the ongoing encroachment of Euro-American settlements, even in northern and isolated areas of North America, was rapidly and drastically transforming Native lifeways. McCord greatly lamented what he viewed as the erosion of traditional aboriginal culture and, like many Euro-Canadians, may have believed that aboriginal people themselves were doomed to extinction. Thus, he shared the tremendous sense of urgency that prevailed among Victorian scientists to preserve a record of these supposedly vanishing peoples. McCord, along with other private collectors and nascent museums, was a major player in the Museum Period—the age from about 1840 to 1890 when most of the major ethnographic collections in the world today were amassed.[28]

In many ways McCord was a typical Victorian ethnographic collector. He romanticized aboriginal history and culture and was obsessed with the significance and authenticity of his acquisitions. Yet to characterize him in this manner alone would be to trivialize what appears to have been a deep

and genuine interest in aboriginal history. His correspondence and notes do not reflect the derogatory views about Native people that generally prevailed at the turn of the century. Rather, they reveal a remarkably well-read individual, with interests in subjects as diverse as treaty rights, spirituality, and beadwork motifs. Moreover, McCord's writings show that he viewed aboriginal people as an integral part of Canadian history, not as elements of the natural setting or mere adjuncts to the colonial story. The origin of McCord's distinctive attitudes and assumptions can be traced to four main sources: the books he read, his interest in the Romantic movement, his strong Canadian nationalism, and his belief in an early form of science, called inventory science today, as a way to strengthen the nation.

Anthropology as a discipline was slow to develop in Canada, although natural history societies were active in the eastern part of the country as early as the 1820s. The Geological Survey of Canada established a separate anthropology department in 1910, providing employment for professional anthropologists in Canada for the first time. T. F. McIlwraith (1899–1964), who came to the University of Toronto in the 1920s, was the first anthropologist to teach the subject full time in a Canadian university. Remarks in David Ross McCord's notes and letters indicate that the writings of three scholars who worked before the turn of the century—Daniel Wilson, John William Dawson, and Horatio Hale—played an important part in shaping his views.[29]

Daniel Wilson (1816–92), an archaeologist by training, was president of the University of Toronto from 1887 until his death in 1892. He was keenly interested in the parallels between aboriginal groups in Canada and prehistoric European society. His most influential publication, *Prehistoric Man: Researches into the Origin of Civilization in the Old and the New Worlds,* was well known to McCord. Wilson differed from many evolutionary anthropologists in that he rejected views generally prevalent in American physical anthropology. For example, he held that peoples in small-scale societies had the same inherent intellectual abilities as those of complex societies.[30]

McCord was a great admirer of John William Dawson (1820–99), a devout Christian fundamentalist who was a highly esteemed geologist and principal of McGill University from 1855 to 1893. In 1860 Dawson carried out a rescue excavation of an Iroquoian archaeological site located in downtown Montreal, and in 1874 he published *Fossil Men and Their Modern Representatives,* a treatise on the unity and unchanging nature of the

human species. Dawson envisioned God as the only possible creator and rejected the doctrine of biological and cultural evolution.[31]

McCord also read the work of Horatio Hale (1817–96), a graduate of Harvard University who carried out important linguistic and ethnographic research in Oregon and Polynesia. Hale moved to Ontario in 1856 and, after devoting nearly two decades to his law practice, returned to his interest in aboriginal cultures. In 1870 he visited the Six Nations Reserve near Brantford and began to collect information about Iroquois languages and traditions, culminating in his publication of *The Iroquois Book of Rites* in 1883. Like Wilson, Hale rejected the idea that Western civilization was inherently superior to aboriginal culture.[32]

Interestingly, the writings of McCord's three mentors appear to have gone against the current at a time when both scientific and popular attitudes toward aboriginal people were generally riddled with negative imagery and government policies were geared toward assimilation. In effect, the old-fashioned definition of human nature held by these scholars (and probably shared by McCord) "led all three to reject what modern anthropologists regard as some of the most abhorrent views of nineteenth-century anthropologists."[33]

McCord's attitudes about Native people were also strongly influenced by his attraction to an intellectual movement that was already considered old-fashioned at the time when McCord began to collect. Romanticism was a viewpoint no doubt instilled in him by both parents, but especially his father. The diverse characteristics of the Romantic movement included "a love of natural beauty much influenced by the aesthetic standards of the 'picturesque' and the 'sublime;' a penchant for reverie, melancholy, and nostalgia, often expressed through a fondness for ruins and relics that evoked such feelings; a love of the primitive; a fascination with both the individual quest and the organic unity of nations; and a tendency towards hero-worship, especially directed at persons who seemed to embody the spirit of the nation."[34] In keeping with these views, McCord was fascinated with the "noble" and "virtuous" characteristics of aboriginal cultures, and he felt both nostalgia and melancholy for their "vanishing" way of life. He stated with emotion that his goal was to build a collection "that would stand unrivalled on the continent" as a testimony to "the skill and industry of the original Masters of the Forest and the Prairie."[35]

Romanticism may have greatly appealed to McCord as a refuge from the rapidly changing conditions of Canadian society that confronted him. Dur-

ing the late nineteenth century, Montreal was in the throes of unprecedented change. Industrialization and urbanization created a legacy of poverty, slums, disease, and violence that seemed to threaten the ideals of Canadian society. Across the country, internal conflict, regional dissent, and stagnant economic growth made the future of the young nation look doubtful.[36] McCord's fascination with aboriginal culture may have served as an antidote to this "mean and rootless modernity."[37] Not surprisingly, McCord exalted an idealized image of aboriginal culture and values. In his museum planning notes he wrote: "The Indian is accused of being cruel—in his methods of warfare—he was not gentle—but there is an element of stoic virtue, which dilutes the cruelty—but the white man—with all the elevating influences of Christianity—was dreadfully cruel—What right have we to make despising comments upon North American Indians?"[38] For McCord, aboriginal people embodied and symbolized much of what was right with the past and wrong with the present.

Thus McCord's decision to collect ethnographic objects was intimately tied to his quest to build a museum that would help relieve the stress and disjunction of modern life by fostering a distinctly Canadian national identity. As he wrote in 1919, "Canada is beginning to take her place as a nation and assume responsibilities, but she must be taught."[39] Imperialists like McCord sought a way for Canada to develop beyond colonial status without separating from the British Empire.[40] In this regard, McCord "believed profoundly in the importance and utility of history and the founding myths great nations are made of, myths to ensure solidarity, provide stability and meaning, to combat centrifugal forces by reinforcing shared experiences."[41] McCord's views on the future place and treatment of aboriginal peoples in the new Canadian nation are not always clear. At different times, he may have envisioned them as assimilated into a new Canadian society, or surviving more or less unchanged as relics of a noble race overcome by progress, or falling victim to extinction.

As he sought strategies for building a strong Canadian nation and facing the challenges of industrialization and modernization, McCord turned to the tradition of inventory science that had been so important to his father. In its earliest manifestation, this took the form of natural history collections. As Carl Berger has explained:

Natural history had reflected and channeled some of the strongest drives in colonial culture. It was an instrument for the appropriation and control of nature and a vehicle through which divine purpose stood revealed; it was at once an acceptable

form of leisure and a path to recognition; it provided an outlet for intellectual activity in a colonial environment that seemed to have no past and no traditions to stimulate the literary imagination.[42]

McCord applied these same principles of inventory science, involving the systematic collection of well-documented specimens, to his quest to preserve Canadian history.

## THE COLLECTION TAKES SHAPE

In general, McCord did not travel to acquire ethnographic objects. Most of his collecting was done by mail during the period 1890–1920.[43] He sent appeals to a wide range of individuals and groups, including aboriginal friends and contacts, missionaries, government agents, McGill University alumni, and other collectors. A form letter he composed read as follows:

I would be very much obliged, nay more, Canada would be benefited, if you would kindly obtain donations in your neighbourhood of objects of Indian manufacture—costumes, arms, wampum, etc.—for this National Museum. I may remark that the earlier objects are of greater value than the recent ones, but it may happen that the latter are the only ones procurable. . . . Domestic utensils, such as cookery and the like, which have been superceded [*sic*] by those of European manufacture are specially desirable. Neglect nothing however humble it may appear. . . . When objects have belonged to a particular Chief, or have a history, such should be noted. In fact as many notes as possible should be procured with objects.[44]

McCord was determined to collect as diverse a range of aboriginal objects as possible, confident that the fledgling discipline of ethnology would one day sort out these disparate elements. As he explained in a letter to a prospective supporter, "No object connected with Indian life [is] too small or insignificant to donate. We see connections, often of the greatest value, which are naturally passed over by others highly educated, but whose attention has not been directed, as ours is, to special departments."[45] McCord's comment aptly reflects the incremental spirit of Victorian inventory science—and echoes remarks by John Langton in an address to the Literacy and Historical Society of Quebec in 1863: "A stray fact may be collected or a chance thought evolved, which however imperfectly turned to account by us, may lead to consequences of which we little dream."[46]

McCord's written requests reveal a bias typical of Victorian collectors. He was particularly interested in older objects—those considered "traditional" or representative of aboriginal life before contact with Europeans. Nevertheless, in other ways, McCord's approach was remarkable in that he attempted to acquire a broad range of objects, not just unique and spectacular pieces. In addition, for each object he demanded documentation. It is uncertain how successful McCord's general solicitations actually were. He appears to have acquired objects more reliably when his letters targeted specific individuals for the purchase of specific pieces. He typically paid very high prices, a factor that surely contributed to his collecting success.

One of McCord's particularly fruitful alliances was with M. E. Roberts of Halifax, Nova Scotia. Between 1912 and 1919, Roberts appears to have combed the province of Nova Scotia for anything she thought might interest him—purchasing Mi'kmaq objects at marketplaces and contacting aboriginal people directly. She often sent items to Montreal for McCord's approval and occasionally took material to him in person. Though one of her letters was written on Church of England Institute letterhead, no evidence has been uncovered to suggest that she was engaged in Anglican charity work. Through Roberts's efforts, McCord amassed an outstanding collection of more than 250 objects, including clothing, beadwork, and quillwork. Of particular interest are four Mi'kmaq and Maliseet outfits identified as "Warrior Dance Costumes." Possibly created and worn for the Prince of Wales on his visit to Halifax in 1860, they are unique to McCord's collection—thus far no other examples have been located (fig. 2.4).[47]

When McCord began to collect actively, he evidently built on preexisting contacts in aboriginal communities to acquire donations, as is suggested by the following letter of thanks to Maurice Bastien, chief of the Huron Tribe at Lorette:

Dear Brother Chief, Allow me to thank you from the bottom of my heart for the splendid *Turtle totemed Papoose cradle*, which I trust may be only the beginning of the interest of all our Tribes in this National Museum. . . . We expect that you and fellow Chiefs will represent your great Tribe at our opening; and if you be in Montreal fail not to come to see us. In the Pipe of Peace, Your brother . . .[48]

McCord often wrote letters as though his honorary Iroquois name had made him part of the aboriginal community. He expressed this forcefully in notes for a letter to a Reverend Trench in Alberta, dated 1913: "I asked Mr. Trench if he could not, in his kind work for me, get the chiefs and warriors

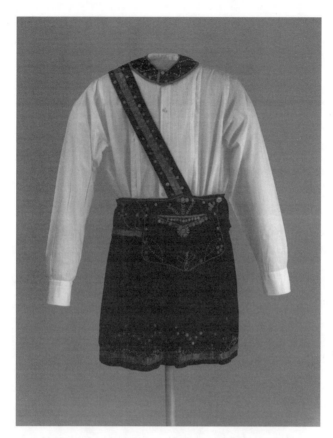

Figure 2.4. Man's dance outfit, Mi'kmaq, late nineteenth century. Velvet, metallic ribbon, metallic braid, metal sequins, glass beads, cotton tape, cotton thread, wool, china button. Skirt length 46 cm. The white shirt was not acquired at the same time as the costume. McCord Museum of Canadian History, M122.1-4, M87.2.

to appreciate that I was not a pale face, but a brother by adoption into the six nations, endeavouring to preserve for posterity [what] was *in fact* becoming lost—the traces of the former greatness of the Indian."[49] Appropriating an aboriginal identity was a means for McCord to naturalize his role as a cultural and national spokesperson. As a member of a dominant elite, he viewed class structure as central to the natural progression of Canadian society. By invariably linking the objects he collected to chiefs and warriors, not only could he reinforce to the public the inviolate pres-

ence of class structure even in societies considered "primitive," but he could also increase his own influence by demonstrating his membership in this elite group.

McCord sometimes exaggerated his credentials in appeals to aboriginal people. For example, in a letter to Chief William Loft of Six Nations, Ontario, written in 1916, he requested assistance with regard to purchasing objects: "I am a true Indian brother devoting my life to preserving for posterity, the past greatness of us Indians. No one has ever done anything of what I have—everyone else is buying and *selling*! Profit (alas) I am not thinking of profit—I am thinking only of the preservation of our Indian glory."[50] Apparently not all aboriginal people appreciated McCord's enthusiastic hard sell, as can be seen in Chief Loft's reply: "I will do all in my power to [purchase objects] as you suggest in your letter[.] [A]t the same time you may be aware that many of our people are quite hard to approach in that regard."[51]

McCord felt that the race against time to collect vanishing ethnographic specimens was also a race against rival collectors, particularly Americans. He lost no opportunity to impress upon potential supporters the urgency of his task, as can be seen from this letter of 1919 soliciting money from a Miss Wheeler of Montreal: "You don't require to be told how far behind the Americans we are in museum work, and I want to see if Montreal will not wake to a sense of her duty."[52] He sometimes thanked donors with such ominous references as the following: "Canada has unfortunately suffered so much by the energy of the American that every such object is doubly valuable."[53] Astute aboriginal dealers exploited this rivalry in order to raise the value of artifacts to a sum they found satisfactory. The following extract from a letter written by David Swan of Oka in 1911 exemplifies this tactic: "Bro[ther] Rononshonni . . . Been at Lake [H]uron among the natives looking for relics. The American with the big silver dollar has been ahead of me almost everywhere I went[,] more so at Six Nations and he has been busy buying up Indian relics. So to say that good relics are scarce is puting [*sic*] it mild and at two Hundred and Fifty dollars I know of only one."[54] Apparently McCord had written previously that Swan should pay no more than seventy-five dollars for the object in question (fig. 2.5).

Early in his collecting career, McCord recognized that missionaries working in aboriginal communities could be valuable allies. In his letters to church workers, such as the following one written in 1917, he did not hesitate to adopt an appropriately pious tone: "I have been much blessed in my whole work. This has been the secret of my success. It has been all done to

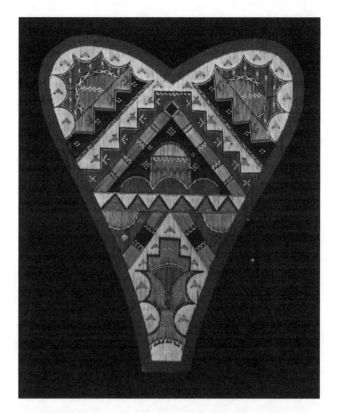

Figure 2.5. Chair back panel, Mi'kmaq, mid-nineteenth
century. Birchbark, porcupine quills, spruce root, organic dyes.
Back height 40 cm. McCord Museum of Canadian History,
M2201.

the Glory of God. I have only been the humble instrument."[55] In general,
missionaries encouraged aboriginal people to shed traditional material cul-
ture, in an effort to speed their assimilation. The sale of craft items was also
a means of raising money for mission-inspired community projects.[56] This
is clear in a letter to McCord written by Reverend MacPherson of Glendale,
New Brunswick, in 1915: "The Papoose Carrier I have was made last year
for Doctor Clarke. I have given the Indian who made it an order for another,
which will be yours. It will cost you $15.00. Let me know if this is satisfac-
tory. Intrinsically the thing is not worth near that much but we are selling
these articles to finish our little church."[57]

Another method McCord used to augment his collection was convincing other collectors to consolidate their ethnographic material in his future museum. His own ambitious goal to oversee the largest collection in Canada may have been the main motivating force behind this, yet he was quite right when he argued: "These things remaining in private families means they will be lost and alas, sometimes very soon. I have had plenty of experience of such."[58] In some instances, he was able to raise enough money personally or through supporters to purchase large private collections. For example, McCord acquired the E. W. Gill collection of Plains material and a part of the J. B. Learmont collection in just such a manner.[59]

McCord was not always successful, however, in convincing other collectors that his mission should take precedence. For instance, in 1919 he made this dramatic appeal to Cyrille Tessier, a Quebec City notary who possessed a number of wampum belts:

> It is a national museum, and will be known as such; not a museum of any particular educational institution. I am not going to make a [P]rotestant or a [C]atholic museum, and above all, I am not going to make an English museum. I will make it an Indian museum as much as I possibly can—the museum of the original owners of the land. And here our wampum plays a conspicuous part.[60]

Apparently Tessier remained unmoved by this impassioned plea, since his wampum did not join the museum's collection.

As McCord developed into a more discerning collector, he became less credulous and frequently badgered donors for information on the age and authenticity of the objects he acquired. In 1910, an exasperated Chief Moses Stacey of Kahnawake responded to one of many letters doubting the age of a beaded silk cradle shade: "Regarding my claim about the age and make of the cover, I was under the impression that you understood fully all about the cover. I have fully ascertained that the age of the cover is 72 or 73 years old, but the new stitching and other parts which show new were recently put in. . . . One thing I am sure of is, that the cover was not misrepresented."[61]

Yet at other times, McCord could be remarkably naive in his pursuit of authentic and historically significant artifacts. Experienced aboriginal and non-aboriginal dealers were more than willing to assign their goods a pedigree that they knew McCord could not resist. For example, a number of dubious-looking objects acquired by McCord are described in the accession books as having been used or owned by the famous Mohawk leader Joseph

Brant. Even more dubious is the alleged history of a humble birchbark roll, identified as the moose call that belonged to a famous Mi'kmaq guide:

This Moose call is unsurpassed in interest and also in collateral association. . . . It was used by . . . guides to five Royal parties—The Duke of Kent, The Duke of Edinburgh, King Edward VII, when Prince of Wales, King George V, when Duke of York, and a fifth—thought now to be a foreign Royal personage—this will be ascertained for me—the last owner, as well as his talented little son, are dead—this boy drew the moose head—within the last three years.[62]

No doubt both buyer and seller came away from this transaction with smiles on their faces.

## A PERMANENT HOME FOR THE COLLECTION

By 1908, Temple Grove had been transformed into an impressive, if somewhat cluttered, private museum where paintings, manuscripts, furniture, and aboriginal clothing and headdresses were admired by family friends and invited guests. Around this time, McCord appears to have decided definitively that his personal collection should become a public museum.[63] He offered to donate the contents of Temple Grove to his alma mater, McGill University, with the understanding that the university would create a national museum. McGill refused for the next eleven years, no doubt fearing the financial burden that would ensue.[64] In the interim, McCord fumed, worried, threatened, cajoled, and continued to collect with undaunted passion. He invited several journalists to Temple Grove to draw attention to his treasures. They responded with enthusiasm. "The writing of this article was prompted from the fear that this splendid and intensely interesting collection, as well as its collector and owner, might be coaxed away to another great educational centre in Canada. Attempts are indeed being made to get it and him."[65]

By 1914 the situation at Temple Grove had become precarious. The house could no longer contain McCord's burgeoning collection. An article in *Maclean's* magazine described the following chaotic scene: "[Every] room on the ground floor had been invaded, and the family had been driven for house room to the upstair apartments. Even these are being invaded by relics, and the family, retreating before them, will apparently soon find itself on the roof."[66] Meanwhile, McCord was now seventy years old, and

his health was failing. He was desperate to see his dream realized. "There's no denying it, I'm getting old—getting old. . . . My work is just beginning, but it is drawing to a close. Suppose I should die, what would happen to this collection. No one but myself knows what is here. It is scattered about and needs to be put together. The time has come when something has to be done."[67] Finally, McGill University decided to accept McCord's donation in 1919; otherwise, it risked losing the collection to another institution. The former residence of prominent Montreal financier Jesse Joseph was renovated in preparation for the opening of the McCord National Museum.

The initial deed of gift to McGill University was for 15,000 objects related to all aspects of Canadian history. Of this total number, the ethnographic collection consisted of more than 2,500 objects of aboriginal manufacture, more than 1,000 archaeological specimens, and a large number of manuscripts, archival documents, and images (photographs, paintings, prints, and drawings) depicting aboriginal life.[68] In addition, numerous large collections that McCord had sought to acquire entered the museum over the years following his death in 1930. McCord's ethnographic collection was remarkable for its scope, quality, and documentation. The collection was Canada-wide, and the following groups were particularly well represented: Mi'kmaq, Huron, Iroquois, Eastern Cree, Athapaskan, and Plains. Although McCord may have occasionally embellished source information (by insinuating that he had acquired an object personally rather than through an intermediary), for the most part his cultural attributions appear to be accurate.

## RESEARCHING AND EXHIBITING THE COLLECTION

Assured at last that his collection would have a permanent home, McCord set out to plan the new exhibition galleries and to research specific objects in the ethnology collection. Despite advancing age and continuing health problems, he devoted prodigious energies to many research projects, including the determination of geological sources of stone used to make hunting tools and pipes, the identification of feathers in headdresses, the chemical analysis of glass beads, the meaning of wampum belts, and the interpretation of design motifs. These interests instigated a flood of letters from McCord to various aboriginal leaders and the different science laboratories at McGill University, as well as to museums in the United States and Europe.[69]

Letters and notes on several objects in the collection illustrate McCord's keen interest in broad cross-cultural comparisons, such as different methods of moccasin manufacture or similarities in designs and decorative elements. This reflects McCord's awareness of then current diffusionist theories in anthropology, which held that innovations occurred only rarely and in specific locations, and then gradually spread to neighboring groups. Thus, groups with many similar traits were thought to be closely related. This diffusionist thinking is particularly apparent in a letter of thanks written to Mrs. W. S. Robertson of Montreal in 1921: "It is difficult to express how deeply I am indebted to you for those superb Montagnais leggings . . . They furnish a hereto missing link between two apparently distinct tribes. That is one of the values of a National Museum comparison."[70]

McCord's earliest attempts at thematic displays were typically Victorian in style. A 1914 photograph taken in the library at Temple Grove shows curio cabinets crammed with objects (fig. 2.6).[71] The ethnological artifacts displayed in the cabinets, as well as the Euro-Canadian material, appear to illustrate the theme of warfare. The inclusion of a beautifully beaded Iroquois cradle shade suggests, however, that some objects were selected primarily for their aesthetic qualities. From 1919 to 1921, McCord worked feverishly with his devoted secretary, Mary Dudley Muir, to draft detailed plans for the exhibition rooms in the new museum. He began by sending the following inquiry to the director of the Smithsonian Institution: "If you were establishing a new museum today how would you classify on the general labels the tribes, or the groups of tribes, or the nations, represented[?]"[72] In response he received a pamphlet on classifying and arranging exhibits for an anthropological museum.

McCord was certain that he did not want his collection to be decontextualized and presented as art. For example, in a rare display of humor, he chastised F. Cleveland Morgan for obtaining Velina P. Molson's exceptional Northwest Coast basket collection for the Art Association of Montreal (predecessor of the Montreal Museum of Fine Arts). In so doing, he foreshadowed a still unresolved debate on whether aboriginal objects should be exhibited in museums of ethnology or museums of art.[73]

You know that I approve of you on general grounds and I approve of baskets on general grounds and I felt sore at the Art Association, and not the McCord National Museum, getting Mrs. Molson's baskets. I applaud you on having secured them as being the next worthy man to the signer of this letter in the Highland accomplishment of "lifting". Now for some serious reservations. Had I acquired the baskets I would not have done so without their having been examined by an expert

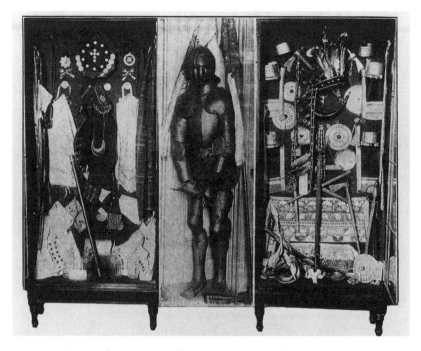

Figure 2.6. Curio cabinets at Temple Grove, 1908. *Maclean's* magazine, March 1914, 9. Maclean's Magazine and the Thomas Fisher Rare Book Library, University of Toronto.

in baskets. . . . [I]s not this a departure somewhat foreign to the scope of an Art Association? Would not these baskets naturally fall rather within the scope of such a Museum as mine[?][74]

Ironically, Mrs. Molson's baskets did become part of the McCord collection in 1928.[75]

## THE McCORD NATIONAL MUSEUM

The McCord National Museum was officially opened on October 13, 1921, as part of McGill University's centenary celebrations. Based on elaborate documents prepared by McCord, it is possible to re-create the layout of the new museum. Each room was devoted to a different historical theme: aboriginal people, the French Regime in Canada, Major General James Wolfe and the conquest of Quebec, McCord family objects, the history of

Montreal and McGill University, Arctic exploration and the fur trade, early Protestant missions in Canada, early Jesuit missions and the Roman Catholic Church in Canada, the American War of Independence, and the War of 1812.

Two large rooms just beyond the entrance to the new museum were dedicated exclusively to exhibits on aboriginal people (fig. 2.7). According to a 1931 review that appeared in *The Teachers' Magazine,* ten years after the opening: "The two rooms containing Indian material are on the ground floor of the Museum, the Eskimo and Western Indian specimens being to the left as one enters, those connected with the Indians of Eastern Canada, to the right, while in the hall there is a case devoted to the handiwork of the Haida Indians of the Queen Charlotte Islands—carving in black slate, models of totem poles and a Chilkat blanket."[76] Within these broad geographical divisions, the collection was arranged typologically. For example, the Mi'kmaq headings included: Art, Basket, Beads, Costumes, De-

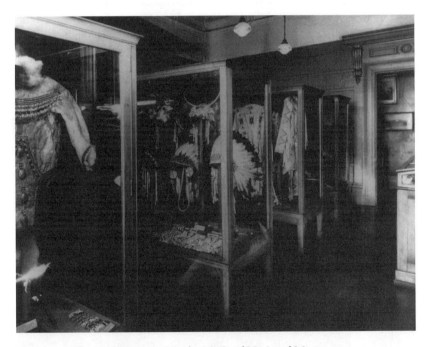

Figure 2.7. The "Indian Room" in the McCord National Museum, ca. 1921. Notman Photographic Archives, McCord Museum of Canadian History, Mp181(2).

sign, Games, Gorget, Implements, Missions, Moose call, Necklaces, Ornaments, Pipes, Pouches, Toys, Weapons.[77] Public reaction to the new museum, and especially the ethnology exhibits, seems to have been quite favorable. Newspaper articles published after the opening suggest that the exhibits were very popular, and that the "constant stream of children who visit the Museum bears witness to their interest."[78]

Tragically, David Ross McCord could not attend the opening of his long-awaited museum, since he suffered from arteriosclerosis, a condition that caused mental deterioration. By the year 1922, at the age of seventy-eight, McCord was no longer able to manage his estate. Although he did have periods of lucidity, William D. Lighthall, a legal associate and close family friend, recommended that he be placed in an institution. McCord spent the last eight years of his life in a sanitarium, where he died on April 12, 1930, at the age of eighty-seven.[79]

When Lighthall took over McCord's estate, it was in a shambles. To fund his household and his collection, McCord followed a family tradition of depending heavily on credit, particularly mortgages. In addition, he borrowed against his life insurance policies and wrote promissory notes to his sisters. Even his pew rents in Christ Church Cathedral were in arrears. In the last years of his life, as he slipped in and out of lucidity, McCord fretted that no rents were coming in, that his taxes were unpaid, and that he had left his wife virtually destitute.[80] Throughout his life McCord's passion for Canada and collecting had taken precedence over all else. As he had explained to a potential donor, "While I have been presented with priceless objects, I have, as everybody knows, spent a small fortune on this labour of love for Canada, and I felt it a privilege so to do. Some one had to do it and no one appeared."[81]

## "HERE I AM IN COLLABORATION WITH THE DEAD": McCORD'S LEGACY[82]

Like many eccentric collectors, McCord could have kept his passionate interest in Canadian history, and in aboriginal culture specifically, on the level of merely a hobby—a diversion from his professional and family obligations, and an addendum to his large ego and acquisitive personality. Instead, collecting became the driving force of his life, leading him to sacrifice virtually everything he had. In so doing, he became one of the few Victorian private collectors who ultimately succeeded in building a museum.[83] As he

once said: "Printed books are useful for scholarly purposes—I do not undervalue them—far from it, but they inspire not. I want to get at hearts."[84] Today, David Ross McCord's ethnology collection must be understood both as a remarkable glimpse of aboriginal life and values and as a fascinating reflection of this one man's distinctly nineteenth-century outlook.

McCord was no doubt convinced that his representations of aboriginal culture were grounded in the most advanced scientific thinking of the day. In retrospect, we now realize that like most museum exhibits conceived in the early twentieth century, McCord's displays decontextualized objects and helped to perpetuate an idealized image of aboriginal people that situated them in a timeless past. As a result, they contributed to a tenacious stereotype of aboriginal history as simple and unchanging, if romantically appealing, with its warrior figures and clever artisans. No doubt this stereotype was only enhanced by its juxtaposition with representations of colonial history, filled with exciting imagery of a dynamic new Canadian nation.

McCord, like many of his contemporaries, could not envision that these "vanishing" peoples not only would survive but would one day take charge of their own history. Aboriginal groups in Canada are now questioning a wide range of practices related to the care and display of objects of aboriginal heritage. They are gradually building their own museums and are challenging non-aboriginal institutions to recognize and eradicate remnants of these Victorian attitudes.[85]

Nevertheless, the legacy of David Ross McCord's "mission" extends well beyond his early attempts at exhibiting Native culture. In addition to the remarkable ethnographic collection he assembled, McCord's most enduring contribution to contemporary aboriginal peoples may well be the amount of documentation that accompanies many of the objects. His self-consciously scientific approach to building a museum has meant that objects in his collection often can be traced to specific aboriginal communities, and in some instances, to particular individuals. With incredible foresight, McCord had stipulated: "Keep my letters as they . . . should come back & form part of the record—dossiers of the transactions—this is a habit of mine—so that both correspondents' methods of analysis will be preserved for the future—questions & answers—We are not living for ourselves, thank God, in this work."[86]

Today, McCord's collection provides both aboriginal and non-aboriginal researchers with a remarkable resource for the preparation of exhibitions, books, films, and CD-ROMs that document and explain

aboriginal history. For example, in the aftermath of the 1991 armed stand-off between the Canadian army and Mohawk warriors in Kanehsatà:ke, community members decided to organize a history exhibition for both Mo-hawks and Montrealers as part of the healing process.[87] A committee from the Kanehsatà:ke Education Center visited the McCord Museum hoping to find objects from their community that could be used to educate and to in-spire. David Ross McCord had indeed collected objects in Kanehsatà:ke; moreover, his notes elicited as much interest as did the brilliant silk dress and the beautifully carved cradleboard. For although McCord ostensibly set out to "preserve the past glory" of aboriginal people, both the objects he collected and the descendants of their makers speak eloquently and force-fully of contemporary realities and future aspirations.

## Acknowledgments

An earlier version of this paper appeared in *The McCord Family: A Passionate Vision,* edited by Pamela Miller (Montreal: McCord Museum of Canadian History, 1992), 103–15. I would like to thank a number of individuals who assisted me in writing this essay. Pamela Miller, former Curator of Archives at the McCord, origi-nally suggested the project and provided assistance throughout. Guislaine Lemay and Susan McNabb helped with archival research. The following colleagues com-mented on a draft version of the essay: Bruce Bourque, Charles A. Martijn, Kanatakta, and Brian Deer (who also provided the Mohawk translation of the name Rononshonni). I am particularly grateful to Kathryn Harvey, who generously shared research notes on David Ross McCord and kindly agreed to comment on a draft of this essay. For help in securing photographic illustrations, I am indebted to Anette McConnell and Tom Humphry of the McCord Museum.

## Notes

1. Community and Club Activities, September 13, 1916, McCord Family Pa-pers, FONDS I001, McCord Museum of Canadian History, Montreal, Que-bec (hereafter cited as MCFP), file 1998. According to Brian Deer of the Kanien'kehaka Raotitohkwa Cultural Center in Kahnawake, Quebec, the Mohawk name Rononshonni means literally "he built a house."

2. Only a small amount of information has been found concerning McCord's professional involvement in aboriginal affairs before 1890; nevertheless, his correspondence with the Iroquois leader Jeremiah Hill of Marysville, On-tario, during the years 1893 to 1895 suggests that McCord was, as Hill put it, "well posted in the Indian matters." See Legal Correspondence, MCFP, file 1994.

3. Donald Wright, "David Ross McCord's Crusade," in *The McCord Family: A Passionate Vision,* ed. Pamela Miller (Montreal: McCord Museum of Cana-dian History, 1992), 89–91.

4. For reference to this collection, see *McCord Family Papers, 1776–1945,* 2

vols. (Montreal: McCord Museum of Canadian History, 1986). Other sources on the McCord family can be found in the Public Records Office in Belfast, the Public Records Office in Dublin, the Archives Nationales du Québec in both Montreal and Quebec City, and the National Archives of Canada.

5. Donald Fryson and Brian Young, "Origins, Wealth, and Work," in Miller, *The McCord Family,* 27–53 passim.

6. Pamela Miller and Brian Young, "Private, Family, and Community Life," in Miller, *The McCord Family,* 43, 65, 75; John Samuel McCord's Diaries, MCFP, file 410, vol. 1.

7. The list of prestigious institutions and organizations in which John Samuel McCord was involved is remarkable. He was a founder of the Preparatory School of Bishop's College, chancellor of Bishop's College, chairman of Montreal High School, director of Montreal General Hospital, and chairman of the Protestant Burying Ground. He was also a member of the London Meteorological Society, the Natural History Society of Montreal, the Literary and Historical Society of Quebec, and the Albany Institute, New York State. See Miller and Young, "Private, Family, and Community Life," 63, 77; John Samuel McCord's Diaries, MCFP, files 410–21 passim.

8. Miller and Young, "Private, Family, and Community Life," 73.

9. John Samuel McCord's Diaries, MCFP, file 411, vol. 2.

10. For more information on the range of cultural events that McCord might have attended, see Sylvie Dufresne, "Attractions, curiosités, carnaval d'hiver, expositions agricoles et industrielles: Le loisir public à Montréal au XIX$^e$ siècle," in *Montréal au XIX$^e$ siècle,* ed. Jean-Rémi Brault (Ottawa: Leméac, 1990), 233–67; Susan Sheets-Pyenson, "Better Than a Travelling Circus: Museums and Meetings in Montreal during the Early 1880s," *Transactions of the Royal Society of Canada,* 4th ser., 20 (1982): 599–618.

11. The Natural History Society of Montreal, established in 1827, was the oldest scientific organization in Canada, and one of the earliest such societies in North America. See Barbara Lawson, *Collected Curios: Missionary Tales from the South Seas,* Fontanus Monograph Series 3 (Montreal: McGill University Libraries, 1994), 23–32; Stanley Brice Frost, "Science Education in the Nineteenth Century: The Natural History Society of Montreal, 1827–1925," *McGill Journal of Education* 17, no. 1 (1982): 31–43.

12. John Samuel McCord's Diaries, MCFP, file 419, vol. 10.

13. John Samuel McCord's Diaries, newspaper clipping in diary, MCFP, file 421, vol. 12.

14. John Samuel McCord's Diaries, MCFP, files 411–12.

15. See "David Ross McCord (1844–1930)," in *McCord Family Papers, 1776–1945,* vol. 2.

16. Legal Correspondence, MCFP, file 1994.

17. Harvey, conversation with author, August 27, 1996, based on ongoing research for "David Ross McCord, 1844–1930: Imagining a Life, Imagining a Nation" (Ph.D. diss., McGill University, forthcoming).

18. John Samuel McCord's Diaries, MCFP, file 411, vol. 2.

19. John Samuel McCord's Diaries, MCFP, file 410, vol. 1. According to John Samuel's remarks, the Industrial Exhibition was staged over a number of days and included—in addition to the Indian games—a horticultural display, a regatta, speeches, a public ball, firemen's gymnastics, a grand Montreal steeplechase, and a display of fireworks from the island wharf.

20. James Henry Morgan, *The Tour of H.R.H. the Prince of Wales through British America and the United States, by a British Canadian* (Montreal: Lovell, 1860), 125; Conrad Graham, "The Celebration," in *Victoria Bridge: The Vital Link,* ed. Stanley Triggs (Montreal: McCord Museum of Canadian History, 1992), 90–91. For additional information on Montreal-region events involving aboriginal people at the turn of the century, see Trudy Nicks, "Indian Villages and Entertainments: Setting the Stage for Tourist Souvenir Sales," in *Unpacking Culture: Arts and Goods in Colonial and Postcolonial Worlds,* ed. Ruth B. Phillips and Christopher B. Steiner (Berkeley: University of California Press, 1998).

21. John Samuel McCord's Diaries, MCFP, file 415, vol. 6. Interestingly, the archaeological artifacts in Dr. Edward Van Cortlandt's "cabinet" eventually entered the McCord Museum collection, but only after David Ross McCord's death.

22. John Samuel McCord's Diaries, MCFP, file 415, vol. 6.

23. Legal Correspondence, MCFP, file 1994.

24. "Huron Belts of Wampum. Lorette, Dec. 16+21, 1895," handwritten notes by DRM, Archives, McCord Museum of Canadian History, Montreal, Quebec (hereafter cited as MMA). McCord remained very interested in the subject of wampum, and in 1919 he wrote to more than fifteen museums in the United States and England in order to compile a list of all known wampum belts. See MCFP, file 5317.

25. Miller and Young, "Private, Family, and Community Life," 79–81; Kathryn Harvey, conversation with author, July 1996.

26. David Ross McCord's Catalog of Paintings, vol. I, handwritten notes on the inside cover, MCFP.

27. Pamela Miller, "David Ross McCord," in Miller, *The McCord Family,* 85.

28. For further discussion of the attitudes that shaped ethnographic collecting in the Victorian era, see Douglas Cole, *Captured Heritage: The Scramble for Northwest Coast Artifacts* (Seattle: University of Washington Press, 1985), 287–88; Bruce G. Trigger, "A Present of their Past? Anthropologists, Native People, and Their Heritage," *Culture* 8, no. 1 (1988): 75; George W. Stocking, *Victorian Anthropology* (New York: Free Press, 1987), 289 passim; Janet Catherine Berlo, *The Early Years of Native American Art History: The Politics of Scholarship and Collecting* (Seattle: University of Washington Press, 1992).

29. For an overview of Victorian anthropology in Canada, see Bruce Trigger, *Natives and Newcomers: Canada's Heroic Age Reconsidered* (Kingston, Ontario: McGill-Queen's University Press, 1985), 39–44; Daniel Francis, *The Imaginary Indian: The Image of the Indian in Canadian Culture* (Vancouver: Arsenal Pulp Press, 1992).

30. Daniel Wilson, *Prehistoric Man: Researches into the Origin of Civilization in the Old and New World* (London: Macmillan, 1862; 3d ed. 1876); Trigger, *Natives and Newcomers*, 40.

31. J. W. Dawson, *Fossil Men and Their Modern Representatives: An Attempt to Illustrate the Characters and Condition of Prehistoric Men in Europe by Those of the American Races*, 3d ed. (Montreal: Dawson, 1888); Trigger, *Natives and Newcomers*, 42. See also Lawson, *Collected Curios*, 34–36.

32. Horatio Hale, *The Iroquois Book of Rites* (Philadelphia: Brinton, 1883); Trigger, *Natives and Newcomers*, 42.

33. Trigger, *Natives and Newcomers*, 42.

34. Patricia Jasen, "Romanticism, Modernity, and the Evolution of Tourism on the Niagara Frontier, 1790-1850," *Canadian Historical Review* 72, no. 3 (1991): 283.

35. David Ross McCord (hereafter cited as DRM) to McGill Alma Mater, February 1920, MCFP, file 5317.

36. Miller, "David Ross McCord," 85.

37. David Lowenthal, *The Past Is a Foreign Country* (Cambridge: Cambridge University Press, 1985), 97. See also Don Wright, "W. D. Lighthall and David Ross McCord: Antimodernity and English-Canadian Imperialism, 1880s–1918" (unpublished paper, Department of History, McGill University, n.d.).

38. First Museum Arrangement, MCFP, file 2062.

39. DRM to Miss Horden and Miss Broughton, February 13, 1919, MCFP, file 5324.

40. Carl Berger, *The Sense of Power: Studies in the Ideas of Canadian Imperialism, 1867–1914* (Toronto: University of Toronto Press, 1970), passim.

41. Miller, "David Ross McCord," 91.

42. Carl Berger, *Science, God, and Nature in Victorian Canada* (Toronto: University of Toronto Press, 1983), 77.

43. In at least one instance, on September 12, 1916, McCord writes of visiting Kahnawake and signing his name in the visitor register. See MCFP, file 1998. In addition, a remark in a letter from Chief Moses Stacey of Kahnawake implies that McCord visited the community regularly to choose objects for his collection. See Moses Stacey to DRM, undated, MCFP, file 5310.

44. DRM form letter, February 1920, MCFP, file 2055.

45. DRM to Charles G. Hallowell, Esq., February 5, 1921, MCFP, file 5318.

46. This passage is quoted in Berger, *Science, God, and Nature in Victorian Canada*, 15. For a discussion of the incremental spirit of Victorian inventory science, see Suzanne Zeller, *Inventing Canada: Early Victorian Canada and the Idea of a Transcontinental Nation* (Toronto: University of Toronto Press, 1987), 4.

47. MCFP, file 5299. For a discussion on the Mi'kmaq objects in the McCord collection, see Ruth Holmes Whitehead, "A Brief Glimpse of Micmac Life: Objects from the McCord Collection," in *Wrapped in the Colours of the Earth, Cultural Heritage of the First Nations*, ed. Moira T. McCaffrey (Montreal: McCord Museum of Canadian History, 1992), 66–87.

48. DRM to Chief Maurice Bastien, June 16, 1921, MCFP, file 5306.

49. Rev. A. C. Trench to DRM, margin annotations by DRM, August 28, 1913, MCFP, file 5318.

50. DRM to Chief William Loft, February 6, 1916, MCFP, file 5296.

51. Chief William Loft to DRM, March 18, 1916, MCFP, file 5296.

52. DRM to Miss Wheeler, September 18, 1919, MCFP, file 2055.

53. DRM to Charles G. Hallowell, Esq., February 5, 1921, MCFP, file 5318.

54. David Swan to DRM, December 29, 1911, MCFP, file 5302. David Swan was a Mohawk from Kanehsatà:ke, located near Montreal. He appears to have traveled widely to Iroquois communities in the Northeast and was one of McCord's most reliable buyers.

55. DRM to Mrs. Alfred Dudoward, December 7, 1917, MCFP, file 5319.

56. See Lawson, *Collected Curios, Missionary Tales from the South Seas,* passim. In general, the observations presented by Lawson apply equally well to the missionization process among aboriginal people in Canada.

57. D. MacPherson to DRM, April 8, 1915, MCFP, file 5306.

58. DRM to Mrs. Alfred Dudoward, December 7, 1917, MCFP, file 5319.

59. J. B. Learmont was a prominent Montreal businessman and antiques collector. The identity of E. W. Gill is not known. See MCFP, file 5346, for the correspondence with Mrs. J. B. Learmont.

60. DRM to Cyrille Tessier, August 1919, MCFP, file 5317.

61. Chief Moses Stacey to DRM, November 30, 1910, MCFP, file 5305.

62. M103, Original Labels—Ethnology, MMA.

63. Kathryn Harvey, conversation with author, August 27, 1996. Apparently McCord was quite shaken by a period of illness around 1908—a factor that may have induced him to find a public home for his collection.

64. At the turn of the century, McGill University was already having enormous problems in financing the Peter Redpath Museum, Canada's first natural history museum, which had opened on campus in 1882. See Susan Sheets-Pyenson, *Cathedrals of Science: The Development of Colonial Natural History Museums during the Late Nineteenth Century* (Kingston and Montreal: McGill-Queen's University Press), 58, 85–86.

65. J. M. B., "A Valuable Museum Now Ready for Installation in the Henry Joseph Residence," *Standard,* June 12, 1908. See also "Temple Grove: A Revelation," *Westmount News,* May 2, 1908.

66. C. Lintern Sibley, "An Archipelago of Memories: The Trappings of the Storied Past, Rich, Varied and Priceless Mark a Montreal Lawyer's Hobby as Historically Unique," *Maclean's,* March 1914, 7.

67. "Historic Relics Require Some Suitable Home," *Daily Telegraph,* October 20, 1913.

68. An inventory completed in 1930 after McCord's death lists the value of the ethnology objects as $131,000, and values the entire collection at $449,000. See MCFP, file 2049.

69. For a sample of McCord's many letters related to artifact research, see MCFP, files 5296, 5307, 5310, 5317.

70. DRM to Mrs. W. S. Robertson, May 14, 1921, MCFP, file 5305.

71. Sibley, "An Archipelago of Memories," 9.

72. DRM to director of Smithsonian Institution, Washington, D.C., November 1, 1920, MCFP, file 5308.
73. For a discussion on exhibitions of ethnographic artifacts in art museums, see Sally Price, *Primitive Art in Civilized Places* (Chicago and London: University of Chicago Press, 1989); James Clifford, *The Predicament of Culture: Twentieth-Century Ethnography, Literature, and Art* (Cambridge: Harvard University Press, 1988), 189–214.
74. DRM to F. Cleveland Morgan, December 6, 1919, Administrative Papers 1920–40, MMA, file 7731.
75. "Art Association of Montreal," Information Files, MMA.
76. Isabel Craig, "The McCord National Museum," *The Teachers' Magazine* 13, no. 57 (1931): 11–13. For a general overview of the ethnology exhibit layout, see also Cyril Fox, *A Survey of McGill University Museums* (Montreal: McGill University, 1932).
77. First Museum Arrangement, MCFP, files 2059–2062.
78. Craig, "The McCord National Museum." See also "Collection Shows Indians Had Taste for Gorgeous Colours," *Montreal Daily Star*, October 4, 1924.
79. See "David Ross McCord (1844–1930)," in *McCord Family Papers, 1776–1945.*
80. Pamela Miller, "Conclusion," in Miller, *The McCord Family*, 141; and "David Ross McCord (1844–1930)," in *McCord Family Papers, 1776–1945.*
81. DRM to Miss Wheeler, September 18, 1919, MCFP, file 2055.
82. DRM quoted in "Historic Relics Require Some Suitable Home," *Daily Telegraph*, October 20, 1913.
83. For the history of another collector who succeeded in building a museum, see Shepard Krech III, ed., *Passionate Hobby: Rudolf Haffenreffer and the King Philip Museum* (Bristol, R.I.: Haffenreffer Museum of Anthropology, 1994).
84. DRM to Miss Horden and Miss Broughton, July 13, 1919, MCFP, file 5324.
85. See Trudy Nicks and Tom Hill, *Turning the Page: Forging New Partnerships between Museums and First Peoples* (Ottawa: Assembly of First Nations and Canadian Museums Association, 1992).
86. McCord wrote these words in September 1915. See *McCord Family Papers, 1776–1945.*
87. "Karihwatatie Kahswenhtha: An Exhibition of Iroquois and Mohawk History and Culture with Specific References to Kanesatake" was produced by the Kanehsatà:ke Education Center in cooperation with the McCord Museum of Canadian History and presented at Collège La Mennais, Kanehsatà:ke, Quebec, June 26 to September 15, 1993.

THOMAS H. WILSON AND CHERI FALKENSTIEN-DOYLE

# 3
# CHARLES FLETCHER LUMMIS
# AND THE ORIGINS OF THE
# SOUTHWEST MUSEUM

When Charles Fletcher Lummis died in 1928 at the age of sixty-nine, he left behind a full legacy of accomplishment. He had been successful editor, prolific author, outdoorsman, amateur archaeologist and ethnologist, librarian, accomplished photographer, architectural conservationist, and supporter of American Indian rights. He retained much of the ethos of his Eastern origins, yet insisted that Southern California's climate, Spanish heritage, and entrepreneurial spirit made it an unequaled land of opportunity. A tireless booster of Southern California and the West, Lummis nurtured the vibrant intellectual and artistic life of the region by featuring local writers and artists in the pages of publications that he controlled (fig. 3.1).[1]

Among all his achievements, his greatest legacy may be the Southwest Museum in Los Angeles. About halfway through its construction, in 1912, he wrote:

Who was Mayor of Athens in 450 BC? Who cares? Who loaned the money for 1776? Who cares? But we all know and care about the Parthenon and the Independence. Even so, we shall dedicate to our children and their children—free as the spirit of Seventy-Six, and built to outlast the Parthenon—this Temple of History, Science and Art. A hundred years from today, the money we may have left them, the heirlooms we shall have bequeathed, may need a Burns or a Sherlock Holmes to find. But the Southwest Museum will be There. And in it the love and thought we have given.[2]

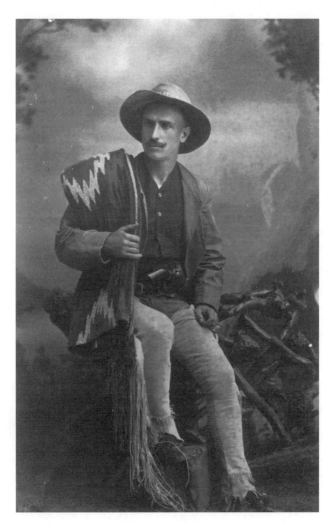

Figure 3.1. Charles F. Lummis in 1885, at the end of his
"Tramp across the Continent." Southwest Museum, Los
Angeles, photo P.32528A.

His characteristic rhetorical flourishes notwithstanding, Lummis was
wrong about what future scholars would want to know about the founding
of this and other museums. Now more than ever we recognize that in order
to understand contemporary institutions and disciplines, we must under-
stand the motives and influences that brought together founders, directors,

staff, collectors, donors, members, and others for the great enterprise of founding and supporting museums. Past actions resonate across history, their consequences affecting the missions and programs of museums today. By examining the processes by which museums were formed we learn why our institutions exist as they do and how anthropology in museums has developed as it has.

For better and for worse, the Southwest Museum is indelibly stamped with Charles Lummis's vision. This essay examines Lummis's life and cultural milieu, the influences that led him to develop a vision for the Southwest Museum and the processes by which he transformed his vision into a viable institution, how he persuaded others to share his dream, the nature of his life as a collector and his relationships with those from whom he collected, the circumstances of his downfall within the museum, and the ramifications of his actions upon the institution today. The Southwest Museum is an expression of its founder's character and experience. Understanding the Southwest Museum is inexorably linked with understanding Lummis himself.

## EARLY LIFE

Charles Fletcher Lummis was born in Lynn, Massachusetts, on March 1, 1859, to Henry and Harriet Lummis.[3] His mother died when he was two, leaving him in the care of his grandparents and his father, a Methodist minister and principal of a women's seminary. Lummis's own children describe him as reckless and pugnacious, and these qualities appeared early in his life. At eight, he refused to attend elementary school, demanding instead that his father teach him. For the next ten years his father drilled young Charles in Latin, Greek, and Hebrew, so that by the time he entered Harvard in 1878, he was already familiar with most of the elective reading list. At Harvard, Lummis pursued athletics and poker and supported himself by publishing his own poetry.[4] He worked hard at the subjects that interested him (later crediting Harvard's Charles Eliot Norton with awakening his interest in archaeology), but left the rest alone. Sickly as a child, he became an obsessive body builder, challenging himself to perform rigorous and dangerous feats of survival in the mountains of New Hampshire. In his freshman year, a prank led to his meeting Theodore Roosevelt, who became a lifelong friend. In 1880 Lummis secretly married Dorothea Rhodes, a young medical student. Later he said that these experiences provided the

most important lessons he learned at Harvard, enabling him to free himself from the restrictions of his cloistered childhood.

But in 1881 Lummis found his energies exhausted and his health spent. Just before commencement, he learned that he had failed trigonometry and analytical geometry. To his later regret, he left the university. In the spring of 1881, Charles and Dorothea moved to Chillicothe, Ohio, where he could recover from the attack of brain fever that he claimed had made graduation impossible.

While Dorothea studied medicine in Boston, Charles stayed in Ohio to work on her father's farm. Within a year, he tired of farming and took on the editorship of the local paper, the *Scioto Gazette*. As editor, much of the work of producing the paper fell to Lummis himself, and he gathered valuable journalistic experience. But by 1883 he was ready to leave Ohio. He hated the climate and, ever conscious of his physical condition, feared for his health after suffering an attack of malaria. Moreover, his relationship with Dorothea, tumultuous from the beginning, was becoming even more difficult. She would soon graduate and would be coming home for good.

## A TRAMP ACROSS THE CONTINENT

In 1884 Lummis announced a scheme by which he would leave Ohio with money in his pocket.[5] Crossing the country to California on foot, he would wire stories of his adventures to the *Chillicothe Leader*. He also pitched the idea to Harrison Grey Otis, publisher of the *Los Angeles Times*, who not only agreed to buy the travel stories but promised Lummis a job upon his arrival in Los Angeles. An Ohio native and Civil War hero, Otis had arrived in Los Angeles two years earlier after his failure at a publishing venture in Santa Barbara. Determined to make a fresh start, Otis built the *Times* into a hugely successful enterprise, using it to sell Southern California as a paradise of clear skies and endless opportunity.[6] By the mid-1880s, Southern California was booming, as many Americans migrated west. The kind of romantic adventure that Lummis proposed fit perfectly into Otis's program, and given the mood of the country, it was bound to sell papers.

In planning his escape from Ohio, Lummis was perhaps inspired by another young adventurer. In 1882, Frank Hamilton Cushing visited Harvard University with a delegation from Zuni Pueblo. Although Lummis was no longer a Harvard student, in writing about the event years later, he represented himself as an eyewitness. "I remember it very well . . . ," he wrote,

"[Cushing's] personal magnetism, his witchcraft of speech, his ardor, his wisdom in the unknowabilities, the undoubted romance of his life of research among 'wild Indians of the frontier' . . . and the impressive dignity and poise of his Indian comrades—all were contagious."[7] Lummis was clearly swept away and may have seen in Cushing the model for his own self-promotion.

In walking to California, Lummis discovered the region that engaged him for the rest of his life and provided a focus for his creative and scholarly efforts. As he tramped through the Southwest and Southern California, he encountered a territory that seemed strange, wonderful, dangerous, romantic, and noble. His letters to the *Chillicothe Leader* show his rapid transformation from a somewhat arrogant Eastern visitor, uncomfortable at the prospect of dealing with the Mexican and Indian residents of the towns through which he traveled, to an ardent admirer and advocate for Western ways of life. Within a few days, infatuated by a romanticized view of the exotic peoples he encountered, Lummis dropped his initial aversion to Mexicans (whom he first referred to as "Greasers"), deciding, "I find [them] not half bad people. In fact, they rather discount the whites, who are all on the make."[8] He found Pueblo Indians to be generous, hospitable, handsome, and he also discovered an affection for cowboys, labeling them heroic "Centaur figures."

Perhaps most important to Lummis's transformation was the time he spent with the Chavez family of San Mateo. Amado Chavez, Speaker of the territorial House of Representatives and scion of one of New Mexico's oldest ranching families, invited him to visit the family estate. In San Mateo, Lummis found a gracious household and a lavish table outfitted in Western style, presided over by dark-eyed women of "the true Spanish type of beauty. . . . [I]f there is any type more seductive, you may keep it—I don't want anything better."[9] He spent an evening with the family, learning his first Spanish songs, playing parlor games, and listening to stories of Indian battles told by Don Manuel Chavez, Amado's father and a pioneering settler of the territory. Best of all, the family allowed Lummis to excavate a village site on the property, where he turned up pottery, beads, and bones. When he left San Mateo, friends of the Chavez family presented him with a small collection of pottery from Acoma Pueblo, which he shipped ahead to Los Angeles. He reluctantly left the Southwest, citing Santa Fe as the "hardest place I ever saw to break loose from."[10] He took with him an identification with the West and a passion to preserve its Spanish American cultural heritage that lasted his lifetime.

On February 2, 1885, Lummis met General Otis at Mission San Gabriel,

ten miles east of downtown Los Angeles. Together they walked the rest of the way into the city, and the next day Lummis reported for work as city editor of the *Times*.

## LOS ANGELES, THE SOUTHWEST, AND PERU

For the next three years, Lummis labored at the *Times*, driving himself with the same intensity that characterized his walk to Los Angeles. He covered the crime scene, working twenty-one-hour days, drinking, smoking, and womanizing to excess. The paper sent him in 1886 to report on the U.S. Army's final campaign against Geronimo.[11] His marriage to Dorothea, who had set up a medical practice in Los Angeles, deteriorated rapidly. In 1887 he had a stroke that paralyzed the left side of his body, leaving his left arm useless. In February 1888 he traveled back to New Mexico, to San Mateo and the home of his friend Amado Chavez.

Although he went to New Mexico for rest and recovery, Lummis was never inactive. Here he began in earnest to collect the Southwest: objects, images, narratives, and people. He began a diary that he kept for the rest of his life, and its first entries show that, paralysis notwithstanding, he had taken up photography. He spent the next four years in New Mexico packing a heavy 5 x 8 camera, loaded with glass plates that he developed and printed in the darkness of a rented adobe house. He made photographs of New Mexican scenes and people nearly every day, capturing images of Pueblo Indian dances and Penetente religious ceremonies, the latter made at some risk to his own life.[12]

By the end of 1888, Lummis had set up housekeeping at Isleta Pueblo, renting a house in the family compound of his friend Juan Rey Abieta. In Isleta, he became immersed in the life of the community, even to the extent of becoming involved in local political issues. When government agents forcibly removed Juan Abieta's youngest son to a boarding school, Lummis obtained a writ of habeas corpus, securing the release of all of Isleta's children.[13] While in New Mexico, Lummis supported himself by producing a flurry of illustrated articles on Southwestern subjects for newspapers and magazines throughout the country. Between 1891 and 1896 his output resulted in six books based on his stories.[14] His extended stay in the Southwest honed his skills as a writer and photographer, exposed him to Native American points of view, enabled him to collect ethnographic materials, and brought him a new young wife, Eve Douglas, a teacher at Isleta.[15]

During a violent sandstorm in August 1888, Adolph Bandelier wandered

into Lummis's camp at Los Alamitos. The two men shared a passionate interest in the combined Spanish and Indian heritage of the Americas, and Lummis found Bandelier's scholarship awesome. Lummis served as Bandelier's photographer on his Southwest surveys, and in 1892 accompanied him on archaeological explorations in Peru and Bolivia.[16] Although Lummis was actively involved in excavations at Pachacamac, Peru, he saw his real contribution in his function as Bandelier's popular chronicler. Throughout his life, Lummis played the role of advocate for people, places, or ideas and was happy to bask in reflected glory. The money for the fieldwork ran out earlier than expected, and by 1893 Lummis was back in Los Angeles.

## BOOSTER OF THE SOUTHWEST

Upon his return to Los Angeles, Lummis began his career as Southern California's foremost booster and promoter of the region's Spanish legacy. For him, Los Angeles was "the great metropolis of the Southwest," and he took on the job of building its cultural reputation. Asked in 1894 to become editor of *Land of Sunshine* (renamed *Out West* in 1902), a magazine dedicated to the promotion of rapid growth and development in Southern California, Lummis promised to provide a first-class literary journal devoted to the life and culture of the Southwest.[17] Very soon the publication became the vehicle for Lummis's numerous causes, among them the Landmarks Club, organized in 1895 to conserve and restore California's missions, and the Sequoya League, formed in 1902 to take up the cause of American Indian rights.[18] From 1905 to 1910, Lummis served as city librarian of Los Angeles, a position in which he built a strong collection of works concerning Southern California and indulged his own passion for books.

It was in the February 1895 issue of *Land of Sunshine* that Lummis first called for a "great . . . characteristic Southern California museum," to be located in Los Angeles and dedicated to the region's vast and varied interests:

Distinctively Southern Californian, covering accurately and fully the infinite range of scientific and esthetic interests peculiar to the seven counties—the flora and fauna, the ethnological and archaeology, the history and the romance—it would be a collection so endlessly valuable and ceaselessly fascinating that it would be famous the world over.

California, he asserted, already contained notable private collections, some of which surpassed "corresponding departments in great museums." Lummis promised that *Land of Sunshine* would "labor for the actual assembling of these private museums," and he proposed a series of articles about them. The next three issues featured articles about the Palmer collection of California archaeological materials (March 1895), the Campbell collection of American Indian baskets (April 1895), and the Yates collection of shells, minerals, and archaeological specimens (May 1895).[19] After this initial flurry of interest, *Land of Sunshine* was silent on the subject of museums.

Meanwhile, Lummis incorporated the museum idea into his private life. In 1897 he began to build his own home. Set in the Arroyo Seco, about midway between downtown Los Angeles and Pasadena, El Alisal was the house of a Spanish don, where Lummis could indulge in the Western lifestyle of his dreams. Built of boulders found at the site and rough-hewn beams, every aspect of the house was designed to incorporate elements of the romantic Southwest. Still obsessed with physical fitness, Lummis did most of the labor himself over a period of twenty years, with the help of Indian workers imported from Isleta. The house featured details that reminded him of his travels and his causes—arches resembling those at Mission San Gabriel and elaborate fixtures based on Peruvian designs. The main front room he called the *museo,* and there he displayed his personal collections for all to see. Navajo blankets covered floors and benches, Pueblo pottery lined the shelves, and framed arrangements of small artifacts shared wall space with paintings by Western artists such as William Keith and Maynard Dixon. Photographs of Pueblo scenes, printed as glass positives, served as panes surrounding the large bay window, and his library filled shelves along the walls (fig. 3.2). In this house Don Carlos lived out his version of the Spanish American myth, re-creating the graciousness and ease that he experienced with the Chavez family in New Mexico. At El Alisal, Lummis treated his friends to noisy, song-filled evenings and plied Los Angeles's newly emerged oligarchs with lavish "Spanish Dinners."[20]

Lummis fancied himself a latter-day Californio, and he took pains to dress the part. A photograph taken in 1885, when he had completed his journey through New Mexico and Arizona, shows him dressed in a broad hat and fringed buckskin leggings, with a Navajo blanket tossed over his shoulder. Once he settled in Los Angeles, his everyday dress for the rest of his life consisted of a corduroy suit, belted with a Navajo or Pueblo sash and set off by lace shirtfronts made for him in Isleta. Wherever he traveled he

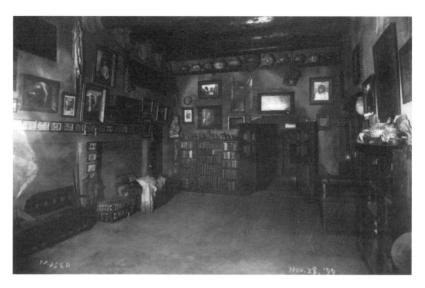

Figure 3.2. The Museo at El Alisal, photographed by Lummis on November 28, 1899. Southwest Museum, Los Angeles, photo P.35566.1.

collected costumes, later photographing his baby daughter, Turbesé, dressed as a Guatemalan child or as a tiny Isleta woman. Lummis had himself photographed wearing Andean ponchos or Navajo serapes. His scrapbooks contain photographs, lovingly hand-colored, of Pueblo people wearing early Navajo blankets that are now housed in the Southwest Museum.

## EARLY COLLECTING

Lummis collected textiles, books, archaeological and ethnographic objects, colonial antiques, pictures of places, portraits of people, and recordings of their voices and songs. He never had much money, but he was prepared to spend his last cent on an object that caught his fancy, and he was willing to barter. He began collecting at least as early as his college days, and his strong sense of the symbolic and representational significance of objects was probably part of his motivation for founding the Southwest Museum.

Lummis's first recorded collecting expeditions took place at Harvard, where he and his friend Boies "Pen" Penrose enjoyed stealing advertising signs from various Cambridge businesses and displaying them in their private museum.

Signs had been stolen in amateur ways before by Harvard undergraduates but never had there been such a Napoleonic campaign as we conducted in 1878–80. Penrose hadn't a touch of the Collector's Fever. All he wanted was the fun and the risk. I had the Fever on both sides.[21]

In Ohio, relic hunting provided a diversion from farming, and in writing about his transcontinental walk, Lummis referred frequently to the souvenirs he picked up along the way. He arrived in Los Angeles with his pockets loaded with "rattlesnake skins, gold nuggets, copper specimens, moss agates, turquoises, petrified wood, Navajo jewelry and other mementos . . . while deer skins, antlers, Zuni and Acoma pottery had been shipped by rail to Los Angeles from various points along the route."[22]

He continued to collect in Bolivia and Peru, and his diaries show that there, as in New Mexico, he earned money by selling curios. Even when funds for the expedition were cut off and he had no real income, he found a way to acquire a pair of massive silver spoons of old Inca carving that figured in many a Lummis banquet, the 1723 edition of Garcilasco de la Vega's *Comentarios Reales*, and the eighteenth-century gold-inlaid musket of Juan de Soto, descendant of the discoverer of the Mississippi, for which Lummis traded his favorite revolver, his camera, and other items.[23]

Lummis made no systematic collections. He acquired objects as mementoes of occasions in which he participated, amassing souvenirs that held meaning for him because of their age or their association with important people or events. An assiduous diarist, he nevertheless was careless in recording provenance. Sometimes he acknowledged buying an object, but more often he implied that he excavated it (as in the case of an incised bone vessel from Peru). He built stories around gifts from esteemed and prominent friends, such as "The King of Blankets," his tale of a classic Navajo serape given to him by Martin Valle, "seven times governor of his little sky-built republic of Acoma."[24] With hyperbolic aplomb, Lummis claimed "the best Navajo blanket known," "the next best Navajo Bayeta blanket known," and "the best basket ever made on the Campo reservation of San Diego, California."[25]

## THE SOUTHWEST SOCIETY

It was not until 1903 that Lummis returned to the idea of building a great Southern California museum. Then, perhaps because nobody else had done it, he undertook the project himself. Francis W. Kelsey of the Archaeologi-

cal Institute of America (AIA) asked him to found a Los Angeles chapter of the organization, to be called the Southwest Society. Sensing his opportunity, Lummis agreed on the condition that the main purpose of the society would be to create the museum.[26] He declared his intent to begin "at once," and by the next year he reported that "the Society has taken definite steps for the foundation of a great public museum in Los Angeles, to be called the Southwest Museum."[27] Within a year Lummis had persuaded many of Los Angeles's leading luminaries to join the Southwest Society, establish research and acquisitions programs, hire a curator, and share his vision for the museum.

After twenty years as journalist, editor, preservationist, and local personality, Lummis had amassed a wide circle of acquaintances, and he now used all his skills to recruit prominent members of the city's emerging oligarchy. Businessmen and professionals who had made fortunes developing Southern California answered Lummis's call. For example, the first president of the society was banker Jonathan S. Slauson, one of Los Angeles's leading citizens and developer of the town of Azusa. *Los Angeles Times* publisher General Harrison Grey Otis served as vice president, as did Frederick H. Rindge, whose holdings included what is now Malibu, and Norman Bridge, a physician for whom oil and gas speculation made millions. Bridge became the Southwest Museum's second president and greatest patron.[28]

Lummis befriended authors, artists, military men, developers, socialites, academics, and politicians. To further his goals, he sought individuals of talent, success, and position from all quarters. In highly Protestant and Anglo Los Angeles, Lummis brought Catholic bishops, Mexican American aristocrats, and Jewish commercialists into the museum's circle.[29] The Southwest Society's membership roster reads like a who's who of early Southern California.[30] The AIA's Los Angeles organization soon outgrew all the other national chapters, and Lummis took the opportunity to tweak the Eastern establishment, by emphasizing research in the Americas ("Out here we do not need to depend upon Greek professors, no matter how excellent") and declaring that the reason for success was that the Californians "mix business with our science."[31]

## FIELD RESEARCH

While he developed the Southwest Society and his network of supporters, Lummis also built a research program and acquired collections for the

emergent museum. In 1904 the society engaged amateur archaeologist and artifact hound Frank M. Palmer as curator. An avid collector, Palmer was a poor recorder of even minimal archaeological information. In the summer of 1905, he excavated under AIA auspices at sites near Redondo Beach, California, and Snowflake, Arizona. His report of the "First Arizona Expedition" is vague even for the time. The Southwest Society never published his "Second Arizona Expedition" to the Cliff Dweller country in 1906, and Palmer later accused Lummis of suppressing his report.[32]

Lummis himself began a program he called "Catching Our Archaeology Alive," wherein he recorded on wax cylinders the folk songs of Hispanic ("Old") California and songs of American Indians. By 1905 he had made more than 500 recordings, 110 in twenty-four different Indian languages and 400 in Spanish.[33] Lummis also continued to make photographs, now concentrating on Southern California.

In 1907 the Southwest Society sponsored Edgar Lee Hewett's archaeological explorations in the area of Puyé, New Mexico.[34] Harvard students A. V. Kidder and Sylvanus Morley, who later became leading Americanist archaeologists, accompanied Hewett.[35] Morley published a short monograph through the Southwest Society on the excavations at Puyé, and Kidder subsequently became an influential voice in the direction of the Southwest Museum.[36] When the School of American Archaeology (now the School of American Research) was founded, Lummis bid unsuccessfully to establish it in Los Angeles. Nevertheless, he continued to support it in Santa Fe and served on its governing board most of the rest of his life. Lummis and Edgar Lee Hewett, the first director of the school, had previously lobbied together to pass the Antiquities Act of 1906, and the two men maintained a long friendship.[37]

In spite of their variable quality, these research projects and expeditions imbued the Southwest Society with an aura of scientific purpose and respectability, raised the enthusiasm of the members, and gave Lummis a record of success with which to argue for further participation and donations. Field research also yielded collections for the society, but Lummis did not rely solely upon these sources to stock the museum.

## CREATING THE SOUTHWEST MUSEUM

In addition to the materials assembled as a result of field research, the Southwest Society solicited donations and sought sponsorship for the purchase of collections. In 1904 the society purchased the Palmer-Campbell

collection of Southern California archaeological materials[38] and secured the Caballeria collection of forty-four books and thirty-four oil paintings, which, according to Lummis, represented holdings from California's missions prior to secularization in 1834.[39] They also received heirlooms from the family of General John C. Frémont, William Keith's sketches of California missions painted between 1882 and 1883, relics from Generals Pico and Vallejo, and a Coleoptera collection.

Lummis extolled the society's field research and collections in *Out West* and the *Southwest Society Bulletin,* and in 1907 proclaimed "a museum already."[40] The society installed its collections that year in the Pacific Electric Building at Sixth and Main Streets, the downtown Los Angeles terminal and headquarters of Henry E. Huntington's Pacific Electric Railway.[41] Photographs of the arrangement show California archaeological material displayed in the manner of a cabinet of curiosities, and Spanish Colonial paintings hung closely on the walls, as in a salon. About a year later the museum moved to the Hamburger Building, at 320 West Eighth Street, into spaces on the sixth floor donated by M. A. Hamburger, a president of the Southwest Society. The sequence of early museum sites illustrates Lummis's ability to turn his associations with powerful businessmen to his and the museum's advantage.

By the end of 1907, Lummis reported that "the Southwest Museum is a fact." By then, society members had selected a site and made progress on the building's design. A meeting to organize the museum selected seven incorporators, who later became the first directors, and the State of California incorporated the Southwest Museum on the last day of 1907, thus creating the first museum in Los Angeles.[42]

Its mission, as described in the articles of incorporation, was to establish "a free public museum of science, history and art, for the benefit of the people of Los Angeles and the Southwest [and for collecting, conducting research, and educating in these areas]." Lummis wrote that the geographic focus of the museum would be the Southwest (including Southern California) and that its themes would be archaeology, history, and the Old California of the missions and ranchos. But at the same time, he welcomed eclectic collections, arguing that the only way to preserve family valuables, "your grandmother's wedding dress or her spoons, or her turkey platter . . . is to put them, *in the family name,* in a fireproof museum in perpetual trust" (Lummis's emphasis).

With great fanfare, Lummis donated his own collections and library to the Southwest Museum in early 1910. "Believing that life is a trust; that a

man owes it to his children, and to the community of which he and they are a part, to preserve and pass on to them, in perpetuity, so much as is possible of all that he may accumulate in knowledge and in material possessions," he argued for donations "to [a museum] where my children and the public may enjoy them forever."[43]

The Southwest Museum's broad mission, coupled with Lummis's contradictory statements regarding focus and his encouragement of an eclectic collecting policy, sowed the seeds of future problems. The Los Angeles Museum of History, Science and Art (now the Natural History Museum of Los Angeles County) opened to the public on November 6, 1913, in direct competition with the still unfinished Southwest Museum. Nine months later the Southwest Museum opened without a clear set of priorities for collecting and exhibiting. This problem was not addressed effectively until James A. B. Scherer became director in 1926 and firmly redirected the museum toward anthropology—long after Lummis had become inactive in the institution.[44]

## LUMMIS AND HIS CURATORS

Frank M. Palmer became curator for the Southwest Society in 1904 and in January 1908 was appointed curator of the Southwest Museum.[45] When the museum relocated to the Hamburger Building, Lummis's comment that "Curator Palmer has made a most tasteful display" belied the rising tension between the two. After four years, Palmer had yet to begin cataloging the museum's collections, prompting Lummis to accuse him of neglect, and the unpublished report of the Second Arizona Expedition still rankled Palmer. In June 1909, in a public quarrel covered prominently by the *Los Angeles Times* and the *Herald,* Palmer accused Lummis of coercion, slander, manipulation, misappropriation, exaggeration, domination of the board, encouraging despoliation of sites, and conflict of interest for his support of the School of American Archaeology. The affair made Lummis ill, and no one associated with the Southwest Society or the museum could have relished such public bloodletting. A board committee set up to explore the matter exonerated Lummis and concluded that "of the two men there is no doubt in our mind as to which would be the greater loss to the movement to which both organizations are allied." Palmer was asked to resign.[46]

Lummis already had a replacement in mind: French archaeologist and art historian Hector Alliot. Educated at the Universities of France and of

Lombardy, Alliot had field experience at Tyre and had led an expedition to Cliff Dweller sites in the Southwest, the finds from which he exhibited at the World's Columbian Exposition in 1893. Before joining the Southwest Museum, he served as professor of art history at the University of Southern California. In Alliot, Lummis had found a "Curator who curates," and the Southwest Museum had a popular lecturer and public figure who brought credibility and recognition to the institution.[47]

## A BUILDING OF CLASSIC BEAUTY

As early as 1905 the executive committee of the Southwest Society developed guidelines for site selection. Echoing Lummis's desires, they mandated that the museum be built upon some slightly commanding eminence, on over five acres, and in Spanish Mission patio plan. They determined to build "as noble an architectural monument as it shall be possible to build in this community."[48]

It was decided at the outset that such an institution should not be set down under the feet of commerce, nor upon buzzing streets where in a few years it would be smothered. It was decided that this museum shall be built where it "cannot be walked on"—on a hill, where it shall See and Be Seen; above and outside the smoke and dust and noise of metropolitan streets, and yet absolutely easy of access from any part of this city as it now is or as it ever shall be. It was made a condition precedent that the site must be such that those who come to the museum shall pause at its entrance to look forth upon the panorama which God and man have spread; and that when they emerge from the building—no matter what cars are clanging below for an urgent engagement—they shall pause for another car, that they may have another look.[49]

In the search for a site for the museum, Henry Huntington offered to donate one of four locations in Eastlake Park in East Los Angeles, and Abbot Kinney offered a site in his new cultural and recreational development at Venice. Lummis campaigned for a location on the side of Mount Washington, north of downtown Los Angeles, that he characterized as "the most beautiful location and outlook of any public building in America." Predictably, his preference was the site selected: 16.9 acres for $38,000. In 1910, Carrie Jones bequeathed $50,000 to the museum for the construction of the first buildings.

Lummis developed his vision with the architect Sumner Hunt, whose of-

fice produced a watercolor sketch of a museum of "sufficient scale for the Future of Los Angeles."[50] Although the final design would not be completed until 1912, Lummis envisioned a grand edifice:

The architecture is in general that of the Alhambra of Spain, in its outward manifestation—but bent to the requirements and opportunities of California. . . . The rise of the hill, and its contour, will be followed in the architecture; and while the complete museum will sometime be two rows of halls a hundred feet apart and 1,200 feet long, besides the (at least six) cross-halls marking off a series of patios, the general effect will be even more massive and varied than that of the Alhambra.[51]

In 1911 Lummis contracted an eye disease while visiting Guatemala, and he was left blind through 1912. Undaunted, he imposed his view of museum design upon the architects, working with pencils and folded paper to design a Caracol Tower with an internal spiral staircase of 160 steps. Critics might remark that the Southwest Museum, for all its attractiveness, was designed by a blind man.

Lummis harbored no doubts about the quality or significance of his museum design. He enthused about a building of majestic size and classic beauty, and boasted about the

[m]any features [that] will make the Museum unique. Its site has no parallel among the Museums of the world. The patio plan and the out-door auditorium are in a class by themselves. The great exhibition halls, with barrel vault ceilings, recessed cases, 3-foot walls, indirect lighting, vacuum cleaning, all fire-proof, quake-proof and time-proof—will be a new record in Museums. . . . [T]he great Caracol staircase in the tower—a spiral without a core, [is] the first in the United States, and rivaled in America only by the world-famous Caracol in the Cathedral of Mexico.[52]

Groundbreaking took place on November 16, 1912, and with his usual flair, Lummis arranged for Elizabeth Benton Frémont to raise the flag that her father, General John C. Frémont, the Pathfinder, first unfurled in the Rocky Mountains on August 16, 1842. Various dignitaries spoke about the museum, and Woodrow Wilson and Theodore Roosevelt sent congratulations, but the substantive business was transferring almost all the society's assets to the museum. Workmen began pouring concrete on July 9, 1913, and quickly laid the foundations and erected the molds for the walls. Within a month they poured 1,400 tons of concrete for the foundations, and by September they had set both floors of the great halls and three stories

of the great tower. Lummis noted that "the staircase, the first of its kind in the world, attracted much attention."[53]

On December 6, 1913, twenty-five dignitaries, many of whom had participated in the groundbreaking, gathered to lay the cornerstone. Set into the west facade below the great window between the two entrances, the stone bears the seal of the museum, the image of an Aztec eagle holding a rattlesnake, which Lummis imaginatively interpreted as representing clear vision, high aspiration, and decisive action. He created the legend, *Mañana flor de sus ayeres,* and translated it "Tomorrow is the flower of its yesterdays."[54] Officials placed mementoes in the stone and addressed an audience at the construction site.[55]

In July 1914, Lummis photographed the starkly beautiful interior spaces of the completed museum. He recorded a long two-story building divided, not quite in the center, by a monumental stairway rising from the lobby to the high barrel-vaulted galleries above. The seven-story Caracol Tower terminated the long axis of the museum at the north end, and the three-level Torrance Tower engaged the main building on the south.[56] Lummis, his son Jordan, and Hector Alliot moved collections into the storerooms and galleries. The Southwest Museum opened to the public without ceremony at noon on August 1, 1914.

## EARLY EXHIBITIONS AND PROGRAMS

If Lummis celebrated his great accomplishment, it is not recorded. Perhaps the guns of August in Europe deflated a celebratory mood, or maybe the heavy indebtedness undertaken to complete the museum dampened spirits. The apparent lack of formal opening might simply have been more practical: Even though the museum was open to the public, there were almost no exhibition cases.

The museum opened with its main exhibition hall dedicated to the archaeology of California and the Southwest (fig. 3.3), and soon afterward a major shell collection appeared in the northern upper gallery (fig. 3.4). Photographs reveal a typological approach, with objects densely displayed. The room in the Caracol Tower adjacent to the shells was first devoted to ornithology, but within a few years it was committed to Oriental art. In the tower room above was the Munk Library of Arizoniana, and below was Southwestern ethnography (fig. 3.5).[57] By 1920, the Torrance Tower housed a fine arts gallery. There is no evidence that Lummis was particu-

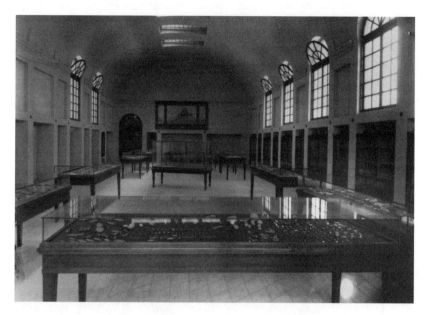

Figure 3.3. Hall of Archaeology, 1914–15. Southwest Museum, Los Angeles, photo S1.169.

larly interested in exhibits or programming, nor apparently was he active in acquiring collections for the museum during this period. He had other things on his mind by then.

## EXITING THE MUSEUM, 1914–1919

With the opening of the museum, Lummis should have been celebrating one of his greatest personal triumphs. Instead, trouble within the museum organization foreshadowed his downfall. As early as 1913, it was clear that there was not enough money to complete the museum building as planned. The board of directors considered omitting the two towers and building only the central halls, thus gutting Lummis's treasured plan.[58] Jared Torrance pledged $14,000 for the smaller tower that now bears his name, but the museum incurred a substantial debt to complete the Caracol Tower, the defining feature of Lummis's design. When board president Norman Bridge expressed his disappointment in the directors' ability to raise money during the crisis, Lummis surmised that the criticism was directed at him. In Sep-

Figure 3.4. Hall of Conchology, ca. 1919. In the early years the museum of "history, science and art" also housed an "Asiatic Hall" and an art gallery. Southwest Museum, Los Angeles, photo S2.8.

tember 1914, one month after opening, the board took out a $25,000 mortgage on the museum building; by the beginning of 1915 liabilities totaled $36,000.

Lummis's term as secretary, the position from which he virtually ran the museum, expired in February 1915. The board postponed elections until the March meeting and asked that Lummis present the account books for inspection. At the February meeting, Norman Bridge had tendered his resignation. In March, Lummis stated his belief that Bridge held him largely responsible for the museum's financial predicament and resigned as secretary. Bridge responded by encouraging the board to accept Lummis's resignation and withdrawing his own. Thus stripped of the executive authority he had held since the beginning, Lummis requested an independent audit of the books, saying, "All I care about now is the facts, and I have a right to your judicial inquest after the lynching."[59]

On March 11, he wrote Joseph Scott, a vice president of the museum:

Figure 3.5. Hall of Ethnology in the Caracol Tower, 1919. Southwest Museum, Los Angeles, photo S2.182.

None of you will ever feel proud of what you have done to me. It would be doubly humiliating if this action—the most ungrateful I have ever known, and I think the most unbusinesslike—failed to bring financial ease to the museum. It has been the hardest blow I ever had in my life. . . . In one or two or three years—if it takes that long—I think you will all be heartily ashamed.[60]

Although he remained a member of the board, Lummis was never again fully engaged with the museum, and his efforts to prolong his association with it only inspired conflict. He fought to maintain the Southwest Society, even though by 1914 most members of the museum's board believed that the organization had outlived its usefulness and that its continued existence diverted money and energy from the museum itself. In 1917, president Jared Torrance asked Lummis to dissolve the society on the grounds that its use of the word *southwest* was a source of confusion. Lummis complied, but incorporated a successor, the "Institute of the West," and established

headquarters at El Alisal. The museum reconveyed his collections to him, with a public statement of support for his new venture. But in 1918 museum trustees forced the dissolution of the Institute of the West and resolved that Lummis's involvement with it constituted a conflict of interest. Lummis's term as a trustee expired in 1919. At the January 8 meeting, the board hurried to elect a replacement. Arriving at the meeting ten minutes late, Lummis remained ignorant of his ouster until two days later, when he read about it in the *Los Angeles Times*.[61]

As a final blow, Hector Alliot died suddenly in February 1919, to Lummis's heartfelt distress.[62] Lummis offered himself as a replacement saying, "I should not expect his salary—I am not worth what he was. A bare living at taking care of 'My Baby' would be all that I desire."[63] The board ignored his offer.

### REHABILITATION, 1923–1928

As the decade closed, Lummis's financial situation became precarious. Although he sold some of his collections to make ends meet, in 1922 his annual income may have been as low as $255.06.[64] The following year the museum board made plans to reintegrate Lummis into the fold and, in the bargain, reacquire his collections. They declared Lummis's birthday in March "Founder's Day"—this was also the approximate anniversary of the donation of his collections to the museum in 1910. Lummis told his old friend Maurice H. Newmark that he would most appreciate having the Caracol Tower named in his honor, and the board readily agreed to this.

By January 1924, Lummis agreed to reconvey his collections and title to El Alisal to the Southwest Museum for either $500 or $800 (the records are unclear) and the right to live in his house for the rest of his life. The transaction poignantly underscores his desperate financial situation as well as his true wish for the museum that he founded to house his personal collections. The board appointed him curator of history at a salary of $100 per month. The position was primarily honorary: museum programming did not emphasize history, and Lummis's annual reports were never published. When he became ill by the end of 1927, however, the museum agreed to pay his medical costs of $100 per month.[65]

Lummis died of a brain tumor on November 25, 1928, with his most recent book upon his chest. The museum paid for his funeral, proposed a memorial and endowment in his honor, and noted the need for funds to re-

habilitate El Alisal. Because of fire hazard, all objects of "intrinsic" value were removed to the museum. By the middle of 1929, the Lummis Memorial Committee was moribund.[66]

It was Lummis's wish that, after his death, El Alisal would be used as a "living museum" with the front rooms open to the public and the private rooms occupied by his children. Turbesé and Jordan took up residence at El Alisal, the museum paying them each $50 a month as custodians. By 1935, the house was in need of maintenance, and lack of funds precluded opening it to the public. A memorial association was formed in 1939 to purchase and care for El Alisal, but enthusiasm waned. In 1943 the house was transferred for $5,000 to the state, which entrusted administration to the Los Angeles Parks Department. Plans were made for an ethnobotanical garden and opening the house to the public. The Southwest Museum left on loan those of Lummis's ethnographic and archaeological collections in the residence not "immediately required by the Museum." These collections were later returned to the museum, and today El Alisal is the headquarters of the Historical Society of Southern California.[67]

## CONCLUSIONS

By almost any standard, Charles F. Lummis lived a singular life: one of calculated extremes, overwork, excesses concerning women and drink, flamboyant dress and lifestyle, and prodigious literary output hovering somewhere between journalism and scholarship. A displaced Easterner and almost-graduate of Harvard, he came to symbolize the vision of an old Spanish California that, if it ever existed, passed on long before his time. He was proud that his books continued to be read throughout his lifetime; but those qualified to assess his literary merit judge him a quick writer dependent upon secondary sources rather than a scholar and deep thinker.[68] At the height of his powers he counted among his friends and acquaintances some of the most powerful and creative persons in Southern California, and social evenings ("noises") at El Alisal were noted for the variety of talented people who attended. Yet one views his later life with a certain sadness. He died lonely, the memories of his accomplishments and disappointments his closest companions.

Although the Southwest Museum became one of the country's preeminent museums concerned with American Indians, they were but a part of Lummis's broader focus on Spanish America. He was interested in the tan-

gible evidence of Spanish and Indian interaction, often in the form of mission architecture; his writings argue that Spanish policy toward native populations was enlightened and benign.[69] He sympathized with Indian groups that, in his mind, represented the successful blending of those ancient cultures but who were now imperiled by the actions of misguided Yankee "progressives." Thus, in founding the Sequoya League, he addressed his vitriolic pen to the forced assimilation of Hopi children and the relocation of California Mission Indians from Warner's Ranch, but he practically ignored his colleagues' attempts to interest him in the plight of Plains people at Standing Rock Reservation.[70] In the manner of Cushing, Lummis "adopted" Isleta Pueblo and maintained long personal relationships with people there; and in typical fashion, he used his long acquaintance with Theodore Roosevelt to influence changes in United States Indian policy.[71] In general, his involvement with issues surrounding American Indian rights was separate from his efforts to found the Southwest Museum, which he envisioned as devoted to a broad range of regional subjects.

Various motives drove Lummis to found the Southwest Museum. He had museums "in his blood" to some extent, judging from his rooms at Harvard and the *museo* at El Alisal (and his plans for a living museum there). A born collector, he intuitively understood the symbolic and educational value of objects. Yet he did not concern himself with provenance or the details of labeling or organized presentation, nor did he engage the issue of the relationship between interpretive strategies and public learning. His passion for the Southwest and his dedication to the California myth played a part, and he saw the need for a great educational institution to boost Los Angeles's status as a major city. Lummis was a salesman whose products were Southern California, its Spanish legacy, and himself. On one level he was honest in stating, when he resigned as secretary, that he wanted what was best for the Southwest Museum ("this my youngest child"), but on another, by building the museum he surely sought immortality for himself.

The very force of personality that makes founders successful in achieving their goals sometimes leads to tensions with financial backers or staff and creates lasting consequences for the institutions involved. Lummis's unrelenting stubbornness created the museum as well as some of its more intractable problems. Potential visitors perceive its location, unquestionably scenic, as remote and difficult to access (fig. 3.6). Gallery spaces are static and hard to modify for exhibitions. Lummis's favorite architectural flourish, the Caracol Tower, is nearly impossible to use—for example, today ap-

Figure 3.6. "The site must be such that those who come to the museum shall pause at its entrance to look forth upon the panorama which God and man have spread; and that when they emerge from the building—no matter what cars are clanging below for an urgent engagement—they shall pause for another car, that they may have another look." Southwest Museum, ca. 1920. Southwest Museum, Los Angeles, photo S1.569.

proximately twelve thousand ceramic vessels occupy the upper two stories, accessible only by the steep spiral staircase. An unavoidable tension arises in regard to Lummis as museum founder: Without him there would be no Southwest Museum, but does the heritage of his vision inhibit the museum from fulfilling its potential?

## Acknowledgments

The authors would like to thank Kim Walters, director of the Braun Research Library of the Southwest Museum, for her assistance with this project, including making available to us both library and archival materials and providing the illustrations. Thanks also to Curtis M. Hinsley, Northern Arizona University, who gave us a thoughtful commentary on the manuscript.

## Notes

1. No critical biography of Lummis exists, nor has anyone worked comprehensively on his relationship with the Southwest Museum. M. A. Sarber's *Charles F. Lummis: A Bibliography* (Tucson: University of Arizona, 1977) lists Lummis's publications and works about him. Dudley Gordon's *Charles F. Lummis: Crusader in Corduroy* (Los Angeles: Cultural Assets Press, 1972) is uncritically laudatory and based upon Lummis's point of view. Turbesé Lummis Fiske and Keith Lummis's *Charles F. Lummis: The Man and His West* (Norman: University of Oklahoma Press, 1975) contains the insights that offspring can bring and does not avoid potentially unpleasant situations in Lummis's life, but it lacks a fully developed, scholarly, critical approach. F. Walker, *A Literary History of Southern California* (Berkeley and Los Angeles: University of California Press, 1950) and E. Bingham, *Charles F. Lummis, Editor of the Southwest* (San Marino: Huntington Library, 1955) include many insights about Lummis, mainly his literary accomplishments. James W. Byrkit's introduction to Byrkit, ed., *Charles Lummis: Letters from the Southwest* (Tucson: University of Arizona Press, 1989), offers a more contemporary assessment, also from the point of view of Lummis's writing, although within historical and intellectual contexts. Kevin Starr, in his *Americans and the California Dream, 1850–1915* (New York and Oxford: Oxford University Press, 1973), *Inventing the Dream: California through the Progressive Era* (New York and Oxford: Oxford University Press, 1985), and *Material Dreams: California through the 1920s* (New York and Oxford: Oxford University Press, 1990), offers a contemporary assessment that also briefly discusses the Southwest Museum (and see his bibliographical essays, particularly in the 1985 volume, 346–47 and 350–51). These books also present the historical and intellectual milieu in California surrounding the creation of the Southwest Museum and often contain information concerning individuals associated with the museum. Harris Newmark's *Sixty Years in Southern California, 1853–1913*, ed. M. H. and M. R. Newmark, 4th ed. (Los Angeles: Zeitlin and Ver Brugge, 1970), is well known for its information on the period and its people.

   The best internal documentary sources are the minutes of the meetings of the board of directors/trustees of the Southwest Society and of the Southwest Museum (cited as SWS Minutes and SWM Minutes), Lummis's cryptic handwritten diaries in the Braun Research Library of the Southwest Museum, and his typed journals based on the diaries. There are also scrapbooks and other special collections, including wax cylinder recordings. His unpublished reminiscences, "As I Remember," are in the Special Collections Library of the University of Arizona. An anonymous pamphlet, *The Works of Charles F. Lum-*

*mis* (Los Angeles: Lummis Foundation, 1928), relates a brief popular account of his life and hawks his publications. The photographic archives of the Southwest Museum are an invaluable source for research.

The *Bulletins* of the Southwest Society/Southwest Museum relate the history of the founding of the museum and contain information on collections and research expeditions (1904–11). The *Annual Reports* series (1921–27) documents the history of museum departments and policies; in the spring of 1927 the museum initiated *The Masterkey,* the members' general publication, of which one issue each year was dedicated to the annual report. The *Bulletins, Annual Reports,* and *The Masterkey* are excellent sources for the history of the Southwest Museum.

D. L. Clark wrote a little-known but sometimes insightful thesis, "A History of the Southwest Museum, 1905–1955" (master's thesis, Claremont Graduate School, 1956), and W. W. Robinson published a brief popular history, *The Story of the Southwest Museum* (Los Angeles: Ward Richie Press, 1960). Daniela P. Moneta, ed., *Charles F. Lummis: The Centennial Exhibition* (Los Angeles: Southwest Museum, 1985) contains essays on Lummis and various aspects of his life and contributions.

2. Report of the Secretary, SWM Minutes 1/10/12.
3. Fiske and Lummis, *Charles F. Lummis.*
4. Lummis, *Birch Bark Poems* (Cambridge, 1879).
5. Charles F. Lummis, *A Tramp across the Continent* (New York: Scribner's, 1892; reprint, Lincoln and London: University of Nebraska Press, 1982); Lummis, *Letters from the Southwest.*
6. Starr, *Inventing the Dream.*
7. Lummis, "The White Indian," *Land of Sunshine* 13 (1900): 8–17. See also Curtis M. Hinsley, "Zunis and Brahmins: Cultural Ambivalence in the Gilded Age," in *Romantic Motives: Essays on Anthropological Sensibility,* ed. George W. Stocking Jr. (Madison: University of Wisconsin Press, 1989), 169–207; Lummis to Frederick W. Hodge, March 17, 1900, Frederick Webb Hodge Manuscript Collection, Southwest Museum, Los Angeles.
8. Lummis, *Letters,* 113.
9. Ibid., 207
10. Ibid., 123.
11. Dan L. Thrapp, ed., *Dateline Fort Bowie: Charles Fletcher Lummis Reports on an Apache War* (Norman: University of Oklahoma Press, 1979).
12. P. Houlihan and C. Campbell, "Lummis as a Photographer," in Moneta, *Centennial Exhibition,* 21–34; Michael Heisley, "Lummis and Mexican-American Folklore," in Moneta, *Centennial Exhibition,* 60–67.
13. Daniela P. Moneta, "Sequoya League," in Moneta, *Centennial Exhibition,* 74–77. As a result of this incident, the fight against government boarding schools became a key issue in Lummis's advocacy of American Indian rights. When Lummis founded the Sequoya League in 1902 "to make better Indians by treating them better," one of his first objectives was to remove from office Charles E. Burton, the agent at Keam's Canyon. Among other things, Lummis charged Burton with raiding Hopi homes and abducting children. See Charles

F. Lummis, "Bullying the Quaker Indians," *Out West* 18 (1903): 668–90; "Bullying the Quaker Indians, Part II," *Out West* 19 (1903): 43–46; and "The Moqui Investigation," *Out West* 19 (1903): 296–309.

14. Charles F. Lummis's publications include *A New Mexico David and Other Stories and Sketches of the Southwest* (New York: Scribner's, 1891); *A Tramp across the Continent: Some Strange Corners of our Country* (New York: Century, 1892; expanded ed. published in 1925 as *Mesa, Canyon, and Pueblo: Our Wonderland of the Southwest*); *The Land of Poco Tiempo* (New York: Scribner's, 1893); *The Spanish Pioneers* (Chicago: McClurg, 1893); *The Man Who Married the Moon, and Other Pueblo Indian Folk-Stories* (New York: Century, 1894).

15. Keith Lummis, "The Lady Eve: Prairie Princess, Queen of El Alisal," *The Californians* 11, no. 6 (1994): 13–21.

16. F. W. Hodge, "Bandelier's Researches in Peru and Bolivia," *American Anthropologist* 10, no. 9 (1897): 303–11; Hodge, "Biographical Sketch and Bibliography of A.F.A. Bandelier," *New Mexico Historical Review* 7 (1932): 353–70; Charles H. Lange and Carroll L. Riley, *Bandelier: The Life and Adventures of Adolph Bandelier, American Archaeologist and Scientist* (Salt Lake City: University of Utah Press, 1996).

17. Walker, *Literary History;* Bingham, *Charles F. Lummis;* Starr, *California Dream; Inventing the Dream; Material Dreams.*

18. P. A. Butz, "Landmarks Club," in Moneta, *Centennial Exhibition*, 68–73; C. F. Lummis, *The Landmarks Club: What It Has Done, What It Has to Do* (Los Angeles: Out West, 1903); Moneta, "Sequoya League"; Frances Watkins, "Charles F. Lummis and the Sequoya League," *Historical Society of Southern California Quarterly* 26 (1939): 99–114.

19. This same year, undoubtedly encouraged by Lummis, Jonathan S. Slauson purchased the Palmer archaeology collection and placed it on exhibit in the chamber of commerce building (SWM Minutes 2/11/15, 3/25/15). Lummis maintained close connections with the chamber of commerce. Charles Dwight Willard, executive secretary of the chamber, founded *Land of Sunshine* in 1894 and sold it to Lummis, who began editing it in January 1895 (see Starr, *Inventing the Dream*, 228–30). Several officers of the chamber also served as officers of the Southwest Society or Museum.

20. Fiske and Lummis, *Charles F. Lummis;* Starr, *Inventing the Dream;* Robert W. Winter, "The Arroyo Culture," in *California Design 1910* (Santa Barbara and Salt Lake City: Peregrine Smith, 1980).

21. Fiske and Lummis, *Charles F. Lummis,* 8.

22. Gordon, *Crusader in Corduroy,* 114.

23. Fiske and Lummis, *Charles F. Lummis,* 84–86.

24. Lummis, *Mesa, Canyon, and Pueblo.*

25. SWM Accession files.

26. Fiske and Lummis, *Charles F. Lummis,* 122.

27. Lummis, "A Brief Summary," *Southwest Society of the Archaeological Institute of America, Second Bulletin* (Los Angeles, 1905; reprinted from *Out West,* January 1905), 1–3.

28. Others from the business community who made substantial contributions to the Southwest Museum include: Henry O'Melveny, founder of one of the largest law firms in the United States; Mira Hershey, proprietress of the Hollywood Hotel and owner of much of the land on which the Hollywood Bowl now stands; and Jared S. Torrance, future president of the museum and founder of the town that bears his name.

29. Bishops T. J. Conaty and J. H. Johnson participated and promised religious relics of Spanish California, and Arturo Bandini and Don Romulo Pico represented California's pioneering ranching families. The Newmarks, a prominent early Jewish family, were part of the effort. Maurice H. Newmark became Lummis's good friend and supported the museum until Lummis's death.

30. For example, artists such as Maynard Dixon, William Keith, and Eva Scott Fényes; authors such as Mary Austin; architects, including Sumner Hunt; developers like Abbot Kinney, who created Venice, California, and Frank Miller, who built the Mission Inn in Riverside. Lummis drew attention to the Southwest Society (and to himself) by honoring high-placed friends with life memberships in the society or museum; among those so honored were Theodore Roosevelt, Harvard's Charles Eliot Norton, and William Henry Holmes, chief of the Bureau of American Ethnology.

31. "Sixth Annual Report," *Southwest Society of the Archaeological Institute of America, Fifth Bulletin* (Los Angeles, 1910).

32. Frank M. Palmer, "The First Arizona Expedition," *Southwest Society of the Archaeological Institute of America, Third Bulletin* (Los Angeles, 1907; condensed from *Out West*, December 1905), 2–32; Lummis, "The Swallow's Nest People," *Out West* 26 (1907): 485–505.

33. Lummis, "Catching Our Archaeology Alive," *Southwest Society of the Archaeological Institute of America, Second Bulletin* (Los Angeles, 1905; reprinted from *Out West*, January 1905), 3–15; Lummis, *Spanish Songs of Old California* (Los Angeles, New York, and San Francisco: G. Schirmer, 1923).

34. Edgar Lee Hewett, *Antiquities of the Jemez Plateau, New Mexico,* Bureau of American Ethnology, Bulletin 32 (Washington, D.C., 1906); Edgar Lee Hewett, "Archaeology of the Rio Grande Valley, N.M.," *Southwest Society of the Archaeological Institute of America, Fourth Bulletin* (Los Angeles, 1909; reprinted from *Out West*, August 1909); *Pajarito Plateau and Its Ancient People* (Albuquerque: University of New Mexico Press, 1938; 2d ed. rev. by Bertha P. Dutton, 1953).

35. R. L. Brunhouse, *Sylvanus G. Morley and the World of the Ancient Maya* (Norman: University of Oklahoma Press, 1971), 46; Richard B. Woodbury, *Alfred V. Kidder* (New York and London: Columbia University Press, 1973), 17; Alfred Vincent Kidder, "Reminiscences in South West Archaeology," *Kiva* 25 (1960): 1–32.

36. Sylvanus Griswold Morley, "The South House of the Pu-ye," *Southwest Society of the Archaeological Institute of America, Sixth Bulletin* (Los Angeles, 1910).

37. Hewett and Lummis met with President Theodore Roosevelt, W. H. Holmes,

and two Cabinet secretaries at the White House on June 6, 1907, regarding implementation of the Antiquities Act. For Hewett's role in developing the school, and Kelsey's efforts to expand the American Institute of Archaeology, see Curtis M. Hinsley Jr.'s insightful essay, "Edgar Lee Hewett and the School of American Research in Santa Fe, 1906–1912," in *American Archaeology Past and Future,* ed. D. J. Meltzer, D. D. Fowler, and J. A. Sabloff (Washington and London: Smithsonian Institution Press, 1986), 217–33.

38. Frank M. Palmer, "Beginning the Southwest Museum," *Southwest Society of the Archaeological Institute of America, Second Bulletin,* (Los Angeles, 1905; reprinted from *Out West,* January 1905), 16–27. Palmer assembled the Palmer and the Palmer-Campbell collections before he came to the Southwest Society. Both collections now reside in the Southwest Museum.

39. Charles F. Lummis, "Old Art in California," *Southwest Society of the Archaeological Institute of America, First Bulletin,* 2d ed. (Los Angeles, 1904; reprinted from *Out West,* September 1904).

40. Lummis, "The Southwest Museum," in *Southwest Society of the Archaeological Institute of America, Third Bulletin* (Los Angeles, 1907), 2–32; see also "Sixth Annual Report," *Southwest Society of the Archaeological Institute of America, Fifth Bulletin* (Los Angeles, 1910; reprinted from *Out West*).

41. Marion Parks, "The Museum Yesterday," *The Masterkey* 1, no. 2 (1927): 11–15, 25–29; Starr, *Material Dreams.*

42. Chosen president was Lieutenant General Adna Chaffee, chairman of the Los Angeles Board of Public Works, which oversaw construction of the Los Angeles Aqueduct, William Mulholland's project to bring water to Los Angeles from the Owens Valley. A former Chief of Staff of the United States Army, Chaffee was a veteran of the Civil War, the Indian campaigns of the Southwest, the Spanish-American War, and the Boxer Rebellion. Chaffee was just the sort of leader Lummis wanted for his museum. Starr, *Inventing the Dream,* 250; *Material Dreams,* 56. The others were Lummis's loyal friend M. H. Newmark; Joseph Scott, prominent attorney and future president of the Southwest Museum; William Lacy; Mary Foy; Mrs. Robert Burdette, the wife of a *Times* editor and a well-known Pasadena socialite; and Lummis.

43. Hector Alliot, "Two Great Gifts: The Lummis Library and Collections; The Munk Library," *Southwest Society of the Archaeological Institute of America, Seventh Bulletin* (Los Angeles, 1910); SWM Minutes 4/7/10. To honor Lummis for his gift, the board dubbed him "Founder Emeritus."

44. Thomas H. Wilson, "F. W. Hodge and the Southwest Museum 1932–1955," Hodge Lecture Series, Southwest Museum, Braun Research Library, manuscript, 1993).

45. The position of director of the museum was not created until 1916, and full executive authority was not extended to the director until 1926. Until then, the president of the board of trustees wielded executive power, although Lummis, through his positions of secretary of the Southwest Society and the Southwest Museum, functionally operated as director of the two organizations.

46. See, for example, "Archaeologist Scores Lummis," *Los Angeles Herald,* June 22, 1909, 8; SWM Minutes 10/27/09.

47. Lummis, "Hector Alliot," *El Palacio* 6, no. 10 (1919): 156–59 (Santa Fe: Museum of New Mexico); SWM Minutes 1/19/10; C. F. Lummis, ed., "Seventh Annual Report and Roster"; "Third Annual Report, The Southwest Museum," *Southwest Society of the Archaeological Institute of America, Eighth Bulletin* (Los Angeles, 1911). In addition to a vigorous public life, Alliot conducted brief field research for the museum on California's Channel Islands; see Alliot, "Burial Methods of the Southern California Islanders," *Bulletin of the Southern California Academy of Sciences* 15 (1916): 11–15, and "Pre-Historic Use of Bitumen in Southern California," *Bulletin of the Southern California Academy of Sciences* 16 (1917): 41–44.

48. SWM Minutes 4/15/05.

49. Lummis, "The Southwest Museum," 5.

50. Ibid. Lummis claimed that the Southwest Society hired Hunt in 1906 to create preliminary plans for the museum, but he was not formally engaged until June 1912, when he was given two months to complete plans and bids (SWM Minutes 6/10/12).

51. Ibid., 9.

52. Fifth annual report of the secretary, SWM Minutes 1/8/13. Later, curator Charles Amsden was not as fulsome as Lummis about the tower and staircase: "Museums are usually planned by architects who think in terms of exterior appearance, being largely ignorant of interior requirements. Witness the Southwest Museum, with a good fifth of its total floor space reached by a stairway so narrow that a packing-case of moderate size, a desk, or a display case, must be hoisted in through a window." Charles Avery Amsden, "Notes of a Museum Tour," *The Masterkey* 4, no. 8 (1931): 242–50, and also Amsden's "Museums and the Museum Idea," *The Masterkey* 4, no. 5 (1930): 139–45.

53. SWM Minutes 9/22/13.

54. Ibid., 2/12/08.

55. The contents are not a particularly imaginative assemblage. Included were photographs of the Frémont family, copies of the Southwest Museum *Bulletin,* various documents conveying collections to the museum, architectural drawings, freshly minted coins, a copy of the *Los Angeles Times* of 11/30/13, which announced the festivities, a list of principal donors, copies of several of the day's addresses, an ostrich egg engraved with the museum's seal, and a copy of the articles of incorporation wrapped in the American flag.

56. Lummis carefully cataloged superlatives concerning the structure: 105 miles of steel rebar, 17,100 roof tiles, 2,422 panes of glass, about three acres of plastering inside and out, and 15,000 tons of concrete. He calculated that, empty, the Caracol Tower weighs more than five million pounds. Construction costs were $106,649, and architects' fees, utilities, and fixtures brought the total cost to $123,551.

57. Alliot, *Two Great Gifts.*

58. Norman Bridge, *The Marching Years* (New York: Duffield, 1920), 223–26.

59. Letter of 3/25/15, SWM Archives, folder L, 1909–15; SWM Minutes 7/9/14, 2/11/15, 3/11/15, 3/25/15, 7/8/15. Bridge's frustration with fund-raising efforts was probably exacerbated by the $10,000 donation he had just made to the building fund. Much of the financial burden was falling upon him and a very few supporters. Lummis's swashbuckling ways probably annoyed Bridge, who instituted certain financial reforms (such as governing expenditures by a budget) as soon as Lummis was removed as secretary.

60. Letter of 3/11/15, SWM Archives, folder L, 1909–15.

61. Southwest Museum correspondence files; Charles F. Lummis Diaries; Charles F. Lummis Journals; SWM Minutes 1/8/19.

62. Lummis, "Hector Alliot"; "Hector Alliot Is Dead," *Los Angeles Times,* 2/16/19.

63. Fiske and Lummis, *Charles F. Lummis,* 204.

64. Starr, *Inventing the Dream,* 126.

65. SWM Minutes 1/25/24, 11/25/27.

66. The book was *A Bronco Pegasus* (Boston: Houghton Mifflin, 1928); SWM Minutes 11/26/28, 12/4/28, 3/29/29, 6/5/29.

67. SWM Minutes 12/19/23, 3/4/31; *The Masterkey* 10, no. 2 (1936): 59; 15, no. 2 (1941): 53; 17, no. 5 (1943): 161; 18, no. 2 (1944): 55.

68. Bingham, *Lummis;* Walker, *Literary History;* Byrkit, Introduction, in Lummis, *Letters;* Starr, *Inventing the Dream* and *Material Dreams.* Lummis still enjoys an audience; in addition to his letters, seven of his books are in print in 1996.

69. Lummis, *Spanish Pioneers.*

70. Lummis and C. Hart Merriam, correspondence 1901–1903, Braun Research Library, Southwest Museum; Lummis and George Bird Grinnell, correspondence 1901–1902, Braun Research Library, Southwest Museum.

71. C. F. Lummis, *Bullying the Moqui,* ed. Robert Easton and Mackenzie Brown (Prescott: Prescott College Press, 1968).

# 4

# RUDOLF F. HAFFENREFFER AND THE KING PHILIP MUSEUM

Before 1929, a private museum in Rhode Island attracted little public notice beyond an occasional mention in the press in a story on statewide archaeology collections or some local matter, but that January it suddenly catapulted into regional consciousness. Featured prominently in Massachusetts and Rhode Island newspapers, it acquired a name—the King Philip Museum—and was depicted as a "shrine" or "sanctuary" for Philip, the Pokanoket leader who died virtually within sight of where the museum stood. The name of the museum and of its founder, Rudolf F. Haffenreffer, subsequently became widely known. Reporters reached for superlatives to describe the museum. "Collection of Red Men's Relics, Now Largest in New England, Expected to Be Greatest in World," one headline shouted; it would become "a mecca for students," another predicted.[1]

A local, partisan newspaper might be forgiven for hyperbole or stating expectations impossible to fulfill, but in time thousands of people did come through the museum's door, and many clearly liked what they saw. One was LeRoy Perry or Yellow Feather, a Wampanoag Indian from Fall River, Massachusetts. In June 1929 in a register at the museum he addressed Haffenreffer as "Quai Nun Memaeu Netomp," which can be translated as "Hello my loving friend," then wrote as follows: "In appreciation of the Heart interest, of one who perpetuate that which we are unable to, whose work speaks its worth, and whose spirit will never die: proud as a descendant of this People to know him who has wrought so well I subscribe in ap-

preciation and heart felt satisfaction to all that he has so wonderfully done." He signed the register, "Chief Sachem, Ousa Mekin, Yellow Feather, Wampanoag," and left his mark, a feather superimposed on a turtle.[2] Two years later, George Gustav Heye, the unrelenting collector whose Museum of the American Indian in New York was an unparalleled repository of American Indian artifacts, recorded more prosaic thoughts on his first visit to the King Philip Museum. Heye wrote that this was "the best" of many private collections he had seen and that Rhode Islanders were "forever indebted" to Haffenreffer for "a shrine that for all time will mean much to the lover of the American Indian. What he has done to perpetuate the history of our aboriginals is great and wonderful."[3]

Unlike Heye, whose eyes never wandered very far from his museum collections, Haffenreffer was primarily a successful businessman who made his mark as a brewer and industrialist. For years he headed one of the largest brewing operations in the United States. When his museum first came into the public eye, he was in his forties and had been collecting for some years. To convincingly grasp what drove Haffenreffer to collect and to establish a museum for American Indian artifacts, we need to know something about his childhood influences, his adolescent experiences, and the communities in which he lived. To make the story complete, we must then identify the main catalysts of his interest in Indian America, comprehend how he used the museum, and reveal his attitudes about the indigenous people of North America and their history.

Rudolf Frederick Haffenreffer Jr. was born in 1874 in Boston, Massachusetts, the first son of German immigrants (fig. 4.1). His father, Rudolf Friedrich Haffenreffer, came to America from southwestern Germany at age twenty-one, six years before his son was born. He arrived with the skills of a cooper, maltster, and brewer, which he had already put to use in Germany and France. Both he and Rudolf's mother, Katharine Burkhardt Haffenreffer, were born near Stuttgart. Swept up in an emigrant tide, they and many others were pushed out of Germany by economic dislocation, famine, and political adversity (especially in 1848) and pulled toward America by the prospect of opportunity and freedom.[4]

Most nineteenth-century German immigrants who came to America settled in the Mid-Atlantic and Midwest regions. Rudolf Friedrich Haffenreffer was among the few who went to Boston, where he settled in Roxbury (Boston's "German district") and neighboring Jamaica Plain, which were ethnically mixed areas where German immigrants and their offspring more

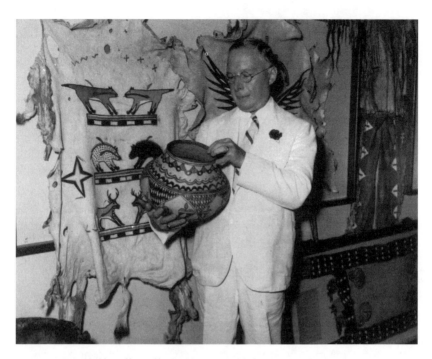

Figure 4.1. Rudolf Haffenreffer holding San Ildefonso polychrome water jar obtained in the Southwest, ca. 1934. Mount Hope Farm.

quickly became American than they did in cities with large, compact German residential neighborhoods in which German culture and language persisted tenaciously.[5]

In nineteenth-century Boston, German immigrants adapted to a social landscape that included Irish, Italians, and other new arrivals from Europe as well as old-stock Yankees, including the "Brahmin caste." Brahmin ambivalence toward all immigrants ran deep, but Germans fared better than others did because they were Teutonic, Protestant (in part), and admired for their educational, musical, and intellectual achievements. Nevertheless, like other immigrants and their children, Germans remained less upwardly mobile in occupation than native-born Yankees. Over time, economic and political realities forced Boston's Brahmins to temper their culturally determined attitudes concerning their new neighbors.[6]

For a maltster, brewer, and cooper like Rudolf Haffenreffer, Boston was a land of opportunity, in part (ironically) because the area was a hotbed of temperance and many drinkers had switched from hard liquor to ale early

in the nineteenth century. By 1860 more than twenty brewers vied for a brisk trade, with German American brewers in Roxbury and Jamaica Plain in the thick of the competition with their ready-made ethnic-based market and wide appeal of lighter, sparkling German-brewed lager. Haffenreffer went to work for George F. Burkhardt, a forty-eighter and pioneer lager brewer. Skilled as a manager, with an unlimited capacity for work and boundless faith in God, he rose rapidly in the firm and in 1871 married Katharine Burkhardt, George Burkhardt's cousin, and formed his own brewery, which became Haffenreffer and Company.[7]

Between 1872 and 1885, Katharine Haffenreffer gave birth to ten children, five of whom survived infancy. Rudolf, born in 1874, was the oldest surviving child, and with his siblings and other German Americans he grew up in a Lutheran, patriarchal, bilingual household in which they no doubt learned the value of hard work and strong faith. Unlike other immigrant families, the Haffenreffers lived in a house that was located on brewery property and contained domestic servants, and the anglophone children were sent to a select private school in Boston called Chauncy Hall. Among the "most notable" of Boston's private schools, Chauncy Hall had a reputation for being open to students regardless of class, sect, or nationality (even if Yankee surnames predominated), and for academic standards; many of its graduates went on to MIT and Harvard.[8]

Searching for the origin of Rudolf Haffenreffer's interests in collecting and American Indians in his childhood experiences is a speculative exercise, but the trail begins at Chauncy Hall, where Rudolf remained for six years in a rigorous course of study in mathematics, geography, grammar, literature, natural science, and other subjects. He could easily have learned about American Indians in zoology classes held at the Boston Society of Natural History, which housed objects collected by Meriwether Lewis and William Clark on their epic trip west in 1804–6, or in literature classes where he read selections from Washington Irving's *Sketch Book* and possibly from one of James Fenimore Cooper's works or Prescott's *Conquest of Mexico* or *Conquest of Peru*.[9]

Rudolf did not graduate from Chauncy Hall. His mother died in 1888, when he was fourteen, and Rudolf and his father went to Stuttgart, where he enrolled at the Institut Rauscher, a residential school for polytechnic instruction in chemistry and other subjects. He remained in Germany through the summer of 1890, during which time his father remarried. Ap-

parently Rudolf's path had been set to follow his father into brewing. In Stuttgart he could combine polytechnic instruction with the opportunity to instill or re-absorb, through his kin, German culture, language, and Weltanschauung. Some of his most pleasurable moments were hunting deer and rabbits and trout fishing with his mother's relatives in the Schwarzwald (Black Forest) west of Stuttgart, and a lifelong interest in the countryside might well have developed at that time.[10]

Rudolf's interest in collecting and his curiosity about American Indian imagery might also have formed in Germany. In 1889–90, a friend obtained for him—seemingly in response to a stated desire—an American stamp with an Indian on it. There were two possibilities, both of them newspaper and periodical bulk shipment stamps: a two-cent stamp that showed Thomas Crawford's *Freedom* (which draws on American Indian imagery and is atop the Capitol dome) and a $60 stamp depicting an "Indian Maiden" in a typical nineteenth-century wooded genre scene.[11]

Back in America, Haffenreffer continued his technical education—in 1894 he enrolled at MIT for course work in fermentation—and might also have worked for his father in the brewery. In 1895 he left Boston, perhaps in order to establish his independence from his father, for Fall River, Massachusetts, a city of more than 100,000 people, many of them thirsty immigrants who worked in cotton textile mills. Haffenreffer settled in, married a Bostonian of Scottish descent, started a family of his own, and within two decades controlled with financial partners three Fall River breweries, including one named King Philip. He became active in the city in several arenas, one being the effort to improve the water system, and his awareness of local Native people might have increased when Mrs. William Perry, the last Wampanoag Indian resident on the Fall River Indian Reservation, was relocated from the watershed. Perhaps Haffenreffer first heard of the Perrys—the kin of LeRoy Perry, whose words were quoted at the beginning of this essay—at this time.[12]

In 1903 and 1912, Haffenreffer purchased contiguous properties—480 acres in all—in the small town of Bristol, Rhode Island, across Mount Hope Bay from Fall River (fig. 4.2). A homogeneous Yankee seaport and shipbuilding town since the seventeenth century, Bristol experienced industrial and ethnic transformations in the mid-nineteenth century, when textile and rubber-goods manufacturing plants and immigrant Portuguese and Italian labor moved in. By 1900, half of Bristol's population was foreign-

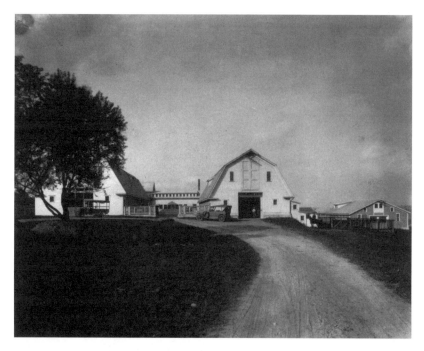

Figure 4.2. Mount Hope Farm, Rudolf Haffenreffer's farm complex at Mount Hope, ca. 1918. Mount Hope Farm.

born, and many of its residents looked toward Providence for political, economic, and social connections.[13]

After 1912, Haffenreffer's new lands increasingly became the geographical and social focus of his life and of utmost significance in the development of the King Philip Museum. Taking its name from its most preeminent physical feature—Mount Hope, a granite gneiss and quartz outcrop that towered 220 feet above Mount Hope Bay and surrounding farmlands and woods—the property embraced sites where important seventeenth-century events relating to King Philip's War took place.

The historic significance of the site was widely recognized. In 1876–77, the Rhode Island Historical Society erected two monuments to the memory of King Philip on the bicentenary of his death. One was a boulder atop Mount Hope itself, the other a granite block near the spring where he died. Mount Hope was so pivotal to Bristol's identity that its image, a green mount beside the blue waters of Mount Hope Bay, was represented cen-

trally on the town's coat of arms. A citizens' historical association had hoped to make Mount Hope a public park at the time of Haffenreffer's purchase. The association's head spoke of Mount Hope in Arcadian and sublime imagery as "one of the most beautiful spots imaginable, having mountain scenery, uplands, crags, and cliffs, charming forests and all that go to make up an ideal spot for a public park." It was the location of "King Philip's Spring, and chair, and the swamp in which the wily chief was killed Aug. 12, 1676" and was thus one of the "two points in Rhode Island that really have historic value," and perhaps "the only point of value in Indian history in New England."[14]

From the 1870s until after 1900, the northernmost portion was an amusement park and summer resort and contained many houses and other buildings. It attracted the public, who arrived by steamboat from Fall River and elsewhere and amused themselves on the carousel, baseball field, trails, dance hall, and so on. One of several coastal parks in Rhode Island that enticed urban dwellers fleeing summer heat, Mount Hope Park had failed, but Haffenreffer reopened it with a clear intention to turn a profit. These plans had changed by the time he acquired the larger adjacent property and started to use the "King Philip House" on the east slope of Mount Hope as his summer residence until he could restore the property's most distinguished residential structure: the so-called Bradford House from its most famous former owner, William Bradford, United States senator and onetime host of George Washington. In 1933 the Haffenreffers moved their winter residence from Fall River to Providence. Their seasonal movement from the city to the bay was typical of other well-to-do residents, who abandoned urban homes for summer life in quiet lakeside or seaside communities.[15]

Haffenreffer made the former Mount Hope Park into the core of "King Philip Farm" and drilled a well, brought in electricity, and built roads. Buildings, including the first structure that would house Haffenreffer's growing collection of artifacts, followed. In 1921 fire destroyed a cow barn, granary, and creamery (in which the farm's mahogany-paneled business offices were located) but spared other structures. As important to him as an earlier farm near Fall River had been, and as New Hampshire and Massachusetts farms were for his father, Haffenreffer later mentioned "farming and raising pure bred Guernsey cattle and horses" as an "Amusement" in his MIT twenty-fifth reunion class book. In Haffenreffer's day the rural life of the country gentleman held wide appeal, and country life and imagery were important to Haffenreffer's self-perception. He was attached to ro-

mantic and sublime images of landscape and painted small watercolors of German castles and landscapes. In purchasing a farm, Haffenreffer imitated his father but also re-created, wittingly or not, an American setting for experiences similar to the Schwarzwald events of his youth.[16]

Haffenreffer lost no time integrating himself into his new community. Perhaps because of his support of the Boy Scouts and his economic standing, in 1916 he was appointed chief marshal of the Fourth of July parade, Bristol's focal annual event. This was the very moment when anti-German hysteria was on the rise across the nation, including in Rhode Island and even Bristol, where Herreshoff Manufacturing Company was building boats under contract for the government, but Haffenreffer (who followed the war intently) was not seriously affected by any of this.[17]

In 1917 Haffenreffer expanded his business holdings by becoming president and managing director of two tunnel mines producing lead and silver in Utah and California. Simultaneously he fulfilled a curiosity that may have developed earlier in geology and minerals classes at Chauncy Hall. This was a significant step for the formation of his collections of American Indian artifacts. Each spring over the next several decades, he and his wife traveled to inspect his mines and stopped en route at Santa Fe, Tucson, and Phoenix, from which he sent "boxes, if not trunk loads, of his acquisitions back to Bristol." He even once visited Mexico.[18]

It is conceivable that these trips west also changed Haffenreffer's impressions of American Indians. Compared to the East, Indians in the West carried in their hands, balanced on their heads, displayed on the ground around them, and dressed up in artifacts that Haffenreffer and others wanted to collect. The appearances of these Western Indians were also different, and despite great variation, they more nearly corresponded to his and others' expectations of "authenticity" framed by Wild West shows, fairs, Pan-Indian organizations, literature, and visual print media. Given Haffenreffer's interests, Indians adept at taking advantage of the market he represented could not fail to impress him.[19]

Haffenreffer's other new business ventures were Rhode Island–based and increasingly expanded his circle of acquaintances and friends, bringing him closer to the state's business and political leaders. In 1924 he purchased at auction the Herreshoff Manufacturing Company, the famous designer and builder of yachts whose name was synonymous with the America's Cup. The company was in liquidation, but under Haffenreffer it built the last of the syndicate-financed America's Cup defenders; Haffenreffer's circle expanded to include coinvestors who moved along a New York–

Newport axis. A second enterprise that enhanced Haffenreffer's local visibility was the Mount Hope Bridge linking Bristol and points south, which Haffenreffer acquired at auction and ran for more than twenty years. On its masthead, the *Bristol Phoenix* pictured three images. In the center was Mount Hope in the town seal. Flanking it was a yacht under full sail (Herreshoff was the most noted boatbuilder) and a factory, standing for manufacturing. Inasmuch as Bristolians derived their identity from these three icons, it is interesting to note that Haffenreffer owned two of them.[20]

Haffenreffer remained a brewer to the end of his life. Near the end of Prohibition, Narragansett Brewing Company approached him to finance modernization of and manage its Cranston, Rhode Island, plant, which was in precarious financial condition. For decades Haffenreffer served as chairman of the board of Narragansett, the beer of consumers across the nation and Red Sox baseball, ensuring its position among the top breweries in the nation.[21]

Today people remember Rudolf Haffenreffer in contrasting terms—as stern, kind, hard-driving, warm and cordial, imposing, generous, controlling, quietly austere, entrepreneurial, and so on—but many agree that he was a hardworking man with great drive and organizational ability, a political independent (and self-described "mugwump"), and a philanthropist. A member of the board or director of a number of institutions, including MIT and George Heye's Museum of the American Indian, honored for his contributions in the last decade of his life, Rudolf Haffenreffer died in October 1954, several months after his eightieth birthday.[22]

Mount Hope looms as an important influence on the genesis of Rudolf Haffenreffer's interest in the American Indian. Shortly after consolidating the two properties, Haffenreffer issued privately "Some Legends of Mount Hope," a sixty-one-page booklet written by Wilfred Harold Munro, emeritus professor of European history at Brown University and longtime president of the Rhode Island Historical Society. Bound with beaded leather thongs and a cover depicting an Indian with a feather in his hair sitting before a Plains tipi on a wooded shore, this booklet contained chapters on the Norse, Massasoit and Edward Winslow, King Philip and Benjamin Church, and William Bradford and George Washington. It was illustrated with small engravings of Indians bonneted, feathered, armed, paddling a canoe, blanketed, or dancing. It dispelled any doubt about the centrality of Mount Hope and its owners to New England history by situating there significant events and individuals over a nine-hundred-year period.[23]

This publication revealed in Haffenreffer not necessarily (or not only) a desire to associate himself with the former owners of his historic property but, perhaps, intellectual curiosity about New England history, especially the seventeenth-century wars and the region's indigenous inhabitants. Although Chauncy Hall might have piqued Haffenreffer's curiosity in history and American Indians long before, the purchase of the historic Mount Hope was perhaps the catalyst for articulating interests that he could scarcely avoid contemplating as he rode or drove around the mount, passing the Rhode Island Historical Society monuments that canonized both.

The connection with seventeenth-century New England was of central importance. Mount Hope was an important site for the Pokanoket or Wampanoag (who lived south of the Massachusett and east of the Narragansett), of symbolic value because of its height, of social importance because of its location near King Philip or Metacom's summer village, and of historical import as the site of his death. King Philip's War, a conflict deeply rooted in the colonial relationship between English settlers and Native people in southeastern Massachusetts and Rhode Island, started near Mount Hope, and it ended at Mount Hope. Early in the seventeenth century, Indians died in droves from introduced epidemic diseases, then lost access to lands in transactions legal and illegal, misunderstood and manipulated. Reduced in numbers, politically disempowered, their communities internally riven, Indians had many grievances. King Philip, a proud leader who deeply resented how the English treated his people, rebelled. He almost succeeded, but eventually his enemies caught and killed him at Mount Hope, and in the manner of the day quartered his body and piked and displayed his head, and sold his wife and children into slavery in the West Indies.[24]

In Mount Hope, Haffenreffer acquired the site of one of the most significant seventeenth-century events (and hallowed especially by the descendants of the seventeenth-century Pokanoket); "Some Legends of Mount Hope" signaled his awareness of that fact. No matter how altered by human hands, Mount Hope embodied an essential history of Indian-White relations. At a time when American Indians were increasingly constructed as a noble yet doomed race, a museum dedicated to the Native American might well have occurred to Haffenreffer.

There is, in fact, evidence that Haffenreffer's interest in archaeological "relics" developed about the time he bought Mount Hope. After 1912, Mount Hope's status as farm and summer residence, analogous to an Arca-

dian estate or an Adirondack lodge, evolved quickly. Workmen evidently "uncovered . . . curios" that interested Haffenreffer, and he "soon thereafter" purchased other objects to make "a representative collection," perhaps because he was "always interested in the American Indian." Haffenreffer apparently dedicated one building on his estate to housing artifacts found at Mount Hope and collected on annual trips west after 1917 and through other means.[25]

According to his son, Carl, Rudolf Haffenreffer was an "accumulator" who sometimes "sent his emissary" to purchase objects or tended himself to "buy the whole thing," believing that it was "less expensive to buy a collection at one fell swoop instead of item by item." The idea was to "accumulate to collect with the idea he would winnow out good from bad, wheat from chaff," but he "never really got around to it."[26] A local reporter wrote about Haffenreffer two decades after he started to collect that he had been "inspired by a desire to learn more of the Indian's religious, tribal and other habits," and therefore "began the collection of objects which would interpret these things truthfully for he found the white man's history of the Indian scarcely unprejudiced." The reporter continued in language ennobling a powerful man: "It has been with the purpose of inquisitiveness, rather than one of acquisitiveness" that "the Rhode Islander has built up his collection. He is more interested in the interpretation that may be obtained from his relics than in their mere possession." Perhaps for this reason, Haffenreffer reportedly "disliked the term museum as not fitting his purpose in collecting the relics."[27]

These two ways of looking at Haffenreffer are not necessarily incompatible. He did sometimes buy by lot, and he was indeed inspired to speak about American Indian culture and history. Throughout his adult life, Haffenreffer collected not just ethnographic and archaeological artifacts but stamps, rare autographs, maps, rare books, antiques, carousel figures, and cigar-store Indians. He purchased in bulk the furnishings of a church, cobblestones from a street, lampposts from Newport, and items recycled in use at Mount Hope Farm.[28]

The first reference to the existence of a collection large enough to be housed in a separate building came in 1916, when the Rhode Island Field Naturalists visited Mount Hope, where they "inspect[ed] the many objects of interest contained" in Haffenreffer's "museum." That building was a modest single-story rectangular wooden and shingle-roofed building and seems to have been as much a storage shed as a museum, for it contained both archaeological artifacts and amusement-park carousel horses. By

1923 (two years after the destructive fire), the growing and "valuable collection of Indian relics," which included "10,000 arrowheads, stone axes, mortar and pestles, weapons and blankets . . . antique firearms and buffalo robes" had been moved to a stone building said to be fireproof. Haffenreffer marked the occasion with a speech to the Fall River Historical Society. The new building is part of the museum today, and from 1925 to 1931 a porch was attached to its entrance.[29]

In 1925, the museum—nameless but linked with Haffenreffer—received top billing in a newspaper story on Rhode Island archaeological collections. It was said to have "many thousand specimens from all parts of North America," including "perhaps the largest collection of Indian implements in Rhode Island." No single account of the museum before this date contained such detail:

> The collection is in a separate fireproof building which has become a museum of Indian implements and ornithological specimens. The walls are literally covered with countless specimens on display boards, while larger objects, such as blankets, pottery, moccasins and the like are piled upon chairs and tables. A very beautiful bead jacket, remarkably heavy, hangs on one of the chairs and immediately attracts the attention of the visitor. Rugs, books on Indians and various objects of earthenware, leather and basketry make up the vast collection.

With archaeological, ethnographic, and ornithological specimens, and tables and chairs, the museum resembled a private natural history museum.[30]

The three years beginning in 1928 represented a watershed period for the museum. Signaling his intent to acquire and systematically document, display, and use artifacts, Haffenreffer hired Foster H. Saville, an archaeologist and longtime member of the staff of the Museum of the American Indian, Heye Foundation.[31] Immediately, his Northeast archaeological collections grew; indeed, Haffenreffer may have purchased most objects in his collections in the next two years.

In 1929 Haffenreffer and others began calling his museum the King Philip Museum. As one reporter predicted that the museum would become a "mecca for students," its treatment in local newspapers both shifted perceptibly and converged (probably either reporters drew on each other's accounts or the museum issued press releases). In one account, "the importance of preserving relics" was linked with inevitable American Indian assimilation, and in the public mind the museum was becoming a repository of Indian history. In four years the "Haffenreffer Museum at Mount Hope" became a "Shrine of Indian Relics," a "Sanctuary for New England

Indian Relics," a "Sanctuary for Indian History," a "Memorial to King Philip," and a "Shrine to King Philip." The King Philip Museum was born.[32]

In 1929 the museum contained archaeological and ethnographic materials from throughout North America. Haffenreffer showed a concern for documentation, research, and education, all of which may be attributed to Saville's perspective and advice. Artifacts were displayed densely, with stone tools on one shelf, baskets on another, and pots on a third, and the shelves were inclined forward "so a visitor a few feet away can see all without stooping." Some objects were in self-contained mobile cases. There was a new interest in organized and accessible information—objects were "numbered so that the student by referring to a card index in the same room can immediately get the history of each subject." Under Saville, Haffenreffer expanded his appreciation for legal possession of collections with affidavits "subscribed and sworn to by the original collectors" displayed authoritatively next to—and thereby authenticating—artifacts.

These typological exhibits reduced American Indians to their artifacts, relegating them to an archaeological and ethnographic past and linking the King Philip Museum to other small regional museums lacking the "life groups" of major anthropological museums. Yet at the same time, the King Philip Museum placed American Indians in the history of Indian-White relations, displaying Indian artifacts alongside maps, manuscripts, and other documents: "A large collection of historic documents, Indian deeds, sermons in Gay Head language, manuscripts in Indian tongues, yellow with age and closely connected with the pioneers of New England's old white families, is shown in special cases." The museum's purpose was didactic: "Generations of white people have risen to give Philip the credit due him, and throughout the years to come thousands more will come here to Mount Hope, his last refuge, to pay him tribute and to study all that is left of his race, the crude stone implements and weapons they pathetically pitted against the powder and shot of the conquering whites."[33]

In 1931 Haffenreffer completed a new fireproof wing, "a single-storied structure of steel, concrete and stucco, fire and burglar proof" that dwarfed the original building, and the Rhode Island Historical Society and other guests witnessed its dedication. It was an apogean moment in the history of the museum, occasioning lyrical descriptions of the interior of a modern, secure building in which one's eyes were drawn to a "colorful, tiled floor," and to "great mahogany tables and leather-covered chairs and divans." In "several rooms . . . filled with thousands of catalogued exhibits, many of

them priceless," one could see "part of the collection of invaluable Indian ceremonial rugs and blankets . . . headdresses, saddle blankets, footwear and jewelry . . . [and] some of the most perfect examples of bead work in existence." These artifacts were "[skillfully and appropriately] displayed to relieve the expanses of dull gray stone," some arrayed as "treasures . . . on inclined trays within tightly sealed glass cases" that lined the walls of the main room. In another room were "hundreds of exquisitely bound volumes, most of them relating to Indian lore." Betraying his prejudices, a reporter concluded: "The place, despite the predominant note sounded by the stone utensils and weapons so common to the red man, is beautiful."[34]

After 1931, the pace of the collecting slowed. Haffenreffer continued to add to the holdings, but Saville no longer worked for him, his place taken by several individuals who prepared labels for objects and typed correspondence. Haffenreffer's attentions were deflected by Narragansett Brewing, which presented new and important challenges, and his interests in Native America shifted away from Indian artifacts and toward Indian imagery (reviving an interest expressed in the "Indianer" stamp he had obtained in Stuttgart). He started to collect cigar-store Indians, Edward Sherriff Curtis orotones, the Cyrus E. Dallin sculpture *Appeal to the Great Spirit*, and other objects. Of these, the cigar-store Indians gained him the most national attention. Haffenreffer possessed other wood-sculpted figures as well, including Black Forest bears and coatracks, carousel figures and ship figureheads.

These were the products of a wood-sculpting craft with deep roots in Germany as well as among German Americans in America, yet however these ethnic considerations resonated, there was a practical side to Haffenreffer's interest in cigar-store Indians: He used images of them to promote Narragansett. He hired Theodore Geisel (Dr. Seuss), a Dartmouth acquaintance of his sons, who designed a series of cartoons showing "Chief Gansett," an angular wooden Indian on a base with wheels, in various poses, including offering customers a frothy glass of "Gansett" beer (fig. 4.3).[35]

For Haffenreffer, collecting cigar-store Indians and wooden trade signs became one more "passionate hobby," and he eventually owned more than two hundred that he had collected personally, bidding at auctions in Detroit and elsewhere, or that his agents located and purchased. He kept them in his office at the brewery and in the King Philip Museum, where they dominated exhibition space in one room. Many remembering the museum in the 1940s recall the cigar-store Indians most of all: rows of them, standing like

Figure 4.3. Your 'Gansett, Sir. Chief Gansett, by Dr. Seuss (Theodore Seuss Geisel), *Bristol Phoenix*, February 21, 1941, Roger Williams University Archives, Custodian.

they were "in bleachers, facing inwards," and the visitor walked between them; "you felt," as one man remarked, "like you were in the middle of a tribe."[36]

The King Philip Museum was, above all, Haffenreffer's personal space. He spent much time there on weekends, whether or not others joined him. Here he pursued his avocation without distraction, or here he retreated with guests for cigars and wine. Native American artifacts, Indian images, Black Forest wooden bears—all were there. This was not just a museum but a comfortable setting containing books, reading chairs and sofas, ready access to a wine cellar and a humidor, and a fire in a large fireplace. It was men's space, fully analogous to the Victorian smoking room.[37]

Although private, geographically isolated at the heart of Haffenreffer's farm two and a half miles from the property's main entrance, and largely out of sight, the King Philip Museum was open to the public. Like other private museums, the owner determined access; any individual or group could arrange in advance to see the collection, and Haffenreffer enjoyed showing the collection to his guests. From 1929 to 1955, arriving once or twice each month, more than six thousand visitors signed their names in a register kept at the museum. Family members and their personal friends and guests gained entrance most often, and they remember visiting the museum, sometimes to help arrange artifacts, after Sunday lunch, or during family gatherings.[38]

Many who came to the museum were connected personally in some way with Haffenreffer and his family. Some were linked to his business, philanthropic, or community concerns. Some groups were small, and Haffenreffer was often involved: a class from Moses Brown School in Providence or a Scout troop, for example. More than a third of the visitors arrived in a few large, organized groups: Boy Scouts in numbers of more than two hundred, garden club members more than one hundred strong.

Three times between 1923 and 1931, Haffenreffer and others marked significant changes in the museum's status. In 1923 Haffenreffer spoke to the Fall River Historical Society after it toured the museum building that had replaced the farm offices destroyed in a fire. In 1929 (after Saville had been working for several months), several "groups of scientists and archaeologists" and the trustees of a local library visited, and Haffenreffer may have determined at that point to make collections more "open to students of archaeology and Indian lore" than they had been. Finally, in 1931, the Rhode Island Historical Society gathered to celebrate the new wing of the museum "erected . . . as a memorial to King Philip."[39]

Other special events drew people to the King Philip Museum. In 1936, the year of Rhode Island's tercentenary, hundreds of visitors toured Mount Hope and the museum, where a special exhibition of Governor Bradford memorabilia had been assembled. In 1946, the Yankee Network came to the museum to broadcast a drama about King Philip's capture of Mary Rowlandson; perhaps mindful of Haffenreffer's attitudes, the narrator concluded that one should not paint King Philip as a savage or assign him full responsibility for the war that bore his name.[40]

Within a year of purchasing Mount Hope, Haffenreffer discovered that the newly organized Boy Scouts were interested in using his property as a sum-

mer camp. From that moment on, his and the Scouts' interests were often mutually supportive, and in the years ahead, Scouts, more than any other public organization, gained access to Mount Hope and the King Philip Museum. One can readily comprehend why the Scouts were interested in Mount Hope Farm's bayside setting and the cleared spaces and buildings formerly used at the amusement park. As for why Haffenreffer accommodated them, the northern part of his property was suited for them, the historical society monuments reminded him and others of the public dimensions of this property, and his sons were active Scouts. In making Mount Hope available, Haffenreffer also linked himself with an organization whose goals were openly patriotic, simultaneously underscoring his identity as an American.

Scouting began to take shape in America in 1910. In Rhode Island, troops quickly formed and held a summer camp. The first Bristol Troop formed in 1912 and soon joined the Rhode Island Boy Scouts (RIBS). For the first several years, Rhode Island camps were located at sites where the facilities and water were problematic—including Mount Hope, to which the Bristol Troop hiked in January 1913 and "cooked their dinner in real Indian style," using forked green branches for frying pans for meat and bread toasters, and eating in front of two roaring wood fires. That summer, Haffenreffer offered Mount Hope to the Scouts for their summer encampments and hosted another dinner. The Scoutmasters liked what they discovered, and for ten weeks that summer, Providence, East Providence, and Bristol Scouts came to King Philip Camp, "the best location that could be found in the state."[41]

Two years later, King Philip Camp was designated as the official RIBS camp, more than one thousand Scouts were expected over a seven-week period, and Haffenreffer's sons (thirteen and nine at the time) presented prizes to various contest winners. Some years after, the *Bristol Phoenix*—hardly an unbiased source—called this "the State's outstanding camp." Yet in 1916, the Scouts left Mount Hope, probably because its facilities were limiting and RIBS sought its own assets, including campsites, as it became better organized and concerned about its identity as a formal organization. In 1916 the Scouts settled on a 130-acre site in southwestern Rhode Island with better woods and safer waters, which to this day remains the RIBS summer headquarters. In 1920 the Bristol troops started their own local Camp Takarest on Mount Hope Bay north of Haffenreffer's property, formed an honorary society called the "Braves of King Philip," and started to share the site with Camp Fire Girls and Girl Scouts. Mount Hope was not

used, except for limited events like a hike hosted by Haffenreffer during Boy Scout Week in February 1924, followed by a ceremony at one of the historical society monuments.

Scouting in Rhode Island at first stressed military drill, discipline, and responsibility in order to build character. Visitors to King Philip Camp might see dress parade, a drum and bugle corps, and competitive events like gymnastics, a relay race, building a bridge of birch poles, flag signaling, tent pitching, and Indian club swinging. Summer camps also offered tracking and woodcraft. In 1924 awards were given for development of morale, physical activity, and scoutcraft; one award included membership in the "Wincheek Indians."[42]

Scouting was replete with American Indian imagery and woodcraft, which made Haffenreffer's collection of American Indian artifacts at Mount Hope timely. Two men were principally responsible for their presence: Ernest Thompson Seton and Charles A. Eastman, also known as Ohiyesa. Seton, chief Scout in 1910, played the larger role.[43] His main contribution was to promote "Woodcraft, the oldest of all sciences and one of the best," first in *Ladies Home Journal* and then in sections in the *Official Handbook for Boys* (the first Boy Scouts of America manual) on woodlore, animals, trees, mushrooms, and tracking and signaling.[44]

Seton's Progressive-era version of the practical and skilled Indian and Eastman's idealized stories of his youth and Indian customs complemented each other well and were very popular in the 1910s and 1920s. In 1911, they both came to Rhode Island and southeastern Massachusetts, and Eastman spoke to a large audience in Fall River. During the same period, Indians on tour also visited Rhode Island Scouts: Chief Rain-in-the-Face, an Oklahoma Sioux, came to Bristol for a Fourth of July parade and spoke to Scouts about Indians; and Chief Bluesky, a Cherokee, performed in full regalia for Bristol Scouts (and other troops) "in various imitations of the birds and animals and the dances and ancient customs of the real American Indian."[45]

In January 1927, Providence-area Scouts "'Turn[ed]' Indian for Winter Camping"—as a newspaper headline proclaimed—living for four days in two canvas-covered tipis to convince people that "they could take care of themselves in the open at any season after the manner and customs of the original Americans." By 1930, "the study of the customs, dances and ceremonials and handicraft of the American Indian" had surged in popularity, Plains Indians came to Rhode Island on educational tours, RIBS sponsored an "Indiancraft Leaders' Club" to train Scout leaders, and any troop that

could not "boast of at least one member . . . trained in Indian lore" was regarded as "unfortunate."[46]

These trends played to Haffenreffer's strengths and interest in promoting American Indian customs in scouting. Although like others he advocated imagery and material culture of Plains Indians, Haffenreffer was unusual in also pushing an agenda focusing on the history of local American Indians. His impact was dependent on the use of the museum and Mount Hope, a healthy Camp Takarest, and his willingness to commit resources. He always seemed to make Mount Hope and the King Philip Museum available to the Scouts. In October 1936, five hundred Scouts assembled at Mount Hope and visited the museum. That month, all members of RIBS "were mobilized . . . in a unique campaign of friendship for the Wampanoag Indians," a powerful expression of symbolic association between RIBS and local Native people. Haffenreffer took advantage of this occasion by announcing that he would sponsor a contest and prizes (they became known as the Rudolf Frederick Haffenreffer Awards) for the three best essays on the Wampanoags written by Scouts. The Scouts received a rulebook on length and permissible subjects (all on Wampanoag culture and history), including "the origin of the tribe; the principal sachems of the Wampanoags—Massasoit, Alexander, and King Philip; the relationship of the Wampanoags with the New England tribes; their weapons, utensils, and systems of warfare; the military history of King Philip's War; and the origin of the name, 'Mount Hope' and its close relationship with the history of the Wampanoags." First prize was "a solid gold medal" and "a selection from Mr. Haffenreffer's collection of Indian relics which it is hoped, will be the start of a collection of [a Scout's] own, if not a prized addition to one already started." The following September, seventy-five people gathered in the museum, where Haffenreffer and sculptor Cyrus Dallin presented awards and gave speeches (fig. 4.4).[47]

By 1936, financial problems and unsafe buildings beset Camp Takarest, which Haffenreffer (and the Works Progress Administration) helped transform "into an Indian Village" through actions that, the *Bristol Phoenix* editorialized, were as "fine an example of public spirit at its best" as could be had. Haffenreffer paid for all materials and sent Federal Art Project artists to the American Museum of Natural History in New York in order to copy Arapaho tipi designs for designs then painted on cement tipis, which arose next to a concrete roundhouse and other structures (fig. 4.5). Camp Takarest changed its name to Camp Wampanoag and then to Camp King Philip, and in 1939, one thousand people attended its dedication. Presented

Figure 4.4. Rudolf Frederick Haffenreffer Award. Designed by
Cyrus E. Dallin. In the 1937 contest for the best Boy Scout
essays on the Wampanoag, Keith Wilbur won this silver medal
as second prize. Courtesy of C. Keith Wilbur.

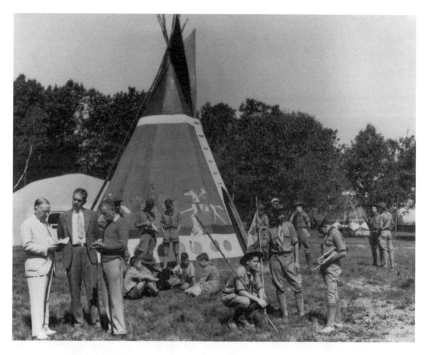

Figure 4.5. Rudolf Haffenreffer and John Haley, far left, and Boy Scouts in front of Camp King Philip's cement tipis, ca. 1940. Haffenreffer Museum of Anthropology.

with an inscribed deerskin and extolled for having done much to make the camp become "so closely identified with the Indian history of this section of New England," Haffenreffer remarked, "When I began collecting Indian relics it was my hope that I might pass on to others the many interesting facts about a powerful and honorable race."[48]

In addition to sponsoring essays and encouraging boys to start their own collections, Haffenreffer urged Scouts to undertake archaeological investigations and provided funds for Indian costume-making. The museum was a means to these and other ends. He gave away artifacts in the hope that boys would "get to know the first owners" of Mount Hope and "find a fascinating hobby in making collections of their own of the traces which the Indians have left of their life in this country." He sponsored "Indiancraft," and in the mid-1940s gave prizes for the best Indian clothing and underwrote costs of courses to "[perpetuate the] knowledge of Indian lore, customs, and costumes" in which students made their own garments.[49]

Haffenreffer's educational intentions were clear when he spoke to medal winners in the 1937 essay contest: "The strange customs and ceremonies [of American Indians] and their inner meanings [are] largely hidden from the observer. I wanted to clothe this collection with flesh and blood. The American Indian had perfect equilibrium and absolute poise in body, mind and spirit. The simplicity and the uprightness of the Indian should appeal to the American of today." But he also embraced the larger goals of scouting when he called Boy Scouts "America's greatest hope, her greatest safeguard against radicalism, disloyalty, immorality, un-Americanism, crime, and all vicious and undermining disbeliefs in God, man, and country."[50]

In the 1940s Haffenreffer sponsored several three-day powwows or camporees at Mount Hope. In 1941, 1,000 Scouts assembled, and in 1946–47, some 2,500 to 3,000 boys registered for powwows, camped on Mount Hope, visited the historic sites, and toured the King Philip Museum. To this day, the torrential rains of 1946 that drowned out a planned "Indian pageant" and mired everything in mud are remembered. But in 1947 Scouts gathered in "an amphitheater for Indian dances and other shenanigans," and witnessed "an Indian pageant" at which 100 costumed Scouts danced under the direction of "Chief Trailmaker," Charles Harrington. Newport-area Scouts presented Haffenreffer with a totem pole they had made, and he gave all Scouts souvenirs: a metal neckerchief slide or a pocket medallion on which appeared two Indians and the legend "Narragansett Pow Wow, Bristol, R.I., 1947."[51]

But the strain on resources at Mount Hope was too great, and the Scouts soon went elsewhere for their powwows. Haffenreffer was nearing the end of forty years of active involvement with an organization that had meant a great deal to him and that honored him for his contributions.[52]

What did Rudolf Haffenreffer think about the indigenous people whose artifacts were in his collections? Some hints come from the architecture and interior design of his museum. His King Philip Museum evolved into a low concrete building whose exterior was unimposing, blocklike, and rather bland in appearance, with the exception of four Doric columns supporting the roof of the front porch that existed from 1922 to 1931 and set the museum apart architecturally from the surrounding barns and other buildings. Solid, unprepossessing, functional—this was no temple for art but a practical building doubling as his own space and a safe repository for artifacts that could be deployed to the edification of those he invited within.

Inside, a commanding stone fireplace, sofa, bookcases, and tables—all

heavy, American-made contemporary furniture—gave the sense of a building that was both museum and a man's private space. Artifacts were displayed densely—arrow points mounted on boards or on shelves with other lithics and ethnographic objects in built-in mahogany cases made at the Herreshoff Boat Yard. Their labels and cases gave them a taxonomic, scientific context. But other objects standing around or on walls, including carved wooden bears and a coatrack in the German and Swiss rustic Black Forest style, and various sculptures and paintings reflecting a romantic Indian past—an oil painting of a young Indian man and woman in a sylvan setting by T. H. Matteson, Dallin's and Curtis's works—spoke to romantic, historical, and extraneous artifactual contexts. When in the 1940s, cigar-store Indians and other smoke-shop signs dominated freestanding space in one gallery, they overwhelmed the archaeological and ethnographic artifacts.

Haffenreffer's interests in science, history, and education were reflected in the library at his disposal in cases and cabinets: more than six hundred works, mainly on North American Indian ethnology, archaeology, material culture, and history, published by the Smithsonian Institution's Bureau of American Ethnology, the American Museum of Natural History, the Museum of the American Indian, and Canadian federal departments. Many related to the archaeology of New England, exploration and the frontier, and New England history. He possessed works by many who were active in Indian reform or actively promoting Native perspectives, including Thomas L. McKenney and James Hall, Helen Hunt Jackson, Hamlin Garland, Warren K. Moorehead, Charles Eastman, and Ernest Thompson Seton.[53]

Haffenreffer had limited contact with collectors, academics, and artists whose lives revolved around Native America, although during the course of his life, he met men and women who left their salutations in his copies of their books (Mary E. Laing and William Brooks Cabot) or who, like Cyrus Dallin, sculpted or painted Indians. He exchanged extensive correspondence with Warren K. Moorehead, the archaeologist and reformer, but their relationship was vexed by Haffenreffer's attempt to purchase the coveted King Philip's Club. Mary Wheelwright visited the King Philip Museum once. In the collecting or museum world, Haffenreffer's closest relationship was with George Heye: They were each other's advisors, Haffenreffer served as a trustee of Heye's Museum of the American Indian for more than two decades, they were on a familiar first-name basis, and their relationship was defined by shared social interests as much as by shared avocational and business interests.[54]

Figure 4.6. Ernest G. Rogers of the New London Historical Society, speaking at Mount Hope on the occasion of the American Indian Federation meeting, October 23, 1932. Silver Star (Pequot) stands behind Rogers; William L. Wilcox (Narragansett) is obscured by Rogers's figure; two unknown Indians in regalia (probably Black Hawk and Crazy Bull); Frank Nichols, Narragansett; unknown figure (perhaps Ronald Senabah Francis). Rudolf Haffenreffer is leaning on the railing at the far right, and Rhode Island historian John Haley is at front left. Mount Hope Farm.

The inferences concerning Haffenreffer's attitudes about Native people that can be drawn from these relationships, books, and museum architecture are unhappily limited and conjectural. Haffenreffer spent little time with Native people, despite hiring LeRoy Perry, Yellow Feather, to interpret his museum on certain public occasions, and despite his involvement in the National Algonquin Indian Council, which reached its peak of influence in the 1920s (fig. 4.6). His participation in that local Pan-Indian organization and other evidence suggest that he developed his own thoughts concerning Native people, independent of people like Heye and Moorehead.[55]

If there were not additional information, any further conclusions would probably be unsatisfactory. Fortunately, there is more. In 1931, upon the dedication of the museum's new wing, Haffenreffer spoke to the Rhode Island Historical Society. Newspapers duly summarized his remarks, which evidently emphasized that Indians "were nearer God-like than the civilized

people before they were contaminated by the white man's ways," that Indi-
ans "were not savages but were reduced to savagery by the white men," and
that "lessons learned from the Indians will be of much value to present
civilization."[56]

These thoughts are intriguing, but they are largely a reporter's para-
phrasing of Haffenreffer's words—and woefully brief. Nevertheless, the
remarks suggest that Haffenreffer held sentiments concerning Indians and
Indian-White history that were romantic, revisionist, and in part reformist.
Although there is no reason to suspect that the reporter was writing some-
thing other than what he thought he heard, Haffenreffer's 1931 remarks
are in fact clearly related to his most revealing, and only fully recorded, talk
about New England Native people and history: a speech to the Fall River
Historical Society (joined by members of the Providence and Bristol soci-
eties) in 1923. This event was reported in Providence, Bristol, and Fall
River newspapers, and the speech was published fully in the *Fall River
Evening Herald,* as well as, later, in the *Proceedings of the Fall River His-
torical Society.*[57]

The speech traces the seventeenth-century history of relations between
the Indians and the English in Massachusetts and Rhode Island. Beginning
with the Pokanoket or Wampanoag and their sachems, Massasoit and his
son Metacom (King Philip), Haffenreffer mentioned the devastating im-
pact of disease, the political aggression of the Narragansett, and the al-
liances sought by the Wampanoag in a rapidly changing landscape. Some of
Haffenreffer's comments constituted a Pokanoket-centered version of his-
tory in which, in the changing relations between the Narragansett and
Pokanoket during the seventeenth century, Massasoit was "humbled" in a
"galling" ceremony by hegemonic Narragansett leaders who looked "cov-
etously" on Pokanoket lands. Though weaker in arms and men than the
Narragansett, Massasoit possessed "far-sighted vision," while his enemies,
in contrast, were pictured as aggressive imperialists.

Shifting to Pokanoket-English relations, Haffenreffer painted Massasoit
as faithful in upholding his end of a treaty of alliance and as "justified"
when he thought ill of the Whites. Haffenreffer reserved his most pointed
irony for the English. When the Pilgrims displayed the head of a decapitated
Massachusett sachem it was "testimony" to their "Christianity, civilization
and humanity." When the English executed a captive Narragansett and for-
mer ally, it was his "reward . . . for assisting the English" in earlier days.
"Inhumanity charged against the Indians," Haffenreffer emphasized, "was
practiced by their white associates." In fact, in commenting on the Pequot

Figure 4.7. LeRoy Perry (Ousa Mekin or Yellow Feather) examining Rhode Island Historical Society monument at Cold Spring, Mount Hope, near site of King Philip's death, ca. 1931. Mount Hope Farm.

War of 1637, Haffenreffer found it "scarcely . . . possible to picture a more disgraceful and wanton act of destruction, a slaughter of innocents," than an incident in which English were reported to kill defenseless, unarmed women and children.

Haffenreffer built up to the war led by King Philip against the English and his death at Mount Hope. It is clear that Haffenreffer's sympathies lay with

Philip and his people. "No independent sovereign with any self-respect," Haffenreffer said, "could be expected to submit" to what Philip's older brother, Alexander, had been asked to by the Plymouth authorities. As for Philip himself, who "grieved to make war on his personal friends," conflict was inevitable. There was no other way to "check this vast stream of white men" that flooded and isolated the "ethnological islands" that were his and other Indians' communities (fig. 4.7).

Haffenreffer also argued that the Indian was born "where everything in nature was dignified and sublime." His speech ended with the unburied Philip, who "gave his life, his wife, his son, all he had to give, to save his native land—his fellow countrymen. He lost, and now Mount Hope, lifting its lofty head, stands in beautiful solitary loneliness, eternally his mausoleum."[58]

This speech placed Haffenreffer squarely in sympathy with romantic readings of the past, which thrived in particular genres like poetry and appeared occasionally in the writings of scholars looking at the distant events of two centuries ago in New England. The sentiments were even reminiscent of Washington Irving's "Philip of Pokanoket." Munro had excerpted this particular essay in "Some Legends of Mount Hope," published by Haffenreffer several years earlier, and it appeared in Irving's *Sketch-Book,* which was a key text at Chauncy Hall when Haffenreffer was a student. The speech also allied Haffenreffer with reformists of the day. At one point he invoked Helen Hunt Jackson's *Century of Dishonor.* Published some decades earlier, this was a critical text for many seeking a corrective to Manifest Destiny versions of history painting Indians as savages without rights impeding the progress of civilized people who had law, reason, and ethics on their side. Haffenreffer's remarks separated him from local historians who continued to extol the English as conquerors of King Philip.[59]

When he spoke, Haffenreffer cautioned his audience that he stood before them with "trepidation," because "I realize that, in the comparisons that I am to draw, the English settlers, the ancestors of many of you, will stand in a rather unfavorable light as regards their treatment of the Indians, and will present a rather sorry picture when contrasted with the savage red man." Those words never made it into print, which is just one of the ways that Haffenreffer's speech as published departed from the spoken version. Another passage, which was excised (by whom we do not know), remarked on the breaches of faith that Haffenreffer thought marked Puritan actions. He called the English "opportunists, with a warped sense of humor, unbound by their obligations" and spoke of them as presenting "a foul picture of hypocritical morality."[60]

From phrases like these, which were undoubtedly his voice, one gets the sense that this speech may above all have been about ethnic intolerance, and it may not be coincidental that Haffenreffer spoke as he did during an era when the German ancestry of German Americans was periodically called to question. Compared with Yankees who were his neighbors and whom he pointedly addressed in his audience, Haffenreffer was far more likely to have been aware of the problems faced in America by what were then known as "hyphenated" Americans (like "Irish-Americans" and "German-Americans"), which they shared with minorities like Native Americans, and he was also far more likely to have been sensitive to different readings of history.

The different versions of his speech to the Fall River Historical Society, together with the King Philip Museum and its collections, and his work with the Boy Scouts, constitute part of Rudolf Haffenreffer's legacy. That he was interested in the fate of the thoughts he expressed in that speech can be inferred not only from his later decision to dedicate a museum to King Philip and his sponsorship of essays on Wampanoag history among the Boy Scouts but also from his concern about how local American Indians would react to his remarks. In 1925 he read a feature article in the *Boston Sunday Post* about Emma Safford, an elderly descendant of the Pokanoket sachem, Massasoit, and sister of Melinda and Charlotte Mitchell, whom he had met more than a decade earlier. In his address to the Fall River Historical Society, Haffenreffer remembered that meeting with the Mitchells. Their perception of their own past, he said, as well as the "unjust" words he had read about that past, led to a "combative yearning ... to defend the Indian cause." Haffenreffer invited Emma Safford or "any of your descendants" to visit Mount Hope at any time, and he sent her a copy of the address, hoping, as his final thoughts, "that you will approve of my remarks."[61]

## Acknowledgments

This essay is an abbreviated version of "Rudolf F. Haffenreffer and the King Philip Museum," in *Passionate Hobby: Rudolf Frederick Haffenreffer and the King Philip Museum* (Bristol, R.I.: Haffenreffer Museum of Anthropology, Brown University, 1994), 49–89. The notes are especially attenuated here. I acknowledge again with gratitude the assistance and advice of Carl W. Haffenreffer, David Haffenreffer, Rudolf F. Haffenreffer IV, David W. Gregg, Barbara Hail, and Ann McMullen; and the support of the Woodrow Wilson International Center for Scholars, National Humanities Center, and Haffenreffer Family Fund.

## Notes

1. These headlines are from the *Providence Journal,* March 8, 1925, and other sources; for details, see endnotes for Shepard Krech III, "Rudolf F. Haffenreffer and the King Philip Museum," in *Passionate Hobby: Rudolf Frederick Haffenreffer and the King Philip Museum,* ed. Shepard Krech III (Bristol, R.I.: Haffenreffer Museum of Anthropology, Brown University, 1994), 49–89 (hereafter cited as RFH&KPM, especially when original endnotes are extensive).

2. I am grateful to the late Nanepashemet and to Kathleen Bragdon for suggesting translations and meanings of LeRoy Perry's entry in the Visitors' Book (personal communications).

3. Haffenreffer Museum of Anthropology Archives (hereafter cited as HMAA) Visitor's Book 1929–1954.

4. Genealogy of the Haffenreffer Family, Mount Hope Farm Papers (hereafter cited as Genealogy); Rudolf F. Haffenreffer, *Letters to Home 1864–1879* (privately printed, n.d.); Carl W. Haffenreffer (hereafter cited as CWH), personal communication; Theodore C. Haffenreffer (hereafter cited as TCH), personal communication; Harriet Haffenreffer Shields (hereafter cited as HHS), personal communication. On German emigration, see RFH&KPM.

5. Genealogy; CWH; TCH. On Germans and German Americans (among many "hyphenated" Americans) in Boston, see RFH&KPM.

6. Oliver Wendell Holmes called his own Anglo-Saxon Protestant gentry the Brahmin caste. I use "Yankee" for New England residents who were descendants of seventeenth-century Puritan settlers (Oscar Handlin, "Yankees," in *Harvard Encyclopedia of American Ethnic Groups,* ed. Stephan Thernstrom (Cambridge: Harvard University Press, 1980), 1028–30; Barbara Miller Solomon, *Ancestors and Immigrants: A Changing New England Tradition* (1956; reprint, Boston: Northeastern University Press, 1989). On ethnic Boston and upward mobility and Brahmin-German relations, see RFH&KPM.

7. Dun and Bradstreet Credit Reports, Baker Library, Harvard Business School, R. G. Dun/MA 85/ p. 71, 349; R. G. Dun/MA 79/ p. a–4, 18, R. G. Dun/MA 87/ p. 314; *Letters to Home;* TCH. On German American brewers and the Boston brewing scene, see RFH&KPM.

8. The Haffenreffers were Missouri Synod Lutherans. Genealogy; *Letters to Home;* TCH; Thomas Cushing, *Historical Sketch of Chauncy-Hall School* (Boston, 1895), 40–41 and passim; George W. Engelhardt, *Boston Massachusetts* (Boston, 1897), 65; Bacon, *King's Dictionary,* 378–79; Bacon, *Bacon's Dictionary of Boston* (Boston, 1886), advertisement. On language use in German American families and at Chauncy Hall, see RFH&KPM.

9. Other possible (but even more speculative) influences on Rudolf's later interests include knowledge of Chauncy Hall's illustrious graduates Horatio Hale and Francis Parkman, whose works exemplified the period's North American Indian ethnology and linguistics, and the history of Indian-White relations (if the school brought their lives to the attention of its students); one of the Wild

West shows touring the East during this era (more than one million people saw Buffalo Bill tour the East in 1885—night and day performances in Boston were highly publicized; he returned in 1895–97); Harvard University's Peabody Museum of Archaeology and Ethnology, whose galleries contained American Indian artifacts and were open for public tours each week, or other Boston-area museums. On all of these, see RFH&KPM.

10. Haffenreffer never returned to Germany; see RFH&KPM.

11. Whether or not Rudolf "discovered" Native America in other ways in Germany—for example, through Karl May, Buffalo Bill on tour, or reprints and translations of Cooper's *Leatherstocking Tales* (wildly popular at the time)— is speculative. On these matters, stamps, and Rudolf in Germany, see RFH&KPM.

12. Haffenreffer was a special student at MIT in the fall of 1894, at which time he studied Fermentation, and he is listed as a member of the class of 1895 (Bonny Kellermann, associate registrar, MIT, personal communication, March 31, 1993); CWH. For details, see RFH&KPM.

13. Elizabeth Warren and Pamela Kennedy, *Historic and Architectural Resources of Bristol, Rhode Island* (Providence: Rhode Island Historical Preservation Commission, 1990), 18–22.

14. Thomas W. Bicknell, "Historic Mount Hope," *Bristol Phoenix*, October 21, 1913; Warren and Kennedy, *Historic and Architectural Resources of Bristol*, 1; *Rhode Island Tercentenary, 1636–1936* (State of Rhode Island and Providence Plantations: Rhode Island Tercentenary Commission, 1937), 85; *Bristol Phoenix*, March 25, 1913 ("two points . . ." —paraphrasing Thomas Bicknell here). See RHF&KPM.

15. Haffenreffer acquired these properties with business partners, but by 1916 he was the sole owner. On the history of Mount Hope lands and Mount Hope Park, see RFH&KPM.

16. According to Carl Haffenreffer, his father was an "ardent horseman" and rode often. A riding accident in 1917 seriously injured one leg, on which he wore a brace for the rest of his life. CWH, Peter Haffenreffer (hereafter cited as PH), personal communication; *Class Book, 25th Anniversary, MIT 95* (Boston, 1920), 62; *Bristol Phoenix*, 1914–21 passim.

17. HMAA, clippings of Bernhard Hermann Ritter's columns; PH; *Bristol Phoenix*, 1915–18 passim. On German Americans during the war, see Frederick C. Luebke, *Bonds of Loyalty: German-Americans and World War I* (DeKalb: Northern Illinois University Press, 1974); RFH&KPM.

18. Haffenreffer's interest in mineral mining probably developed at Chauncy Hall or MIT, and he was a heavy investor in and president and managing director of both mines until they were sold to Anaconda Copper Company years later. CWH ("boxes . . ."); HMA Collection Files.

19. Barbara Babcock, "'A New Mexican Rebecca': Imaging Pueblo Women," *Journal of the Southwest* 32 (1990): 400–37; Marvin Cahodas, "Louisa Keyser and the Cohns: Mythmaking and Basket Making in the American West," in *The Early Years of Native American Art History*, ed. Janet Berlo (Seattle: University of Washington Press, 1992), 88–133; Ann T. Walton,

"The Louis W. Hill, Sr., Collection of American Indian Art," in *After the Buffalo Were Gone: The Louis Warren Hill, Sr., Collection of Indian Art* (St. Paul: Northwest Area Foundation, 1985), 10–35.

20. On Herreshoff, Haffenreffer's associates in the venture, and Mount Hope Bridge, see RFH&KPM.

21. On Narragansett, see RFH&KPM.

22. *Mugwump* is an Algonquian loan form (it came to denote "big chief"), and its use for fence-straddlers in American politics derives from the fence-sitting image of a mug (face) on one side and wump (rump) on the other. Mugwumps included Theodore Roosevelt, Henry Cabot Lodge, and other descendants of reform-minded Republicans who broke with James Blaine and the Republican Party to vote for Grover Cleveland in 1884. It is interesting that Haffenreffer purchased and used Lodge's desk in the King Philip Museum. As a United States senator, this old-stock Yankee was a key participant in the 1890s national debates on immigration and a political force behind the Immigration Restriction League, yet he also trumpeted German American virtues. On these issues and Haffenreffer's involvement in various charities, see Solomon, *Ancestors and Immigrants,* 111–21, 158, and passim); *Providence Journal,* October 9, 1954; *Fall River Herald News,* October 9, 1954; RFH&KPM.

23. Haffenreffer issued this booklet with his business partner in Fall River breweries and Mount Hope lands (*Bristol Phoenix,* April 27, 1915). In 1880, Munro published *The Story of the Mount Hope Lands* (Providence, 1880), a several-hundred-page history of Bristol; his shorter booklet is an adaptation of parts of this earlier work.

24. Bert Salwen, "Indians of Southern New England and Long Island: Early Period," in *Handbook of North American Indians,* vol. 15: *Northeast,* ed. Bruce G. Trigger (Washington, D.C.: Smithsonian Institution Press, 1978), 160–76; Douglas E. Leach, *Flintlock and Tomahawk: New England in King Philip's War* (New York: Macmillan, 1958); Francis Jennings, *Invasion of America: Indians, Colonialism, and the Cant of Conquest* (Chapel Hill: University of North Carolina Press, 1975); Wilcomb Washburn, "Seventeenth-Century Indian Wars," in *Handbook of North American Indians,* Vol. 15: *Northeast,* 89–100; Douglas E. Leach, "Colonial Indian Wars," in *Handbook of North American Indians,* Vol. 4: *History of Indian-White Relations,* ed. Wilcomb Washburn (Washington, D.C.: Smithsonian Institution, 1988), 128–43.

25. *Bristol Phoenix,* January 22, 1929; *Providence Journal,* January 20, 1929; *Providence Journal,* October 11, 1931.

26. CWH used the phrase "part squirrel blood" to refer to his father's accumulating habits.

27. *Providence Journal,* October 11, 1931.

28. CWH.

29. CWH; *Bristol Phoenix,* November 3, 1916 ("inspected . . ."); *Bristol Phoenix,* September 18, 1923 ("valuable collection . . .").

30. *Providence Journal,* March 8, 1925.

31. Before 1925, Haffenreffer's methods have to be pieced together from oral his-

tory and newspaper accounts; from the late 1920s on, there is a museum record. On Saville's work for Haffenreffer, see HMAA, Rudolf Haffenreffer Collection (hereafter cited as RHC); *Providence Journal*, January 20, 1929; *Bristol Phoenix*, January 22, 1929.

32. There was a surge of interest in the museum in late January 1929, when identical photographs were published in several newspapers, suggesting that Haffenreffer had had materials sent to the press or alerted them simultaneously to his museum. A typescript (dated 1930) either is the basis for one of these reports or is based on them. HMAA, RHC, Correspondence; *Boston Sunday Post*, January 20, 1929; *Providence Journal*, January 20, 1929; *New Bedford Sunday Standard*, January 20, 1929; *Bristol Phoenix*, January 22, 1929; *Boston Herald*, July 21, 1929.

33. All quotations from *Providence Journal*, January 20, 1929; *Bristol Phoenix*, January 22, 1929; *New Bedford Sunday Standard*, January 20, 1929.

34. *Providence Journal*, October 11, 1931.

35. *Bristol Phoenix*, February 21, 1941 (Chief Gansett). On carousel figures at Mount Hope Park, German American carvers, see Frederick Fried, *A Pictorial History of the Carousel* (New York: A. S. Barnes, 1964); Frederick Fried, *Artists in Wood: American Carvers of Cigar-Store Indians, Show Figures, and Circus Wagons* (New York: Clarkson N. Potter, 1970); Jean Lipman, *American Folk Art in Wood, Metal, and Stone* (New York: Pantheon, 1948); Erwin O. Christensen, *Early American Wood Carving* (New York: Dover, 1952); Anthony Pendergast and W. Porter Ware, *Cigar Store Figures in American Folk Art* (Chicago: Lightner Publishing, 1953); *The Haffenreffer Collection of Cigar-Store Indians and Other American Trade Signs*, pts. 1 and 2 (New York: Parke-Bernet Galleries, 1956).

36. "The Vanishing American," *Time*, May 12, 1952 ("passionate hobby"); *The Haffenreffer Collection;* John Ewers, personal communication ("bleachers"); William Fenton, personal communication; H. Cushman Anthony, personal communication ("tribe"); see RFH&KPM.

37. CWH, personal communication.

38. HMAA, Visitors' Book; CWH; PH.

39. *Providence Journal*, January 20, 1929; *Providence Journal*, October 18, 1931.

40. HMAA, Visitor's Book; *Bristol Phoenix*, June 12 and 30, 1936; *Bristol Phoenix*, July 3 and 7, 1936; *Bristol Phoenix*, February 15, 1946.

41. At first, RIBS formed as a nonsectarian, separate state-chartered body distinct from the national scouting movement, which consisted of two feuding bodies from which Rhode Island leaders wished to distance themselves; by the end of the war, however, RIBS was part of the national movement. See RFH&KPM.

42. *Bristol Phoenix*, 1914–23 passim; *Providence Journal*, June 26, 1915; *Providence Journal*, September 26, 1920; CWH; see RFH&KPM.

43. For Seton, see John Henry Wadland, *Ernest Thompson Seton: Man in Nature and the Progressive Era, 1880–1915* (New York: Arno Press, 1978); H. Allen Anderson, *The Chief: Ernest Thompson Seton and the Changing West* (College Station: Texas A&M University Press, 1986).

44. Ernest Thompson Seton, "Ernest Thompson Seton's Boys," *Ladies Home Journal*, May 1902, 15, 41; June 1902, 15; July 1902, 17; August 1902, 16; September 1902, 15; October 1902, 14; November 1902, 15; Boy Scouts of America, *The Official Manual for Boys, 1911*.

45. Raymond Wilson, *Ohiyesa: Charles Eastman, Santee Sioux* (Urbana: University of Illinois Press, 1983); David Reed Miller, "Charles Alexander Eastman, Santee Sioux, 1858–1939," in *American Indian Intellectuals*, ed. Margot Liberty (St. Paul: West, 1978), 60–73; Charles A. Eastman (Ohiyesa), *Indian Boyhood* (1902; reprint, New York: Dover, 1971); Charles A. Eastman (Ohiyesa), *The Soul of the Indian: An Interpretation* (1911; reprint, New York: Johnson Reprint, 1971); Charles A. Eastman (Ohiyesa), *Indian Scout Talks: A Guide for Boy Scouts and Camp Fire Girls* (Boston: Little, Brown, 1914); Anthony, personal communication; *Fall River Daily Globe*, February 27, 1911; *Bristol Phoenix*, July 11, 1916; *Bristol Phoenix*, January 3, 1919 ("in various imitations").

46. *Providence Journal*, January 2, 1927; *Providence Journal*, December 28, 1930.

47. *Providence Journal*, October 25, 1936; *Bristol Phoenix*, 1936–37 passim. In 1952 the Narragansett Indians Council Powwow, also called the R. F. Haffenreffer Powwow, was held in Providence, and the Haffenreffer Foundation gave prizes in the Indian Essay Contest (*Bristol Phoenix*, February 12 and 19, 1952).

48. *Bristol Phoenix*, 1936–39 passim; *Providence Journal*, September 11, 1939. In 1940 a lease from the Rhode Island Soldiers Home to Camp King Philip was assured by the legislature (*Bristol Phoenix*, April 16, 1940). In the period from 1935 to 1940, scouting in Rhode Island grew greatly by virtue of its endorsement by the Catholic Church; see J. Harold Williams, *Scout Trail, 1910–1962* (Providence: Rhode Island Boy Scouts and Narragansett Council, Boy Scouts of America, 1964), 31.

49. Anthony, personal communication; *Providence Journal*, 1936, 1946 passim; *Bristol Phoenix*, 1936 passim; HMAA, RHC Files; see RFH&KPM.

50. *Bristol Phoenix*, September 28, 1937; *Bristol Phoenix*, January 11, 1938.

51. Anthony, personal communication; *Providence Journal*, 1941, 1945–47 passim; *Bristol Phoenix*, 1946–47 passim.

52. Williams, *Scout Trail, 1910–1962*, 52–53, 59; *Bristol Phoenix*, December 31, 1937.

53. HMAA, Inventory of Book Cases, ca. 1955.

54. Barbara A. Hail, "The Ethnographic Collection," in Krech, *Passionate Hobby*, 91–134.

55. Ann McMullen, "The Heart Interest," in Krech, *Passionate Hobby*, 167–85. Unfortunately, very little has come to light that yields insight on any thoughts Haffenreffer and Heye may have shared with each other about Native people.

56. *Providence Journal*, October 18, 1931.

57. *Providence Journal*, September 16, 1923; *Fall River Evening Herald*, September 17, 1923; *Fall River Evening News*, September 17, 1923; R. F. Haffenreffer Jr., "Indian History of Mount Hope and Vicinity," in *Proceedings of the*

*Society from Its Organization in 1921 to August 1926* (Fall River: Fall River Historical Society, 1927), 34–62. Haffenreffer, who never hesitated to employ others to fulfill various tasks for him, possibly had help drafting this speech. After 1924, he employed John Haley at Herreshoff and later at Narragansett in advertising and publicity, and Haley wrote for him in the 1930s and 1940s. There is no evidence that he or anyone else actually played any role. The rhetoric does not resemble his. Moreover, there are indisputable signs that the spoken version, a typescript of which is in the Haffenreffer Museum archives, was indeed Haffenreffer's.

58. All quotations, unless otherwise indicated, are from Haffenreffer, "Indian History of Mount Hope and Vicinity."

59. Helen Hunt Jackson, *A Century of Dishonor: A Sketch of the United States Government's Dealings with Some of the Indian Tribes* (Boston: Roberts Brothers, 1888). Haffenreffer was certainly not a lone voice in either romantic or revisionist readings of New England's past, but his forceful words separated him from many others of his day and were no doubt especially unusual among those with whom he associated in the business world. For a variety of texts, see, e.g., *Bristol Phoenix*, July 29, 1927; *Providence Journal*, August 8, 1926; William J. Miller, *Celebration of the Two-Hundredth Anniversary of the Settlement of the Town of Bristol, Rhode Island, September 24th, A.D. 1880*; Munro, *The Story of the Mount Hope Lands*.

60. HMAA, "Indian History of Mount Hope and Vicinity" (typescript).

61. *Boston Sunday Post*, November 22, 1925; Rudolf Haffenreffer to Mrs. Emma Safford, November 24, 1925, Mount Hope Farm Papers.

IRA JACKNIS

5

# PATRONS, POTTERS, AND PAINTERS

## Phoebe Hearst's Collections from the American Southwest

Although collections from the American Southwest are not known as one of the regional strengths of the anthropology museum at the University of California, Berkeley, the museum does indeed possess many important artifacts gathered from this region around the turn of the century. Some were collected even before the museum was founded in 1901 by Phoebe Hearst. Some of the objects that she gave to the museum came from her personal collection (purchased from dealers), others were gathered on her behalf by collectors in the field, and still others were part of entire collections that she purchased for the university. This essay reviews the Southwestern collections donated by Phoebe Hearst to the museum and considers the role they played in the founding of the institution.[1]

### THE FOUNDING OF AN ANTHROPOLOGY MUSEUM

Education—from kindergarten to graduate research—was at the root of the many philanthropies supported by Phoebe Apperson Hearst (1842–1919). This interest undoubtedly stemmed from her occupation as a schoolteacher in rural Missouri when she was a young woman. Born to a prosperous farming family, Phoebe Apperson herself had a modest educa-

tion, attending the local one-room school and spending another year in a nearby church-operated seminary. She began teaching at the age of seventeen, but gave it up in 1862 upon her marriage to George Hearst, a mining entrepreneur who had made his fortune in California and Nevada.[2] She moved with her husband to San Francisco, where her only child, William Randolph Hearst, was born the following year. After his birth, Phoebe Hearst devoted herself increasingly to the arts, an interest that was deepened during a wonderful eighteen-month trip to Europe in 1873. She had prepared herself for this Grand Tour, conducted partly for the education of her son, by extensive reading. It was on this trip that she first encountered a museum of anthropology.[3]

During the course of her life, Phoebe Hearst traveled extensively throughout the world beyond Europe, including Egypt, India, and Japan. On these trips she found much to admire in foreign cultures. Of the Japanese princess she met in 1903, she wrote to a friend: "The little Japanese Princess looked *very* small in European dress. They wore wonderful gowns and jewels. One was extremely pretty but it is dreadful that they should not dress in their own exquisite costumes. The Prince and high officials were gorgeous in gold embroidered coats and many decorations."[4] Historian Richard Peterson has aptly glossed this attraction for foreign cultures. Although impressed by material embellishment and appreciative of elites, she did respond positively to a people whose immigrants to America at the time were subjected to profound discrimination.

Hearst was quite adventurous in her travels and did not mind putting up with some discomfort. In February 1905, at the age of sixty-three, she spent a month traveling through Egypt by boat, camel, and donkey (fig. 5.1). "The *air* is very pure and good at the Pyramids and there is plenty of it. The views also are fine. It is most interesting to be there, but a bit uncomfortable at times. I don't at all mind living in mud and stone houses, but the lack of conveniences in such places are a little trying at times. However, it is all very good discipline and makes us appreciate home more than ever."[5] Writing to a friend of her visit to the excavation that she had funded, she spoke of her personal enthusiasm in the research she would come to finance: "We saw a tomb opened where they found *two* statues. If you had seen me hanging *over* the edge of the place looking down to see the figures as they were uncovered, you might have thought it right to class me with excavators. I was more excited than any one."[6]

Upon her return from a second trip to Europe in 1879–80, Phoebe Hearst began to concentrate on public philanthropy, which would remain

Figure 5.1. Phoebe Hearst (back row, center) visiting the pyramids, Giza, Egypt, ca. 1905. Phoebe Apperson Hearst Museum of Anthropology and the Regents of the University of California, 15–18884.

her principal occupation for the rest of her life. Among her many causes were hospitals, orphanages, libraries, and schools. In 1886, with the appointment of her husband to the U.S. Senate, much of Mrs. Hearst's patronage became centered in Washington, D.C. Following her husband's death in 1891, however, she gradually shifted her philanthropy to California and especially to its state university. In 1897 she became the first female regent of the university, a position she held until her death. Her many gifts to the university were diverse: scholarships (particularly for women), lectureships, books, buildings, and the sponsorship of an architectural competition for the campus. Dearest to her heart, perhaps, was anthropology, "her favorite subject," according to her grandson.[7] At her instigation and with her funding for its first seven years, the regents established a museum and department of anthropology in September of 1901.[8]

When Hearst began her initial collections in 1899 they were all archaeological in nature: George Reisner in Egypt, Max Uhle in Peru, Philip Mills

Jones in California, and Alfred Emerson in Greece and Rome. Jones began ethnological collecting in the summer of 1901 (primarily in California, but also in the Plains), which was taken up in earnest when Alfred Kroeber arrived in September of 1901 (working in California). Although she was generally supportive, Mrs. Hearst seems not to have been especially interested in living Californian peoples.[9] The survey of Californian archaeology and ethnology, formally announced in 1903, was clearly formed at Kroeber's insistence: "The research activities of the Department have gradually become more and more concentrated in the field most proper to a State University: the prehistory, languages, ethnic customs, and types of the Natives of California and adjacent regions. Studies in other fields have not been abandoned, but investigations concerned with the home area have been increasingly systematized."[10] At the turn of the century, regional collecting in American anthropology was subject to a kind of colonial "sphere of influence." As it was natural for a major museum in California to focus on the Natives of its region, it was conversely appropriate for Southwestern collecting to be conducted by other, older, institutions in the East, which had been working in the area for several decades.

In fact, the first Southwestern collections in the Berkeley museum, and the institution itself, were formed several years earlier on the East Coast.[11] Phoebe Hearst began her collections from the region by means of exchanges, and it is this mode of acquisition that most sharply reveals the sources of her interest in anthropology. These connections center around two institutions and two key individuals: William Pepper at the University of Pennsylvania and Frederic Putnam at Harvard. Along with Pepper and Putnam were two close female friends, Zelia Nuttall and Alice Fletcher, both of whom were anthropologists associated with these two institutions (fig. 5.2).

Phoebe Hearst's first patronage of anthropology came in early 1896, when she purchased for the University of Pennsylvania museum of anthropology a large archaeological collection gathered from Mesa Verde, Colorado.[12] She was encouraged in this action by her friendship with Dr. William Pepper, provost of the university and one of the museum's founders, who by 1891 was Mrs. Hearst's personal physician. Pepper soon fired her enthusiasm for the anthropological work the university was doing. Like many members of the general public, Phoebe Hearst was fascinated by the mystery of the so-called Cliff Dwellers, whose ruins had first been popularized at the 1876 Centennial Exposition in Philadelphia. Pepper convinced her to purchase a disparate collection that had been assem-

Figure 5.2. Frederic W. Putnam in Spruce Tree House at Mesa Verde, Colorado, September 19, 1899. Photograph by Sumner W. Matteson. Phoebe Apperson Hearst Museum of Anthropology and the Regents of the University of California, 13–376J.

bled by entrepreneur Charles D. Hazzard of Minneapolis and exhibited in 1893 at the Chicago World's Fair.[13]

In interpreting the Cliff Dwellers collection, Phoebe Hearst drew upon the expertise of Smithsonian ethnologist Frank Hamilton Cushing (1857–1900). Upon the collection's arrival in Philadelphia in 1895, Stewart Culin, director of the museum and a friend of Cushing's, asked him for relevant cultural background, and through that connection with the Philadelphia museum, Phoebe Hearst met Cushing (who was also one of Dr. Pepper's patients).[14] She funded Cushing's 1895–96 archaeological expedition to Key

Marco, Florida, for the university, and upon his return he stayed as her houseguest in Washington. For two years thereafter, Mrs. Hearst paid him a stipend to write up his research.[15] His vivid stories of lost worlds and aboriginal peoples stimulated her support of anthropology, first at the University of Pennsylvania and subsequently in California.

Another of Phoebe Hearst's anthropological colleagues was Zelia Nuttall (1857–1933), who was associated with the anthropology museums at both Pennsylvania and Harvard.[16] Born in San Francisco, Nuttall had been a youthful friend of Mrs. Hearst's. She had collected for the Philadelphia museum (with funds supplied by her friend) but became alienated by Culin. Through her, Mrs. Hearst was put in touch with Frederic Ward Putnam, whom she selected as the first director of her new museum in California.[17] Putnam added this to his multiple duties as director of Harvard's Peabody Museum of Archaeology and Ethnology (where he had served since 1875) and head of the anthropology department at the American Museum of Natural History (a position he had held since 1894). Putnam was to remain as director of the California museum until his retirement in 1909, but because he was so often away, day-to-day supervision of the museum rested with the first curator, Alfred Kroeber, the first Columbia graduate student of Franz Boas (who also served on the museum's advisory committee). Because of her connections with Putnam and other Eastern anthropologists, Phoebe Hearst was able to amass an important representation of Southwestern Native cultures within a few years.

## INITIAL COLLECTIONS: ARCHAEOLOGICAL EXCHANGES

By 1900, Mrs. Hearst, having decided to transfer her patronage to the West, requested that a portion of the Cliff Dweller collection in Philadelphia be sent to the University of California. The following year, Putnam's student George H. Pepper went to Philadelphia to make the selection of 288 pieces for the soon-to-be-founded museum of anthropology. This marked the beginning of the California museum's Southwestern collections.

Each of Putnam's two East Coast institutions supplied specimens to his West Coast home. From the American Museum of Natural History came two collections of anthropological representations—paintings and plaster busts—generated by the Hyde Exploring Expedition to Chaco Canyon, New Mexico.[18] The expedition was led by the same George Pepper between 1896 and 1899. The paintings consisted of a set of twenty meticulous

opaque watercolors, depicting Anasazi specimens from Pueblo Bonito. These were painted between 1900 and 1902 by German artist Rudolf D. L. Cronau as illustrations for Pepper's projected reports. Pepper brought at least some of this set with him to California in 1902, when he came to review the Mesa Verde collection and lecture on the Southwest at the university. The young archaeologist was a guest at Mrs. Hearst's Hacienda del Pozo de Verona, the family country estate in Pleasanton, thirty miles east of San Francisco. Here he joined Alice Fletcher, another of her anthropological friends, in a combination seminar and holiday, one way in which Phoebe Hearst maintained a strong personal connection to the research she funded.[19]

The second New York acquisition was a set of thirty-nine plaster busts and ten face casts, originally made in 1900 on the Hyde Expedition and purchased by the California museum in 1903. Physical anthropologist Aleš Hrdlička had cast the faces from life from Navajo and Apache men and women, and then museum artist Caspar Mayer used the molds as the basis for clay sculptures of the entire head. Finally, the figures were cast in plaster and painted. Although the primary purpose of these busts was to record human form and racial types, they could also be exhibited, which was how they were primarily used in California.[20]

From the Peabody Museum at Harvard, the University of California anthropology museum acquired by exchange two important and related collections, both originally funded by Boston philanthropist Mary Hemenway (1820–94), a woman similar in many respects to Phoebe Hearst.[21] In 1904 the California museum acquired 301 Southwestern archaeological specimens that had been collected between 1886 and 1888 on an expedition sponsored by Hemenway. Directed by Frank Hamilton Cushing, the expedition excavated at the site of Los Muertos, in Arizona's Salt River Valley. In 1910, California acquired another of the Hemenway collections: thirty pots and sixteen baskets from the more than 1,500 objects gathered on the Hopi mesas between 1875 and 1890 by Alexander M. Stephen (1850?–94), a Scottish mining-prospector-turned-ethnologist, and Thomas V. Keam (1846–1904), a local trader. The Peabody Museum had purchased the Keam collection in 1892.[22] By acquiring representative samples from Mesa Verde, Pueblo Bonito, and the Hemenway-Keam collections, the University of California was starting with what were, in effect, "type collections" of Southwestern prehistory; all were made possible by Phoebe Hearst's personal connections to the anthropological establishment of her time.

## "SYSTEMATIC" FIELD COLLECTIONS

Unlike many museum patrons of her period, Phoebe Hearst did more than donate objects or pay for existing collections; she funded expeditions that systematically gathered artifacts in the field. Although the ancient Egyptian and Andean holdings are among the largest and best known of the museum's collections of this kind, the Southwest was not left out. Collectors such as George Pepper (in ethnology) and Joseph Peterson (in archaeology) returned with objects that were relatively well documented by time and place. The appearance of order and comprehensiveness in these "systematic collections" is deceiving, however, for these assemblages were still only a sample, biased by the interests and experiences of the collector. While we must remember the fictive and constructed nature of collections, it is still useful to differentiate between those that are more or less internally ordered.[23]

One of the most important of the Hearst collections from the Southwest was the assemblage of pueblo pottery gathered in 1903 by George H. Pepper (1873–1924). It was one of three that Pepper made simultaneously while employed by the American Museum of Natural History: one for Phoebe Hearst, one for the museum, and one for Mrs. Emily de Forest. The wife of the man who would soon be president of New York's Metropolitan Museum of Art, Mrs. Robert de Forest was gathering a collection of folk pottery of the world. Pepper collected systematically, visiting every inhabited pueblo, as well as the neighboring Navajo and Pima. As he observed, "I find that very few investigators have visited all of the Pueblos and it is therefore very satisfying to have seen them and thereby to be in a position to use first hand information."[24] Notable for its range of types (utilitarian and ceremonial) and functions (domestic use as well as sale to outsiders), the collection of 588 pieces is also relatively well documented. Along with a wide variety of pottery types, Pepper collected samples of raw materials (clays, tempers, and paints) and several unfinished vessels demonstrating the stages in pottery construction. Included in the Pepper collections were several materials, tools, and pots attributed to Nampeyo (c. 1860–1942), the famous Hopi-Tewa potter of First Mesa, Arizona.[25]

Although it has never been properly analyzed, the archaeology collection made by Joseph Peterson in the area around Snowflake, Arizona, is one of the most important of the Hearst collections from the Southwest. Born in Utah, Peterson (1874–1943) came to Snowflake in 1898 to begin a career as a schoolteacher.[26] He moved to California in 1903 for his health but

soon enrolled as a student of anthropology under Alfred Kroeber. Peterson's first exposure to archaeological techniques came in the summer of 1904, when he excavated parts of the West Berkeley shell mounds. Dr. Kroeber was very impressed with Peterson and arranged for Mrs. Hearst to fund further work in the Southwest when he returned home. Kroeber, who desired prehistoric material from Arizona to complement the Mesa Verde collections, had high hopes for Peterson's excavations: "As he would be careful to get the exact localities and other accompanying data, material from him would be superior to much that is now in other museums and might bring out points new to science."[27]

The Peterson collection, accessioned between 1906 and 1908, numbers 710 specimens from sites that have been dated to the period c. A.D 900–1100. The collection is exceptionally well documented with maps, site plans, catalogs, and reports. Although Peterson carried out the work largely during school vacations, his residence in the area allowed him to be careful and thorough. The resulting collection is the only one of Southwestern prehistory that was gathered specifically for the museum. Unfortunately, Peterson was never able to properly prepare the collection for publication.[28]

Another of the museum's systematic collections, though in a different medium, comprises the Navajo and Pueblo photographs taken by Philip Mills Jones (fig. 5.3). One of the first employees of the anthropology museum, Jones served Phoebe Hearst in several capacities between March 1900 and the fall of 1902. A physician by training, Jones (1870–1916) spent most of his time excavating in California, but he also acted as Mrs. Hearst's agent in acquiring other collections for the museum. After his brief museum career, Dr. Jones returned to his medical work, devoting himself largely to public health.[29] In the summer of 1902 he traveled to the Southwest with the explicit purpose of taking "as many photographs as possible of the Indians that could be visited in a reasonable time, their pueblos, life and manners." He returned with nearly six hundred images from the pueblos of Hopi, Acoma, and Laguna; the Navajo and ruins in the Canyon de Chelly area of Arizona; and the Mojave of Southern California. Believing his photographic work to be "very important," Jones recommended that it be continued, because "in a few years it will be too late to get any material of this sort."[30] Although he was not authorized to do any collecting, Jones did bring back a miscellaneous collection of thirteen Hopi and Navajo artifacts.[31]

There was one final great Southwestern collection that came to the mu-

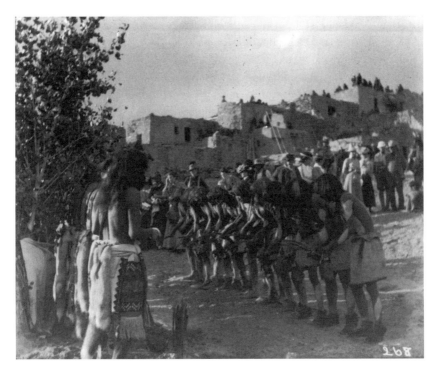

Figure 5.3. Hopi Snake Dance, Oraibi, Arizona, 1902. Photograph by Philip M. Jones. Phoebe Apperson Hearst Museum of Anthropology and the Regents of the University of California, 15–268.

seum through personal, East Coast connections. At the turn of the century, Washington Matthews (1843–1905), an army surgeon who was the pre-eminent Navajo scholar of his day, was nearing the end of his long career.[32] Learning in late 1902 of Matthews's intention to destroy his manuscripts upon his death, Frederic Putnam arranged for Phoebe Hearst to pay the ethnologist a stipend to prepare the material for publication, with the understanding that they would come to the university upon his death.

Pliny Earle Goddard (1869–1928), who had been working with related Athapaskan languages in California, agreed to assist Matthews. Goddard, a professor in the anthropology department, went to Arizona in 1904 to work with Matthews's original Navajo consultants, but the trip was unsuccessful. Matthews continued to translate his texts, add entries to his dictionary, and annotate his previous work, but he died soon thereafter in 1905. The following year Goddard obtained the necessary information on a trip

to Arizona, and their jointly written monograph was finally published in 1907.[33] The rich archives of Matthews's papers remained in Berkeley—essentially forgotten and unused after Goddard's departure in 1909—until 1951, when they were donated to the Museum of Navajo Ceremonial Art (now the Wheelwright Museum) in Santa Fe. Matthews's valuable collection of 226 photographs, however, remains at Berkeley (along with a small miscellaneous collection of artifacts). For a few years at the turn of the century, the University of California was a center for Navajo studies.

That this collection was primarily non-artifactual was not at all unusual for an anthropology museum at the time. Vocabularies, texts, and sound recordings, gathered as materials for the study of Native languages and verbal art, music, and religion, all had a material expression and could be collected as discrete objects. The California museum began to use the cylinder recording machine in 1901—only eleven years after the first recordings of American Indian music.[34] Like the artifact collections, cylinders, photographs, and texts were part of the systematic collecting funded by Phoebe Hearst.

## A PATRON OF PAINTERS

Turn-of-the-century Whites attempted to possess the Indian by means of painting and photography, as well as artifacts. The common sentiments of the time were expressed by painter Carl Oscar Borg: "The Indians, of course, interested me because to my mind they are the 'only Americans,' a fast disappearing race, and I wanted to try and preserve some of their customs and religions in a permanent form."[35] Throughout her life, Phoebe Hearst was an active and generous patron of the arts, and she donated relevant paintings and photographs to the anthropology museum that she founded. Accessioning them as documentary objects in their own right, the museum displayed most of these paintings in its original exhibitions.

Phoebe Hearst was also critical to the career of Joseph Henry Sharp (1859–1953), one of the foremost painters of the American Indian and one of the founders of the Taos School.[36] She first learned about his work from a display at the Pan-American Exposition, held in Buffalo in 1901.[37] Because of the glowing reports of Orrin Peck, a painter and friend of the Hearst family, Hearst bought the entire contents of Sharp's Cincinnati studio, plus the paintings in the show. Mrs. Hearst donated these seventy-nine canvases to the university museum and contracted with Sharp to purchase

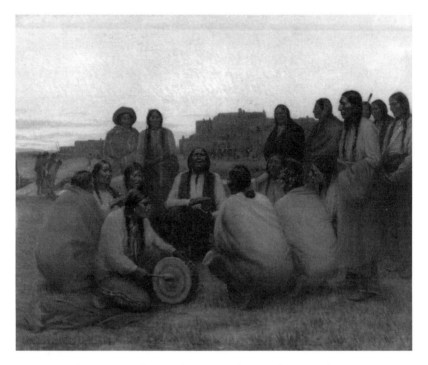

Figure 5.4. *The Evening Chant.* Oil on canvas by Joseph Henry Sharp, 1900. Phoebe Apperson Hearst Museum of Anthropology and the Regents of the University of California, 17–671.

fifteen paintings a year for five years. Although she later released him from this obligation, she continued his payments. In the end, she bought eighteen more of his pictures for the university, mostly of Crow and other Plains Indians. Sharp always regarded Mrs. Hearst with affection, as her largesse had allowed him to give up teaching and devote himself exclusively to painting, and she continued to acquire his works when he was in financial difficulties.

Much of Sharp's work is characterized by a desire for factual recording; he often worked from photographs and had his own collection of artifacts. Recognizing this bent, his colleagues referred to him as "the anthropologist." The most ambitious of the Sharp paintings donated by Phoebe Hearst was *The Evening Chant* (1900) (fig. 5.4). Here the artist paints a romantic and nostalgic scene, with the twilight evoking the passing of the old ways. The work was evidently a favorite of Mrs. Hearst's; it hung over her office

desk in the Examiner Building in San Francisco. The fire associated with the 1906 earthquake destroyed or damaged more than twenty of his paintings that had been exhibited at the Examiner Building. Fearing (incorrectly, as it turned out) that this work—"my best painting of composition"—had been included in the casualties, Sharp offered to replace it.[38]

Phoebe Hearst's influence on Carl Oscar Borg was even more dramatic.[39] Born in Sweden, Borg (1879–1947) immigrated to America in 1901. He was first attracted to what became his life's work—painting the Native peoples and landscapes of the Southwest—through a 1906 meeting with Charles F. Lummis, the indefatigable popularizer of Southwestern culture.[40] In 1909, Mrs. Eve Lummis introduced Borg to Phoebe Hearst, who immediately invited him to stay with her at her homes in Pleasanton and near Mount Shasta and purchased several of his paintings. In September 1910, Phoebe Hearst sent Borg to Europe and North Africa on a projected five-year tour of the great cities, museums, and archaeological sites. Borg returned to America when the war broke out in 1914 and spent extended periods over the next several years living at Mrs. Hearst's Pleasanton estate. Until her death in early 1919, Borg maintained a close relationship with Phoebe Hearst, whom he called his "little mother."[41]

Although we can only speculate, it appears that one of the bonds between Borg and Hearst was spiritual. Although raised as a Presbyterian, she was put off by that denomination's "strict austerity," according to her biographer, and was not a devout or consistent adherent of any religion for most of her life. Since she often suffered from poor health and was challenged by the headstrong behavior of her husband and son, she sought solace in extensive reading of religious and metaphysical texts. Around the turn of the century, Phoebe Hearst became quite absorbed by the Baha'i faith. In 1898 she led a group of fifteen Americans to visit the Baha'i leader in Syria. Baha'i's appreciation of all the world's religions must have been compatible with her interest in world cultures.[42] Borg was essentially a pantheist, whose paintings, and occasional poetry, expressed his belief in the oneness of humanity (particularly Native races) and nature.[43]

In the summer of 1916 Phoebe Hearst and the Smithsonian Institution sent Borg to the Hopi and Navajo reservations. Mrs. Hearst charged him with photographing and painting the Indians as they were. "The West needs a painter who understands the Indian soul. Your eyes are clear enough to see, and your hand is strong enough to paint these twilight gods."[44] Borg was to return annually to the region until 1932. Although Phoebe Hearst donated only five of Borg's Southwestern paintings, she

shared with her protégé a profound romantic nostalgia for Indian cultures. These paintings, along with others, were hung over cases of specimens in the museum's galleries.

## PERSONAL COLLECTORS

Between 1880 and 1920, museums competed with private collectors in the acquisition of American Indian objects. Under the influence of the Arts and Crafts movement, many individuals amassed large collections of Native artifacts—especially baskets and blankets—as home decoration and as samples of hand-crafting.[45] Eventually, many of these private collections were donated or sold to anthropology museums, where they were reevaluated as ethnological specimens representing Native cultures.

In the early history of the museum, there was a good deal of exchange between Phoebe Hearst's personal collections and her museum donations (fig. 5.5). She would often select out items of personal interest (such as furniture) from a collection destined for the museum and, conversely, would send to the museum objects she did not wish to keep or thought would be more suitable in a research institution. Like many wealthy people of her time, Phoebe Hearst possessed a large and lavish art collection. Her aesthetic tastes were representative of Victorians, such as herself, born before the Civil War. According to her biographer, "Her collection consisted largely of nineteenth-century realist paintings of dark and traditional subjects, mixed with portraits of European royalty and quantities of lace, statuary, oriental rugs, tapestries, fans, enamels, miniatures, carved ivories, and other curios, including a Louis XV French sedan chair. It was singularly lacking in 'modern' works of art."[46] Like her son's collecting, Mrs. Hearst's acquisitions were, her biographer continues, "random and impetuous." "Neither of them relied much on art experts to advise them in their collecting; they bought through dealers, who knew that the Hearsts were free-handed in their purchases."[47] Following popular decorating tastes of the day, Mrs. Hearst scattered baskets and textiles from California and the Southwest around the rooms of her estate in Pleasanton. Her style, however, leaned more toward Victorian clutter than Arts and Crafts simplicity, and American Indian objects were in the minority (fig. 5.6).[48]

Most of these baskets and textiles—like her Navajo silver and Hopi kachina dolls—were acquired from the Fred Harvey Company of Albuquerque. A hotel and restaurant chain along the railroads, the Harvey

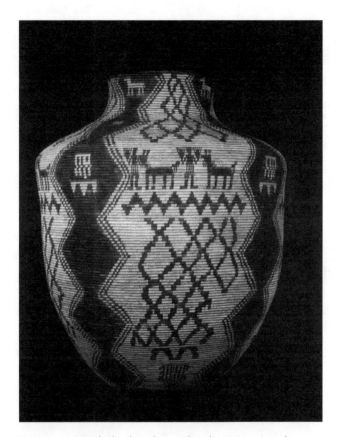

Figure 5.5. Apache basket, donated to the University of
California Museum of Anthropology by Phoebe A. Hearst,
1903. Phoebe Apperson Hearst Museum of Anthropology and
the Regents of the University of California, 2–2.

Company had opened a department to sell Indian artifacts in 1902.[49]
Phoebe Hearst selected at least some of her Indian items directly from the
Harvey showroom in Albuquerque. The kachina dolls appear to have been
part of Mrs. Hearst's own collection, as they were sent from her Pleasanton
home in 1913; their collection date is otherwise unknown. We do not know
if she ever wore or used any of the silverwork (including spoons, wrist
guards, bracelets, buttons, concha belts, necklaces, and earrings), which
she donated in 1905 and 1909. Phoebe Hearst's last donation to the mu-
seum she had founded—a bequest of some of her personal possessions—

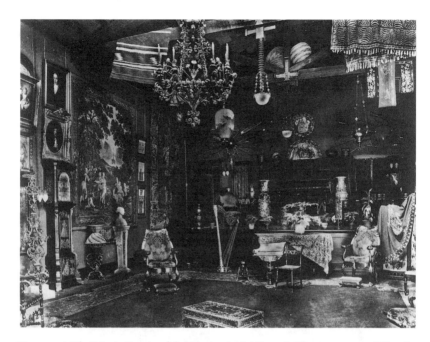

Figure 5.6. The Music Room of the Hacienda del Pozo de Verona, estate of Phoebe A. Hearst in Pleasanton, California, ca. 1910. Note the Southwestern blanket (left) and the Pomo baskets (right) in the rafters, among the other pieces of ethnic art. California Historical Society, North Baker Library, San Francisco, FN–29185.

arrived the year after her death in 1919. Like many of the other personal collections in the museum, they came with virtually no documentation.[50]

Although Mrs. Hearst may have held pride of place as a private donor of Southwestern objects to the museum, she was not alone; her funds allowed the purchase of several other important assemblages from the region. In July 1901, Philip M. Jones purchased for his patron the entire Indian collection of John P. Stanley of Santa Rosa, California. Little is known about Stanley (1833–?) other than that he was the local undertaker and had arrived in Santa Rosa by the 1880s. His collection of about 480 items consisted largely of miscellaneous stone implements (many from around Santa Rosa), pipes, games, shell beads, and other Indian artifacts, but it also included 178 baskets. Like most basket collectors in California, Stanley focused on productions from the state—only 10 come from the Southwest—and since many of the local baskets have makers' names, it is likely that he obtained them directly from the weavers. Several of the Southwestern baskets, such as the Pima and Papago (Tohono O'odham) examples, are novel

forms that had been made for sale. There is no apparent logic to the Stanley collection; like many local antiquarians, he seems to have picked up whatever strange objects passed his way.

The following month, Jones purchased for Mrs. Hearst another, better-documented, collection—124 pieces assembled by Hugh Lenox Scott, who was then captain of the Seventh Cavalry.[51] One of the few soldiers with a fluency in Plains Sign Language, Scott (1853–1934) had a great respect for Indian cultures. Although he believed in modernization for the Indians, he felt that aspects of their traditional cultures should be preserved. Scott had gathered these objects between 1876 and 1898, while serving on the Plains. Richest in Kiowa artifacts, the collection contains only 14 items from Southwestern peoples. Most of these are Apache, reflecting perhaps Scott's supervision of Apache prisoners at Fort Sill, Oklahoma. The collection is quite miscellaneous (including clothing, cooking and household objects, ceremonial calendars, baskets), but its shields, clubs, bows, and arrows reflect Scott's interests as a soldier.

A small but important collection was gathered on the Hopi mesas by Kate T. Cory (1861–1958).[52] After years of obscurity, Kate Cory has recently become known for her sensitive photographs of the Hopi. While an art student in New York in 1904, she was encouraged to visit the Southwest by painter Louis Akin, who had just returned from a year on the Hopi reservation. From 1905 to 1912, Cory lived in the villages of Oraibi and Walpi. Following her Hopi sojourn, she settled in Prescott, Arizona, giving up photography for painting. In 1907, while on a visit to Berkeley, Cory sold thirty-five Hopi objects to the Museum of Anthropology. This relatively small but diverse collection is notable for its focus on objects made and used by women, offering a complementary perspective to collections gathered by men. For instance, Cory was the only Hearst collector to get the plain baskets used by Hopi women in their daily lives (other, male, collectors had acquired the decorated ceremonial plaques).

Without doubt, the most important of these several personal collections devoted to the Southwest was the Edward L. McLeod collection of baskets.[53] Consisting of 230 pieces, the collection comes predominantly from California, but Alaska, British Columbia, Arizona, and New Mexico are also represented. Bakersfield merchant E. L. McLeod began to assemble the baskets in 1892 for the world's fair to be held in Chicago the following year. McLeod continued to add to it, at least through 1905, from diverse sources—directly from Native makers, as well as from previous collectors (the source of the Southwestern pieces). The collection was well known in basket circles, having been featured in Otis T. Mason's *Aboriginal Ameri-*

*can Basketry* of 1904.[54] Upon McLeod's death in 1908, the baskets were inherited by his sister, Jessie Taylor, who was courted by the university for many years. The entire collection was again exhibited at the Panama-Pacific International Exposition, held in San Francisco in 1915, and subsequently purchased by Phoebe Hearst for the university. When it arrived at the museum the following year, Alfred Kroeber hailed it as "one of the most carefully chosen and precious ever formed in California."[55]

The tension between personal and institutional order arose when the museum planned to display the McLeod collection. Mrs. Taylor wanted to exhibit the baskets together as a memorial to her brother, while Kroeber explained that the museum needed to disperse them throughout its various halls, dedicated to cultures of specific regions. They finally compromised by placing one McLeod case in each gallery. In this exchange, Phoebe Hearst proved to be quite supportive of Kroeber's scientific prerogative over the personal feelings of a fellow collector: "I did not know that this [a separate memorial case] would conflict with the rules of the museum, and would not, on any account interfere with the principles according to which it is arranged; but if you can, as you suggest, 'devise a plan which will, at the same time fit into the scheme of the museum and satisfy Mrs. Taylor,' I shall be very glad, and shall be grateful to you for taking the trouble to do it." In a subsequent letter she added: "I am sure she will be quite willing to abide by your advice and suggestions as it is impossible for her, or any one on the outside, to know the details and difficulties of arranging all those things to the best possible advantages."[56]

The issues raised by the McLeod collection were not unusual in turn-of-the-century museums, especially in those devoted to art. Many donors to the Metropolitan Museum of Art, for example, wanted to have their own galleries and to specify the conditions under which the art was to be maintained and displayed. In that case, J. P. Morgan, president from 1904 to 1913, opposed his fellow donors, advocating the ruling principle of art historical chronology.[57] On a higher level, this conflict between donor associations and disciplinary order applied to all of Phoebe Hearst's anthropological collecting and patronage.

## THE LEGACY OF PHOEBE HEARST

When the Museum of Anthropology at the University of California opened to the public in San Francisco in 1911, it consisted almost entirely of collec-

Figure 5.7. Inaugural brochure, University of California Museum of Anthropology, 1911. Phoebe Apperson Hearst Museum of Anthropology and the Regents of the University of California.

tions donated by Phoebe Hearst (fig. 5.7). The Southwestern Indian Hall opened two years later, in its own gallery. It comprised three major parts: the Cliff Dweller collection, the Pueblos, and the Navajo and Apache. Although we lack pictures of the hall, newspaper accounts suggest that it resembled most other Southwestern displays of the time. The Pueblo section, for example, contained "a fine array of pottery. . . . A double section

of shelves is devoted to brilliantly decorated images of the gods and god-desses of the Hopi Indians of Arizona. The Indians themselves are repre-sented by busts and numerous paintings. Six large models give a concrete idea of the ancient and modern towns and cliff dwellings, as well as their surroundings."[58]

As we have seen, essentially because of the priority placed on the South-west by the older, East Coast anthropology museums, Indian artifacts from the region played a prominent role in the founding and early history of the University of California Museum of Anthropology. The components and nature of the Hearst Southwest collections thus throw into vivid relief the small, interlocked world of anthropological scholarship at the turn of the century and the critical role played by private—particularly female—patrons as the discipline became professionalized and institutionalized.

A central issue in this essay is the formation of a museum as an institution and, secondarily, the alternate modes of acquiring anthropological collec-tions (primarily the transformation of private to public collections but also exchanges and systematic field expeditions). The story we have traced calls for an analysis of the role of various sorts of elites—of class, gender, and profession—in turn-of-the-century America. The role of class in the pa-tronage of museums of the time is well known. Most of them, even the su-perficially municipal ones, were funded and run by the wealthy.[59] The role of wealthy patrons may be generally less evident for anthropology, but in the California case, at least, it was critical.

Women, of course, were not the ruling elite of Phoebe Hearst's day, al-though wealthy women like her possessed power that compensated for their gender. Philanthropy, education, and the arts—the primary concerns of Mrs. Hearst—were commonly associated with women's roles. Of the three successive phases of female cultural philanthropy in the nineteenth century identified by historian Kathleen McCarthy—separatists, assimila-tionists, and individualists—Mrs. Hearst was more of an assimilationist, like other suddenly wealthy widows of the 1890s who were born before the Civil War.[60] She was quite influenced by a circle of close female professional friends, especially Zelia Nuttall but also Alice Fletcher. In the nineteenth century, women such as Mrs. Hearst practiced a different kind of patronage than their husbands or brothers did. Maneuvering in arenas that male con-noisseurs shunned, they found themselves more free to collect neglected kinds of objects, such as Native, folk, decorative, or modern art, all rela-tively more available and thus cheaper.[61] Phoebe Hearst certainly did champion the marginal other, but she also supported classical European

civilization. Although she was a tireless promoter of women's causes at the university, her museum was ultimately run by men, not women, and by professionals, not patrons like herself.[62] In these assimilationist modes, she was different from such twentieth-century Southwesterners as Mary Cabot Wheelwright or Maie Bartlett Heard, who founded and ran their own museums.

Although not herself of the professorial elite, Phoebe Hearst was a tireless supporter and personal friend of academic anthropologists. At the University of California, her museum patronage was almost exactly coincident with the presidency of Benjamin Ide Wheeler (1899–1919) and her tenure as a regent (1897–1919). Her patronage could have come in the form of a stand-alone urban museum (as Nuttall had proposed), but Hearst chose to work within the context of a graduate university, and a state one at that.

Berkeley as a university and anthropology as a discipline were both somewhat marginal to the national scene when Hearst began her patronage. As historian Henry May has noted, "For many [at Berkeley], the model of culture was Harvard, to which some California departments had a colonial relation in this period."[63] Anthropology at California looked to two mother universities, Harvard with Putnam (for the museum) and Columbia with Boas (for the academic department), for these were the two mentors who guided Alfred Kroeber.[64] So, while California anthropology may have been marginal at conception, it certainly tried to make up for that by its associations during infancy. Undoubtedly, this very marginality was part of Mrs. Hearst's motivation for supporting both the university and anthropology, for in each she could have a substantial impact.[65]

The founding of the museum flowed from the coincidence and coordination of several overlapping generations of mentors. First Frederic Putnam and then his protégé Franz Boas developed plans for the national coordination of anthropology.[66] Alfred Kroeber and the place of California came relatively early, at least in the development of Boas's scheme. Kroeber, in 1901, was the first Columbia doctoral student of Boas, who had begun teaching there only five years before. Four years after his arrival, Kroeber was instrumental in getting the American Anthropological Association, founded in 1902, to hold its first West Coast meeting in San Francisco.[67]

Several scholars have compared the governance of museums of the time to the major enterprise of most of their directors—the corporation—using a kind of cultural, rather than financial, capital: "Like business corporations, urban repositories replaced the informality of market mechanisms with a more coordinated approach, gathering cultural capital from all cor-

ners of the community, sifting it, systematizing it, categorizing it, and making it available to the public in new ways."[68] Like the businesses, these "nonprofit corporations" were usually run by men. Although the directorate of anthropological institutions at the time may not have come from the privileged classes, they clearly acted as an elite. The limited number of players in this story resembles the interlocked directorates of capitalist corporations. Frederic Putnam was one of the more successful of the anthropological entrepreneurs of the nineteenth century. He was followed by Franz Boas, who was especially concerned, as the discipline professionalized, that knowledge be restricted to a group of scholars who had been "properly" trained and certified.

This model of disciplinary professionalization was a major goal for President Wheeler, who, like Mrs. Hearst, was a supporter of the university as a research institution at the national level. Yet research was only one of three competing ideologies that Henry May has discerned in the Wheeler era: the democratic and utilitarian, genteel or polite traditional culture, and specialized research.[69] The anthropology museum was caught somewhat between the second and third of these. While it was primarily dedicated to the production of scientific knowledge, the inclusion of art objects and its exposure to the general public after 1911 also aligned it with traditional notions of humanistic culture.

The museum's mixture of motives reflects an ambivalence on the part of Phoebe Hearst herself. Timothy Thoresen, the author of the best account of the founding of the Hearst Museum, writes of the uneasy juxtaposition of Mrs. Hearst's interests as "patron of the arts and traditional archaeology" in relation to Wheeler's concerns "as educator and administrator" and Putnam's "as an anthropological archaeologist."[70] He stresses the discontinuities in the early history of the department; at Berkeley, the university ultimately took over the museum/department's funding and its control shifted to Kroeber and university-trained anthropologists. While this view is essentially correct, a consideration of Hearst's personal interests suggests that Thoresen has overstated the case. Certainly Phoebe Hearst's greatest attraction was to classical archaeology, but she did have a genuine interest in Native American cultures, as seen in her early support for Frank Cushing, the purchase of the Mesa Verde collection, and her patronage of Indian painters such as Sharp and Borg.

Beyond the question of a ruling elite, there is the question of the kind of knowledge being produced and its relation to objects. Phoebe Hearst was distinctive for the high value she placed on the production of professional

knowledge. Critical to an understanding of Mrs. Hearst's museum patronage is her support for the systematic collections of Uhle, Reisner, and Kroeber. A scholarly elite defined what should be collected, even if the objects obtained were not superficially beautiful. Even more important was the documentation that accompanied each specimen. Unlike these other collections, from Egypt, Peru, and California, only some of the Southwest collections were acquired systematically; others came by exchanges (even if originally systematic, though mostly not), and others by transformation from personal collections. Yet precisely because the Southwestern collections were relatively marginal to California's anthropology museum, they clarify both the range of possible definitions of objects and knowledge and of Mrs. Hearst's support of them. All the collections reviewed in this essay came to represent "the Southwest" in the museum gallery, and this was the norm for ethnographic science. What was erased, however, were the alternate and even oppositional modes of acquisition.[71]

Finally, in explaining Phoebe Hearst's Southwest collections and the founding of an anthropology museum, there are personal and cultural issues to consider. Because of her generation, she was not an active adherent of the antimodernist impulse chronicled by historian T. J. Jackson Lears, but we can see glimpses of it in her interest in the Baha'i faith and her support of Borg.[72] Phoebe Hearst, although a member of the wealthy elite, was somewhat disaffected from that culture, especially as embodied in the grosser male versions of it exemplified by her husband and son.

Phoebe Hearst's actions had many parallels in the late nineteenth and early twentieth centuries. The founding of museums from the collections of wealthy private donors, such as Henry Clay Frick or Charles L. Freer, was and still is widespread. In Berkeley, though in a different discipline, she was matched by Annie Montague Alexander, heiress to a Hawaiian sugar fortune.[73] A serious student of biology, Alexander founded two museums at the university, those for vertebrate zoology and paleontology. Although she worked on a smaller scale, Mary Hemenway contributed to Harvard's Southwest collection, and in the region itself, the personal collections of Mary Cabot Wheelwright and Millicent Rogers led to the creation of museums.[74] A closer institutional parallel was Rudolf Haffenreffer, whose private collection/museum became the anthropology museum at Brown University.[75]

But as historian Joseph Levenson has observed, it is the failure of analogy that is more historically revealing.[76] Across San Francisco Bay, Jane Stanford's striking similarities to Phoebe Hearst hid many fundamental differ-

ences. In the 1890s, both women were wealthy widows of senators from California, both were the principal patrons of a university in the Bay area, and both were founders of museums. Both Mrs. Hearst and Mrs. Stanford acquired large holdings of art on trips to Europe with their young sons, both of whom were only children to whom they were devoted. Jane Stanford, however, chose to found and fund a private university, whereas Mrs. Hearst contributed her philanthropy to the state. Mrs. Stanford was also notorious for meddling in the affairs of the university, and although the museum she founded was the largest private museum of its day, with many collections, it was less a major research institution and more a monument to her own taste. Jane Stanford, who served as de facto director, installed two rooms as a kind of private shrine to her deceased son, containing his collections as he had arranged them. And in almost every case, Mrs. Stanford acquired already-existing collections.[77]

Anthropological collections are never the direct reflections of Native cultures that they appear to be, but are creatively formed by the intellectual and social interests of their curators, directors, and patrons. The anthropology museum and department at the University of California, Berkeley, have long since lost the stamp of their founder, but their existence and much of their scope is directly attributable to the personal connections of Phoebe Hearst.

## Acknowledgments

Much of the initial research for this essay was conducted between October 1991 and February 1992, in preparation for an exhibition of the same name at the Phoebe Hearst Museum (March 10 through August 16, 1992). For research assistance, I would like to thank Cameron Cartiere, Virginia Knechtel, José Rivera, and Alexis Rowarth, and for help with the research that went into the original exhibit and this subsequent publication, I am grateful to Robert Black, Nancy J. Blomberg, Grace Buzaljko, Mildred Hamilton, Richard Handler, Curtis Hinsley, Roberta Jewett, Kent Lightfoot, Lea McChesney, Peter Palmquist, Ross Parmenter, Alex Patterson, Charles Peterson, Steven Shackley, Mary Stoddard, and Marie Watkins.

## Notes

1. On ethnographic collecting in the Southwest, generally, see Nancy J. Parezo, "The Formation of Ethnographic Collections: The Smithsonian Institution in the American Southwest," in *Advances in Archaeological Method and Theory,* ed. Michael Schiffer (Orlando: Academic Press, 1987), 10:1–47; Curtis M. Hinsley Jr., "Collecting Cultures and Cultures of Collecting: The Lure of the American Southwest, 1880–1915," *Museum Anthropology* 16, no. 1 (1992): 12–20; Edwin L. Wade, "The Ethnic Art Market in the American Southwest, 1880–1980," in *Objects and Others: Essays on Museums and*

*Material Culture,* ed. George W. Stocking Jr., vol. 3 of *History of Anthropology* (Madison: University of Wisconsin Press, 1985), 167–91; Leah Dilworth, *Imagining Indians in the Southwest: Persistent Visions of a Primitive Past* (Washington, D.C.: Smithsonian Institution Press, 1996). For two general histories of nineteenth-century American anthropology, see Curtis M. Hinsley Jr., *Savages and Scientists: The Smithsonian Institution and the Development of American Anthropology, 1846–1910* (Washington, D.C.: Smithsonian Institution Press, 1981), and Joan Mark, *Four Anthropologists: An American Science in Its Early Years* (New York: Science History Publications, 1980).

2. The best current biography of Phoebe Hearst is Judith Robinson, *The Hearsts: An American Dynasty* (Newark: University of Delaware Press, 1991). See also a good review by Richard H. Peterson, "Philanthropic Phoebe: The Educational Charity of Phoebe Apperson Hearst," *California History* 64, no. 4 (1985): 284–89, 313–15.

3. On a trip to Europe in 1889, Mrs. Hearst "visited several archaeological museums, which fascinated her." Robinson, *The Hearsts,* 220.

4. Phoebe Hearst to Orrin Peck, November 5, 1903, quoted in Richard Peterson, "The Philanthropist and the Artist: The Letters of Phoebe A. Hearst to Orrin M. Peck," *California History* 66, no. 4 (1987): 280.

5. Phoebe Hearst to Janet Peck, February 7, 1905, quoted in Peterson, "The Philanthropist and the Artist," 280; see also Robinson, *The Hearsts,* 307.

6. Phoebe Hearst to Orrin Peck, February 9, 1905, quoted in Peterson, "The Philanthropist and the Artist." This was the excavation of George Reisner. She met Reisner in 1898, on her first trip to Egypt.

7. William Randolph Hearst Jr., with Jack Casserly, *The Hearsts: Father and Son* (Niwot, Colo.: Roberts Rinehart Publishers, 1991), 119.

8. There is no adequate history of the department and museum of anthropology at the University of California at Berkeley. Useful sources are Alfred L. Kroeber and Frederic W. Putnam, *The Department of Anthropology of the University of California* (Berkeley: University of California Press, 1905); Albert B. Elsasser, *Treasures of the Lowie Museum* (Berkeley: Lowie Museum of Anthropology, University of California, 1968); Timothy H. H. Thoresen, "Paying the Piper and Calling the Tune: The Beginnings of Academic Anthropology in California," *Journal of the History of the Behavioral Sciences* 11, no. 3 (1975): 257–75; Ira Jacknis, "Museum Anthropology in California, 1889–1939," *Museum Anthropology* 17, no. 2 (1993): 3–6. The most comprehensive study of the first years of the department and museum—focusing on the Californian collections—was completed by Frederick Alexander Long, after the writing of this essay: "'The Kingdom Must Come Soon': The Role of A. L. Kroeber and the Hearst Survey in Shaping California Anthropology, 1901–1920" (master's thesis, Department of History, Simon Fraser University, Burnaby, British Columbia, 1998).

9. Joan Mark reports that at least for a while Mrs. Hearst "wondered why she had allowed the California department to become so concentrated on North America," instead of the archaeological work in Peru and Egypt. Mark, *A Stranger in Her Native Land: Alice Fletcher and the American Indians* (Lin-

coln: University of Nebraska Press, 1988), 287. Thoresen notes similar senti-
ments in "Paying the Piper," 265. Hearst did, however, let a village of Native
Californians, of the Ohlone group, live on her estate at Pleasanton. Robinson,
*The Hearsts*, 263. See also E. Breck Parkman, "Dancing on the Brink of the
World: Deprivation and the Ghost Dance Religion," in *California Indian
Shamanism*, ed. Lowell John Bean (Menlo Park, Calif.: Ballena Press, 1992),
182–83.

10. Alfred Kroeber, "Historical Introduction," *Phoebe Apperson Hearst Memo-
rial Volume*, University of California Publications in American Archaeology
and Ethnology, vol. 20 (Berkeley: University of California Press, 1923), xiii.

11. Although the academic department founded by Phoebe Hearst was located on
the Berkeley campus of the University of California, from 1903 until 1931 the
anthropology museum occupied a building on Parnassus Heights in San Fran-
cisco. Opened to the public in 1911, the museum was essentially restricted to
researchers during its Berkeley years until moving into its present home in
Kroeber Hall in 1959.

12. For the University of Pennsylvania, see Regna D. Darnell, "The Emergence of
Academic Anthropology at the University of Pennsylvania," *Journal of the
History of the Behavioral Sciences* 6 (1970): 80–92; Dilys Pegler Winegrad,
*Through Time, Across Continents: A Hundred Years of Archaeology and An-
thropology at the University Museum* (Philadelphia: University Museum,
University of Pennsylvania, 1993); Bruce Kuklick, *Puritans in Babylon: The
Ancient Near East and American Intellectual Life, 1880–1930* (Princeton:
Princeton University Press, 1996), 27–31, 59–63, 78–81, 101–3.

13. The Centennial Exposition display was prepared by photographer William
Henry Jackson and archaeologist/artist William H. Holmes. The Mesa Verde
collection has a tangled history, with many collections taken from many sites
over an extended period. It was assembled from three sources by Charles D.
Hazzard of Minneapolis, representing the H. Jay Smith Exploring Company,
a commercial enterprise. Hazzard combined a collection gathered by rancher
Richard Wetherill and his three brothers between 1889 and 1892 with one
brought together by C. M. Viets, a local pothunter, and exhibited both at the
World's Columbian Exposition, held at Chicago in 1893. After the fair, Haz-
zard bought a third collection from the region and stored them all in Chicago
as he tried to find a buyer. See Rebecca Allen, "The History of the University
Museum's Southwestern Pottery Collection," in J. J. Brody, *Beauty from the
Earth: Pueblo Indian Pottery from the University Museum of Archaeology
and Anthropology* (Philadelphia: University Museum of Archaeology and
Anthropology, University of Pennsylvania, 1990), 61–87; Duane A. Smith,
*Mesa Verde National Park: Shadows of the Centuries* (Lawrence: University
Press of Kansas, 1988).

14. When she suffered a heart attack in 1895, Phoebe Hearst sought relief from
Dr. Pepper, who was also treating Cushing at the time. Robinson, *The
Hearsts*, 255.

15. Frank Hamilton Cushing, "Exploration of Ancient Key-Dweller Remains on
the Gulf Coast of Florida," *Proceedings of the American Philosophical Soci-*

*ety* 35 (1896): 329–448; Marion Spjut Gilliland, *The Material Culture of Key Marco, Florida* (Gainesville: University of Florida Press, 1975), 3–6, 23, 181; Cushing to William Pepper, April 27, May 10, and May 18, 1896; Phoebe Hearst to Stewart Culin, July 24, 1900, Archives, University of Pennsylvania Museum.

16. Ross Parmenter, "Glimpses of a Friendship: Zelia Nuttall and Franz Boas," in *Pioneers of American Anthropology*, ed. June Helm (Seattle: University of Washington Press, 1966), 88–147; "Zelia Nuttall and the Recovery of Mexico's Past" (manuscript in possession of Parmenter, [1993]).

17. Ralph W. Dexter, "The Role of F. W. Putnam in Developing Anthropology at the American Museum of Natural History," *Curator* 19 (1976): 303–10; Mark, *Four Anthropologists*, 14–61.

18. Robert H. Lister and Florence C. Lister, *Chaco Canyon: Archaeology and Archaeologists* (Albuquerque: University of New Mexico Press, 1981), 20–62. For other examples of the Cronau paintings, see Pepper's report, *Pueblo Bonito*, Anthropological Papers of the American Museum of Natural History, vol. 27 (New York: American Museum of Natural History, 1920).

19. Pepper to Putnam, September 15 and 27, 1902, Frederic W. Putnam Papers, Harvard University Archives (hereafter cited as FPP); Mark, *Stranger in Her Native Land*, 281–89, 291; on Zelia Nuttall and Hearst, see 296–98. Sometimes these social occasions became quite elaborate, as Phoebe Hearst used her wealth to indulge exotic fantasies. Her biographer has described the gala she threw for Reisner: "The Hacienda was transformed into a scene evoking Arabian nights. The courtyard was covered with a deep blue canopy and hung with hundreds of small lights to resemble an Egyptian sky; servants were dressed in tasseled red fezzes and gold-embroidered blue pantaloons with lavender sashes; the fountain tinkled among masses of lotus blossoms, and a hidden orchestra played arias from 'Aida.' The male guests also donned fezzes and were given duplicates of a ring with a cartouch bearing the name of a Pharaoh, the original of which Phoebe owned"; Robinson, *The Hearsts*, 307; account based on "Historic Splendor of Ancient Egypt," *San Francisco Examiner*, September 19, 1902. After dinner, Reisner gave a lecture on Egyptian archaeology, illustrated with lantern slides; Mark, *Stranger in Her Native Land*, 287. The role of exotic fantasy in Hearst's life can also be seen in the architectural allusions in two of her country estates: a Spanish/Mexican villa at Pleasanton and a Germanic hunting lodge/Rhine River castle on the McCloud River, near Mount Shasta; Robinson, *The Hearsts*, 258–59, 337.

20. Both Putnam and Kroeber welcomed the busts as the beginning of the museum's physical anthropology collection; Putnam to Kroeber, May 23, 1903; Kroeber to Putnam, June 1, 1903, FPP. Interestingly, while the names of the models were recorded in the museum catalogs, this information was omitted from contemporary labels under the assumption that individuals could represent entire groups. The busts were also sexually differentiated; males were given square mounts, while females were placed on circular bases.

21. Curtis M. Hinsley Jr., "Zunis and Brahmins: Cultural Ambivalence in the Gilded Age," in *Romantic Motives: Essays on Anthropological Sensibility*, ed.

George W. Stocking Jr., vol. 6 of *History of Anthropology* (Madison: University of Wisconsin Press, 1989), 169–207; Hinsley and David R. Wilcox, eds., *The Southwest in the American Imagination: The Writings of Sylvester Baxter, 1881–1889* (Tucson: University of Arizona Press, 1996).

22. Edwin L. Wade and Lea S. McChesney, *America's Great Lost Expedition: The Thomas Keam Collection of Hopi Pottery from the Second Hemenway Expedition, 1890–1894* (Phoenix: Heard Museum, 1980); Alex Patterson, *Hopi Pottery Symbols* (Boulder: Johnson Books, 1994).

23. For a good review of the interplay between the goal of completeness and the reality of ethnographic collecting, see Diana Fane, "The Language of Things: Stewart Culin as Collector," in Diana Fane, Ira Jacknis, and Lise M. Breen, *Objects of Myth and Memory: American Indian Art at the Brooklyn Museum* (Brooklyn/Seattle: Brooklyn Museum/University of Washington Press, 1991), 13–27; see also Parezo, "The Formation of Ethnographic Collections."

24. George H. Pepper to Harlan I. Smith, September 12, 1903, Department of Anthropology, American Museum of Natural History. At times Pepper is vague in his documentation; while we know he visited every pueblo, he may have purchased some of these pieces from local traders. And some of these pots are likely to have been made by other groups, as there was an extensive intra-pueblo trade in ceramics.

25. The rich documentation of the Pepper collection is demonstrated by several pieces that he attributed to Nampeyo. Because of her fame, many works have been associated with her name, often on meager evidence. It is unlikely that Pepper would have obtained the raw materials from any sources other than the artist herself. Although Nampeyo's use of prehistoric models has been widely discussed, the identification of her actual examples is especially rare. Included are a jar (2–8253), samples of clay (2–8630), an old potsherd she used to grind and mix with clay for pottery (2–8635), and an old potsherd she used as a design model for pottery (2–8636). Pepper had collected twenty-two pots from Nampeyo in 1901. Cf. Barbara Kramer, *Nampeyo and Her Pottery* (Albuquerque: University of New Mexico Press, 1996), 82, 148, 211.

26. Charles S. Peterson, "Sketch of Joseph Peterson's Life for Lowie Museum, UC Berkeley" (manuscript, 1992, Access. 224, Hearst Museum of Anthropology, hereafter cited as HMA); Albert J. Levine, *From Indian Trails to Jet Trails: Snowflake's Centennial History* (Snowflake, Ariz.: Snowflake Historical Society, 1977), 3–4, 72–88 (passim).

27. Alfred L. Kroeber to Frederic W. Putnam, March 14, 1905; see also September 7, 1904, FPP.

28. The only part of Peterson's research that has been published is a map of ruins in the Silver Creek area of Arizona, drawn by Nels Nelson in 1912 and based on Peterson's original. See Leslie Spier, *Notes on Some Little Colorado Ruins*, Anthropological Papers of the American Museum of Natural History, vol. 18, no. 4 (New York: American Museum of Natural History, 1918), 333–62.

29. Robert F. Heizer and Albert B. Elsasser, "Editors' Preface," in Philip Mills Jones, *Archaeological Investigations on Santa Rosa Island in 1901*, vol. 17,

no. 2 of *Anthropological Records* (Berkeley: University of California Press, 1956), 201.

30. Philip M. Jones, in "Last Quarterly Report, Sept. 30, 1902," 8; Correspondence, 1901–10, Re: Univ. of California, Dept. of Anthropology, FPP. See also "Desperate Situation of the Navajo and Moqui Indians," *San Francisco Examiner Magazine,* [c. October 1902]. In 1902, Jones was not the only one with a camera at the Hopi Snake Dance in Oraibi. The newspaper reported that he was accompanied by San Francisco photographer Frederick Monsen, and his pictures show that he must have been standing next to Adam Clark Vroman. Compare the Jones photo reproduced here with Vroman's in William Webb and Robert A. Weinstein, *Dwellers at the Source: Southwestern Indian Photographs of A. C. Vroman, 1895–1904* (New York: Grossman, 1973), 85–102.

31. Phoebe Hearst donated an important collection of classic Southwestern photographs by Timothy H. O'Sullivan, John K. Hillers, William Henry Jackson, and Edward S. Curtis. The O'Sullivan images, produced on the Wheeler Surveys of 1871, 1873, and 1874, were printed by the photographer himself in several limited-edition sets of fifty plates. While some albums were sold to the public, sets were also distributed to members of Congress; this one may have come to Phoebe Hearst through her husband, George, who was a senator from California (1886–91).

32. Katherine Spencer Halpern and Susan Brown McGreevy, eds., *Washington Matthews: Studies of Navajo Culture, 1880–1894* (Albuquerque: University of New Mexico Press, 1997), xiii, 10, 145–50.

33. Washington Matthews, *Navaho Myths, Prayers and Songs, with Texts and Translations,* ed. Pliny Goddard, University of California Publications in American Archaeology and Ethnology, vol. 5, no. 2 (Berkeley: University of California, 1907): 21–63. This series was initiated in 1903 with funds supplied by Phoebe Hearst. Goddard, who was primarily a linguist, gathered only two Southwestern objects for the museum.

34. Richard Keeling, *A Guide to Early Field Recordings (1900–1949) at the Lowie Museum of Anthropology* (Berkeley: University of California Press, 1991). The first recordings of Southwestern song were made in 1909 when Papago Juan Dolores visited San Francisco.

35. Quoted in Jessie A. Selkinghaus, "The Art of Carl Oscar Borg," *American Magazine of Art* 18 (March 1927): 147. Cited in Katherine Plake Hough, Michael R. Grauer, and Helen Laird, *Carl Oscar Borg: A Niche in Time* (Palm Springs: Palm Springs Desert Museum, 1990), 14.

36. Forrest Fenn, *The Beat of the Drum and the Whoop of the Dance: A Study of the Life and Work of Joseph Henry Sharp* (Santa Fe: Forrest Fenn Publishing, 1983). The most detailed investigation of the Hearst-Sharp relationship is contained in a doctoral dissertation in preparation by Marie Watkins, "Painting the American Indian: Joseph Henry Sharp and the Poetics and Politics of American Anthropology" (Department of Art History, Florida State University, Tallahassee), esp. ch. 3: "Phoebe Apperson Hearst: A Turn-of-the-Century Network of Art, Anthropology, Feminism, and Philanthropy." Her

extensive consultation of extant sources casts doubt on many of Fenn's un-
documented assertions. My account has been revised on the basis of her re-
search. For a useful review of Hearst's patronage of another artist, see Richard
Peterson, "The Philanthropist and the Artist."

37. There is some uncertainty over Mrs. Hearst's attendance at the Buffalo fair.
Fenn, *The Beat of the Drum*, 158, reports that she did see Sharp's paintings
there, but he does not give a reference for this statement. According to letters
consulted by Nuttall biographer Ross Parmenter, only Nuttall and Fletcher
went, before going west to visit Mrs. Hearst (personal communication).

38. Joseph H. Sharp to Alfred L. Kroeber, October 8, 1906, Museum History
folder, HMA; J. H. Sharp to Phoebe Hearst, October 22, 1907, Phoebe A.
Hearst Papers (hereafter cited as PAHP) Bancroft Library, University of Cali-
fornia, Berkeley. Watkins doubts Fenn's discussion of damage to Sharp's
paintings in the fire ("Painting the American Indian," ch. 3).

39. Helen Laird, *Carl Oscar Borg and the Magic Region* (Layton, Utah: Gibbs M.
Smith, 1986); Hough, Grauer, and Laird, *Carl Oscar Borg*, 43–85.

40. Phoebe Hearst was close to the entire Lummis family. In addition to her sup-
port for several causes of Charles Lummis's (e.g., the Sequoya League and the
Landmarks Club), Mrs. Hearst often invited Eve Lummis and her children for
extended stays at the Hacienda, and between 1910 and 1915 Mrs. Hearst
paid the educational expenses of Charles's daughter Turbesé (at the National
Cathedral School in Washington, founded by Mrs. Hearst). See Turbesé Lum-
mis Fiske and Keith Lummis, *Charles F. Lummis: The Man and His West*
(Norman: University of Oklahoma Press), 90, 101, 115 n, 132, 136; Lummis
to Hearst, September 13, 1909; T. Lummis to Hearst, 1910–15, PAHP.

41. Carl Oscar Borg to "Little Mother" [Phoebe Hearst], May 26, 1918; PAHP.

42. Robinson, *The Hearsts*, 321.

43. Borg's poem, "On the Desert Horizon," reads: "Far in your haze haunted dis-
tance / I am walking alone / Holy, sequestered, apart. / And the soul of the
world comes to bide with me there. / The beauty of opal and amethyst dis-
tance / Are but the garments it wears. / In those moments I hear the music / Of
the all, uncontradicted, sublime / Moments divine / When the soul of the
world / Speaks to my own." Laird, *Carl Oscar Borg*, 80.

44. The exact attribution of this quotation is obscure. It appears to be from
Phoebe Hearst to Carl O. Borg, but it is cited as "Lannie Haynes Martin quot-
ing Borg in *L.A. Examiner, February 29, 1920" in Laird, Carl Oscar Borg*,
75. It is credited to Hearst, though in a transposed form, in Laird's essay in
Hough, Grauer, and Laird, *Carl Oscar Borg*, 40.

45. The literature on the Arts and Crafts movement and Native American art is
large; see, for example, Molly Lee, "Appropriating the Primitive: Turn-of-the-
Century Collection and Display of Native Alaskan Art," *Arctic Anthropology*
28 (1991): 6–15; Melanie Herzog, "Aesthetics and Meanings: The Arts and
Crafts Movement and the Revival of American Indian Basketry," in *The Sub-
stance of Style: Perspectives on the American Arts and Crafts Movement*, ed.
Bert Denker (Winterthur, Del.: Henry Francis du Pont Winterthur Museum,
1996), 69–92; Marvin Cohodas, *Basket Weavers for the California Curio*

*Trade: Elizabeth and Louise Hickox* (Tucson/Los Angeles: University of Arizona Press/Southwest Museum, 1997), including references to Phoebe Hearst's basket collecting, 314 n. 2, 315 n. 3. Joseph Sharp furnished his Montana cabin in the style, which included his substantial collection of Native American artifacts. Sarah E. Boehme, *Absarokee Hut: The Joseph Henry Sharp Cabin* (Cody, Wyo.: Buffalo Bill Historical Center, 1992), 23–32. Although Phoebe Hearst generally avoided Arts and Crafts decoration, she furnished some of the rooms in her northern estate with tables and chairs in that style. The estate, called Wyntoon, was on the McCloud River, near Mount Shasta. Bernard Maybeck, the architect, designed the furniture to add to the mood of a medieval Germanic castle. See Kenneth H. Cardwell, *Bernard Maybeck: Artisan, Architect, Artist* (Santa Barbara and Salt Lake City: Peregrine Smith, 1977), 52–55.

46. Robinson, *The Hearsts*, 226. See also J. Nilsen Laurvik, ed., *Catalogue, Mrs. Phoebe A. Hearst Loan Collection* (San Francisco: San Francisco Art Association, 1917).

47. Robinson, *The Hearsts*, 227, 226.

48. For discussion and illustrations of Hearst's Pleasanton estate, see Sara Holmes Boutelle, *Julia Morgan: Architect* (New York: Abbeville, 1988), 169–74. Unlike Pleasanton, however, no Native American art is visible in extant photographs of Wyntoon.

49. Byron Harvey III, "The Fred Harvey Collection, 1899–1963," *Plateau* 36, no. 1 (1963): 33–63; Marta Weigle and Barbara A. Babcock, eds., *The Great Southwest of the Fred Harvey Company and the Santa Fe Railway* (Phoenix: Heard Museum; distributed by University of Arizona Press, 1996).

50. Some of the better documented of Phoebe Hearst's personal Southwestern pieces are the three Navajo blankets bought for her by her son in 1905. With great effort, William Randolph Hearst persuaded the Harvey Company Indian Department to sell part of their advertising display. Although these specific textiles have not been identified, they are undoubtedly among the Navajo blankets that came to the museum in the Hearst bequest. Stopping in Albuquerque a few weeks earlier, Phoebe Hearst had also "selected some of our finest blankets," according to Harvey agent Herman Schweizer. Schweizer to William Randolph Hearst, December 15, 1905, Fred Harvey Company Papers, Heard Museum Archives, Phoenix. This letter was kindly shared with me by Nancy J. Blomberg. See Blomberg, "William Randolph Hearst: Collector Extraordinaire," in Weigle and Babcock, *The Great Southwest*, 143. See also Blomberg, *Navajo Textiles: The William Randolph Hearst Collection* (Tucson: University of Arizona Press, 1988). Both mother and son derived almost all their personal Southwest collections from the Harvey company.

51. Hugh Lenox Scott, *Some Memories of a Soldier* (New York: Century, 1928).

52. Barton Wright, Marnie Gaede, and Marc Gaede, *The Hopi Photographs, Kate Cory: 1905–1912* (Albuquerque: University of New Mexico Press, 1988).

53. Richard C. Bailey, *Collector's Choice: The McLeod Basket Collection* (Bakersfield: Kern County Historical Society, 1951), 25, 31.

54. Otis Tufton Mason, *Aboriginal American Basketry: Studies in a Textile Art without Machinery,* Annual Report of the Smithsonian Institution for 1902 (Washington, D.C.: Smithsonian Institution, 1904).

55. Alfred Kroeber to Benjamin Ide Wheeler, October 3, 1916, Access. 511, HMA.

56. Phoebe Hearst to Alfred Kroeber, September 25 and October 3, 1916, Access. 511, HMA.

57. For an excellent analysis of the relation of personal interests of patrons versus institutional order, see Carol Duncan, *Civilizing Rituals: Inside Public Art Museums* (New York: Routledge, 1995), 48–101.

58. The other permanent galleries were devoted to the museum's large founding collections—Egypt, Greece, Peru, and California—each in its own room, in addition to disparate smaller collections. See "New Exhibition Hall Is Installed," *Oakland Enquirer,* November 15, 1913, Museum Scrapbook, July–December 1913, HMA.

59. Duncan, *Civilizing Rituals.*

60. Kathleen D. McCarthy, *Women's Culture: American Philanthropy and Art, 1830–1930* (Chicago: University of Chicago Press, 1991), 140–41.

61. Ibid., 179.

62. Geraldine Jonçich Clifford, *"Equally in View": The University of California, Its Women, and the Schools,* Chapters in the History of the University of California, no. 4 (Berkeley: Center for Studies in Higher Education/Institute of Governmental Studies, University of California, 1995), 21, 52–53.

63. Henry F. May, *Three Faces of Berkeley: Competing Ideologies in the Wheeler Era, 1899–1919,* Chapters in the History of the University of California, no. 1 (Berkeley: Center for Studies in Higher Education/Institute of Governmental Studies, University of California, 1993), 10. See Duncan, *Civilizing Rituals.*

64. Ira Jacknis, "Alfred Kroeber as Museum Anthropologist," *Museum Anthropology* 17, no. 2 (1993): 27; Ralph W. Dexter, "Frederic Ward Putnam and the Development of Museums of Natural History and Anthropology in the United States," *Curator* 9 (1966): 150–55; Curtis M. Hinsley Jr., "The Museum Origins of Harvard Anthropology, 1866–1915," in *Science at Harvard University: Historical Perspectives,* ed. Clark A. Elliott and Margaret W. Rossiter (Bethlehem: Lehigh University Press, 1992), 121–45.

65. In explaining her motivation for removing collections from Pennsylvania to California, Mrs. Hearst wrote: "In looking at the true object in view in centralizing collections, which, as I take it, is the dissemination of knowledge among the many, *not* the pride of possession by the few, I think it must be obvious to your Board that most real good can be done by placing in this distant West some portion of the collections referred to as a nucleus of what may one day become a great educator." See Hearst to Stewart Culin, July 24, 1900, Archives, University of Pennsylvania Museum.

66. Mark, *Four Anthropologists,* 32–55.

67. See Regna Darnell, "The Professionalization of American Anthropology: A

Case Study in the Sociology of Knowledge," *Social Science Information* 10, no. 2 (1972): 83–103.

68. McCarthy, *Women's Culture*, 113.

69. May, *Three Faces of Berkeley*, 7.

70. Thoresen, *Paying the Piper*, 273, 266. This is paralleled by the common mixture of motives among art patrons of the nineteenth century noted by art historian Carol Duncan: "The motives of the American bankers and business tycoons who founded public art museums were both complex and contradictory, a mix of personal and public ambitions, elitist and democratic sentiments." *Civilizing Rituals*, 54.

71. See Hinsley, "Collecting Cultures," 15. The successive ownership of collections, with their subsequent redefinition, can best be seen here in the Mesa Verde and McLeod collections. A stimulating theoretical perspective on this process is provided by Igor Kopytoff in "The Cultural Biography of Things: Commoditization as Process," in *The Social Life of Things: Commodities in Cultural Perspective*, ed. Arjun Appadurai (Cambridge: Cambridge University Press, 1986), 64–91.

72. T. J. Jackson Lears, *No Place of Grace: Antimodernism and the Transformation of American Culture, 1880–1920* (New York: Pantheon, 1981).

73. Hilda W. Grinnell, *Annie Montague Alexander* (Berkeley: Grinnell Naturalists Society, 1958); Marcia Myers Bonta, "Annie Montague Alexander," in *Women in the Field: America's Pioneering Women Naturalists* (College Station, Tex.: Texas A&M University Press, 1991), 49–60.

74. Susan Brown McGreevy, "Daughters of Affluence: Wealth, Collecting, and Southwestern Institutions," in *Hidden Scholars: Women Anthropologists and the Native American Southwest*, ed. Nancy J. Parezo (Albuquerque: University of New Mexico Press, 1993), 76–106.

75. Shepard Krech III, ed., *Passionate Hobby: Rudolf Frederick Haffenreffer and the King Philip Museum* (Bristol: Haffenreffer Museum of Anthropology, Brown University, 1994).

76. Joseph R. Levenson, *Confucian China and Its Modern Fate*, vol. 3, *The Problem of Historical Significance* (Berkeley: University of California Press, 1965), 110–25.

77. Carol M. Osborne et al., *Museum Builders in the West: The Stanfords as Collectors and Patrons of Art, 1870–1906* (Stanford: Stanford University Museum of Art, 1986), 52, 79.

BARBARA A. HAIL

# 6
# MUSEUMS AS INSPIRATION

## Clara Endicott Sears and the Fruitlands Museums

### THE VISION

Between 1914 and 1945, Clara Endicott Sears, historic preservationist, author, arts patron, and museum founder, created a cluster of museums on her historic property in Harvard, Massachusetts, which, although distinct in type of collection, were united in theme—they each celebrated alternative cultural approaches to those of the postindustrial Western world.

The museums were the Fruitlands Farmhouse (1914), site of Bronson Alcott and Charles Lane's brief 1840s utopian experiment in communal living; the Shaker House, actual home of the Harvard Shaker community from the late eighteenth century until 1920, when Sears saved it from being torn down by moving it the several miles to her property; the American Indian Museum (1929), housed in a schoolhouse dating to 1845, also moved to her property; and the Picture Gallery, the only nonhistoric structure, built between 1940 and 1945 to house her collection of Romantic nineteenth-century landscape art and early American primitives. To Sears, each group represented in her museums—transcendentalists, Shakers, American Indians, and artists—held a worldview that encouraged human personal development, celebrating the spiritual rather than the material world. Bronson Alcott had described his Fruitlands days as a time when he "entered spiritually into a fairer Eden," and Sears followed his lead, writing,

"Humanity must ever reach out towards a New Eden."[1] With her museums, Sears tried to create "new Edens" through which she might share her vision of the world with others. She memorialized certain groups to whom spirituality was important in the nineteenth century, envisioning Fruitlands as a place for education and reflection upon differing aspects of spirituality.

## THE TIMES

Both Michael Kammen and T. J. Jackson Lears have identified some of the major intellectual currents that led to the creation of an American aesthetic during the first third of the twentieth century. One of these was a nostalgia for the past, called in its varying forms antimodernism, nostalgic modernism, and colonial revivalism.[2] Sears, with others of her disposition, yearned for a return to the pastoral serenity, simplicity, intensity of feeling, and authenticity of experience that she identified with preindustrial societies. She was a strong believer in the beneficent powers of nature, and in her museum setting she provided scenic overlooks, walking trails, benches, and an outdoor luncheon area so that her museums might truly be conducive to contemplation—as she said, "a place where thinkers can come."[3]

Her self-designed home was on the same property with the museums and overlooked the Nashua River Valley. She called it "The Pergolas," meaning "the arbor," after the sculptural Byzantine colonnade she had brought back in 1906 from a medieval monastery in Venice to grace the gardens. In the distance stood Mount Wachusett, where in 1676 King Philip of the Wampanoags had summoned Algonquian leaders to form a confederation against the encroaching English. Below the house was a covered cloisters, with marble busts of—among others—Dante, Michelangelo, Socrates, Pericles, and the Americans—Alcott, Emerson, Hawthorne, and Thoreau. Here she retired to read, study, and write. She wrote prolifically—fourteen books accompanied and put in context her museum collections.[4] Sears had the colonial revivalist's fascination with medieval times and art—when the "spirit" dominated man's thinking. Both her home and the objects to which she gave precedence in arranging the exhibits in the Indian Museum provide evidence for this. Others of her time who shared her interest in the medieval were John D. Rockefeller, who subsidized the building of the Cloisters, a museum in the likeness of a medieval monastery in upper Manhattan, and Sears's cousin Isabella Stewart Gardner, who created a me-

dieval courtyard of flowers within Fenway Court, her Boston home, built in the style of a fifteenth-century Venetian palazzo, and eventually a museum of European and Oriental antiquities.

One of the forces important to the success of Fruitlands and other rural museums was the transportation revolution of the 1920s. As motorcars became available, people were able to visit destination points on weekends, leading to the creation of wayside museums as both educational and entertainment stops for families. Sears's initial name for her museum was Fruitlands and the Wayside Museums, Inc.[5] Her museum building was in tune with other broad national trends, including a widespread interest in regionalism and ethnicity. With a rising immigrant pool creating a so-called melting pot of ethnic groups, early-twentieth-century Americans looked for both unifying threads to define themselves and justification for maintaining pride in their roots. Sears had a strong sense of the importance of geographic place. She wished to create a time capsule of her region, showcasing the earliest indigenous inhabitants through archaeological specimens excavated on the property and in nearby field expeditions.[6] Her exhibits featured a lithic collection gathered by Henry David Thoreau in Concord and around Walden Pond. She portrayed the Wampanoag people of the seventeenth century through life-size dioramas interpreting events of King Philip's War, in 1675–76, some of which occurred in the Nashua valley.[7] In her other museums on the property she progressed in time through the eighteenth and nineteenth centuries of valley life by interpreting the local transcendentalist and Shaker communities, and the itinerant portrait painters who had wandered the New England hills, painting the faces and capturing the essence of the forthright farmers who had lived there.

The 1920s and 1930s were times when the wealthy and the educated set their stamp on American history through the creation of museums celebrating Americana, particularly "living museums."[8] Among these were Henry Ford, who founded Greenfield Village in Michigan; John D. and Abby Aldrich Rockefeller, who re-created Colonial Williamsburg in the 1930s and 1940s and restored Washington Irving's home, Sunnyside, in the lower Hudson valley; the Wells family of Southbridge, Massachusetts, who created Old Sturbridge Village in 1936 as a working eighteenth-century New England town; and later, Electra Havemeyer Webb, who built Shelburne Museum on the shores of Lake Champlain, Vermont. Sears, whose relatives included two governors of the Massachusetts Bay Colony, as well as the philanthropic museum founder George Peabody, was one of these patrician leaders. Although her museums' interpretive staff did not dress in

period costume representing the time period of the exhibits, as is the case in true living museums, the historic structures themselves, their many original furnishings, and their pastoral setting evoked the past in an intensely personal manner. Her intent was to bring back the spirit of the earlier people who had lived in the Nashua valley of Massachusetts.

## THE FOUNDER

Clara Endicott Sears was an appropriate person to champion the primacy of New England history (fig. 6.1). She was born in 1863, the daughter of Mary Crowninshield Peabody and Knyvet Winthrop Sears. She grew up on Beacon Hill, and was independently wealthy, since both the Sears and the Peabody great-grandfathers had made fortunes in the China trade. Indeed, she was a true "Boston Brahmin," one of that special group who traced their ancestry to the earliest European settlement of New England and who had continuously held positions of intellectual, financial, and social leadership in the region. Clara Sears's maternal grandmother, Clarissa Endicott Peabody, was a descendant of John Endicott, governor of Massachusetts Bay Colony, who arrived in New England in 1628 aboard the ship *Abigail*. Sears's paternal great-grandmother was Ann Winthrop (Sears), a descendant of John Winthrop, who arrived in the New World in 1630 aboard the ship *Arbella* and succeeded Endicott as governor of Massachusetts Bay.

The first Peabody ancestor, Lieutenant Francis Peabody (1612–98), had arrived in America in 1635 on the ship *Planter*. His numerous descendants were undistinguished New England farmers and shopkeepers until Joseph Peabody (1757–1844), Sears's maternal great-grandfather, who became the leading merchant of his day in the maritime city of Salem, Massachusetts. Joseph's son Francis, an inventor, visited London in 1865 and, as president of the Essex Institute of Salem, called on his fourth cousin George Peabody (1795–1869), for support of the institute. George was a South Danvers farm boy who had moved to London and become an international banker and philanthropist. The result was the establishment of the Peabody Academy of Science (later Peabody Museum of Salem, now Peabody and Essex Institute), with Francis as its first president.[9] In 1866 George Peabody also founded both the Peabody Museum of Natural History and Natural Science at Yale University and the Peabody Museum of Archaeology and Ethnology at Harvard University. And a bequest from George Peabody to his nephew, Robert Singleton Peabody, a lawyer and amateur

Figure 6.1. Clara Endicott Sears at home in the Pergolas around 1917. Fruitlands Museums, Harvard, Massachusetts.

archaeologist, enabled the latter to found the Robert S. Peabody Museum of Archaeology at Phillips Academy, Andover, in 1901. R. S. Peabody appointed William K. Moorehead as the first curator (later director), and it was thus quite natural that Clara Endicott Sears should later seek out Moorehead as her primary advisor on local archaeological collections.

As a young girl, Clara Sears was a celebrated debutante, but resisted the

idea of marriage. She enjoyed spending her time in the serious study of art, literature, music, and—her own particular flair—photography. She was educated privately, spending many of her formative years abroad with her mother, father, and sister, eagerly absorbing the pleasures of the art galleries, theaters, operatic presentations, and literary salons that flourished in the European capitals of the late nineteenth century. Her closest friend and first cousin, Mary Crowninshield Endicott, married Joseph Chamberlain, a British statesman and a member of Parliament, and Clara was a frequent visitor in their home, providing her access to the upper levels of British social and political life.[10]

At her home in Boston, Sears, like other influential Victorian women, pursued interests in art, philanthropy, and civic betterment as part of the new expectations of women for public service. After her father's unexpected death in 1891, she became the primary companion of her mother, who lived for another thirty-eight years. This arrangement suited Sears, freeing her from the obligation to marry, which might have curtailed her independence. Her one serious romantic attachment had been to a married man, a neighbor in Groton, where she and her mother kept a summer home. They first met on shipboard while traveling to Europe, and their affair was then considered scandalous. In a time when divorce was generally unacceptable, Sears conformed to society's rules and overcame her infatuation, seeking inner strength through an increasing devotion to spiritual literature, and eventually publishing a small volume of sustaining personal philosophy titled *The Power Within*. During her thirties and forties she was active in charities and in fulfilling the duties of her social position in Boston. Throughout her early life she kept searching for a purposeful avenue through which she might voice her strongly held personal values for America's future. At age fifty, with the purchase of the estate on Prospect Hill, on a site of historic significance thirty miles west of Boston, she inadvertently began the real work of her life as author, preservationist, and museum builder. She did not buy the land because she knew of its historic significance; rather, she acquired it because she longed for the pastoral life and had decided to run a dairy farm. But she discovered that Bronson Alcott's Fruitlands farmhouse occupied a far corner of her property, and through it she became interested in historic preservation and the eventual creation of her first museum.

Her mother fully supported her Fruitlands pursuits, and the entire family was proud of her literary and preservation accomplishments. Sears was an independent thinker, in some ways even a feminist, acutely conscious of her

descent from a number of similarly strong-minded, intellectual women. On her mother's side, she was related to the Peabody sisters of Salem and Concord, Massachusetts—Elizabeth, Mary, and Sophia—who with their circle of friends, helped define the American transcendentalist movement of the 1840s.[11] Elizabeth Peabody assisted Bronson Alcott at his Temple School in Boston; founded the first kindergarten in the United States; was proprietress of the bookstore at Number 13 West Street, home of famed "conversations" among transcendentalists such as Margaret Fuller; and served as an editor of the transcendentalist journal, the *Dial*. She and her sister Mary were both educators who directed schools attuned to the latest in educational theory. Mary married Horace Mann, educational reformer, founder of the modern public school system, and first president of Antioch College. Sophia was a professional painter and had studied under Thomas Doughty, founder of the Hudson River School of landscape painting, whose members were well represented in Sears's Picture Gallery. She was also the wife of Nathaniel Hawthorne, noted author and good friend of Herman Melville. The Peabody women's friends included Henry David Thoreau, Ralph Waldo Emerson, Bronson Alcott, Margaret Fuller, and William Ellery Channing, nephew and namesake of the great Unitarian minister.[12]

Clara Sears, like her famous female relatives, enjoyed the company of interesting men provided they treated her as an equal, and she esteemed the friendship of women of talent. Among the latter was Elaine Goodale Eastman, teacher, writer, and wife of the Sioux chronicler Dr. Charles Eastman. Mrs. Eastman frankly critiqued Sears's book on King Philip's War, *The Great Powwow,* commenting: "The sympathetic tone unites with historical accuracy to make it very readable. . . . Reading your chapter on religious beliefs of the Indians, I thought you would be interested in Doctor Eastman's book on that theme, 'The Soul of the Indian.' . . . [His] account is a poetic and highly idealized interpretation which probably few have been able to reach, and which he himself admits no longer holds good."[13]

A mutual admiration existed between Sears and the artist Kathryn Leighton, whose Sioux Indian portraits of Chief Luther Standing Bear and Chief Little Bison hang in the Indian Museum. Leighton once wrote Sears: "My visit to your beautiful home and museum was one of the highlights of 1931. The history of Chief Standing Bear is very completely recorded in the book he has written of his life, 'My People, the Sioux.' Your encouragement means so much. . . . I appreciate your interest and thank you for the purchase of two of my best canvasses. If I can assist you in any way in the collection for your museum of old time Indian specimens I would deem it a

privilege."[14] In another letter Leighton wrote: "[I am] very happy that you liked the book by Chief Standing Bear. He was posing for me the day your letter arrived. He says he has written to you and insisted upon sending you a medicine whistle, made from the bone of an eagle's wing."[15]

Novelist Emilie Loring was also a valued friend who often visited the Pergolas and attended the gala openings of the Indian Museum. She was a fellow member of the Boston Authors' Club, one of Sears's favorite groups. Sears's writing was highly important to her, and she saved her afternoons and evenings strictly for it, using the sacredness of this writing time as an excuse to refuse social obligations: luncheon with friends, but not dinner, was always her rule. She often inserted literary references into her feelings about the purpose of her museum: "This place is not meant for recreation. It is meant for inspiration. The surrounding view lends itself to it. The history of Fruitlands and the Shaker house and the Indian Museum with its historic lore and the whole breadth of the Nashua Valley are both conducive to it. It must always remain more or less like a poem."[16]

Sears believed, as did many others of her privileged social status, in the importance of public education in a democracy as a means of instilling patriotism and defining what it means to be an American. Still, her Beacon Street family and friends were a bit surprised at her willingness to open a museum on her private estate to strangers. A letter from a friend reads: "I think you are doing a very fine thing to collect all these treasures and allow the public to share them with you."[17] Sears's open-mindedness, as well as her ecumenicism in religion, had been absorbed both through her transcendentalist heritage and through her grandfather David Sears's activism. He founded his own nonsectarian church in Brookline when the strictures of his former Boston Episcopalian place of worship became too narrow for his beliefs, and Sears and her parents were a part of his ecumenical congregation. Sears emulated both his desire for Christian unity and his pursuit of utopian causes, and she always remained receptive to different lifestyles and alternative ways of looking at the world. She was intellectually in tune with those of far different social status than her own and was a ready correspondent to anyone capable of exchanging ideas in areas of her interests— spirituality, American Indian worldview, transcendentalism, Shakerism, the preservation of the New England landscape, and the importance of primitive portrait painters.

Yet her divided perceptions led her to maintain elitist connections in her private life. Although she opened her museum doors to everyone, only the select of society were entertained in her home. At her Indian Museum open-

ings, for example, the Native American participants ate separately, at the museum, while the invited guests had their luncheon at the Pergolas, trooping down the hill afterward for the ceremonies. She was careful to tell correspondents who wrote her concerning collections that she was very busy most of the time and could not promise a meeting, although if she happened to be at the museum when they came, she would be glad to see them. Throughout her life she kept affiliation in a number of membership-restrictive social organizations, including the Massachusetts Society of Colonial Dames of America, the Society of Mayflower Descendants, the Historic Genealogical Society, the Women's City Club of Boston, and the Chilton Club. At the same time she took pride in her many professional affiliations—the Academy of Social Science of New England and New York, the Boston Authors' Club, the New England Poetry Club, the National Pen Women's Association, the National Institute of Social Sciences, the Society for the Preservation of New England Antiquities, and the National Society of New England Women, from whom she received a medal of honor.[18]

## THE INDIAN MUSEUM: COLLECTING CULTURES

Unlike some of the collectors and museum founders in this volume, Sears was not passionate about collecting for its own sake. Rather, her interest was in museum building for the purpose of historic preservation and public education. Through these avenues she hoped to tell the story of cultural adaptations in which spiritual approaches to life were dominant. First she acquired historic buildings, then filled them with appropriate collections. When the exhibits were completed to her satisfaction, so that her story was told, she had no trouble in bringing her collecting to an end.

While the Shaker Museum and the Fruitlands Farmhouse emphasized the regional history of central Massachusetts, the Indian Museum holdings reflected the material culture of the major Indian groups across North America. The later Picture Gallery showcased the importance of nature through landscape paintings and embraced both New England and artists of the Hudson River School. It also celebrated the simple joys of preindustrial society through portraits of early-nineteenth-century New England country people executed by itinerant artists. Sears's belief that the natural man will succeed where the trained one may not led her to favor these untrained artists and mirrored her own self-taught education in the arts. Her decision to move beyond the regional history of southern New England for

the Indian collections was a break with her earlier regional emphasis. But it was in line with her desire to express the essential spirituality of all Native people and emphasize the primary importance of the spirit in the whole of human society.

## USE OF AUTHORITIES

Sears had taken on a major task in seeking to become familiar with American Indian objects of all regions. She attempted to educate herself in Native American material culture in less than two years, amassing almost one thousand objects between 1927, when she first discovered Indian artifacts turned up by a plow on the grounds of the Pergolas, and 1929, when she opened her Indian museum. By 1934, she had effectively completed her Indian collection at close to two thousand objects. She apparently felt that her two previous successes in creating the Fruitlands Farmhouse Museum and the Shaker Museum had taught her the proper techniques for building a collection. Her first move was to immerse herself in the literature, and she quickly built up an impressive library of more than two thousand volumes, which she opened to others who were serious researchers. The library included a complete set of *Bureau of American Ethnology Annual Reports* and *Bulletins;* the *American Anthropologist* series; the works of George Catlin, Henry Schoolcraft, and Maximilian of Wied-Neuwied; anthropological studies by Robert H. Lowie, George Bird Grinnell, Clark Wissler, Alfred L. Kroeber, and Franz Boas, among others; and a large selection of books on wood lore and Indian craft by authors such as Ernest Thompson Seton.

Second, she sought consultants who could serve as authorities.[19] She turned first to the Peabody Museum at Harvard, enlisting the advice of old friends among the faculty on the authenticity of specific objects before she purchased them. She assured others that her museum was "filled with fine Indian relics which have all been sanctioned by Prof. Willoughby of the Peabody Museum, Harvard University."[20] For archaeology, she relied heavily on Warren K. Moorehead, curator of Phillips Academy, Andover's Peabody Museum, whose expeditions in the Merrimack and Nashua River Valleys she helped to fund.[21] She used the involvement of academics to impress others with her seriousness of purpose, calling her museum opening in 1929 a "test day, for then the prominent museum men, like Prof. Willoughby and Prof. Guernsey of the Peabody Museum of Harvard Col-

lege, Prof. Moorehead of Phillips Academy Andover, the director of the Worcester Museum, the curator of the Isabella Stewart Gardner Museum, and the Trustees of the Society for the Preservation of New England Antiquities, are to come and pass judgment on it."[22] Perhaps her confidence in obtaining authoritative expertise was understandable, given the past Peabody family involvement in these major institutions, and the present influence of her first cousin William Crowninshield Endicott, who, at various times, served as president of the Society for the Preservation of New England Antiquities, the Gardner Museum, the Essex Institute, and the Massachusetts Historical Society, as well as vice president of the Peabody Museum, Salem, and treasurer of the Museum of Fine Arts, Boston.

Sears also sought authority and authenticity for her Indian objects by supplementing them with original written documents, understanding the importance of the written word to Western eyes. For example, on the walls she hung a copy of a "deed transferring land from the Indians of the province of New York to King George the II in 1729"; an "Article of Agreement dated 1686, between the English and certain Native people executed by James the Printer"; an "Indenture between Samuel Sewall and the Indian Occoochick for an Indian boy, Jacob Comfort"; and documents signed by the Reverend John Cotton in 1699, by John Winthrop regarding an ill Indian, and by George Washington in 1779 concerning a scouting expedition on the Mohawk River. Other written materials displayed included an Indian New Testament belonging to the Choctaw from 1848 and a Choctaw hymnbook from 1844. With these documents she set a level of expectation on the part of her audience for similar authenticity in her representation of Native-made objects.

Early on, Sears decided to look westward to the Plains, the Southwest, and the Northwest Coast, rather than locally, for recent historical objects that could represent her ideas of living Native people. Although her interest in an Indian museum was initially sparked when arrowheads were plowed up at the foot of her Pergolas home, she "did not want to make it wholly a museum of lifeless stones that appeal only to the archaeologists. I wanted to bring into this building the spirit of the Indians, to give some idea of their industries and of their love of the beautiful in Art and Nature."[23] Like many in New England, she found present-day local Native people largely invisible. Her interest in them as exhibit material was confined to the past: "The modern things do not make any appeal to me,—nor do I think they make much to the general public. In a Museum, visitors expect to find things of the Past,—they are not looking for things of the Present Day."[24]

Despite this sentiment, she was well aware of current local Native events and maintained a series of well-kept scrapbooks of tribal celebrations, elections, and other signal events at the Wampanoag town of Mashpee, Massachusetts, and among the Nipmuck. At the recommendation of Dr. Frank Speck, chairman of the Department of Anthropology at the University of Pennsylvania, Sears generously contributed to the support of Gladys Tantaquidgeon, a Mohegan scholar, in her doctoral research at Harvard on Wampanoag language and culture. Tantaquidgeon kept Sears informed of her research progress and in 1932 sent her a gift of a rare miniature rye-straw basket made by Emma Mitchell Safford, a descendant of Massasoit.[25] In 1938, Sears invited Gladys's brother, Harold Tantaquidgeon, to represent the New England tribes in the pageantry accompanying the unveiling of her second major outdoor exhibit, the sculpture *Wo-Peen, The Dreamer.* Still, Sears did not incorporate local contemporary Native manufactures nor interpretations of their twentieth-century culture into her collecting, apparently feeling that her public would be interested only in the earlier Indian culture celebrated in her seventeenth-century narrative, *The Great Powwow,* a culture that disappeared in the general mind with the defeat of King Philip in 1676. She was encouraged in this manner of thinking by her mentor for the Northeastern tribes, archaeologist Warren K. Moorehead. Moorehead had confided to another major patron, Rudolf Haffenreffer, that, in his mind, southeastern New England Native people were too mixed with Portuguese or African Americans to warrant serious consideration as Indians.[26]

In 1940, Speck offered Sears a choice of specimens of twentieth-century New England handicrafts, but she was not interested.[27] Again, in 1945, Speck tactfully suggested the inclusion of evidence of present-day southern New England Native people in her exhibits, writing:

There are a number of excellent Indian facial types still and until lately living in Cape Cod and Martha's Vineyard and a collection of photos with life-data from various sources could make a real picture of Indian features of old Massachusetts and New England. This, however, with a reference library of some reading sources on the Indians whose culture is shown in your collections, would be a point that I would not mention unless you expressed a desire to have me make something more than a mere comment of praise of the Indian exhibits you have assembled for the benefit of students and visitors to Harvard.[28]

Sears finally responded to Speck, accepting his offer to help build a reference library on Northeastern Indians and purchasing a contemporary Iro-

quois (Mohawk) hawk feather headdress that he had commissioned at Six Nations Reserve, Canada, made by Sadegonhes, at a cost of five dollars. Sears was "so happy to be able to put the right kind of a headdress on my Iroquois bust, and to get it from such a source."[29]

## THE DECISION TO LOOK WESTWARD

On the whole, however, in her collecting for the Indian Museum Sears moved away from her regional mission to explain the history of the Nashua valley and sought a wider, national scope. She apparently felt that she could not adequately express the beauty, spirituality, and vitality of Indian culture without involving that best known of all regions to non-Natives, the Plains. When she discovered a consultant who could furnish her with both information and collections, she responded enthusiastically and began to fill her museum with Plains objects. More than half of the ethnographic objects in the museum are from the northern and central Plains region. They represent almost all of the important aspects of late-nineteenth- and early-twentieth-century material culture from that region: porcupine quill and bead embroidery on hide, hide paintings, featherwork, carved wood and stone, and examples of the decorative use of a multitude of natural materials. Included in the collection are military society regalia, dress clothing, an excellent group of dolls made for actual use by Native children, weapons, tools, and religious paraphernalia. Next in importance are the materials from the Northwest Coast, with potlatch equipment consisting of three large wood carvings collected in British Columbia, a Chilkat blanket, and carved wooden spoons, halibut hooks, rattle-top twined baskets, carved argillite, and canoe models. The historic Southwestern pottery collection is very fine, as is the Navajo silverwork, and the Hopi and Apache basketry. The Northeast is represented by a rare Ojibwa ceremonial painted hide, early Mi'kmaq birchbark and porcupine quill containers, Huron moose-hair embroidery, a carved wooden belt cup, a northern octopus bag, and a seventeenth-century ball-headed club reputed to be that of the Wampanoag leader King Philip. From the Bering Strait region of the Arctic, there is a carved ivory pipe and caribou incisor belt; from California, a fine collection of baskets including Chumash, Panamint, and Pomo, and a Hupa cradle and twined caps, mostly from the collection of Grace Nicolson.

Sears's primary Plains consultant was Colonel Alfred Burton Welch (1874–1945), an adopted son of John Grass, Standing Rock Sioux. Welch

had grown up on a small farm within the Standing Rock Reservation.[30] He was an army officer who had served in four wars, postmaster of Mandan, North Dakota, the officer in charge of civil affairs for the Standing Rock Sioux, a member of the Bear Clan of the Hunkpapas, an ardent Shriner— and he himself was a collector. Sears corresponded with Welch over a period of almost ten years.[31] Because he willingly passed on his own firsthand knowledge of northern Plains life in answer to her detailed and repeated questioning in letters, she gradually came to a certain level of understanding. But, unlike her earlier immersion in the transcendentalist and Shaker movements involving New England intellectuals much like herself, her ability to gain a deep and broad understanding of Native culture secondhand was limited.

She never accepted Welch's invitations to visit the Standing Rock Reservation, just as she had not shown eagerness to get to know the living Native people of New England, apparently satisfied with the quality of her museum's interpretation of the culture of others and not seeking further Native corroboration. Yet she soon fancied herself an expert on Plains material culture, confidently disputing with curators at Harvard's Peabody Museum about their label information on a split-horn headdress, because her own horned headdress belonging to Shoot Holy had come with a different interpretation (fig. 6.2). She sought Welch's opinion in the dispute:

There are two Medicine-men's bonnets at the Peabody Museum, or at least they look to me exactly like them, and they have marked them War-bonnets. I called it to the attention of one of the Professors, and he was quite embarrassed over my showing it to him especially as I insisted that it was wrong. His reply was that the Medicine men were as much War-lords as anything else, but as to whether that was a sort of bluff, or whether he considered it a fact, I do not know. Now you will know all about that, and I would be extremely obliged if you would let me know sometime which one is right.[32]

Having found in Colonel Welch her authority, she cloaked him with a Native voice in her gallery guide, using his adopted Sioux name, Mato Watakpe, or Charging Bear (actually A Soldier of Charging Bear), when she quoted him, and generally applying Welch's explanations of Standing Rock Sioux culture to all Native people. Again referring to the medicine bonnet of Shoot Holy mentioned above, she wrote to Welch:

Indeed I realize that I have a prize in that Medicine Man's Bonnet. I think it a marvel of barbaric beauty, besides containing the essence of Indian symbolism. What

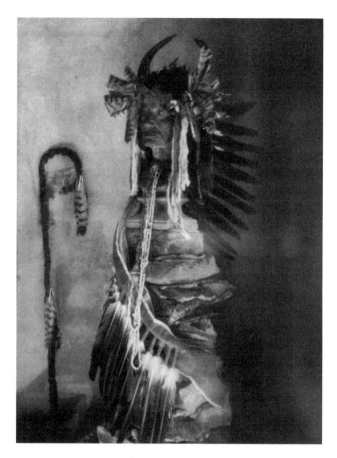

Figure 6.2. "A marvel of barbaric beauty," said Sears of this split-horn medicine bonnet belonging to Standing Rock Sioux medicine man Shoot Holy. Fruitlands Museums, Harvard, Massachusetts.

you tell me of the awe which it inspires, makes me reflect upon that inherent necessity of human nature toward worship,—which to me is so convincing in regard to the soul in all things and in all peoples. All that you tell me about these things you send, that explain them, and reveal their symbolism, I want to have my guides repeat to the visitors. It will give them a view of the whole subject,—little of which is known or understood here.[33]

## EXHIBITINC CULTURES

### Pageantry

Sears was clear about the primacy of her educational mission. She had a good understanding of the power of symbolic displays to influence and educate. She prepared her visitors for the museum experience while they were still outside in the open air. On either side of the Indian Museum she had erected two heroic bronze statues, which visually blended into the distant hills to uplift the mind and spirit of the viewer. One, titled *Pumunangwet,* was modeled on the hero of a Native legend she had heard from a missionary, exemplifying the virtues of aspiration: "At the vernal equinox, a young brave would be sent onto a bit of high ground to shoot upward at the stars."[34] The other, titled *The Dreamer,* represented the virtues of contem-

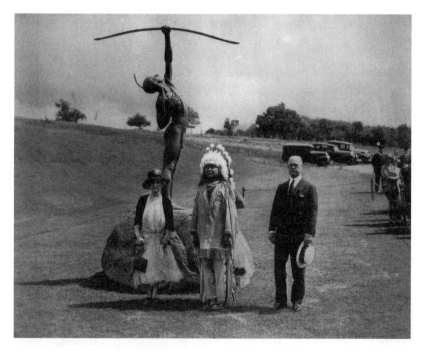

Figure 6.3. The unveiling of *Pumunangwet* in 1931. Clara Endicott Sears, David Buffalo Bear, a Lakota student at nearby Springfield College, and the sculptor, Philip Sears. In the background are invited guests who were treated to an outdoor pageant of dance, song, and poetry, orchestrated by Miss Sears. Fruitlands Museums, Harvard, Massachusetts.

plation, and was a life model of Wo-Peen, a San Ildefonso artist whose acquaintance she had made when he came to the Museum of Fine Arts in Boston to exhibit his paintings and later addressed the American Indian Association.[35] Both statues were the work of her cousin Philip Sears.[36]

The unveiling of the statues, as well as the openings of her museums, were accompanied by elaborate pageantry (figs. 6.3, 6.4, 6.5). On a typical occasion, a selected audience of Sears's friends would meet at the Copley Plaza Hotel in Boston, where they would be picked up by bus for the thirty-mile trip to Fruitlands. Others might arrive by chauffeur-driven auto, and all would enjoy luncheon at the Pergolas before walking down to the museum to attend the carefully orchestrated pageant. Both the Boy Scouts and the Girl Scouts would be in attendance. Various Native representatives—such as David Buffalo Bear, a Sioux student at Springfield College; Chief Bear Heart, a Sioux craftsman living in Massachusetts; Wo-Peen, the mural painter from San Ildefonso; and the Mohegan teacher and Boy Scout leader Harold Tantaquidgeon—would perform in regalia to a script written by Sears, complete with symbolic actions, dances, and speeches. On the occa-

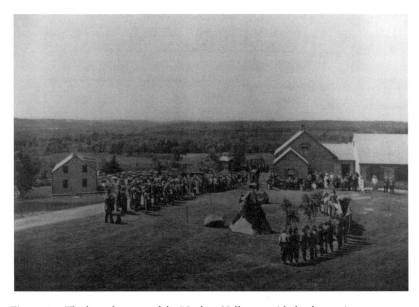

Figure 6.4. The broad sweep of the Nashua Valley provided a dramatic background for Sears's outdoor pageants in the 1930s. On the right is the Fruitlands American Indian Museum; on the left, the Fruitlands Shaker House; and in center rear, Bronson Alcott's Fruitlands Farmhouse. Fruitlands Museums, Harvard, Massachusetts.

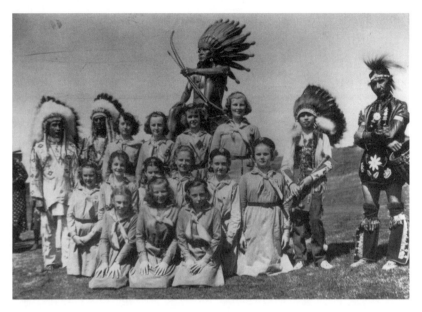

Figure 6.5. The sculpture *The Dreamer,* by Philip Sears, was modeled on a San Ildefonso artist, Wo-Peen, who attended the 1938 ceremony in Plains regalia. Harold Tantaquidgeon, Mohegan, participated in the pageant as a representative of New England Native people. He stands on the far right of the Girl Scouts. On the left are Bear Heart and Eagle Claw. Fruitlands Museums, Harvard, Massachusetts.

sion of the unveiling of the statue of Wo-Peen in 1938, Sears printed a program interpreting what was being said and done for the audience, but privately wrote to Chief Bear Heart:

You will notice that when you and Tantaquidgeon, the Mohegan come out from the corner of the Indian Museum, followed by the Trustees, that you sing an ancient chant. I felt that it would . . . appeal to the audience . . . it would give a seriousness and dignity to the occasion. You must know some such chant, but if you do not you can easily sing something in the Indian language that would produce the right effect . . . no one knows the Indian language in the audience, which gives you a great advantage.[37]

Response to these orchestrated pageants was uniformly enthusiastic, as recorded in numerous letters to Sears from those attending.[38] The enthusiasm was shared by the Native participants. David Buffalo Bear, a descendant of Red Cloud, who participated in the ceremony to unveil the statue

*Pumunangwet,* wrote her: "You are the supreme one to bestow a wonderful Indian statue as an honor and memorial to the Indian race, also for the white people in rising generations to gaze upon and remember the original natives of this wonderful country."[39]

## Symbolism

Inside the Indian Museum, Sears's strong interest in spirituality influenced the manner in which she arranged the exhibits. Symbolic Ojibwa petroglyphs are incised on the floor, placed between lines emanating from a central rock with a stone mortar on it. Her explanation:

Charging Bear told me, and I have also read it in various books, that the Great Spirit was believed by the Indians to permeate all matter, that He was omnipresent in all creation, and that among other things the rock symbolized to them His great and abiding strength. He told me that very often out west in his wanderings he would come across great rocks, and he would find at the foot what in our Christian language we would call votive offerings. . . . But . . . it was never the rock itself to which the appeal was made. The rock was merely a symbol used as an approach to the Great Spirit. So I decided to make the rock the feature of my Museum.[40] (Fig. 6.6)

Sears also described her own inventive symbolism:

I chose the finest that I could find in the pastures and placed it in the middle of the building. From the rock I had rays carved in the concrete floor and painted yellow. These were not only to symbolize the vibrations coming from the rock, but were also to symbolize the sun, which was likewise an object of worship to the Indians, perhaps the greatest of all, as it symbolized the Great Spirit, Himself. On these rays I had carved the Shamanistic symbols or totems for the Shaman, or medicine man.[41]

To achieve this imagery, Sears combined beliefs of Standing Rock Sioux people, as conveyed to her in letters from Colonel Welch, and symbols from the White Lake Chippewa, as recorded by the anthropologist William Hoffman in 1887.[42]

Above this, re-creations of older Lakota vision shields hung from the ceiling, described by Sears as "wholly Indian, barbaric, full of the whiff of waste places—elemental."[43] On the walls hung Plains dance bustles, bear- and eagle-claw necklaces, pipes and pipe bags, and a split-horn medicine bonnet belonging to the Standing Rock Sioux medicine man Shoot Holy. A life-size Sioux group of figures, whose faces were cast from life by William

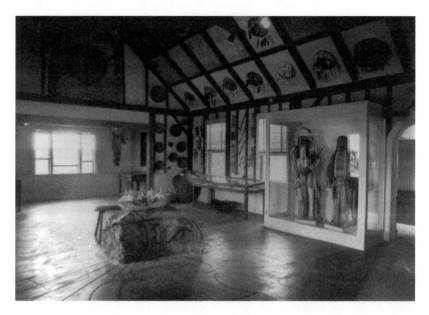

Figure 6.6. Symbols of spirituality dominate the Indian Museum as it appeared in the late 1930s, with Lakota shield replicas hanging from the ceiling and Ojibwa petroglyphs incised in the floor surrounding a great rock, upon which food offerings rest, indicating a means of approaching the Great Spirit. The mannequins were sculpted from life casts by William H. Egberts, chief preparator of the department of anthropology, Smithsonian Institution. They are of the Lakota Chief Kicking Bear and a Lakota woman, White Thunder, who was educated at Carlisle Indian School. Fruitlands Museums, Harvard, Massachusetts.

H. Egberts of the Smithsonian, stood in the front of the first gallery. A life-size diorama in the rear of this gallery showed King Philip and Anawan consulting with a shaman at Mount Wachusett in 1676 about the outcome of King Philip's War.

Ceremonial objects interested Sears most. In the second gallery, important displays included an Ojibwa ceremonial painted buffalo hide; Iroquois false face society masks (some purchased from Plume Trading and Sales, Inc., New York); and terraced prayer offering bowls and a large kachina doll from the Southwest. There was also a fine display of Northwest Coast potlatch equipment, including a feast bowl that had been collected by Madge Hardin Walters and loaned to the Southwest Museum in Los Angeles. When this museum was unable to raise the money to purchase these objects, Sears's friend Professor Frederick Webb Hodge, formerly of the Heye

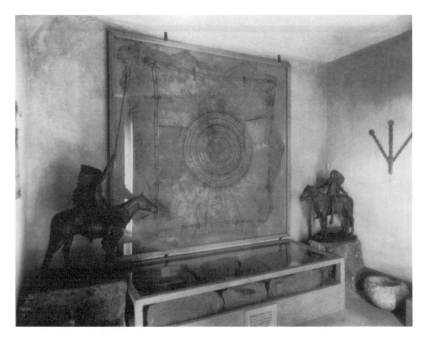

Figure 6.7. At the entry of the Indian Museum the first room is the "Shrine" or
"Crypt," with *In-nah-bah,* meaning "a spirit that is all-embracing and
omnipotent" over the doorway. The shrine featured a grave case with a skeleton
and associated burial materials from a five-hundred- to one-thousand-year-old site
in Georgia, excavated by Warren K. Moorehead. It is flanked by two Cyrus Dallin
bronzes. Over it is a painted hide in feathered circle design, purported to be of
white buffalo calf and therefore considered by Sears a suitably sacred object to put
in the shrine. Fruitlands Museums, Harvard, Massachusetts.

Foundation, Museum of the American Indian, and by 1934 director of the
Southwest Museum, recommended that Sears take the excellent opportu-
nity to acquire them.[44]

Near the front door was a room that Sears called at different times
"Shrine" or "Crypt." Here was the ball-headed club that, according to doc-
umentation accompanying it, had belonged to the Wampanoag leader
Metacom, or King Philip, and was taken as a war spoil at his death in
1676.[45] In a case on the floor was a grave containing a five-hundred- to
one-thousand-year-old skeleton excavated by Professor Moorehead in
Georgia and installed by him with associated burial objects—food bowl,
water jar, and weapons (fig. 6.7). Sears described the installation ceremony:

Prof. Moorehead said, "Now we will lay the spirit." He stood at the head of the grave and the men all bared their heads and stood solemnly around it. I, of course, was with the group, and Prof. Moorehead proceeded to recite a part of the Ghost Song in Indian. It was very dramatic, and very moving, and when it was over all the men walked around on tip toe and spoke in whispers, and they have done so ever since that day. At the foot of the grave is a small statue of Cyrus Dallin's "Messenger of Peace."[46]

The placement of a crypt exhibit at the entrance of the museum made sense to Sears as a way to authenticate the great length of time that Native people had been here and to link past times with the present. The presence of the dead was not an unusual thing for nineteenth- and early-twentieth-century people to accept. They were used to open-casket funerals and to caring for dying people at home.[47] To Sears, death simply exemplified the reality of natural forces and the triumph of the spirit over the flesh.

The crypt exhibit further reinforced the feeling of coming into a medieval chapel, with family members laid to rest about one, which a visitor experiences in the main gallery, with its incised stone floor and ceiling-hung shields recalling European heraldry. The message received here is that shields were the coats of arms of the Plains warrior, linking him to the values of knight-errantry and gallant deeds performed in the name of Christian religious mysticism. By displaying the shields in this fashion, Sears created a feeling of knighthood, and because shields were vision-inspired, she brought notice to the essential spirituality of the Indian, which was her primary message. The shields, the rock, and the petroglyphs provided a sense of awe, a realization that there existed a Native belief system as strong as but different from mainstream Western thought. They permeated the atmosphere of the museum with the mysteries of the other. As an educator, Sears knew the value of effective symbols and took full advantage of their drama to create a compelling museum experience.

### Authenticity and Representation

Today, museums of anthropology are intensely concerned with issues of authenticity and representation. Questions about the appropriateness of exhibiting the culture of others have initiated a self-examination of our motives and of the effects of our exhibition practices on the representation of others. From this standpoint, when we examine Sears's exhibits, we can see discrepancies between her avowed interest in authenticity and her actual practices. The shields, for example, were re-created between 1929 and 1933 at her request, with Colonel Welch as intermediary, by older men—

Yanktonai, Hunkpapa, and Arikara—on the Standing Rock Sioux reservation. Some of these men had the right to re-create their own or a family member's shield design and pass on its story; others did not, and they made the shield but did not pass on its story. The shields were made of horse or cow hide stretched over green saplings and were actually only covers, with no thick buffalo rawhide interiors, and they were never used in battle. Actual war shields were vision-inspired, the protective power coming as much from the vision of the owner and creator as from the rawhide. They were carried into battle, and when not in use they were placed, covered, on a tripod outside and at the rear of a warrior's tipi, to guard it from attack. These historic war shields were enclosed in hide covers when not in use, as the image was considered too powerful and possibly dangerous to others to be left exposed.[48]

Sears gave no indication in Fruitlands Indian Museum labels that the hanging shields were re-creations. She used the shields as an educational device to provide atmosphere and to teach about vision-inspiration, despite the fact that the shields had never been carried into battle. If not vision-inspired, however, the shields still represented something important: They were a means of keeping the vision stories and traditions and technical skills of twentieth-century Lakota elders alive. They were also an adaptation for survival for these older people, who were in desperate need of sources of cash income during the Depression years.

A second example of Sears's problems with authenticity and representation is in the Ojibwa petroglyphs inscribed in the cement floor. They are authentic in that they were copied from W. A. Hoffman's drawings in 1887 of Midewiwin scrolls observed in Red Lake and White Earth, Minnesota, and published in *American Anthropologist* in 1888. But Hoffman warned in his text that he was never able to get satisfactory explanations of individual figures, that the Midé priest at Red Lake, when asked, would simply repeat the entire cycle, and that the priests at White Earth would not explain anything. Despite the obvious unwillingness of the Ojibwa to share private knowledge, Hoffman unobtrusively copied the figures, and he admitted that the study was "incomplete."

In her gallery guide, called "Catalogue of the American Indian Museum" and intended for both docents and the public, Sears elaborated on the Hoffman figures, adding and subtracting bodily parts, and adding to the text in some cases, apparently to reinforce her own feminist philosophies. Hoffman showed two Red Lake images, one without a head—"represents a woman"—and one with a head, signifying "a female who is inspired, as shown by a line extending from the heart to the mouth." Sears drew the same two figures and created additional text for the figure with the head:

"This shows that whenever a woman steps out from her ordinary situation, the wisdom she gains often removes limitation, and so in this Sign she is allowed a head."[49] In another instance, Hoffman described the Red Lake image of a Midé priest with horns coming out of his head, saying that "no explanation was obtained of the power he possessed." Sears incorrectly used this image with the Hoffman text for a female empowered to cure with magic plants, drawing in her eyes, and adding to the text: "She is different from the ordinary woman, and takes a much higher place in the Tribe. She is considered worthy to be given a head in the Sign."[50]

Apparently Sears's personal teaching agenda often got in the way of her desire for authenticity. Although the Midé priests were unwilling to give information to Hoffman in 1887, Sears assumed the right to give it to the public in 1929, even incising it into a concrete floor where everyone could walk over it. Clearly Sears, like others of her time, did not perceive a difference between an outsider's selecting images to represent the essential elements in a people's worldview and a member of that culture's selecting them. Appropriation and representation were not well-recognized issues of the day.

## CONCLUSION

Certain similarities of early orientation and resulting sense of mission can be traced between Clara Endicott Sears and other twentieth-century Indian collectors and museum founders. Mary Cabot Wheelwright, Mary Hemenway, and Mary Crane were also Boston Brahmins who became interested in the spiritual aspect of Indian life. A basic interest in spirituality and meditation, stemming from the nineteenth-century transcendental philosophy with which so many of the Boston Brahmins were imbued, transferred in the twentieth century to an interest in the visionary and spiritual aspects of American Indian culture. Wheelright moved to Santa Fe and became a friend and patron of Navajo medicine man Hosteen Klah, and in 1937 built the House of Navajo Religion to house sandpaintings, their reproductions, the weavings based on them, recordings of Navajo chants, and other related objects. Her museum was later called the Museum of Navajo Ceremonial Art, and is now the Wheelwright Museum of the American Indian. Hemenway financed a major anthropological expedition to Zuni and supported Frank Cushing in his work there. They also corresponded about founding a museum together. Mary Crane and her husband, Francis, built one of the last great Indian collections in America, between 1950 and 1970. When they donated it to the Denver Museum of Natural History, it became

the foundation of that museum's ethnographic hall. In a different kind of parallel, William K. Moorehead perceived a similarity of mission in the historic site museums of Clara Endicott Sears and Rudolf Haffenreffer. He suggested to both that they visit one another's museums, since both were concerned with "the preservation of a local site with the addition of similar comparative collections from elsewhere."[51] Neither of them followed his advice. David McCord, founder of the McCord Museum, Montreal, was an antimodernist who, like Sears, responded to late-nineteenth-century industrialization, violence, and poverty by representing the aboriginal way of life as a simpler and nobler past. Also like Sears, he thoroughly understood the power of objects to inspire.

The educational mission of her Indian museum continued to be Sears's primary interest. Rather than adding to her collections after the major openings in 1929, 1931, 1932, and 1938, she was content to cease collecting when she considered that the exhibits adequately expressed her thoughts and conveyed her message about the spiritual values of alternate cultures. She had amassed nearly two thousand objects, including local archaeological lithics. The ethnographic collections were regionally distributed to reflect the major historic culture areas of North America, with the Plains area the most thoroughly represented. The impact on her audiences was favorable throughout her lifetime. She was frequently on hand to greet visitors and to preside over informative, if regal, tours. Visiting the Fruitlands Museums was always a personalized experience. Sears thrived on praise for her museum, and her consultant Colonel Welch vicariously shared in her glory:

In your description of the 4th inst, I feel your enthusiasm and joy of success. I am glad. To receive commendation from such men as Cyrus Dallin and curators of museums, and notices (the sort you want) from big Boston papers must be highly pleasing to you. I think that you deserve the praise and general notice which your museums attract. It is an effort toward the public good and preservation of things which are rapidly disappearing. . . . I am glad too, that I have given you some stories and legends relating to the articles I have picked up for you—personal touches as it were, which make them live. I feel almost as though I had been a fellow builder with you.[52]

Although she kept every piece of correspondence and every bill related to the collections and made accession lists with dates and a general description of objects, she never assigned numbers to the objects. Hence it is often impossible to reconstruct the relationship of specific objects to specific collec-

tion information. Late in her life, she received a request from a Yale University graduate student for information on her cataloging system and seemed unaware of the need for such a practice, responding: "In regard to your questionnaire on the cataloging of Anthropological specimens at Fruitlands and the Wayside Museums Inc., I am puzzled how to give you an answer. I do not use numbers, but I put the names under things written on cardboard. I am apt to group things together of a certain kind. This may not be a scientific way of doing it, but it is a more artistic way."[53] Like many private collectors, she carried the knowledge in her head, and she proceeded as if she would always be there to share it. Although she lived to be ninety-seven years old, much of the collection information died with her.

An unexpected result of the 1930s shield commissions executed for Sears through Colonel Welch was the creation and preservation of a corpus of twentieth-century art by named elders from the Standing Rock Reservation. Some of the artists have become well known for their drawings on shields, drums, and tipi covers, and their work is represented in a number of museums today.[54] Because the circumstances of the creation of the shields were so well documented by Colonel Welch, we gain an intimate glimpse into the individual thought processes that went into these re-creations, and we can appreciate the sensitivity with which Welch encouraged the artists to fulfill commissions for objects that still held cultural significance for them. In one instance, Welch sent two shields to Sears, and described the process through which they were made:

I am forwarding you two good shields. One, with the Thunder Bird, two bears paws and buffalo skull, was made by an old man. His name is Circling Hawk. I requested that he make me a shield. He balked at that—too sacred—medicine, etc. But he said that a relative of his named Ito Maguju (Rain in the Face) had one and he was dead now; he had watched him make one long ago; he remembered it; he would make me that one; it was a good shield; he had not dreamed it, but Rain had; he would sing about that now. So he sung a song, begged his pardon for making the shield; it was a thing of the past—dead now and gone; but his nephew, Charging Bear, had asked for it; he could not refuse him; he would make it and hold it in the white smoke of the sweet grass; then he would give it to Mato Watakpe. So I waited for him to make it. It took an extra night, but I wanted to bring it with me. So, here it is, a copy of the shield of Rain in the Face, made by a companion warrior of his.[55]

The Native Americans' strong spirituality and close relationship to their environment fit easily into Sears's worldview. In retrospect, one can see that she often took liberties with the spiritual expressions of others to put across

her own strongly held beliefs, reinterpreting and synthesizing Native belief into universals that would be easily understood by the New England museum public. Added to this was her strong, didactic personality, which enjoyed being "the authority," and her inability to cast loose certain attitudes of her own rarefied upbringing. She was at a certain evolutionary point in thinking about Native people. But her Indian Museum must be looked at in the context of her times, rather than ours. And in that context, her decision to emphasize the spiritual rather than the material aspects of Native culture was a direction that, then and now, merits serious attention.

## Acknowledgments

Ideas for this paper were developed during the past several years as the author participated in two self-study committees funded by the National Endowment for the Humanities and the Massachusetts Council for the Humanities, organized by Dr. Robert Farwell, director of Fruitlands Museums, and composed of anthropologists, curators, historians, and New England Native people. Particular insights were gained from unpublished manuscripts of Michael Volmar, then scholar-in-residence, now curator, of the Fruitlands Indian Museums, and from Linda Coombs, Selena Coverdale, and Russell Handsman. I am grateful to Katharine Woodhouse-Beyer and Erica Guyer, students in the Brown University Department of Anthropology, for help in archival research.

## Notes

1. Cynthia H. Barton, *A New Eden: Clara Endicott Sears, Founder of Fruitlands Museums* (Harvard, Mass.: Fruitlands Museums, 1988), 16; Cynthia H. Barton, *History's Daughter: The Life of Clara Endicott Sears, Founder of Fruitlands Museums* (Harvard, Mass.: Fruitlands Museums, 1988), 69.

2. Michael Kammen, *Mystic Chords of Memory: The Transformation of Tradition in American Culture* (New York: Knopf, 1991); T. J. Jackson Lears, *No Place of Grace: Antimodernism and the Transformation of American Culture, 1880–1920* (New York: Pantheon, 1981).

3. Barton, *History's Daughter,* 124.

4. Among Clara Endicott Sears's fourteen books, the following related specifically to her museums: *The Power Within* (privately published, 1911); *Gleanings from Old Shaker Journals* (New York: Houghton Mifflin, 1916); *Bronson Alcott's Fruitlands* (New York: Houghton Mifflin, 1915); *The Romance of Fiddler's Green* (New York: Houghton Mifflin, 1922); *Days of Delusion: A Strange Bit of History* (New York: Houghton Mifflin, 1924); "Catalogue of the American Indian Museum" (ca. 1940, Indian Museum, Fruitlands Archives); *Whispering Pines* (Falmouth, Mass.: Enterprise Press, 1930); *The Great Powwow: The Story of the Nashaway Valley in King Philip's War* (New York: Houghton Mifflin, 1934); *Wind from the Hills and Other Poems* (New York: G. P. Putnam's Sons, 1936).

5. In nearby Sudbury, Henry Ford was also developing a Wayside Museum,

including the eighteenth-century Wayside Inn made famous by Henry Wadsworth Longfellow, a gristmill, and the red schoolhouse immortalized in the poem "Mary Had a Little Lamb."

6. She funded several summer expeditions of Professor Warren K. Moorehead of Phillips Academy, Andover, in the Nashua River Valley area.

7. Among these events is "The ransom of Mrs. Rowlandson from King Philip by Mr. Hoar."

8. Kammen, *Mystic Chords of Memory*, 300–30.

9. For Peabody genealogy, see Walter Muir Whitehill, *Captain Joseph Peabody, East India Merchant of Salem (1757–1844), A Record of his Ships and of His Family, compiled by William Crowninshield Endicott (1860–1936)* (Salem, Mass.: Peabody Museum, 1962).

10. Mary Endicott was Joseph Chamberlain's third wife. A son by his second wife was Neville Chamberlain, prime minister from 1937 to 1940 and associated with England's policy of appeasement of Germany immediately preceding World War II.

11. Sears shared with them a common descent from Isaac Peabody (1650–1726), son of the original New World settler Lieutenant Francis Peabody.

12. See Paul Brooks, *The People of Concord* (Chester, Conn.: Globe Pequot Press, 1990); Edwin P. Hoyt, *The Peabody Influence: How a Great New England Family Helped to Build America* (New York: Dodd, Mead, 1968); and L. H. Tharp, *The Peabody Sisters of Salem* (Boston: Little, Brown, 1950).

13. Elaine Goodale Eastman to C. E. Sears, August 8, 1934, Indian Museum #69, Fruitlands Archives.

14. Katherine Leighton to C. E. Sears, January 10, 1932, Indian Museum #126, Fruitlands Archives.

15. Katherine Leighton to C. E. Sears, February 1932, Indian Museum #127, Fruitlands Archives.

16. C. E. Sears, Account of the first meeting of the Trustees of the Fruitlands and Wayside Museums Incorporate on August 20, 1930, Indian Museum, Fruitlands Archives.

17. Elise A. Belcher, Winchester, Mass., to C. E. Sears, August 18, 1941, Indian Museum, Fruitlands Archives.

18. Barton, *History's Daughter*, 134, 141; Michael Volmar, "Envisioning the Authentic American Indian: Clara Endicott Sears and the American Indian Museum at Fruitlands" (unpublished manuscript, January 1995), 5.

19. For her two previous museums, her authorities had been close at hand—Eldress Josephine Jilson of the Shakers and Frank Hall for the transcendentalists. For the Indian Museum she had to go outside of her immediate acquaintances.

20. C. E. Sears, *Accessions to the Museums, Annual Reports to Trustees* (Harvard, Mass.: Fruitlands Museums, 1939).

21. See Michael Volmar, "Envisioning the Authentic American Indian: Clara Endicott Sears and the American Indian Museum at Fruitlands" (unpublished manuscript, 1996 revision of January 1995 original), 32, for details of archaeological expeditions led by Moorehead and funded by Sears.

22. C. E. Sears to A. B. Welch, June 6, 1929, Indian Museum, Fruitlands Archives.

23. Sears, "Catalogue of the American Indian Museum," 1.

24. C. E. Sears to Warren K. Moorehead, April 28, 1931, Indian Museum, Fruitlands Archives.

25. Gladys Tantaquidgeon to C. E. Sears, January 18, April 7, and April 11, 1932, Indian Museum, Fruitlands Archives.

26. W. K. Moorehead to R. F. Haffenreffer, October 29, 1929, Collections Files, RH: Moorehead, Haffenreffer Museum Archives. See also discussion by Ann McMullen, "The Heart Interest: Native Americans at Mount Hope and the King Philip Museum," in *Passionate Hobby: Rudolf Frederick Haffenreffer and the King Philip Museum*, ed. Shepard Krech (Bristol, R.I.: Haffenreffer Museum, 1991), 167–82, on ambiguous perceptions of southeastern Native people both by professional anthropologists and by laypeople in the 1920s and 1930s.

27. Frank Speck to C. E. Sears, July 15, 1940, and Sears to Speck, July 20, 1940, Indian Museum, Fruitlands Archives.

28. Speck to Sears, October 3, 1945, Indian Museum, Fruitlands Archives.

29. Sears to Speck, December 13, 1945, Indian Museum, Fruitlands Archives.

30. Sears had earlier done business briefly with a Mr. Henry Newman, a Nebraska dealer from whom she bought Plains decorative and archaeological objects, including beads and human finger bones obtained from graves. After she had made contact with Welch, she gradually dropped Newman. Henry T. Newman to C. E. Sears, March 10, 1928, through May 23, 1929, Indian Museum, Fruitlands Archives.

31. Welch's personal collection was offered to Sears by letter on May 21, 1938. He asked $2,500 for the archaeological specimens and $5,000 for the historic pieces. She declined the purchase. Both groups were largely from the Standing Rock Sioux area. Among the ethnographic objects was a muslin tipi cover painted by No Two Horns, now in the collection of the State Historical Society of North Dakota, Bismarck.

32. C. E. Sears to A. B. Welch, March 17, 1929, Indian Museum, Fruitlands Archives.

33. Sears to Welch, March 17, 1929, Indian Museum, Fruitlands Archives.

34. A description of the statue's meaning may be found in Sears, *The Great Powwow*, 23.

35. Harriet E. O'Brien, *Lost Utopias* (Harvard, Mass.: Fruitlands and the Wayside Museums, 1947), frontispiece. Wo-Peen stayed on to paint murals for Camp Massasoit, run by Springfield College (Massachusetts). This teaching college still administers a camp and a counselor training program for its student teachers, and Wo-Peen's murals cover the interior walls of the camp's main building. The Fruitlands collections contain numerous small watercolor drawings by the artist.

36. Sears did not secure a copyright to the statues at the time of their commissioning and installation, and later she had some difficulty keeping others, both individuals and companies like General Motors, from using the images commercially.

37. C. E. Sears to Chief Bear Heart, June 23, 1938, Indian Museum, Fruitlands Archives.

38. Much more elaborate pageantry took place at nearby Springfield College in the 1930s and 1940s, with torch-lit canoes manned by Springfield Camp counselors in deerskins paddling down a moonlit campus lake, with ceremonies of the pipe, et cetera. Similarly, at the Lake Placid Club, New York, guests selected membership in one of the six tribal divisions of the Iroquois Nation for an annual Labor Day pageant that lasted for several hours. They dressed in early-nineteenth-century Iroquois clothing and learned Iroquois phrases suitable for their parts, which they replayed from year to year. This pageant last occurred in 1948.

39. David Buffalo Bear to C. E. Sears, June 14, 1931, Indian Museum, Fruitlands Archives.

40. Sears, "Catalogue of the American Indian Museum," 2, 3.

41. Ibid., 3.

42. William A. Hoffman, "Pictography and Shamanistic Rites of the Ojibwa," *American Anthropologist* 1 (July 1888): 209–29.

43. C. E. Sears to A. B. Welch, February 13, 1932, Indian Museum, Fruitlands Archives.

44. Sears wrote, in *Additions to Fruitlands and the Wayside Museums, Inc., 1935*: "These three relics have been on exhibition for some time at the Southwestern Museum at Los Angeles. I corresponded with Prof. Hodge in regard to them. He was very anxious to retain them permanently at the latter Museum and they had tried to find someone who would present them, but as no one was found to do this, they very reluctantly let them go, and they were shipped to Fruitlands and the Wayside Museums, Inc." Indian Museum, Fruitlands Archives.

45. For a description of the simultaneous quest by Rudolf Haffenreffer to purchase the King Philip Club, also through the agency of Dr. Warren K. Moorehead, see David Gregg, "The Archaeological Collection," and Barbara Hail, "The Ethnographic Collection," both in Krech, *Passionate Hobby*, 151 and 123–24, respectively. The club was stolen from the Fruitlands Museums in the early 1970s. In 1995 it was rediscovered and purchased by Edward Jalbert, a collector of Indian arts, from a yard sale held near Worcester, Massachusetts; he returned it to the Fruitlands Museums.

46. Sears, "Catalogue of the American Indian Museum," 25. The human remains and associated burial objects were on loan from the Peabody Museum, Phillips Academy, Andover, and have recently been returned.

47. For evolving attitudes toward death, see Philippe Aries, *Western Attitudes toward Death from the Middle Ages to the Present* (Baltimore: Johns Hopkins University Press, 1974).

48. In 1996, Standing Rock Sioux elders examined these shields as part of a NAGPRA (Native American Graves Protection and Repatriation Act) consultancy and determined that about half of them were not authentic either because they did not represent a vision or because of inappropriate design depiction. Michael Volmar, personal communication, June 6, 1997.

49. Hoffman, "Pictography and Shamanistic Rites of the Ojibwa," fig. 2, #10, and fig. 3, #12; Sears, "Catalogue of the American Indian Museum," 44.
50. Hoffman, "Pictography and Shamanistic Rites of the Ojibwa," fig. 3, #13; Sears, "Catalogue of the American Indian Museum," 46.
51. W. K. Moorehead to Rudolf F. Haffenreffer, December 18, 1929, Haffenreffer Museum Archives.
52. A. B. Welch to C. E. Sears, July 9, 1929, Indian Museum, Fruitlands Archives.
53. C. E. Sears to Julia F. Lawrence, Graduate School, Yale University, March 29, 1943, Indian Museum, Fruitlands Archives.
54. For instance, the North Dakota Heritage Center. For information on Joseph No Two Horns (1852–1942), see David Wooley and Joseph D. Horse Capture, "Joseph No Two Horns (He Nupa Wanica)," *American Indian Art Magazine* 18, no. 3 (Summer 1993): 32–43. For muslin painting by Jaws, see Jonathan Batkin, ed., *Splendid Heritage, Masterpieces of Native American Art from the Masco Collection* (Santa Fe: Wheelwright Museum of the American Indian, 1995), 38.
55. See descriptive passages about Welch's methods of obtaining shields and his recollections of shield stories as told to him by shield makers in a series of letters from Colonel Welch to Clara Endicott Sears, 1928–34. The letter quoted continued as follows: "While I waited, his wife made one which belonged to her father, Standing Bear (Mato Najin). It has thick clouds over all, below that is the sky and then the earth below. They would not take money for the shields, but I took them to the traders store, some 18 miles away, and filled the auto with flour, sugar, meat, coffee, and a box of apples of which they are very fond. So, while I do not know just what the shields cost, they will cost me plenty before I get through making presents to this old couple, and I shall charge you the same as most of the others, $10 each." A. B. Welch to C. E. Sears, September 5, 1929, Indian Museum, Fruitlands Archives.

# 7
# COLLECTING TO EDUCATE

## Ernest Thompson Seton and
## Mary Cabot Wheelwright

Around 1940, Ernest Thompson Seton was asked to describe what had inspired him to found the Woodcraft Indians in 1902 and later to establish the Seton Institute in Santa Fe. He related how he was motivated "some ten years ago, to sell all I had in the East and move out to this, the last stronghold of the Redman's faith, and here on a chosen Promised Land in my own control . . . proclaim again the faith and culture of the noblest race that has been recorded on the pages of History."[1]

For those interested in Native American cultures and collecting the "Noble Red Man," whether for nostalgic, romantic, or scientific purposes, Santa Fe was a mecca. Beginning in the late nineteenth century with the completion of the Atchison, Topeka, and Santa Fe Railway, the northern Southwest and its Native peoples drew professional and amateur anthropologists, Boston Brahmins and other East Coast elites, artists, and tourists, who sought out the material culture of prehistoric and historic Indians for a variety of reasons. Some came to collect and reproduce supposedly vanishing and assimilating cultures and transport their knowledge and wares to other settings; others came to find adventure or freedom, collect vicarious experience, or regain their health. For artists and those tired of industrial American society and wishing to counter its ills, Santa Fe and, by extension, the nearby indigenous pueblos provided a refuge, a place of peace, purity, and beauty—where the wilderness as symbolized in the Wild West and Native America met colonizing civilization. Since this time, these

visitors have observed the lives of indigenous people, helped to commodify and aestheticize their lives through romanticized discourse, and collected hundreds of thousands of objects. Santa Fe is now and has been a cultural haven for collectors who spend large sums of money acquiring different forms of symbolic capital—art, clothing, music, food, or locale—to serve a multitude of purposes.[2]

Collecting is a universal human activity, and it allows individuals to objectify and make concrete their experiences, values, knowledge, and beliefs. Collections are a "unique bastion against the deluge of time," through which an individual can transform disparate things into something new. Recent works such as John Elsner and Roger Cardinal's *The Cultures of Collecting* document how collecting can be undertaken to memorialize personal journeys and serve as a mnemonic device to recall real and imagined places and times, to amass wealth, or to bring order to a potentially chaotic world. Collecting is classification lived and experienced in three dimensions.[3] "The history of collecting is thus the narrative of how human beings have striven to accommodate, to appropriate and to extend the taxonomies and systems of knowledge they have inherited."[4] Collecting from the mecca of Santa Fe is both personal and social, for it channels both things and people into a dynamic colonial and postcolonial social hierarchy where romance and ethnographic fact battle for authority.

Although most collecting is inherently personal, some individuals have dedicated their lives and capital to improving society by collecting to extend knowledge about others. For these individuals, collecting the romance of the Southwest and its Native peoples also involved a strong desire to educate American society—to obtain information about diverse lifeways, to use objects to eradicate stereotypes, to increase cross-cultural understanding, and to enrich life. Educational collectors amass objectified knowledge to prove arguments empirically and aesthetically, to acquire illustrative materials, and to understand. For educational collectors, it is the knowledge about different cultures contained in objects and verbal discourse, as well as the preservation of that knowledge, that constitutes a collection's basic value. Santa Fe's educational collectors wanted to teach others about the richness and dignity of Indian cultures. In this essay we will compare the activities of two of Santa Fe's educational collectors who founded institutions dedicated to the diffusion of knowledge as initial case studies for a little understood collecting behavior. Our subjects are Ernest Thompson Seton and Mary Cabot Wheelwright (fig. 7.1).

An eclectic collector, Seton amassed material objects from various Na-

Figure 7.1. Mary Cabot Wheelwright in 1954. Photograph by Laura Gilpin. Wheelwright Museum of the American Indian, Santa Fe, 60/473.

tive American groups, as well as information on dance, sign language, music, dress, oral histories, stories, legends, and customs. His ultimate goals were to preserve records of American Indian life and to educate American youths about Native American cultures. Formalized in the Woodcraft Indians and the Seton Institute, Seton's collections served as models from which young men and women could replicate an idealized, generic, Indian way of life.

Wheelwright attempted a different kind of educational collecting. Her museum, the Museum of Navajo Ceremonial Art, was the result of a dedicated, collaborative quest with a Navajo religious specialist to record and preserve the myths, music, poetry, sacred knowledge, religious art, and re-

ligious paraphernalia of a single culture. At its core was the preservation of ephemeral art and unwritten religious acts and dialogues for research students and the Navajo people themselves. It was a unique undertaking for an amateur, for it maintained as an objective the ethical collection and preservation of symbolic depictions rather than the preservation of more commonly collected physical objects.

Educational collecting, like other forms of public and private collecting, involves innovation and agency as well as assemblage, classification, and retention. It is generally purposeful and altruistic. It is also a highly personal activity that may be made public during the collecting process as well as during the display and dissemination process. The personality and the social position of the collector as individual and social agent are no less crucial for understanding educational collecting as a process of cultural reproduction and imaging than they are for other types of collecting activities. We thus turn to a brief discussion of Seton's and Wheelwright's social backgrounds and purposes for spending much of their lives as educational collectors—one to create an idealized model of American Indian life, the other to preserve the religion of a single culture. In the efforts of both of these collectors we see that while objects have importance, it is the knowledge that goes with these objects that is the critical part of the collection.

## ERNEST THOMPSON SETON: ARTIST-NATURALIST AND INDIAN SCHOLAR

Ernest Thompson Seton was born in 1860 in South Shields, England, to Alice Snowden Thompson and Joseph Logan Thompson, a prosperous shipowner.[5] During the years after Seton's birth, his father's business suffered a series of setbacks. This led Thompson to sell his ships and in 1866 move the family to a homestead outside Lindsay, Ontario, Canada, in order to restore their prosperity.[6] After only a few years the family returned to urban life in Toronto, but the years on the homestead instilled in the young Seton a love of nature and outdoor life.

In 1875 Seton fell victim to a lung ailment and was sent to live with the family of William Blackwell, who had purchased the Lindsay farm from his father. There, Seton and neighborhood boys often played outdoors and camped in homemade tipis, "living and thinking like Indians and learning the ways of survival in the wild."[7] This rustic and somewhat idyllic experi-

ence served as the basis for Seton's novel *Two Little Savages* and gave him the idea of forming a youth club based on an American Indian model.[8] These activities in natural settings, he felt, made for healthy bodies and healthy minds.

After this convalescent stay, Seton returned to Toronto to begin formal art training. He attended the Ontario School of Art from 1876 to 1879, then immediately traveled to London to continue his studies. He was accepted at the Royal Academy on a seven-year scholarship on Christmas Day, 1880. He was soon dissatisfied with London and the academy, however, and in 1881 returned to Canada.[9] Throughout the next decade Seton spent several short periods in New York, working as an illustrator and studying part-time at the Art Students' League.[10] In between these intervals, he lived in Manitoba and worked on his brothers' homesteads and, in 1884 and 1885, on his own claim.[11] Throughout his life, he strove to reconcile the dilemma he saw in modern life between the natural and the industrial worlds.[12]

Seton returned to Europe, this time attending classes at L'Académie Julian in Paris in 1891 and 1892. In March 1891 his painting *Sleeping Wolf* was accepted to the Grand Salon.[13] This honor inspired Seton, and he spent the next year producing a major work, *Awaited in Vain (Triumph of the Wolves)*, which depicted a hunter being devoured by a wolf pack. The judges for the 1892 Salon did not share Seton's sympathy for the wolves or appreciate his allegory of civilization being consumed by the wilderness, and they summarily rejected the work, deeming it "Horrible!"[14] Dismayed by the rebuke of his year's labors and vision, Seton went back to Canada.

Seton made one more effort to study art in Europe, returning to L'Académie Julian in 1894. While some of his sketches were accepted in the 1895 Salon competition, the successful completion of the highly scientific *Studies of the Art Anatomy of Animals* diverted him from working as a full-time artist. During this time in Paris he became acquainted with Grace Gallatin, daughter of the California businessman Albert J. Gallatin, and he married her upon returning to New York in 1896.[15]

During the next few years Seton was able to obtain considerable work as an ornithological illustrator, producing illustrations for Frank Chapman's *Handbook of Birds of Eastern North America* and *Bird Life*.[16] At the same time he began to publish natural history articles and animal stories in journals ranging from the *Auk*, the publication of the American Ornithologists Union, to *Forest and Stream*, the most popular outdoors magazine of the

time.[17] His first collection of animal stories, *Wild Animals I Have Known,* was extremely popular and his publications began to provide him with a substantial income.[18]

Around the turn of the century, Seton developed and implemented his idea of a youth club to promote healthy intellectual and spiritual growth. In 1902, in an attempt to counter a wave of trespassing and vandalism on his Wyndygoul estate at Cos Cob, Connecticut, Seton invited all the adolescent boys in attendance at the neighborhood school to a weekend camp at an "Indian village" he had created.[19] Simultaneously, he wrote a series of articles for the *Ladies Home Journal* under the heading "Ernest Thompson Seton's Boys" that provided a rough outline of, and rationale for, his organization and denoted its key activities.[20] At the recommendation of Rudyard Kipling, Seton also chose to present his ideas in the form of a novel.[21] The following year he published *Two Little Savages,* first serially in *Ladies Home Journal,* and then in book form.[22] This story, with its origins in Seton's experiences at the Lindsay farm, described the formation of an ideal Woodcraft "tribe." With these publications the Woodcraft Indians were born, and boys from around the United States and in Europe began to form their own "tribes."

Seton based his youth organization on his concept of "Woodcraft," which required an understanding of natural history, the development of outdoors skills, and an interest in Native American cultures, embedded in a philosophy of conservation. The Woodcraft Indians was by design a loosely organized program rather than a formally institutionalized organization. Seton's desire, particularly in the early years, was simply to help boys to "get the most pleasure possible out of playing Red Man."[23] To establish themselves as Woodcraft Indians, Seton held, boys needed "a tribe of the right kind of boys, woods, one or more teepees, bows and arrows, a headdress or war bonnet for each, and of course a knowledge of Woodcraft."[24] To provide some structure and guidance for local autonomous groups, Seton published under several different titles a series of guidebooks, referred to as his "Birch Bark Roll" of Woodcraft. In each of these editions the Woodcraft program was further elaborated and formalized; within the first few years Seton had added recommendations for political organization, activities, and awards systems to be used by the independent tribes.

Seton was deeply involved in the 1910 introduction of the Boy Scouts into the United States and served as its first "Chief Scout." By 1915, his opposition to the paramilitary nature of the program and organization led to a break with the Scouts' executive board, and Seton turned again to his

Woodcraft movement. In 1916 the Woodcraft League of America was formally organized and expanded to include programs for girls and younger boys. In the 1920s Seton offered training seminars for leaders of children's groups in which he encouraged the use of Indian lore based on his Woodcraft model.[25] This further increased the influence of his program in youth education.

In 1918 Seton met Julia Moss Buttree, who became his secretary and constant companion; the two were eventually married in 1935 after each of them had dissolved a previous marriage.[26] In 1930, Seton and Buttree decided to relocate to the Southwest. They moved to a tract of land just outside Santa Fe, which Seton called "the last stronghold of the Red-man's faith" and "a chosen Promised Land."[27] There they built their home, "Seton Castle," established "Seton Village" and founded the "Seton Institute" and "College of Indian Wisdom," which offered courses for youth leaders and for children each summer from 1932 until 1940. At the Seton Institute, students were offered classes in a wide variety of fields, ranging from natural history studies to "Indian craft," which were taught by local Native artisans but always "in conjunction" with a white instructor.[28] The College of Indian Wisdom was accredited by the American Association of Colleges, and as many as nine quarter-term hours of credit could be earned in a summer session, through New Mexico Normal College (now New Mexico Highlands University) in Las Vegas.[29]

The Setons closed the Seton Institute after the 1940 season, because of Ernest Seton's advanced age and loss of staff to the armed forces as World War II intensified. Nevertheless, the Setons continued to write and to travel around the country on lecture tours until Ernest Thompson Seton died suddenly in October 1946, at the age of eighty-six.

### The Woodcraft Indians

Unlike Wheelwright, who dedicated herself to the study and preservation of the religion of one Native American culture, Ernest Thompson Seton had wide-ranging interests. He studied and collected artifacts from a vast array of Indian cultures. His goal was not to understand deeply and fully the culture of a particular Indian society, but to gain a picture of the culture of THE Indian as well as the cultures of all indigenous peoples of North America (fig. 7.2). While Wheelwright sought to preserve a record of one Native American culture, Seton saw all Native American cultures as fundamentally related and argued that something could be universalized from them in opposition to Western industrialized society. He worked to preserve as-

Figure 7.2. Ernest Thompson Seton with Woodcrafter, ca. 1940. Philmont Museum and Seton Memorial Library, Cimarron, New Mexico.

pects of as many cultures as he could while at the same time creating a generalized American Indian image that incorporated them all with little regard for actual cultural differences.

Seton felt that "authentic" objects were crucial to this creation, but it remains unclear when he began collecting Indian artifacts. His first encounters with Native Americans/First Nation peoples came during his youth in western Canada, when he had at least occasional contact with local Crees.

In the 1880s he met a Cree man named Chaska, who served as his guide on a hunting expedition. He learned much from the hunter and wrote that Chaska was like a "Fenimore Cooper Indian . . . [of] fine physique, manly qualities, and a certain amount of freedom from grosser vices."[30] Although there is no proof, it is probable that Seton obtained some Native-made souvenirs on these trips.

Over the course of the late nineteenth and twentieth centuries, Seton made many trips into the Canadian and American West, where he met numerous Native peoples and began collecting knowledge and artifacts on a larger and more systematic scale. In 1897, after several months studying the wildlife of Yellowstone Park for *Recreation* magazine, he and his first wife, Grace Gallatin, traveled to the Crow Reservation in eastern Montana.[31] During their two-week stay, Seton collected a number of artifacts.[32] He also interviewed several men who had served as scouts under George Custer. Among these was White Swan, who taught Seton some of the sign language used by the Plains tribes and sold him several drawings.[33] Fascinated by his studies, Seton continued to collect information on sign language and in 1918 published *Sign Talk,* his most technical work on Native American culture.

In 1907 Seton traveled some two thousand miles by canoe into northwestern Canada on a personally funded natural history expedition.[34] During this trip he interacted with numerous Native people from several different cultural groups, and no doubt collected some artifacts and information on lifeways that were useful to his Woodcraft movement.

In the 1920s, Seton and Julia Buttree made a number of trips to the West, visiting several Northern Plains reservations and numerous southwestern Pueblos. In addition to adding artifacts to the collection, Seton and Buttree made detailed observations of the songs and dances they witnessed among all of the different tribes that they visited. From these observations the two created a number of traditional dances, which were added to the Woodcraft repertoire.[35]

After their relocation to Santa Fe, Ernest and Julia Seton were frequent visitors to the area's pueblos, and they hired local Native Americans to undertake construction work at Seton Village, perform, and aid in instruction at the Seton Institute. During the latter years of Seton's life he and Julia actively collected objects that were made by local Indian artisans, amassing a significant number of Pueblo pottery pieces.

Seton was always concerned with ethnographic accuracy in his Indian program (even if he used ethnographic detail in a homogenized Plains rep-

resentation), and he supplemented his personal experiences and under-
standings with those of the leading scholars of the time. He had met F. W.
Hodge, Frances Densmore, and James O. Dorsey at the Smithsonian Insti-
tution in the 1880s, and he kept in contact with these researchers and re-
ferred frequently to their works. He also corresponded with ethnomusicol-
ogists Natalie Curtis and Alice Fletcher in order to ensure the accuracy of
songs and dances used in the Woodcraft program. He financially supported
further undertakings as well, contributing to Frederick R. Burton's re-
search on Ojibwa music and was a subscriber to Edward S. Curtis's North
American Indian photographic project.[36]

### Seton's Collections and Education Initiatives

Like all collectors, Seton needed a place to house and display his collection
if it was to serve an educational purpose. His museum was not an indepen-
dent institution but remained part of Seton Village. In 1932 he constructed
a building where the collection was kept on display for visitors to the vil-
lage. The collection was also used extensively for instruction at the Seton
Institute, with the artifacts serving as models for students to use in making
their own costumes. The artifacts also served as illustration models for
drawings Seton made for his and Julia Seton's articles and books, and it is
through these works that many people have been exposed to his ethno-
graphic collection.[37] After the closing of the Seton Institute in 1940, the
number of visitors to Seton Village and the museum decreased, and follow-
ing Ernest Thompson Seton's death the buildings and land of Seton Village
were gradually sold off. By the 1960s, when Julia Seton donated the bulk of
Seton's collections to the Boy Scouts of America, the objects were housed in
Seton Castle, the Setons' Santa Fe home.

Little can be said about Seton's collecting methods or rationale—
whether he had a vision of what the collection should contain, whether he
actively sought out pieces, or whether he collected opportunistically and
haphazardly. Although Seton encouraged young naturalists to carefully la-
bel all specimens that they collected,[38] and he himself was exceptionally
thorough in making records of his natural history collections, this behavior
does not seem to have carried over to his ethnographic collecting. Seton
identified most of the artifacts that he pictured in illustrations by their tribal
origin; this, however, is the limit of surviving records that he made for
his Indian collection. There are no field records that list maker or cultural
affiliation, nor are there fiscal records that document time and place of pur-
chase. Furthermore, the listing of Seton's ethnographic collection is missing

from a 1967 inventory of the Seton Castle (Seton's home) made by the Boy Scouts of America upon the deeding of Seton's collections to that organization.[39] Because of these shortcomings in the record of Seton's collection, the earliest and most complete inventory was made when the collection was cataloged following its accession into the Boy Scouts' Philmont Museum and Seton Memorial Library at Cimarron, New Mexico. Unfortunately, even this record is woefully inadequate.

Around 1940, Seton reported that the Seton Village museum contained about 1,500 ethnographic artifacts. Of these, fewer than 400 were cataloged at the Philmont Museum; it is unclear what happened to the remainder. Julia Seton kept a few pieces that had personal significance for her, some of which are still in the possession of the Setons' adopted daughter, Dee Barber, who resides at Seton Castle. It is probable that numerous pieces were given away or sold after Seton's death.

The remnants of the collection now in the Philmont Museum provide some idea of the wide range of Seton's collecting interests. The vast majority of artifacts come from various Southwestern and Plains societies, but artifacts representing the material culture of the Inuit, the Northwest Coast, the eastern prairies, and the Great Lakes regions are represented as well. Almost a quarter of the collection comprises various types of pottery, most of which comes from New Mexico pueblos. These items appear to have been made for the tourist market in Santa Fe, as are a number of the other artifacts in the collection. Along with the completed pottery, the collection includes a set of unfinished pots at various stages of manufacture, which was almost certainly used in the teaching of pottery making. A third of the collection comes from the Northern Plains and exhibits the greatest diversity of artifacts: men's and women's clothing, moccasins, bags and parfleches, weapons, pipes, and musical instruments. The remainder of the collection is composed of a few miscellaneous artifacts from numerous different cultural groups, as well as a number of artifacts that appear to have been made not by Native artisans but by Woodcrafters. Many of the Native-made artifacts are miniature models of cradleboards, canoe paddles, and tools and weapons. The Woodcraft artifacts include clothing items such as shirts and war bonnets, some of which have Indian-made beadwork pieces sewn to them, and jewelry, pipes, and drums.

Although the artifacts are important, they themselves are not the most crucial part of Seton's collection. Seton's real influence came from his understanding of Native American cultures and his ability to combine and convey verbal and visual materials as elements in a condensed instance of

cultural reproduction. Seton's image of THE American Indian was made available to countless people. Because of the loose organization of the Woodcraft Indians, it is difficult to determine accurately the number of people that Seton influenced directly. Probably more than a thousand individuals participated in the Seton Institute programs during its nine summer sessions. During the first decade after the introduction of the Woodcraft Indians, the membership of the organization counted between 100,000 and 200,000.[40] Many more attended the literally thousands of lectures and programs that Ernest and Julia Seton presented.

It is the result of Seton's educational collecting, rather than the collecting process itself, that characterizes the most crucial aspects of Seton's collecting behavior and institution-building activities. It is selective collecting as information for and proof of a romanticized image of Native American life. Seton's image production reinforced and lent credibility to the Wild West and movie images of the wild yet noble Red Man. Seton's extensive research provided legitimacy for his image and allowed people to "play Indian" and take part in a vanished and imagined way of life. Visitors and Woodcrafters were in this way empowered to reproduce "Indianness" themselves in their own study and play.

Seton's teachings continue to be widely influential, especially among hobbyists. There are also a number of organizations that perpetuate the Woodcraft program explicitly, including the Woodcraft Rangers of California (which in 1994 served 30,000 youths), and several groups in Britain, the Czech Republic, and the Slovak Republic.[41] The Camp Fire program and the YMCA's Indian Guide and Indian Princess programs have continued to use some of the Indian elements introduced by Seton. The most significant organization that continues to be influenced by Seton's work is the Boy Scouts of America, through which millions of boys and their families have been exposed to Seton-derived Indian lore. It is through the Boy Scouts that the public continues to have access to Seton's ethnographic collection at the Philmont Museum.

Ernest Thompson Seton's continuing influence is not limited to his legacy in youth programs. He is fondly remembered by the Native people that he worked with and came to know in the Santa Fe area. A kinlike relationship continues to be fostered between Seton's family and the Native American families that were involved in the Seton Institute. An elderly Pueblo man, visiting Seton Castle many years after Seton died, gazed lovingly at his portrait and whispered, "Grampapa, Grampapa."[42]

## MARY CABOT WHEELWRIGHT: ADVENTUROUS BOSTONIAN

Mary Cabot Wheelwright (1878–1958) was born and raised in Boston, a member of an elite, extremely wealthy Brahmin family. The only child of merchant Andrew Cunningham Wheelwright and Sarah Perkins Cabot, she had no formal education but did attend finishing school. Wheelwright especially loved poetry and music and studied singing and piano. Like other wealthy Bostonians, she summered on Sutton's Island in Maine—a practice that she continued throughout her life—and wintered at the Cosmopolitan Club in New York City.

One biographer described Wheelwright during her early adult years as a "dutiful Victorian daughter," who was "dyspeptic, gawky and opinionated."[43] Another said she was "unmistakably Cabot-y," haute, without frills or tact, insensitive, frequently irritated with others but with a definite flair, sense of style, centeredness, authoritativeness, fearlessness, and self-confidence.[44] As was expected of elite women, Wheelwright conscientiously dedicated her early years to social and civic work. In 1912 she founded and directed the South End Music School. She was also intimately involved in a settlement house and the Carry-On Shop in Boston between 1912 and 1925. Proceeds from the shop's sale of handcrafted items supported the music school. A determined individual, Wheelwright could be stubborn and tactless, but she was also practical, dedicated, meticulous, and enthusiastic about her projects.

Wheelwright continually revolted against repressive conventional Boston morals and craved the adventure and freedom that a sheltered and proper upbringing denied to women of her day. She converted a pilot boat and expertly sailed the Maine and Nova Scotia coasts, became a world traveler and toured Europe annually.[45] The itinerant wealthy female traveler was an accepted eccentric in the late nineteenth and early twentieth centuries, and Wheelwright traveled to California, Greece, and Egypt, and purchased villas in Italy and in Mallorca, Spain. It was this sense of journeys to be taken that served her so well in her work with the Navajo.

Unable to tour in Europe during World War I, Wheelwright traveled to the Southwest following her mother's death in 1918. Accompanied by her cousin Evelyn Sears, she journeyed by horse and camped under the stars, guided by cowboys from the San Gabriel dude ranch. She loved camping, especially "the feeling of the earth when you slept on it," which "made it so much more possible to understand the connection—intimate and consol-

ing—of the Indian to his earth."[46] Falling in love with the land and its peoples, she returned periodically over the next few years. The Southwest, she said, brought her contentment and excitement: "I went to the Southwest where I seemed to get near something I had always wanted, a simple way of living, more adventurous and more exciting than the safety of Boston."[47] Wheelwright eventually purchased a home in Alcalde, north of Santa Fe, in 1923. This working ranch, called Los Luceros, had originally been a Spanish encomienda of the Ortiz family and had belonged to the descendants of King Charles IV of Spain. From this base, Wheelwright took many horseback and camping trips throughout the northern Southwest.

Besides freedom and adventure Wheelwright also craved knowledge, especially knowledge about world religions, mysticism, folklore, and music. In 1928, for example, she brought an ethnomusicologist to her home on Sutton's Island, Maine, to record two hundred old airs. She rejected institutionalized forms of Christianity and searched for spiritual enlightenment through unitarianism, Eastern religions, and eventually Navajo spirituality. She was particularly interested in symbolic imagery and was slowly drawn to anthropology for its wealth of esoteric detail about exotica. Like other wealthy women who moved to Santa Fe (e.g., Amelia White and Elsie Clews Parsons), Wheelwright decided to use her inheritance to further her interests in understanding the Native peoples of the Southwest.[48] Her income stemmed from a trust fund, however, that prohibited her access to the capital. Unmarried daughters had to be protected against fortune-hunting suitors.

### The House of Navajo Religion

The story of Wheelwright's collecting and museological activity is the story of a cross-cultural collaboration dedicated to the study and preservation of Navajo religion. Wheelwright worked closely with Hosteen Klah, a noted Navajo singer.[49] Klah was known as the Diné's foremost *hatááli*, the greatest practitioner of the Nightway, and a noted authority on three other chants: Hailway, Chiricahua Windway, and Mountainway. *Hatááli* is the Diné word that most easily translates as "singer" but also subsumes the Anglo-American social categories of physician, priest, and historian. A *hatááli* is a well-respected figure in the Navajo community, for he is a highly trained specialist who controls rituals, the active part of Navajo religion.[50] He knows all the details of rituals, including chants, prayers, and the myths that justify these practices; he supervises the construction of ephemeral sandpaintings during ceremonies. It is the job of the *hatááli* to ensure that

the world, when it is unbalanced, is brought back into a harmonious state through the performance of proper ritual. This leads to a condition known as *hózhó*, which can be inadequately translated as "beautiful, harmonious, blessed, and pleasant." The *hatááli* brings the powers of the universe into harmonious relationship through the correct use of his knowledge.

Hosteen Klah was one of the most well-known Navajos to both Anglo-Americans and Navajos, thanks in part to the widely read biography of his life written by trader and amateur anthropologist Franc J. Newcomb.[51] A grandson of the famous Navajo leader Narbona, Klah was a *nadle* and an extremely extraordinary and unorthodox individual who was responsible for several innovations in religious practice.[52] He often sketched sand-painting designs for Newcomb, and she would repaint them in watercolor reproductions. Klah also worked with other anthropologists such as Gladys Reichard, who noted his superior intelligence and extreme gentle-ness.[53] He was eager to record his myths, rituals, and sandpaintings so that his intimate knowledge would not be lost after his death. Owing to a lack of Navajo apprentices to carry on his legacy in the traditional Navajo fashion, Klah feared dire consequences for humanity.[54] As Reichard noted, Hosteen Klah believed that a people different from the Navajo would travel to the next world when this one had been destroyed. Believing that these people would be Anglos, he felt it was his duty to teach sincere Anglos who were willing to undertake the arduous task of learning a wealth of critical details (the fundamentals of Navajo religion), so that they would take this knowl-edge with them to the next world.[55]

Wheelwright first learned of Hosteen Klah in 1921 when she attended the Gallup Inter-tribal Ceremonial, an annual rodeo, performance, art show, educational and sales venue in western New Mexico. There she saw and purchased a sandpainting tapestry woven by Klah. Klah was one of the best-known and most prolific weavers of sandpainting tapestries, special rugs that incorporated sandpainting designs. Unlike most Navajo men, Klah wove ordinary rugs for most of his life, completing his first at the Chicago World's Columbian Exposition in 1892–93. Klah waited until 1919, two years after he became an established Nightway singer, before he attempted his first sandpainting tapestry, a whirling logs design from Nightway, because it was a dangerous undertaking.[56] The rug purchased by Wheelwright was Klah's second sandpainting tapestry: a design of the Storm People and Corn People from Hailway.

Wheelwright's first trip to the Navajo reservation occurred in 1925, and she attended her first Navajo ceremony the following year. This was a nine-

night Nightway held in the Chinle Valley. Returning to Santa Fe, she traveled over the Chuska Mountains and stopped at Nava, New Mexico. Accepting the hospitality of traders Franc and Arthur Newcomb, she learned of another Nightway ceremony being held to the west of the Jemez Mountains. Wheelwright attended the ceremony and met the officiating singer, Hosteen Klah; they talked through the night. "I shall never forget my first impression of him," she later recalled in her memoirs. "He had such gentleness and such power."[57]

Like Newcomb and other Anglo-Americans, Wheelwright was intrigued by the sandpainting designs used in the ceremony. *Ii kááh*, the Diné word for sand- or drypainting, means "the place where the gods come and go." The paintings serve as impermanent altars where ritual actions take place. Made of colorful pulverized sands, pigments and pollens, drypaintings are pictorial representations of the supernaturals. They contain sacred symbols in thousands of complex designs and when consecrated are impregnated with supernatural power. They are destroyed at the end of a ceremony.

Wheelwright returned to the Newcomb trading post the following year for a weeklong visit. There she told Klah that she wanted to understand the meanings of his ceremonies. To assess her sincerity, Klah questioned her as to why she wanted this information, how she would use it, and whether, if she once began, she would promise to complete the arduous recording process. Wheelwright invited Klah to Los Luceros, and they both came to the same conclusion—that Navajo religion and philosophy should be preserved in a permanent form. They began the tremendous task in 1927.

The collaboration of Hosteen Klah and Wheelwright constituted a pseudo-apprenticeship relationship. Klah asked Wheelwright to record his myths, prayers, songs, and sandpaintings "so that they would not be lost forever." This was a grave responsibility and fraught with danger, since according to Navajo religious belief it is dangerous to be around such concentrated power and record supernatural symbols unless one is ritually prepared. Klah worried for Wheelwright's safety. He warned her that Washington Matthews, the last anthropologist to write down a chantway and its prayers, had died of paralysis. The same fate could befall her. Wheelwright assured Klah that she was not afraid and was willing to take the responsibility and to learn in the proper way. With this declaration, Wheelwright in essence became Klah's apprentice, as had Newcomb. They began with Klah's Nightway songs, followed by his Mountainway prayers. Klah performed Blessingway ceremonies over Wheelwright and the Newcombs

over the next few years to ensure that they would not be harmed by being near the concentrated power.[58]

Under Klah's direction, Wheelwright began an extensive and intensive study of Navajo religion. "My only qualifications for the undertaking are plenty of time and patience, some knowledge of other religions and backgrounds, and a respect and love for the Navajo people," Wheelwright stated in her memoirs.[59] Although she had no formal training, her interest in people, her ability to sit quietly and listen and to ask for clarification at the appropriate time, and her commitment to do what was right in a culturally appropriate manner, made her an intuitive ethnographer. Combined with her energy and wealth, her personality enabled her to work with singers and pay them for teaching her, following the accepted Navajo learning practices.[60] Nevertheless, Wheelwright was suitably humble about her role.

I leave to experts in psychology and ethnology the definition and analysis of [Navajo] myths for I consider myself no expert, but a humble student and recorder who kept theories in the background, content to be a blank page on which has been written simply and frankly as exact a recording as a member of another race can give, for no white person can be sure that all the thoughts of an Indian are open to him.[61]

The next fall, the Newcombs and Klah traveled to Los Luceros. Arthur Newcomb and Klah's nephew, Clyde Beyal, served as translator and transcriber. Every spring and summer for the next ten years Wheelwright spent many weeks at the Newcombs' trading post and recorded Hosteen Klah's ceremonies and songs. In the fall or winter, they all worked at Los Luceros. In these ways they could respect the seasonally specific nature of transmitting Navajo religious knowledge. Wheelwright also took Klah to her home in Maine and to the West Coast, to see the home of Changing Woman. While on this latter trip Klah shared his version of the Creation Myth.

Wheelwright and Klah respected each other as intellectual equals and strove to understand each other's culture and worldview. This resulted in a true collaborative effort that was designed to preserve for posterity the beauty and compelling designs found in the sandpaintings and the powerful words and poetry in the rituals. That the Holy People approved of these efforts was seen in the continued good health of all participants.

Wheelwright also worked with almost fifty other singers and sandpainters, notably Hosteen Ghani and Hosteen de Johye. Klah's endorsement and introduction helped pave the way for these collaborations:

"Gradually Hasteen Klah persuaded his neighbors to allow Mrs. Newcomb and myself to see and report the ceremonies. They became proud of these recordings. Klah introduced us to many of the Medicine Men until we had recorded over 400 sandpaintings with their songs and prayers."[62] Also understanding that the paintings could not be understood outside their proper context, she recorded the mythology behind each chantway at Klah's suggestion.

Klah insisted that the knowledge needed a permanent home, and Wheelwright agreed. She had first conceptualized a permanent repository for the ephemeral sandpainting designs when she viewed Newcomb's collection in the early 1920s. Remarking on their beauty, she thought they should be on public display for others to see and admire. As Wheelwright remembered: "My purpose through all the work had been to establish a Museum to contain all the material we had collected, as well as all available material collected or published by others, for the use of future students of Navajo religion, art, and culture."[63] But she did not want the institution to be the standard natural history or anthropology repository, nor did she want it to be a monument to herself. "I felt so definitely that I wanted my museum to be different from the usual museum that at first we called it the House of Navaho Religion, but we found that this was not understood and people came expecting to see a ceremony. Many Navahos call it *Hogahn B'Beke,* which means the House of Sandpaintings."[64] She changed the name to the Museum of Navajo Ceremonial Art.

Wheelwright originally thought the museum would be built in Albuquerque at the University of New Mexico. Unfortunately, the campus administration did not want a Navajo-style building to compete with their pueblo-style architecture. A similar situation occurred when she offered the collections to the Laboratory of Anthropology. She refused to alter her plans, however, feeling that Navajo knowledge should reside in a Navajo hogan. Luckily her friend Amelia Elizabeth White gave her land near the Laboratory of Anthropology in Santa Fe.

The building was designed by architect William Penhallow Henderson in the shape of a Navajo hogan rather than the classical and monumental architecture common to museums (fig. 7.3). Wheelwright wanted the feeling of intimacy and quiet that is found in a ceremonial hogan. Klah was frequently consulted on details of symbolism, especially with regard to permanent decoration and appropriate orientation. Built of logs with a domed roof, the octagonal building faced to the east. The upper floor contained a

Figure 7.3. The House of Navajo Religion in 1937, showing two- and three-dimensional replicas of sandpaintings. Photograph by Ernest Knee. Wheelwright Museum of the American Indian, Santa Fe.

large, single-room gallery designed for rotating exhibitions of large sandpainting reproductions. On the ground floor were smaller exhibition rooms, storage and research space, library, office, and living quarters. Details symbolized the essentials of Navajo religious philosophy. Even the cribbed roof of the exhibit space was an interlocking whirling logs design from Nightway with a skylight to represent the smoke hole of a traditional hogan.

Klah blessed the groundbreaking of the museum in the spring of 1937. Unfortunately, he died before the building was completed, and he was buried on the museum grounds. Following his wishes, a member of his family performed a house blessing ceremony on November 22, 1937, officially opening the museum and blessing all who entered.

Wheelwright served as the director of the Museum of Navajo Ceremonial Art from 1937 until her death in 1958. She also supported it, using

$8,500 of her income annually for operating expenses. She was never able to break her trust and was unable to endow the museum as she would have wished.

### Knowledge Collected in Beauty

Wheelwright and Klah's collection is one of knowledge rather than artistic or ethnographic objects. When artifacts were gathered, they were obtained for their symbolic content and informational value.[65] Reproductions were made to fill in the gaps and were as valued as the originals. This does not mean that originals were not treasured. Wheelwright and Klah, like others of their generation, felt that Native American cultures were in danger and that it was the responsibility of all Anglo-Americans and Indians who could to collect and preserve objects of value as records of these cultures. Careful recording and preservation was an act of respect that would ensure that the world continued to operate according to the rules of the Holy People.

The museum's original collection consisted of field notes, painting reproductions, songs and prayers on tape, transcriptions, and Klah's jish (his medicine bundle and ritual paraphernalia). In 1931 Klah's apprentice and successor Beaal Begay died. Begay would have inherited Klah's ceremonial artifacts upon his death so that he could carry on his traditions. To ensure that Klah's ceremonies did not die with him, Wheelwright suggested to Klah that the jish be stored in a place where all could see and study it in a respectful manner. These sacred objects were transferred to the museum only after it had been blessed in the formal house blessing ceremony.

Klah also brought other Navajo artifacts for the museum. These included his grandfather's long war bow, puma-hide quiver, and three iron-tipped arrows, as well as his own rattles and prayer plumes, baskets, armbands, and amulets. Other religious materials included masks, prayer sticks, medicine bundles, rattles, and herbs. Wheelwright added items of Navajo art, including jewelry, basketry, and textiles, and made a comparative collection of similar artifacts from other Indian tribes, especially the Pueblos, as well as from Tibet, China, Japan, India, and New Zealand. In 1940 Wheelwright made a special trip to India and Tibet to study drypaintings to compare them to Navajo designs.

Wheelwright sought out other examples of ritual knowledge as well. Manuscripts for sixteen major chants with variations by different singers form the basis for these research collections. There were also manuscripts and research materials from other major scholars of Navajo religion and culture: Father Berard Haile, George Herzog, Harry Hoijer, Washington

Matthews, Maude Oakes, Gladys Reichard, and Leland Wyman. These included several unique ethnographic films of Pueblo and Navajo peoples and a comprehensive collection of Navajo and Pueblo music in more than 1,500 records. An extensive library of books and journals contextualized the collection. To ensure that the materials were properly categorized, Wheelwright hired anthropologists to label them and check translations and transcriptions to control quality and accuracy.

The collection contains more than 560 distinct Navajo sandpainting designs from all major Holyway and Blessingway chants. The numerous drawings, sketches, and paintings were produced by both Anglo-American scholars and Navajo singers. Newcomb copied more than fifty of Klah's sandpaintings; she placed 530 large and 360 small watercolor sandpainting reproductions in the museums, along with her collection of pottery and basketry and her journals and field notes. Because Newcomb placed the corpus of her lifelong endeavors in the museum, the collections date effectively from 1914 to 1958. Laura Armer, Henry Dendahl, Father Berard Haile, Van Muncy, Kenneth Foster, Maude Oakes, and Leland Wyman also contributed their sandpainting reproductions to the research repository.[66]

Other singers joined in the preservation effort as well, especially those who had no apprentices to study with them and who knew that upon their death their knowledge would be lost unless it was given to the institution. Sixty-eight enormous casein copies, eight feet square, were made for exhibition in the ceremonial chamber. These were eventually sent to reside inside the four sacred mountains that bound the Navajo homeland (Dinetah) at Navajo Community College in the 1970s. Here they serve as educational tools for the Navajo people.

Klah's sandpainting tapestries were also represented. He wove at least seven, and possibly thirteen, of the technically difficult rugs specifically for Wheelwright (fig. 7.4). These pictorial documents of sandpaintings from Hailway and Nightway each took approximately three years to produce. Klah also supervised his nieces, Gladys and Irene Manuelito, who made at least twenty-five and possibly as many as fifty other tapestries with designs from Nightway, Hailway, Shootingway, Mountainway, and Eagleway.[67] Klah especially liked the idea that the tapestries would be hung on the wall of some museum, according to Newcomb, for their proper home was in a locale dedicated to knowledge.[68] He blessed every one.

The materials in the Wheelwright Museum form a collection of beauty, since Wheelwright and Klah used Navajo concepts as their guiding principles. When viewing the museum in 1958, Franc Newcomb remarked:

Figure 7.4. Hosteen Klah, standing next to his tapestry, ca. 1927. Photograph by Franc Newcomb. Wheelwright Museum of the American Indian, Santa Fe, 60/136.

Here, in this beautiful and unique Museum are held the sandpaintings, chants, weavings and religious artifacts which Mary collected through the years. I am reminded of the twenty or more years when we wandered through the Navajo Reservation with Hasteen Klah. The Medicine men seemed to recognize in her an earnest desire to learn their rites and religion . . . by writing down an accurate translation of what she saw in a ceremony.[69]

In this instance of educational collecting it is the collection process itself and its purpose to document what Wheelwright called one of the most beautiful religions in the world that is most important. What marks the activity are the thoughts and dedication of those who participated in the undertaking rather than the amassing of things themselves to satisfy a personal quest to own beauty. The fact that it was done correctly, following Navajo dictates, establishes its value and makes it a harmonious form of cultural reproduction.

Wheelwright's legacy was an institution, but—more important—a body

of knowledge that is unique, symbolic, and beautiful. It captured the essence of *hózhó* in the harmonious interweaving of religion, art, and literature. On the twentieth anniversary of the museum, the Navajo people thanked Wheelwright for building the things of the spirit into visible and physical form in the Museum of Navajo Ceremonial Art. Tribal chairman Paul Jones also said that it was her courage and her deep awareness of Navajo spirituality that enabled her to accomplish so much so well. The museum is "a sort of religious shrine which religious students from all over the world have visited. Yet it is much more than that, for it is also a repository of a great wealth of information which will be kept safe for future generations of all those who are interested in studying the great beliefs and the rituals of my people. . . . The Navajo people will be forever grateful."[70]

## EDUCATIONAL COLLECTING

We tend to associate private collectors with an obsession to possess things. As Margery Akin has demonstrated, however, this is only part of the story.[71] In her work on private collectors and the formation of their collections, she has shown that the transformation of an assemblage of goods into a collection is motivated by a number of desires: to satisfy personal aesthetics, to enhance personal status, as an economic investment, to capture things (the thrill of the chase), and to make a connection with the past. To this we add the altruistic motives of preservation and education and the collector's desire to share what he or she has undertaken, and the knowledge that accrues, with others. Both Wheelwright and Seton left a valuable legacy as educational collectors; their passions to amass and save knowledge have enriched the lives of many individuals, although in different ways.

The two educational collectors shared, and in a very real way continue to share, their interest and knowledge with large audiences. Their activities, by amassing knowledge, are traditional in that they preserve and codify what had previously been ephemeral. At the same time, however, through their collecting and educating activities, these collectors acted as creators and innovators themselves. Educational collecting often involves first constructing an idea or an image and then, secondarily, amassing things. Collected objects tend to have evidential value that enables the collector to validate or authenticate the image being created, or to substantiate as data the knowledge to be conveyed to others. In this sense educational collecting is

Figure 7.5. Wheelwright Museum of the American Indian, Santa Fe, 1976.
Photograph by Herbert Lotz.

a form of cultural production as well as consumption, in which something
new is created. According to Belk et al., "collecting creates and produces a
unique, valued, and lasting contribution to the world."[72]

One of the new and valued contributions is unifying knowledge and its
inherent challenges to the world. Collecting and creating a new whole from
previously incomplete and scattered pieces challenges existing knowledge
while it preserves, and because of the authority inherent to the collector,
who is by definition a knowledgeable individual, it also alters our images.
Collecting, especially educational collecting, produces authoritative im-

ages. Building upon Charles Sanders Peirce's theories of semiology, Carol Hendrickson points out:

An image and what it represents contain within its standing-for relationship a judgment that, for somebody, under some circumstance, and for some particular purpose, the "degree of accuracy" of the representation is adequate or correct. In fact, if the image is accepted as so perfectly representing its object, the line between the two can become largely invisible and the image can be taken (or offered up) as actually *being* the thing.[73]

The images used in such representations can vary greatly, as can the representations that are accepted as reality. Through building collections and using those collections to educate others, both Wheelwright and Seton created images of the Native American peoples whose works they collected. Both used ethnographic detail, but to different ends. Seton selected bits and pieces from many different cultures in the creation of an ideal Indian life. Wheelwright concentrated her attention on the exotic and esoteric knowledge of Navajo religion and philosophy, reifying the whole of Navajo culture from a part (fig. 7.5).

Wheelwright created a concrete view of Navajo religion; the sandpaintings have come to represent the Navajo people. Seton, through his youth programs and writings, created an image of a generalized American Indian that continues to influence American popular consciousness even fifty years after his death. Through their acts of collecting, Wheelwright and Seton created images of American Indians that have come not only to signify the people but to *be* the Indians in American popular consciousness.

## Acknowledgments
The authors wish to thank Shep and Barbara, Ray Fogelson, Tsianina Lomawaima, and Nancy Davis for their thoughtful comments on drafts of this chapter. Stephen Zimmer, Annette Carlisle, and Wayne Baker at Philmont Museum have been extremely helpful, providing information, archival materials, photos, and generous access to collections; Jonathan Batkin at the Wheelwright Museum has likewise been helpful. Thanks also to Dee Barber for welcoming Karl to Seton Castle and providing important information.

## Notes
1. Ernest Thompson Seton, "The Seton Institute," *The Backlog* (ca. 1940), 9–15, 14.
2. Pierre Bourdieu, *The Field of Cultural Production: Essays on Art and Litera-*

*ture*, ed. and trans. Randal Johnson (New York and London: Columbia University Press, 1993), 41. See Barbara Babcock, ed., *Inventing the Southwest*, special issue of *Journal of the Southwest*, 32, no. 4 (1990), for an excellent analysis of Santa Fe as Southwestern mecca.

3. John Elsner and Roger Cardinal, Introduction to *The Cultures of Collecting*, ed. John Elsner and Roger Cardinal (Cambridge: Harvard University Press, 1994), 1–6, 1.

4. Ibid., 2.

5. Born Ernest Evan Thompson, he took the name of Seton because of his relationship to George Seton, Earl of Winton, to whom his father was supposed to be heir. H. Allen Anderson, *The Chief: Ernest Thompson Seton and the Changing West* (College Station: Texas A&M Press, 1986), 4–5; Ernest Thompson Seton, *Trail of an Artist-Naturalist: The Autobiography of Ernest Thompson Seton* (New York: Scribner's, 1940), 391–93.

6. Anderson, *The Chief*, 3–8.

7. Ibid., 15.

8. Ernest Thompson Seton, *Two Little Savages: Being the Adventures of Two Boys Who Lived as Indians and What They Learned* (New York: Grosset and Dunlap, 1903).

9. Anderson, *The Chief*, 18–20.

10. Seton, *Trail of an Artist-Naturalist*, 240–49.

11. Ibid., 164–67, 239, 252.

12. This was a quest that engaged many thoughtful bourgeoisie of the time. See Susan Stewart, *On Longing: Narratives of the Miniature, the Gigantic, the Souvenir, the Collection* (Baltimore and London: Johns Hopkins University Press, 1984); and T. J. Jackson Lears, *No Place of Grace: Antimodernism and the Transformation of American Culture, 1880–1920* (New York: Pantheon Books, 1981).

13. Anderson, *The Chief*, 41; J. H. Wadland, *Ernest Thompson Seton: Man in Nature and the Progressive Era, 1880–1915* (New York: Arno Press, 1978), 119–21.

14. Seton, *Trail of an Artist-Naturalist*, 289.

15. Anderson, *The Chief*, 58–62.

16. Frank M. Chapman, *Handbook of Birds of Eastern North America* (New York: Appleton, 1895); Frank M. Chapman, *Bird Life: A Guide to the Study of Our Common Birds* (New York: Appleton, 1900).

17. Anderson, *The Chief*, 29, 36.

18. Ernest Thompson Seton, *Wild Animals I Have Known* (New York: Scribner's, 1898); Seton, *Trail of an Artist-Naturalist*, 386.

19. Seton, *Trail of an Artist-Naturalist*, 376–78; Anderson, *The Chief*, 138.

20. Ernest Thompson Seton, "Ernest Thompson Seton's Boys," *Ladies Home Journal* 19 (May–November 1902).

21. Anderson, *The Chief*, 142.

22. Wadland, *Ernest Thompson Seton*, 337.

23. Ernest Thompson Seton, "Ernest Thompson Seton's Boys: Part 2, The Second Chapter on Tracks," *Ladies Home Journal* 19 (June 1902): 15.

24. Ibid.

25. Farida A. Wiley, ed., *Ernest Thompson Seton's America* (New York: Devin-Adair, 1954), xx–xxi.

26. Anderson, *The Chief*, 223.

27. Seton, *The Seton Institute*, 14.

28. Seton Institute, advertising flyer (a) for Seton camps (probably written by E. T. Seton and J. M. Seton), n.d.; Anderson, *The Chief*, 221.

29. Seton Institute, advertising flyer (b); Anderson, *The Chief*, 221.

30. Seton, *Trail of an Artist-Naturalist*, 261.

31. Anderson, *The Chief*, 67.

32. Unfortunately, here, as with most of Seton's collecting, there is no record of what objects were acquired during this trip.

33. David C. Cowles, "White Swan: Crow Artist at the Little Big Horn," *American Indian Art Magazine* 7, no. 4 (Autumn 1982): 52–61.

34. Ernest Thompson Seton, *The Arctic Prairies; a canoe-journey of 2,000 miles in search of the caribou; being the account of a voyage to the region north of Aylmer lake* (New York: Scribner's, 1911).

35. See especially Julia Moss Buttree, *The Rhythm of the Redman: In Song, Dance, and Decoration* (New York: A. S. Barnes, 1930).

36. Wadland, *Ernest Thompson Seton*, 326–27; Anderson, *The Chief*, 36–37, 146.

37. Karl A. Hoerig, "Ernest Thompson Seton and the Woodcraft Indians" (master's thesis, University of Arizona, 1995).

38. Seton, *Trail of an Artist-Naturalist*, 166.

39. F. Stanley Buff, "Inventory: Ernest Thompson Seton Collections," Seton Castle, Santa Fe, New Mexico, February 28, 1966, National Archives of Canada, Ottawa, Ontario.

40. Ernest Thompson Seton, "Organized Boyhood," *Success Magazine* 13 (December 1910): 804–5, 843, 849; Wadland, *Ernest Thompson Seton*, 406.

41. Woodcraft Rangers. *Woodcraft Is Lifecraft: Third Annual International Communication* (Santa Fe: Ernest Thompson Seton Institute, 1994), 10; Dee Barber, personal communication.

42. Claudia Boynton, "The Man Who Made Lobo Famous," manuscript, Philmont Museum and Seton Memorial Library, 6. Dee Barber, personal communication.

43. Walter Muir Whitehill, "Mary Cabot Wheelwright," *Dictionary of American Biography*, supp. 6, 1956–60, ed. John A. Garrity (New York: Scribner's, 1980), 687.

44. Helen Howe, *The Gentle Americans, 1864–1960* (New York: Harper and Row, 1965), 204–5. Howe relates many instances of Wheelwright's royal pronouncements. For example, "Of Cleveland Amory, who had ventured to write of Boston and Bar Harbor, she said with decision, 'He should be boiled in oil'" (213).

45. Whitehill, "Mary Cabot Wheelwright," 408.

46. Mary Cabot Wheelwright, "Memoirs: Journey Towards Understanding," Wheelwright Museum, Santa Fe, 1927–58, 7.

47. Ibid.
48. Barbara A. Babcock and Nancy J. Parezo, *Daughters of the Desert: Women Anthropologists and the Native American Southwest, 1880–1980* (Albuquerque: University of New Mexico Press, 1988), 175.
49. "Klah" is a translation for *tl'ah*, which means "left-handed" in Diné.
50. *Hatááli* are usually men because of the danger to unborn children; women who are of childbearing age do not risk endangering their children. Many postmenopausal women have been practitioners, and other women are diagnosticians. Because of this, we use the word *he* to refer to *hatááli* in this essay.
51. Franc Johnson Newcomb, *Hosteen Klah: Navajo Medicine Man and Sandpainter* (Norman: University of Oklahoma Press, 1964).
52. A *nadle* is a "Two-Spirit" person (berdache [*sic*]). The word means literally "being transformed" and constitutes a special status that is conferred on prestigious individuals who have hermaphroditic qualities or who live as transvestites. The *nadle* played an important role in Navajo mythology, and holders of the status are felt to possess special powers that are used for the benefit of the People (W. W. Hill, "The Status of the Hermaphrodite and Transvestite in Navaho Culture," *American Anthropologist*, n.s., 37 [1935]: 273–79). Klah combined both male and female characteristics and activities.
53. Gladys A. Reichard, *Navajo Shepherd and Weaver* (New York: J. J. Augustin, 1936), 167.
54. Nancy J. Parezo, *Navajo Sandpainting: From Religious Act to Commercial Art* (Tucson: University of Arizona Press, 1983), 27. Klah's main apprentice, Beaal Begay, died in 1931, and two other apprentices had died earlier. Klah never worked with another individual who would dedicate his life to learning his chants.
55. Gladys A. Reichard, *Navajo Religion: A Study of Symbolism*, Bollingen Series, no. 18 (Princeton, N.J.: Princeton University Press, 1963), 25.
56. Pictured in Newcomb, *Hosteen Klah*, 157–68. This textile was purchased by Mrs. King C. Gillette and was shown at the first Gallup Ceremonial in 1920; Parezo, *Navajo Sandpainting*, 47.
57. Wheelwright, "Memoirs."
58. Klah also performed parts of the Nightway ceremony over them after a late 1920s influenza outbreak.
59. Wheelwright, "Memoirs."
60. Babcock and Parezo, *Daughters of the Desert*, 175.
61. Mary C. Wheelwright and Hosteen Klah, *Navajo Creation Myth: The Story of the Emergence*, Navajo Religion Series, no. 1 (Santa Fe: Museum of Navajo Ceremonial Art, 1942), preface.
62. Wheelwright, journal entry, Wheelwright Museum Archives, 1949.
63. Wheelwright and Klah, *Navajo Creation Myth*, preface.
64. Wheelwright, "Memoirs," 64.
65. There is also the more traditional side to Wheelwright's collection. During the 1920s and 1940s she owned an Indian arts and crafts store in New York City. Here she arranged exhibits of Indian and Hispanic arts. She did this in part to ensure that these art forms would not die out and also to bring economic self-

sufficiency to Native peoples. Some of these objects were later accessioned in the museum collection. Wheelwright also collected Hispanic art. Her collection of pre-1900 altar cloths, tapestries, bed coverings, saints, and retablos was shown at the Brooklyn Museum in 1933. "Old New Mexican Art on View in Brooklyn," *New York Times*, March 12, 1933, 20.

66. See Parezo, *Navajo Sandpainting,* for a listing of other museums that contain Navajo sandpainting reproductions.

67. Leland C. Wyman, *Southwest Indian Drypainting* (Santa Fe: School of American Research, Albuquerque: University of New Mexico Press, 1983), 174.

68. Newcomb, *Hosteen Klah,* 157–59. Gladys is also known as Mrs. Sam and Irene as Mrs. Jim.

69. Franc J. Newcomb, 1958, journal entry, Wheelwright Museum Archives, Santa Fe, New Mexico.

70. Paul Jones, "Testament," *Santa Fe New Mexican,* December 4, 1956, Wheelwright Museum files.

71. Marjorie Akin, "Passionate Possession: The Formation of Private Collections," in *Learning from Things: Method and Theory of Material Culture Studies,* ed. W. David Kingery (Washington and London: Smithsonian, 1996), 102–28.

72. Russell W. Belk, Melanie Wallendorf, John F. Sherry Jr., and Morris B. Holbrook, "Collecting in a Consumer Culture," in *Highways and Byways: Naturalistic Research from the Consumer Behavior Odyssey,* ed. Russell W. Belk (Provo, Utah: Association for Consumer Research, 1991), 180.

73. Carol Hendrickson, "Images of the Indian in Guatemala: The Role of Indigenous Dress in Indian and Latino Constructions," in *Nation-states and Indians in Latin America,* ed. Gregory Urban and Joel Sherzer (Austin: University of Texas Press, 1991), 289.

# 8
# EVERY LAST DISHCLOTH

## The Prodigious Collecting of George Gustav Heye

I n the movie *Citizen Kane,* the protagonist's overweening ambition and acquisitiveness is epitomized in the word "Rosebud," which he utters on his deathbed. George Gustav Heye, like William Randolph Hearst, upon whom *Citizen Kane* was modeled, was an avid collector of objects. Hearst's tastes were notoriously eclectic, ranging from European castles to Indian artifacts. Heye's were almost obsessively focused on American Indian artifacts. He described the source of his passion as a "collecting bug" that bit him while he was working as an engineer on a railway building project in Kingman, Arizona. "One night I noticed the wife of one of my Indian foremen biting on what seemed to be a piece of skin. Upon inquiry I found she was chewing the seams of her husband's deerskin shirt in order to kill the lice." Heye bought the shirt and, in his words, "became interested in aboriginal customs." When he had the shirt, "I wanted a rattle and moccasins. And then the collecting bug seized me and I was lost."[1]

Heye's "collecting bug" is an enigma of personal motivation, the rationale upon which great private collections are built. The "bug" is documented in one statement that may be as enigmatic as Kane's "Rosebud." In the movie Kane's secret is revealed in the final scene of the sled in the snow, but there is no such revelation for the source of Heye's passion. It produced one of the world's great collections of material from Native American cultures, approximately one million objects, from exquisite Eskimo carved ivory to textiles from the Yamana (Yahgan) people of Tierra del Fuego at the tip of South America, but an anthropologist who knew Heye well ob-

served, "He didn't give a hang about Indians individually, and he never seemed to have heard about their problems in present-day society. . . . George didn't buy Indian stuff in order to study the life of a people, because it never crossed his mind that that's what they were. He bought all those objects solely in order to own them—for what purposes, he never said."[2]

Heye left written records of his collecting in correspondence with his staff, individuals in other institutions, and annual reports of the board of trustees of his museum, but these reveal little of the man. The correspondence deals mainly with business matters. A few personal recollections surface in accounts by those who knew him, such as a memory of collecting Indian arrowheads around his family's summer home in New Jersey. His father had a passion for collecting clocks, but young George was so annoyed by their constant chiming that throughout his life he refused to have clocks anywhere near him.[3]

There may be a clue to Heye's passion in the cultural milieu within which he grew up. His fascination with American Indian cultures may have had something to do with the Germanic fascination with Indians inspired by the novels of Karl May. May's heroes—Old Shatterhand, the white protagonist renowned for his marksmanship and incredible self-sufficiency, and his faithful friend Winnetou, chief of all the Apaches—spoke deeply to a German public seeking a sense of national identity.[4]

May was the son of a poor family, a convicted felon who spent time in prison and whose knowledge of Indian cultures was gained from books in the prison library.[5] George Heye, on the other hand, was the scion of a wealthy family, raised in a privileged environment, but one with a strong sense of German identity. He was born in 1874 in New York City. His parents were Carl Gustav Heye, a native of Germany, and Marie Antoinette Lawrence, whose family went back several generations in New York State. His father made his fortune in the oil business, developing the Economy Refining Company, which he ultimately sold to John D. Rockefeller's Standard Oil Company, where he became a corporate officer. The senior Heye became a member of the Germanic Society in 1867 and was its first vice president, serving from 1888 to 1896. He made frequent trips to Europe for business, and he often took his family with him.[6]

The young George Gustav Heye may well have been exposed to the influence of Karl May's novels. There may be some resonance in the fact that Old Shatterhand in *Winnetou I* was introduced to the West by Mr. Henry, a gunmaker who gave him two exceptionally powerful, high-capacity weapons and set him up with a position on a surveying crew for the railroad

that was moving west.[7] Heye began his working life as an engineer, graduating from the School of Mines of Columbia College with a degree in electrical engineering in 1896 and becoming superintendent of a crew constructing a branch rail line to a mine near Kingman, Arizona. Part of the crew were Navajo laborers; it was from the wife of one of those men that he acquired the deerskin shirt mentioned above.[8] Although there is no evidence that Heye read May's novels, the influence of Winnetou and Old Shatterhand makes for interesting speculation. Heye returned to Europe frequently on collecting trips to European museums and dealers until 1938. After that year he could not countenance the devastation caused by World War II.[9]

Heye grew up in an era when Indians were exhibited regularly as examples of America's past or of primitive types in a great evolutionary chain of human progress. Buffalo Bill's Wild West Show displayed them as fearless warriors who had to be overcome to assure the security of American culture.[10] The Darwinian theory of evolution had been extended to human populations, creating a scientific paradigm of human progress within which Indians represented a primitive type. Samuel G. Morton had already begun to compare the skulls of different racial populations and had determined that Caucasians were superior because of their greater brain capacity. His work formed the basis of the science of phrenology, which was fostered in part by the collection of Indian skulls from battlegrounds on the Great Plains.[11]

In 1876, the centennial of the Declaration of Independence and the year of George Armstrong Custer's defeat at the Battle of Little Big Horn, Americans celebrated their freedom, their technological and material progress, and their racial and cultural superiority over other nations in a series of great fairs and exhibitions. The Centennial Exhibition in Philadelphia demonstrated the nation's progress since its founding by exhibiting Indian cultures as part of its savage past.[12] The World's Columbian Exposition in Chicago in 1893 celebrated the four hundredth anniversary of Christopher Columbus's first voyage, firmly establishing its place in the myth of America's past.[13] The exposition included exhibits of native cultures from around the world, including native "villages" on the Midway. The performance of the Sun Dance, which involved piercing the skin of two Indian men, tying the flesh to a pole with heavy twine, and having them dance till they broke loose, titillated the public and appalled missionaries who thought they had civilized their converts.[14] Frederick Jackson Turner's address to the American Historical Society at the exhibition defined a new paradigm of scholar-

ship in which Indians were cast as an opposing force against which American society had shaped itself.[15] The Columbian Exposition, only three years after the army's massacre of more than three hundred Sioux at Wounded Knee, South Dakota, reinforced ideas of racial and material progress on an evolutionary scale and validated notions of Indian primitiveness and white superiority.[16]

Museums also promoted the display of Indians as objects of scientific curiosity.[17] In New York City, Heye's home, a civic paranoia about the lack of a major museum such as the Smithsonian Institution in Washington or the University Museum in Philadelphia led to the establishment of the American Museum of Natural History in 1867. Morris Jessup, second president of the museum, was fascinated with the question of the origin of American Indians, and he sponsored expeditions that circled the northern part of the globe exploring the possible Asian connections. Through scientific expeditions and the collecting work of Franz Boas, one of the museum's curators, and George Emmons, an officer in the U.S. Army, the museum acquired significant collections of American Indian material during the late 1800s.[18]

Heye was the product not only of American society seeking its own vision of the past but of a particular place, New York City. The city's civic pride put it in competition with other cities where major museums were already established. Heye was also shaped by a particular social environment in New York—the wealthy intellectual elite, many of German descent, who supported the arts and cultural institutions of the city.[19] We do not know the extent to which the circumstances of his upbringing and early youth inspired Heye's personal interest in American Indians. What we do know is that it produced one of the world's preeminent collections of objects from tribes throughout North, Central, and South America.

In 1901, Heye helped form the investment banking firm of Battles, Heye, and Harrison, with offices in Philadelphia and New York, but he also continued to collect, and his interest in Indian cultures expanded. He had become acquainted with Joseph Keppler, who had developed a deep interest in the Iroquois Indians through his friendship with Harriet Maxwell Converse, a champion of Iroquois political rights. In 1899 he accompanied Keppler on a visit to the Cattaraugus and Tonawanda Reservations, the first of many such trips.[20] Heye's acquisitive passion was taken in hand by Marshall H. Saville, the newly appointed Loubat Professor of American Archaeology at Columbia University, and George H. Pepper, then on the staff of the American Museum of Natural History. Heye, the inquisitive and acquisitive amateur, was eager to gain both objects and knowledge.

Through his association with Saville and Pepper, he began to learn the importance of systematic collecting, scientific recording, and preservation, although his early record keeping was certainly lacking, according to later museum standards.[21]

Saville saw "valuable magpie tendencies" in Heye and decided that they could be nurtured for the support of archaeological and scientific research. Saville and Pepper "put Heye on to a cache of several hundred pre-Columbian pots that had been found recently in a New Mexico canyon."[22] Heye acquired this major collection of pottery from Tularosa Canyon, Socorro County, New Mexico, from Harry E. Hale in 1903. The following year he bought another large collection from the San Juan region of Arizona.[23]

Heye entered the collecting field at a crucial point, when interest in Indians as objects of curiosity had begun to decline. The nationalistic tendencies that had inspired the great fairs and exhibitions of the late 1800s were turning to imperialistic tendencies, with the Spanish-American War and the country's entry into the arena of world colonialism. Public interest focused on other exotic cultures, and Indians were no longer so attractive as symbols of American superiority. Public museums largely ceased collecting North American Indian materials during the early twentieth century.[24]

In 1907 delegates of the American Anthropological Society declared at their meeting that "the part of the world in which investigation is most urgently needed is South America," because that continent had been "in recent geological periods farther remote from the great land masses of the Old World than any other continent." The physical distance raised questions about the "racial and cultural development in this continent," and "contact between this remote area and other parts of the world," that were "of the most fundamental theoretical importance for the science of anthropology."[25]

As a collector, Heye was in the vanguard of interest in South America. In 1904 he sponsored expeditions by George Pepper to Michoacán in Mexico and Frank Utley to Puerto Rico, but he also continued to collect extensively in North America, and he subsidized a good deal of the research being carried out in North American archaeology and ethnography.[26]

Heye's wealth and interest in collecting attracted the attention of Franz Boas, head of the anthropology department at Columbia University. Boas had collected Northwest Coast material while conducting ethnographic fieldwork in his position with the American Museum of Natural History (and before). He left the museum in 1905 and joined the faculty of Colum-

bia University, where he was a key figure in establishing anthropology as an academic discipline. To supplement his income and his own ethnographic work, he began selling parts of his personal collection. When the Museum of Natural History did not respond to his offer of a whale hunter's house from Vancouver Island, he approached Heye as a potential buyer.[27]

Boas's plans for the anthropology department at Columbia were ambitious, but institutional support was not particularly strong. His primary interest was not in collecting but in ethnographic work on languages and mythology, which he considered key to understanding cultural differences. He had begun a collaboration with George Hunt, an educated Tlingit/English man who had grown up among the Kwakiutl, to collect descriptions of Kwakiutl ceremonies, tribal beliefs, and oral traditions, but he needed to find a way to pay Hunt. He hit on the idea of having Heye commission Hunt to collect artifacts. Heye responded favorably, asking that Hunt collect "good old material and none of the commercial specimens the Indians are now making." He also asked for "full particulars as to the specimens." Boas also solicited Heye's interest in James Teit's collecting efforts in British Columbia.[28]

Having established a relationship with Heye, Boas solicited Heye's financial support for the department of anthropology at Columbia, "an amount of a few thousand dollars" annually, to be devoted to funding "opportunities for study for our students." He emphasized the urgency of training in anthropology because "the sources from which we can draw information are dwindling away with alarming rapidity. The earliest history of our country can be obtained only from a study of the Indian tribes and of their archaeological remains. Many of these tribes are on the verge of extinction, and others are so rapidly being civilized that the old knowledge will be a matter of the past within a few years."[29]

Heye did not commit to an annual subsidy for Boas's department, but he did provide financial support in the form of funds that he solicited from his mother for Marshall Saville's expedition to sites in Manabi, Ecuador. George Pepper oversaw the excavations. Saville planned an entire South American research program that Heye could support.[30] By this time, Saville was devoting his efforts virtually full-time to Heye's interests, although he was still a full-time faculty member at Columbia. His work may have promoted the research that Boas was trying to encourage for the anthropology department at Columbia, but the relationship between Heye and Saville would cause difficulties.

In his private life, as a member of New York high society, Heye married

in proper fashion in 1904 and moved into an apartment at 667 Madison Avenue with his new wife, Blanche Agnes Williams, of Wellesley Hills, Massachusetts. They entertained lavishly, surrounded by the growing collection of Indian artifacts. Having found a source of material in other people's collections, he bought extensively, and by 1906 he had acquired more than thirty thousand objects, ranging from archaeological stone gorgets from Ohio to pottery from Michoacan to gold objects from Ecuador to stone objects from St. Vincent in the Caribbean.[31]

To house the collection he rented a room in the Knabe Building at Fifth Avenue and Thirty-ninth Street. Even with objects overflowing his apartment, Heye was interested in acquiring material from Alaska, and, in 1907, he signed an agreement with George B. Gordon, director of the University Museum of the University of Pennsylvania. He would support Gordon's research and collecting expedition to Alaska in exchange for duplicates of objects that Gordon collected.[32]

Gordon, like Boas, saw Heye's interests and resources as a way to collect for the University Museum, but Heye's resources as a major benefactor made him a distinct player in the museum's decision-making processes and an arbiter of its research agenda. He was elected vice president, a member of the Board of Managers, and president-chairman of the Committee on the American Section. The museum also provided Heye with the opportunity to display his collection. On February 12, 1910, three large halls filled with Heye's objects opened to the public (fig. 8.1).[33]

Heye also supported the museum's training program in archaeology and ethnology by paying salaries for students and curators. Daniel Brinton had been appointed professor of American linguistics and archaeology at the university in 1886, and its Museum of Anthropology and Ethnology was established in 1889 under the direction of William Pepper. Its academic program was a crucial training ground for new professionals in the emerging field of anthropology.[34] Graduate students Wilson Wallis and William Mechling collected ethnographic materials among the Mi'kmaq and Maliseet under Heye's sponsorship. George Pepper, Mark Raymond Harrington, William Orchard, and Frank Speck were hired as curatorial assistants, their salaries and field expenses paid in whole or in part by Heye. Pepper conducted archaeological excavations in Michigan. Orchard worked among the Sioux. Speck went to the Penobscot, and Speck and Wallis collected material from the Nanticoke in Delaware.[35]

As a member of the Committee for the American Section, Heye set the research agenda for the museum. In 1911 Heye, Gordon, and Frank Battles,

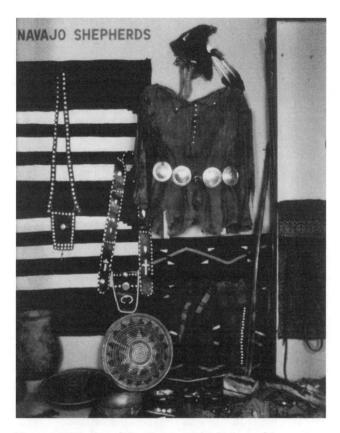

Figure 8.1. Display of Navajo material, Museum of the American Indian, 155th Street at Broadway, New York City. The exhibit was installed about 1960. Photo Archive, George Gustav Heye Center, National Museum of the American Indian, New York City.

Heye's banking partner and a member of the committee, met and decided that Native tribes in both North and South America were disappearing at an "accelerated rate." The museum must collect both artifacts and ethnographic data from all these disappearing cultures, but primarily from those in South America. The University Museum had little material from that area, but Heye's money and his agenda for collecting might make up the deficiencies.[36]

Heye also acquired significant collections from the University Museum. Gordon, as agreed, shared the results of his Alaskan expedition, but he also

gave Heye a number of other artifacts—a painted Osage buffalo hide, Mandan pottery, a shield collected by George Catlin, a Tsimshian chief's armor, Makah masks and rattle, Kwakiutl and Haida material collected by Stewart Culin and C. F. Newcombe, and prehistoric wood and shell artifacts from Frank Cushing's Key Marco collection in Florida.[37]

Heye pursued his own research agenda as well. He sponsored S. A. Barrett's work with the Chachi (Kayapo) Indians of northwestern Ecuador in 1908–9. Barrett went on to become the director of the Milwaukee Public Museum.[38] Heye also paid for Thomas Huckerby's archaeological survey in the West Indies.[39]

In 1908 Heye began to build his own professional staff by hiring M. R. Harrington, a young M.A. graduate from Columbia University. He offered him $100 a month plus expenses, but Harrington held out for $124 because he had a wife to support, and Heye finally agreed. Harrington became one of Heye's most productive collectors, working with the Mohegan in Connecticut, the Pamunkey and Mataponi in Virginia, the Cherokee in North Carolina, the Catawba in South Carolina, and the Seminole in the Everglades of Florida. He sent back material from the Choctaw of Mississippi and Louisiana, the Chitimacha, Houma, and Koasati in Louisiana, and the Alibamu in Texas. When he returned from the field, Heye sent him to the University Museum in Philadelphia to take care of his collection there.[40]

In 1912, Heye hired Theodoor de Booy, who carried out expeditions to the Bahamas and Caicos, Jamaica, Santo Domingo, eastern Cuba, Margarita, Trinidad, the Dutch Indies, and the Virgin Islands.[41] From 1911 to 1914, Saville conducted expeditions to Guatemala, Honduras, British Honduras, and Costa Rica.[42]

Heye's preoccupation with his collection finally led his wife to sue for divorce in 1912.[43] A perhaps apocryphal story that still circulates among staff members at the National Museum of the American Indian in New York City, the present repository of Heye's collection, is that when his wife threatened to divorce him, declaring that he had to choose between her and the collection that crowded their apartment, Heye helped her pack her bags.

By 1914, bereft of wife, Heye also withdrew from his banking firm entirely. He rented a floor of a loft building at 10 East Thirty-third Street to accommodate his collection.[44] From that time onward, he was a full-time collector, and for the rest of his life he devoted his time and his fortune of approximately ten million dollars to acquiring his collection.

He had previously bought from others and sent out expeditions, but he

now began collecting personally. His passion was archaeology, and he made his first major foray into the field with George Pepper in 1914. They excavated an Indian cemetery in New Jersey, and he discovered a major hazard of fieldwork when he found himself and his assistants charged with grave robbing by a New Jersey court. He was found guilty and fined one hundred dollars. He appealed the decision, not because of the money but because of principle, and was finally acquitted. He saw his arrest as a legal threat to archaeological research, and his eventual acquittal as a precedent to free archaeologists to excavate human remains in the future.[45]

The excavation gave Heye a new entrée into the professional world of anthropology and archaeology. He sent the skulls and other skeletal material that he had excavated to Aleš Hrdlička, curator of physical anthropology at the U.S. National Museum of the Smithsonian Institution, for identification, with the suggestion that he could deposit the bones in the natural history collection. The prospect pleased Hrdlička greatly, since he had established himself as a leading student of human evolution, and "our need of skeletal material," he said, was "a very great one."[46]

Heye also sent Hrdlička his paper on the site and asked him to present it at the International Congress of Americanists. He was sensitive to the publicity that surrounded his arrest for grave robbing and did not wish to appear at the Congress himself. He was pleased with Hrdlička's praise for the thoroughness of his work, but Hrdlička also saw Heye as a potential benefactor of his own work and he suggested that Heye might help him acquire a group of Huron skulls for "a very moderate sum." Heye, however, could not "do anything toward the Huron material," citing lack of funds.[47]

Heye's collecting skills had benefited from his association with Saville and Pepper, and his collection itself benefited from his association with the University Museum in Philadelphia. His mother had generously subsidized her son's interests through Saville's expedition in 1906. Heye finally came into his own as a collector when his mother died on February 18, 1915. Her death gave him full control of the family fortune, and he now had the resources to develop his collection in the way he wanted.

In 1915 he undertook a new project, married a second time, and hired a new employee. Heye's interest had been piqued by reports of a mound in North Carolina, and he hired Charles Turbyfill, owner of the local livery stable in Henderson, North Carolina, to drive him to the home of Jim Plott, owner of the land on which the mound was located. When Plott refused to allow Heye to excavate, it was Turbyfill who convinced Plott that he should agree. "Jim," he said, "it'll give my horses work. And you can rent him your

plows." Turbyfill stayed with Heye as a field-worker, and after the excavation was completed, he moved to New York as custodian of Heye's collection, which he came to know perhaps more intimately than did Heye himself.[48]

Heye's new wife shared his interest in collecting and became a lifelong contributor to his collection. He had married Thea Kowne Page in Atlanta on July 8, 1915, and took her to the site of his latest excavation, the Nacooche mound in Georgia. The new Mrs. Heye spent most of her honeymoon in blue jeans at the dig.[49] The mound also produced a new publication to add to Heye's growing reputation in the field of archaeology, as well as more skeletal material, which he sent to Hrdlička via parcel post.[50]

Heye had established his standing as an amateur but skilled archaeologist. He also sent others into the field. M. R. Harrington went to eastern Cuba in 1915 for an expedition that enriched both the collection and the scholarship on the aboriginal populations of the Caribbean. In 1916–17, Harrington's assignment was the excavation of a series of caves and mounds in southwestern Arkansas.[51]

With complete financial independence and a wife who shared his passion, Heye was in a position to realize his great ambition to create his own museum in New York City. News of his decision created major consternation in both New York and Philadelphia. Franz Boas was appalled. He had hoped above all that Heye would put his magnificent collection in the American Museum of Natural History, where it would complement material that Boas had been in part responsible for collecting and where scientific research supported by both the museum and Columbia University could take place. His ambition was to establish anthropology as a science at Columbia University, through both field research and the training of students, and that ambition hinged on a plan to establish a great collaborative effort between the American Museum of Natural History and Columbia University. He had cultivated Heye as a collector and a patron of his own work, and through his efforts Heye had acquired major collections from the Northwest Coast. He had also offered Heye the opportunity to acquire material from Mexico if he would become a patron of the International School of American Archaeology and Ethnology that Boas was establishing at Columbia. The school would train collectors, and patrons could acquire the results. Heye declined Boas's invitation, citing the financial state of his business.[52]

When Boas found out about Heye's plan to establish his own museum, he mounted an intense campaign to change his mind. "It seems to my mind

that the permanent interests of anthropology would not be best served by the establishment of a new independent museum of the kind that I understand you are planning."[53] He also undertook a vigorous effort to promote a grand alliance of all the major museums and cultural organizations in New York. He persuaded the board of aldermen of the city to offer Heye land adjacent to the American Museum on which to build, and Henry Fairfield Osborn, president of the museum, wrote to Heye to offer laboratory space and access to collections.[54]

Heye, the self-made anthropologist, was straightforward in his response to Boas:

When I started my collections I was in business downtown. . . . When I endeavored at my leisure hours . . . to find some place to go where I could at least be directed in the science I wished to take up, I found that there was no place in the city where a man could go and get elementary training, or in fact, any training at all unless he entered a regular college course.[55]

Although he had subsidized academic training in anthropology at Columbia and the University of Pennsylvania, it offered no opportunities to men like himself, businessmen with an interest in anthropology but no time for a college education. "Since there are many men in New York that are placed as I was," he would establish "an institution that is open to them in the evening where they can be taught at least the rudiments of Anthropology."[56]

Boas persisted. "The interests of science, the interests of education, and those of the city, would be best served if a way could be found of uniting your efforts with those of the American Museum of Natural History."[57] Heye's response was brief. "But rather than go into a long and useless discussion, I will fall back on the sentence in your letter which I hereby quote 'It is obvious that nobody can deny that you have the right to do with your money as you please.'" Heye thus declared that "the discussion is ended."[58] And Boas had to inform Columbia University's president, Nicolas Murray Butler, that "the gist of the matter is that Mr. Heye declines to co-operate with the American Museum of Natural History."[59]

In Philadelphia, George Gordon, director of the University Museum, was dismayed when Heye told him that he was withdrawing his collection from the museum. Gordon had understood that Heye's collection would be a permanent part of the museum, and he had collected around its strengths in American Indian materials. To mollify Gordon, Heye agreed to exchange objects from his collection for objects in the University Museum's collec-

tion. Gordon was further dismayed, however, when the objects that Heye sent were of poor quality—large, crudely made things decorated with what appeared to be house paints. Heye described it as representative of "the ordinary run of the collection," but it could not replace what Heye had gained through his association with Gordon.[60]

Heye's ambition became a reality with the establishment of the Heye Foundation and the Museum of the American Indian in 1916. His collection would have a home and a tax shelter as the property of the foundation's board of trustees, men like himself, whose wealth allowed them to collect Indian artifacts but who did not have the time for the academic study of anthropology. The land for the new museum was located at 155th and Broadway, in an elegant upper Manhattan neighborhood on land donated by trustee Archer M. Huntington, son of financier Collis P. Huntington. Huntington was deeply interested in the culture of Spain and had established the Hispanic Society, which was housed in a building on the site where Heye's new museum would be built. The complex also included the Geographical Society and the American Academy of Arts and Letters. Heye's museum could thus take its place among some of the leading cultural institutions in New York, and in the country.[61]

The trustees were members of the New York City elite with whom Heye had grown up. James B. Ford, a vice president of United States Rubber Company, gave generously to the development of a library for the museum and contributed a collection of seventeen turquoise mosaic objects—wooden shields, masks, and an ear ornament, a unique colonial Inca textile, Eskimo ivory carvings, Mayan vases from British Honduras, archaeological collections from the California Channel Islands, and Cree ethnology.[62] Minor C. Keith, a founder of the United Fruit Company, gave his collection of pre-Columbian pottery from Guatemala and Costa Rica.[63] F. Kingsbury Curtis, an attorney, gave a portfolio of George Catlin's drawings. Harmon B. Hendricks, a friend of Heye's father, gave William Penn wampum belts, gold objects from Colombia, and textiles from the Southwest and Mexico.[64] Ford and Hendricks were the major financial supporters for Heye's newly developing staff of archaeologists and ethnographers. Their yearly gifts constituted the bulk of Heye's payroll.

The opening of the new museum was delayed by the nation's entry into World War I. The cornerstone was laid in November 1916, but the neighboring American Geographical Society occupied two floors of the new building to make maps for the navy, and the opening of the museum's displays to the public did not occur until 1922.[65]

Figure 8.2. George Gustav Heye Collection of North American ethnology exhibited in the University of Pennsylvania Museum shortly after installation in February 1910. University of Pennsylvania Museum, Philadelphia, neg. G6-14359.

The museum's objective was ambitious: "the preservation of everything pertaining to our American tribes." The founders hoped the museum would assure that "the History of our primitive races may receive the attention that it deserves and that the proper facilities for the study of American anthropology may be presented to the scientist and general student in the proper way. It would thus be unique in the annals of anthropological work in this country" (figs. 8.2 and 8.3).[66]

After the establishment of his museum, Heye launched new research efforts. Minor Keith's collection of Meso-American pottery became the basis for a major monograph by Samuel Kirkland Lothrop on pottery types.[67] M. R. Harrington excavated in Arkansas in 1916–17 and in 1922–23 and discovered a number of important prehistoric rock shelters along the White River. In 1924 he excavated Lovelock Cave in Nevada in cooperation with the University of California. The cave produced a cache of duck decoys dating to about A.D. 200, the oldest examples of such decoys in the world.[68]

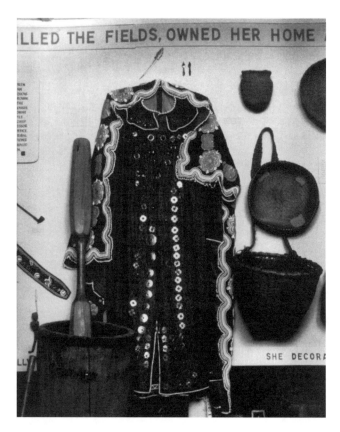

Figure 8.3. Display of Iroquois material, Museum of the
American Indian, 155th Street at Broadway, New York City.
Photo Archive, George Gustav Heye Center, National Museum
of the American Indian, New York City.

Having established a museum with a purpose to educate the business
elite of New York, Heye began to model it upon other institutions. He cre-
ated a department of physical anthropology, in keeping with its scientific
mission. His staff included his brother-in-law, James B. Clemens, a physi-
cian interested in anthropology whom Heye had sent off to study with
Hrdlička at the Smithsonian.[69] He also hired Bruno Oetterking, a newly
appointed member of the anthropology faculty at Columbia University, to
work with Clemens on a plan for the development of the department. Heye
announced the opening of the department, housed at 11 St. Nicholas Place,
its objective being to meet "all the modern demands of that science [physi-

cal anthropology]," and to carry forward the work, Heye announced, "We will be most grateful for any specimens of human and comparative skeletal material . . . we will be willing to make exchanges from our duplicate collections."[70] Clemens was a major benefactor for the department, and Heye's announcement listed him and Oetterking as the department's staff.[71]

Heye knew that a museum must also make its presence known in the scholarly world by its publications. In 1918 Archer Huntington established a publication fund, and Heye hired Frederick Webb Hodge away from the Bureau of American Ethnology at the Smithsonian Institution. Hodge had edited the publications of the bureau and was a major figure in the scholarly community. As the foremost editor in the field of anthropology and ethnography in the country, he brought significant prestige to the Museum of the American Indian. The new publication series consisted in the beginning of reprints of reports of research published in other journals. Because Heye had sponsored much of the research, he could reprint it, but as the museum's staff moved out into the field, their reports provided a rich body of information for publication.[72]

James Ford established a library for the museum by buying the personal libraries of Marshall Saville and Frederick Webb Hodge and donating significant works such as Charles Kingsborough's *Antiquities of Ancient Mexico,* the seventy-three-volume edition of *The Jesuit Relations,* and a second edition of John Eliot's Algonquian Bible. Archer Huntington gave the library an album of original watercolors of Indian scenes by George Catlin.[73]

The flush days after 1916 resulted in a heyday for archaeological and ethnographic research. Heye hired Foster H. Saville, Donald A. Cadzow, William C. Orchard, Frank D. Utley, E. J. Bush, and Edwin F. Coffin. Jesse L. Nusbaum joined the staff in 1918, and Marshall Saville finally left Columbia to become a full-time member of Heye's staff in 1918. Melvin Gilmore and Samuel K. Lothrop were hired in 1923.[74] Heye also hired Amos Oneroad, a Dakota man, who became a close collaborator with Alanson Skinner and brought some of his personal possessions to loan to the museum.

Hodge's editorial skills produced the early numbers of Indian Notes and Monographs and the Contributions from the Museum series. Heye's collectors fanned out across North and South America. Alanson Skinner went to Wisconsin to collect objects and ethnographic data from the Menominee. Hodge and Jesse Nusbaum worked with the Havasupai of Cataract

Canyon in Arizona. T. T. Waterman collected material from the Indians of Puget Sound. Donald A. Cadzow led an expedition to the Mackenzie River delta in 1917–18.[75]

The museum's trustees were generous with their support. Harmon Hendricks funded Frederick Hodge's expedition to an ancient site near Zuni Pueblo (fig. 8.4). Hodge directed fieldwork at Hawikuh intermittently from 1916 through 1923, hiring Zuni workers for his teams. The excavation revealed the ancient sources of Zuni culture.[76] T. Coleman duPont subsidized an expedition by Jesse Nusbaum to a Basketmaker site in Kane County, Utah, in 1920.[77] A. Hyatt Verrill collected ethnographic material from Araucanian groups in Chile and the Pano and Changa in Bolivia and Peru in 1924–25. In 1925, S. K. Lothrop conducted archaeological excavations in the Parana delta of Argentina.[78] John Peabody Harrington excavated Indian graves on San Miguel Island off the California coast. Heye had to prod him to send the skeletons that he dug up, and he disagreed with Harrington

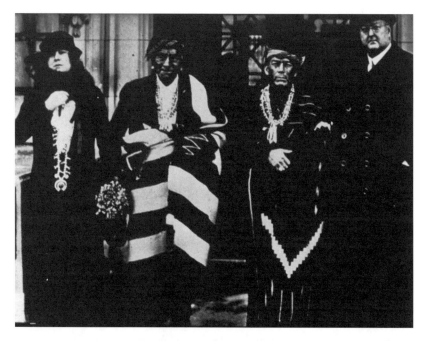

Figure 8.4. George and Thea Heye with Zuni Indians in front of the Museum of the American Indian in 1923. Photo Archive, George Gustav Heye Center, National Museum of the American Indian, New York City.

on the classification of the skulls in an evolutionary scheme, but he took the remains into the collection.[79]

Heye also exercised his financial power by funding the collecting expeditions of other museums. J. Walter Fewkes of the Bureau of American Ethnology at the Smithsonian Institution conducted archaeological explorations in St. Vincent and Trinidad in the West Indies.[80]

The collection was rapidly outgrowing the museum's facilities at 155th Street and Broadway. In 1926 Archer Huntington donated six acres of land in the Bronx and subsidized construction of a building in which to store it. The new facility opened on November 15, 1926. Thea Heye and Melvin Gilmore, an ethnobotanist, planted a garden of indigenous herbs on the grounds, and Mrs. Heye oversaw the construction of several concrete tipis and a Seneca bark house.[81] The museum also subsidized ethnographic research on living Indian cultures. William Wildschut studied the religions of northern Plains tribes, during the course of which he acquired more than three hundred medicine bundles from the Crow, Blackfoot, Shoshoni, and Arapaho.[82] In 1928, however, financial disaster struck. In March, two of Heye's major board members and benefactors, James Ford and Harmon Hendricks, died within two days of each other. Although they provided for the museum in their wills, the immediate cash flow for salaries ceased abruptly, and Heye fired his staff summarily. The scientific work of the museum came to a halt. Jesse Nusbaum was outraged at his treatment, but Mark Raymond Harrington remembered Heye fondly.[83]

Just as Heye had used his wealth to collect other people's objects and other institutions' staff, other collectors and museums picked off Heye's staff. Rudolf Haffenreffer hired Foster Saville to help develop his collection and his museum in Bristol, Rhode Island.[84] Frederick Hodge left for the Southwest Museum in Los Angeles.[85] Heye had learned much from his staff, but having dismissed them, he was on his own. He continued to collect from others. In 1929 he acquired C. B. Moore's collection of material from southeastern Mound sites from the Philadelphia Academy of Science. He flattered Moore, one of the trustees of his museum and a noted archaeologist: "I believe you have done far more for American archaeology than any other one man." The acquisition was in the form of a loan, but it was obvious that Heye considered it an addition to his collection. The academy's curator resigned in a fury over its loss, citing the blow to the academy's prestige and that of the city of Philadelphia, but Heye acquired a preeminent assemblage of Southeastern archaeological material.[86]

He could still support some archaeological expeditions. Edward F. Cof-

fin excavated rock shelters in Bee Cave Canyon, Texas, in 1929. Museum trustees Henry Lee Ferguson, Willard V. King, and Blair S. Williams supported archaeological excavations in New Jersey and Lancaster, Pennsylvania, from 1932 to 1934. Captain Bob Bartlett led an expedition to excavate at Angmagssalik and Scoresby Sound in East Greenland in 1930, and Junius Bird excavated at Cape York, Melville Peninsula, and Southampton and Igloolik Island in 1932–33.[87] And in 1940 Heye acquired a significant amount of material from the collection of Phoebe Apperson Hearst, William Randolph Hearst's mother.[88]

Heye was conscious of the public relations image of the museum with regard to the Indian people whose material culture he collected so passionately. In 1938 two members of the Hidatsa tribe requested the return of a tribal medicine bundle called the Water Buster that Heye had acquired in 1907. Their reservation on the Northern Plains was in the grip of a severe drought, and the bundle was believed to have the power to bring rain. After an exchange of correspondence in which Heye proposed that he would return the bundle in exchange for some artifact of similar value, he finally agreed to the return (fig. 8.5). Two elderly Hidatsa men, Foolish Bear and Drags Wolf, traveled to New York to recover the Water Buster, but what Heye gave them was individual items that he said were contents of the bundle. Museum records reveal that they were indeed not from the Water Buster and that the actual bundle was not returned to the tribe until much later. Heye's biographer made much of the ceremony that accompanied the return with speeches and the smoking of a pipe, the Hidatsa elders in full tribal regalia, but the ceremony was bogus, although Mason reported delightedly that after the return, rain did fall on the Hidatsa reservation.[89]

Heye also continued his own collecting trips on a regular basis. He traveled by car through Indian reservations in the West and, as an associate put it, "At a reservation, the ordinary cultivated collector will select nothing but the tribe's best Sunday-go-to-meeting things, while the everyday scientist will spend his money frugally on a few highly significant objects. But George would be fretful and hard to live with until he'd bought every last dirty dishcloth and discarded shirt and shipped them back to New York."[90]

When Heye died in 1956, he left a collection of objects that represent both the highest artistic expressions of Indian cultures and the evidence of everyday life. Heye had what any museum director in contemporary America would want—a remarkable collection and the resources to promote its growth. When major American museums turned their collecting attention

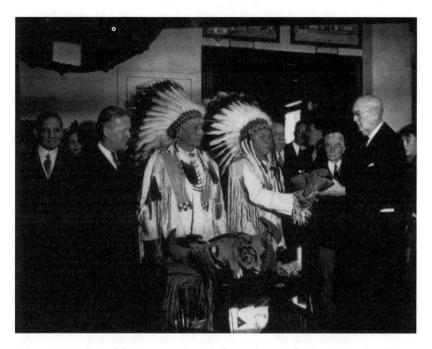

Figure 8.5. Hidatsa delegation at museum for exchange of Water Buster bundle; left to right: Dr. Louis F. Bishop. Mrs. George Gustav Heye, W. J. Zimmerman, Foolish Bear, Drags Wolf, Blair S. Williams, W. H. Howell, John Williams, F. Latham, George G. Heye. Photo Archive, George Gustav Heye Center, National Museum of the American Indian, New York City.

away from North American Indians, Heye continued to support research in ethnography and archaeology. He subsidized academic programs at Columbia University and the University of Pennsylvania.

He was more interested in Indian cultures of the distant past than in the living cultures of his time. He supported M. R. Harrington's excavations in ancient cave sites, but when an elderly Osage man offered to teach Harrington his rituals and language and give the museum his bundles and other possessions, Heye would not support the effort. A Potawatomie medicine man came from Kansas to Shawnee, Oklahoma, to meet Harrington and promised to teach him "all he knew about herbs and their use in doctoring, and to show me the actual herbs growing so that I could have them identified with their 'white man names.'" He would then give the museum his "prescription sticks," with their carved symbols of herbs used in doctoring disease. Heye dismissed the projects, saying, "We can't spare the time."[91]

Heye personally cataloged virtually every object in the collection, and despite his critics, he was concerned with accuracy in describing provenance. He prompted Boas to clarify the names of tribes from which George Hunt had collected material because "I am up to cataloguing it," and "I want to have it absolutely correct."[92] He chided one of his dealers, Julius Carlsbach, for not providing provenance on objects, observing that "place of origin is not as important to lovers of art as it is to archaeological and ethnological collectors. The point of view for purchasing an ethnological piece is entirely different from the artistic point of view than it is from the scientific one."[93]

When provenance was not available, however, Heye felt compelled to provide it. At one point he called S. K. Lothrop and Marshall Saville together for consultation on a small statue that he had bought. Lothrop later recalled, "One of us guessed Guatemala, the other Venezuela. I do not remember which Heye chose, but a guess was recorded as fact."[94]

Heye's death in 1956 left the museum with an endowment of some three million dollars. The income was barely adequate to sustain the museum's basic operations. The facilities were inadequate. The elegant neighborhood at 155th Street and Broadway, which had originally represented the social class of the museum's sponsors, had become one of small stores and low-rent apartment buildings. The museum languished, largely unseen.

After lengthy negotiations with a number of possible donors for a new site, including a possible merger with the American Museum of Natural History, the Heye Foundation's board finally transferred ownership of the collection to the Smithsonian Institution in 1989. The collection became the basis for a National Museum of the American Indian, designated as a "living memorial of the American Indian."[95] The legislation also mandated that the Smithsonian return human remains and funerary objects from Heye's collection and from the National Museum of Natural History to culturally affiliated American Indian tribes, thus establishing a federal policy of repatriation (fig. 8.6).

Heye acquired a collection that remains unsurpassed in its examples of the cultural achievements of Native people throughout the Americas, and he used it primarily for the benefit of an elite community of friends and scholars. What would he have thought of the act that transferred his collection to a major public institution, especially since it mandated the return of certain categories of objects to Indian tribes?

From a lice-infested shirt to an extraordinarily rich and diverse collection of Native American material culture to a living memorial to Indian tribes,

Figure 8.6. Alexander Hamilton U.S. Custom House, New York City, site of the George Gustav Heye Center, National Museum of the American Indian. Photo Archive, George Gustav Heye Center, National Museum of the American Indian, New York City.

Heye's collection has traveled an amazing historical trajectory. It began as an individual's idiosyncratic passion. Significant parts of it may now be returned to contemporary American Indian tribes. The disappearing cultures that Heye and other collectors found so intriguing have descendants in contemporary American culture, and some of what Heye acquired may indeed return to the descendants of its makers.

### Notes

1. J. Alden Mason, "George G. Heye, 1874–1957," *Leaflets of the Museum of the American Indian*, no. 6 (New York: Heye Foundation, 1958), 11.
2. Kevin Wallace, "Slim-Shin's Monument," *New Yorker*, November 19, 1960, 118.
3. Mason, "George G. Heye," 8.
4. Katja H. May, "German Stereotypes of Native Americans in Context of Karl

May and Indianertümelei," in *Victorian Brand, Indian Brand: The White Shadow on the Native Image*, ed. Naila Clerici (Torino: Il Segnalibro, 1993), 57–88.

5. Richard H. Cracroft, "The American West of Karl May," *American Quarterly* 19, no. 2, pt. 1 (Summer 1967): 250–51.

6. Mason, "George G. Heye," 8–9.

7. Cracroft, "American West of Karl May," 250.

8. Mason, "George G. Heye," 11.

9. Ibid., 9.

10. Robert W. Rydell, *All the World's a Fair: Visions of Empire at American International Expositions, 1876–1916* (Chicago: University of Chicago Press, 1984), 119–20.

11. Robert E. Bieder, *Science Encounters the Indian, 1820–1880: The Early Years of American Ethnography* (Norman: University of Oklahoma Press, 1986), 55–103.

12. Robert Rydell, *All the World's a Fair*, 24–25.

13. Michael Kammen, *Mystic Chords of Memory: The Transformation of Tradition in American Culture* (New York: Vintage Books, 1991), 139.

14. Douglas Cole, *Captured Heritage: The Scramble for Northwest Coast Artifacts* (Seattle: University of Washington Press, 1985), 214.

15. Peter Novick, *That Noble Dream: The "Objectivity Question" and the American Historical Profession* (Cambridge: Cambridge University Press, 1988), 88–89. Frederick Jackson Turner, "The Significance of the Frontier in American History," in *The Frontier in American History* (New York: Holt, Rinehart, and Winston, 1920), 15.

16. Rydell, *All the World's a Fair*, 68.

17. Curtis M. Hinsley Jr., *Savages and Scientists: The Smithsonian Institution and the Development of American Anthropology, 1846–1910* (Washington, D.C.: Smithsonian Institution Press, 1981); Michael M. Ames, *Cannibal Tours and Glass Boxes: The Anthropology of Museums* (Vancouver: University of British Columbia Press, 1992), 16–22.

18. Geoffrey Hellman, *Bankers, Bones, and Beetles: The First Century of the American Museum of Natural History* (Garden City, N.Y.: Natural History Press, 1968), 20; Douglas J. Preston, *Dinosaurs in the Attic: An Excursion into the American Museum of Natural History* (New York: St. Martin's, 1986), 23.

19. Sally Gregory Kohlstedt, *The Formation of the American Scientific Community: The American Association for the Advancement of Science, 1840–1860* (Urbana: University of Illinois Press, 1976), 59–64; Ronald Rainger, *An Agenda for Antiquity: Henry Fairfield Osborn and Vertebrate Paleontology at the American Museum of Natural History* (Tuscaloosa: University of Alabama Press, 1991), 3.

20. Mason, "George G. Heye," 12.

21. Ibid.

22. Wallace, "Slim-Shin's Monument," 122.

23. Mason, "George G. Heye," 12.

24. Cole, *Captured Heritage,* 214.
25. Meeting of Delegates of the American Anthropological Societies, held at Cambridge, Mass., Friday, January 11, 1907, 1–2, Franz Boas Papers, reel 8, microfilm series, Scholarly Resources, Inc.
26. Mason, "George G. Heye," 13.
27. Boas to Heye, February 17, 1906, Franz Boas Papers, reel 7.
28. See correspondence between Heye and Boas, April 22–25, 27, 30, 1907, and Heye to Boas, August 12, 1907, concerning material collected by James Teit, for thirty-three dollars, Franz Boas Papers, reel 8.
29. Boas to Heye, November 16, 1906, Franz Boas Papers, reel 7.
30. *Aims and Objects of the Museum of the American Indian, Heye Foundation,* Indian Notes and Monographs, no. 36 (New York: Museum of the American Indian, Heye Foundation, 1929), 4.
31. "Recent Progress in American Anthropology: A Review of the Activities of Institutions and Individuals from 1902 to 1906," *American Anthropologist,* n.s., 8, no. 1 (1906): 537–38.
32. Eleanor M. King and Bryce P. Little, "George Byron Gordon and the Early Development of the University Museum," in *Raven's Journey: The World of Alaska's Native People,* ed. Susan A. Kaplan and Kristin J. Barsness (Philadelphia: University Museum, University of Pennsylvania, 1986), 3; Mason, "George G. Heye," 14.
33. Mason, "George G. Heye," 14.
34. A. I. Hallowell, "Anthropology in Philadelphia," in *Contributions to Anthropology: Selected Papers of A. Irving Hallowell* (Chicago and London: University of Chicago Press, 1976), 146.
35. King and Little, "George Byron Gordon," 39–40.
36. Ibid., 40.
37. Ibid., 32.
38. *Aims and Objects,* 5.
39. Ibid., 5–6.
40. M. R. Harrington, "Memories of My Work with George G. Heye," National Museum of the American Indian Archives, New York City, New York.
41. *Aims and Objects,* 6.
42. "The History of the Museum," *Indian Notes and Monographs,* Miscellaneous Series, no. 55 (New York: Museum of the American Indian, Heye Foundation, 1956), 8.
43. U. Vincent Wilcox, "The Museum of the American Indian, Heye Foundation," *American Indian Art Magazine* 3, no. 2 (Spring 1978): 46.
44. Mason, "George G. Heye," 14.
45. George G. Heye and George H. Pepper, "Exploration of a Munsee Cemetery near Montague, New Jersey," *Contributions from the Museum of the American Indian, Heye Foundation* 2, no. 1 (1915): 1–78.
46. Heye to Hrdlička, July 29, 1914, Hrdlička to Heye, July 10, 1914, Hrdlička Papers, entry 31, National Anthropological Archives, Smithsonian Institution, Washington, D.C.
47. Heye to Hrdlička, July 29, 1914; Hrdlička to Heye, July 10, [1914]; Heye to

Hrdlička, September 3, 1914; Hrdlička to Pepper, April 9, 1915; Hrdlička to Heye, April 29, 1915; Heye to Hrdlička, April 30, 1915, Hrdlička Papers, entry 31. For Hrdlička's scientific work, see Stephen Loring and Miroslav Prokopec, "A Most Peculiar Man: The Life and Times of Aleš Hrdlička," in *Reckoning with the Dead: The Larsen Bay Repatriation and the Smithsonian Institution,* ed. Tamara L. Bray and Thomas W. Killion (Washington: Smithsonian Institution Press, 1994), 26–42.

48. Wallace, "Slim-Shin's Monument," 132–40.

49. Mason, "George G. Heye," 15.

50. George G. Heye, F. W. Hodge, and George H. Pepper, "The Nacoochee Mound in Georgia," Contributions from the Museum of the American Indian, Heye Foundation 4, no. 3 (1918): 1–103.

51. *Aims and Objects,* 6.

52. Boas to Heye, May 3, 1911; Heye to Boas, May 5, 1911; Boas to Heye, November 20, 1912, Franz Boas Papers, reels 12 and 13.

53. Boas to Heye, November 23, 1915, Franz Boas Papers, reel 15.

54. Boas to Hon. George McAneny, President of the Board of Aldermen, City Hall, New York City, November 23, 1915; Boas to President Nicholas Murray Butler, Columbia University, November 26, 1915; Boas to Hon. George McAneny, November 24, 1915; Felix M. Warburg to George McAneny, [November 25, 1915], Franz Boas Papers, reel 15.

55. Heye to Boas, November 29, 1915, Franz Boas Papers, reel 15.

56. Ibid.

57. Boas to Heye, November 12, 1915, Franz Boas Papers, reel 15.

58. Heye to Boas, January 10, 1916, National Museum of the American Indian Archives, box VX, #15.

59. Boas to Nicolas Murray Butler, Columbia University, December 17, 1915, Franz Boas Papers, reel 15.

60. King and Little, "George Byron Gordon," 44–45.

61. Mason, "George G. Heye," 16; Annual Report of the Board of Trustees of the Museum of the American Indian, Heye Foundation to George G. Heye, Grantor for the Year Ending May 1, 1917, National Museum of the American Indian Archives, New York City.

62. *History of the Museum,* 22.

63. Recollections of E. K. Burnett, National Museum of the American Indian Archives, box VW, Smithsonian Institution, Washington, D.C.

64. Mason, "George G. Heye," 17.

65. Ibid., 16–17.

66. George H. Pepper, "The Museum of the American Indian, Heye Foundation," *Geographical Review* 2 (December 1916): 401.

67. Samuel K. Lothrop, *Pottery of Costa Rica and Nicaragua,* 2 vols., Contributions from the Museum of the American Indian, Heye Foundation 8 (1926).

68. *Aims and Objects,* 10; Mark Raymond Harrington, *The Ozark Bluffdwellers,* Indian Notes and Monographs, no. 12 (New York: Museum of the American Indian, Heye Foundation, 1960).

69. Heye to Hrdlička, November 26, 1915, National Anthropological Archives, Hrdlička Papers, entry 31.

70. Undated press release, Hrdlička Papers.

71. Annual Report of the Board of Trustees of the Museum of the American Indian, Heye Foundation to George G. Heye, Grantor, 1919, 12; Annual Report of the Board of Trustees of the Museum of the American Indian, Heye Foundation to George G. Heye, Grantor, 1920, 12, National Museum of the American Indian Archives, Smithsonian Institution, Washington, D.C.

72. The first volume of the new publication series, Contributions from the Museum, included a number of articles from *American Anthropologist,* including several by J. Walter Fewkes.

73. *Aims and Objects,* 15l; Recollections of E. K. Burnett, 13.

74. Mason, "George G. Heye," 17.

75. *History of the Museum,* 12.

76. Watson Smith, Richard B. Woodbury, and Nathalie F. S. Woodbury, *The Excavation of Hawikuh by Frederick Webb Hodge: Report of the Hendricks-Hodge Expedition, 1917–1923,* Contributions from the Museum of the American Indian, Heye Foundation 20 (1966).

77. *History of the Museum,* 10.

78. Ibid., 15.

79. Heye to Harrington, February 12, 1923, May 8, 1923 (his practice was not to clean objects in the field); August 24, 1923; November 12, 1923, John Peabody Harrington Papers, microfilm ed., vol. 9, reel 31.

80. *Aims and Objects,* 6.

81. Mason, "George G. Heye," 19.

82. *History of the Museum,* 9.

83. Jesse Nusbaum to Richard D. Woodbury, Santa Fe, New Mexico, March 10, 1962, National Museum of the American Indian Archives, box OC, folder 2; Harrington, "Memories of My Work with George G. Heye."

84. Barbara A. Hail, "The Ethnographic Collection," in *Passionate Hobby: Rudolf Frederick Haffenreffer and the King Philip Museum,* ed. Shepard Krech III (Providence: Brown University, Haffenreffer Museum of Anthropology, 1994), 93.

85. Fay-Cooper Cole, "Frederick Webb Hodge," *American Anthropologist* 59 (June 1957): 519.

86. Heye to Clarence Moore, April 15, 1929, National Museum of the American Indian Archives, box OC, 121, #1D; Harriett Wardle, Letter, *Science* 70, no. 1805 (August 2, 1929): 120–21.

87. *History of the Museum,* 13.

88. Recollections of E. K. Burnett.

89. Mason, "George G. Heye," 24; Cecil Ganteaume, Curator, National Museum of the American Indian, to author, February 12, 1997.

90. Wallace, "Slim-Shin's Monument," 110, 115.

91. Harrington, "Memories of My Work with George C. Heye."

92. Heye to Boas, August 23, 1907, Boas Papers, reel 8.

93. George Heye to Julius Carlsbach, May 14, 1953, National Museum of the American Indian Archives, box OCE 136, folder 22.
94. S. K. Lothrop, "George Gustav Heye—(1874–1956)," *American Antiquity* 23, no. 1 (July 1957): 67.
95. Public Law 101–185, 101st Congress (November 28, 1989), *National Museum of the American Indian Act,* sec. 3, paragraph (a).

JOYCE HEROLD

# 9
# GRAND AMATEUR COLLECTING IN THE MID-TWENTIETH CENTURY

## The Mary W. A. and Francis V. Crane American Indian Collection

The Denver Museum of Natural History, the primary museum of its kind between Chicago and the West Coast, did not participate in the great period of Indian artifact collecting from 1860 to 1930, yet today it holds an important Native American collection. The history of that collection, the Mary W. A. and Francis V. Crane American Indian Collection, is an astonishing tale of modern American collecting initiative and public benefaction.

In 1951—a century after the American Indian collecting craze gathered momentum in the wake of disappearing Native North American life ways—a New England couple, Mary Winslow Allen Crane and Francis Valentine Crane, quietly refocused their semiretired life around the making of a collection and museum of the American Indian. With unremitting enthusiasm for educational values and with business acumen in an intensive, wide-ranging search over seventeen years, the Cranes coped with formidable restrictions: a late start compared with similar collectors, amateur status, limited background in the field, and moderate financial resources. They succeeded in finding numerous material remnants of Native ways of life that were supposed to have disappeared a century earlier or to have been

collected out thirty to fifty years previously. By late 1958, the Cranes had sufficient range in 5,500 ethnographic and archaeological objects to open a private museum, The Southeast Museum of the North American Indian, near their retirement home at Marathon in the Florida Keys. They advertised it as the largest and finest collection of artifacts south of the Smithsonian Institution.

The Cranes continued to collect on a grand scale, securing individual items as well as primary and secondary collections from collectors and descendants of collectors, dealers, Indian people, and other sources over North American and some Mesoamerican and South American locations. The holdings doubled in the next decade.

To grossly characterize the core ethnological collection, it has at least one—and often many—of the most essential objects tracing Native North American ways of life. Specimens range from made-for-sale to utilitarian and ceremonial, from 1980 to mid-eighteenth century in date, from unidentified to provenanced and maker-identified, and from typical and hobbyist creations to masterpieces. High proportions of objects are original, unrestored, and stable in condition. Special collections related to American Indian ethnology and history consist of peace medals, historic photographs, rare books, prints and art. In archaeology, the Cranes acquired nonscientific collections from the Northeast, Southwest, and California; the Andean Highlands of South America; and West Coast Mexico, Guatemala, and other Mesoamerican areas.

However, Mary and Francis Crane found disappointment in running a small private educationally oriented Indian museum in the recreation-centered, hurricane-endangered Florida Keys. In 1968 the Cranes closed their museum and donated its 11,600 objects to the Denver Museum of Natural History. Their gift constitutes the second-largest donation of Native American materials ever from a private source to any American museum (much smaller, however, than the donation of the Heye Foundation collection to the National Museum of the American Indian). Though the Denver Museum, which ranks among natural history museums in the United States as the largest between Chicago and Los Angeles and one of the top five in attendance in the nation, heretofore had strengths in North American Paleo-Indian, Southwestern, and pre-Columbian archaeology, the Crane Collection founded its Native American ethnology program.

During the next decade, an ethnology staff was established in the anthropology department, a new 13,000-square-feet Mary W. A. and Francis

V. Crane American Indian Hall was built, pre-Columbian exhibits were upgraded, and educational programs, research, and exhibits flourished.

The Cranes' feat of modern-day private collecting contains the stuff of a classic American success story—individuals with a dream, a field laden with romance, a determined independent enterprise, and culmination in cultural and educational riches. Remarkably, the success was accomplished by a middle-aged retired couple who resembled hundreds of other collectors of things Indian across America but applied their considerable resources with extraordinary intensity to a public service mission. This essay examines the founders' lives and collecting history, their motivations, collecting sources and strategies—including business operations and relationship with American Indians, and their vision of a museum.

## FOUNDERS

Mary Winslow Allen (1902–82) was raised as an only child in Massachusetts. Her father, Frank Gilman Allen, headed Winslow and Company (wool) and Winslow Brothers and Smith Company (tanners) of Norwood, family companies founded in 1776. Allen served as governor of Massachusetts in 1929 and 1930. Mary was a Life Member of the Massachusetts Society of Mayflower Descendants, tracing her matrilineal ancestry to William Brewster, patriarch of the Plymouth Colony. Her mother's father, Francis Olney Winslow (1844–1926), was known as a philanthropist and amateur naturalist. Mary attended Norwood public schools until she was ten, Miss Faulkner's School in Dedham for five years, and Windsor School in Boston, graduating in 1921. She attended Wellesley College, where she majored in natural resources and sociology, receiving her degree with honors in 1925.

Francis Valentine Crane (1903–68) was the youngest son of four children of Sarah Follett Platt Crane and Walter Sanger Crane, a banker and trustee in Massachusetts. Francis (called Frannie by family and friends) was educated at Middlesex School, Concord, and, like his father, Harvard University, receiving his B.A. degree in 1925. He married Mary Winslow Allen in 1927. He served from 1933 to 1949 as merchandise and production manager at Winslow Brothers and Smith Company, his wife's family leather-production company (later bought by Armour and Company). He was also a director of the Norfolk County Trust Company and other banking institutions.

Following their marriage, Mary and Francis Crane established their home at Norwood. They had no children. Mary continued as an ardent horsewoman, bird watcher, orchid grower, conservationist, and stamp collector, and in the 1930s they became dog breeders. In 1940, seeking more isolation and space for animals in a country setting, the Cranes established Basquaerie Farm on six hundred woodland acres with a Revolutionary War farmstead, near Holliston. There Francis developed purebred herds of Brown Swiss cattle and, later, Guernseys, raising up to 160 animals in several bloodlines and selling to dairy farms in the United States and Costa Rica.

The Cranes became widely known as dog breeders who introduced the Great Pyrenees from Europe to the United States in 1930. During the next twenty years they popularized the breed and established the world's finest Great Pyrenees lines in America. The Cranes imported fifty of the large white longhair dogs, which they personally selected in the 1930s on motoring trips to farms of the French Pyrenees and all known breeders in France and Belgium. The Cranes wrote the breed standard and history, and their Basquaerie Kennels became the American prototype home for the thousands of Great Pyrenees in the United States today (fig. 9.1).[1]

During World War II, Francis served in Washington, D.C., on the War Production Board and as consultant to the Office of Price Administration and Department of Commerce. He taught pistol marksmanship to local police. Moreover, as an emergency war effort, the Cranes kept about a hundred Great Pyrenees so that the breed was safeguarded for reintroduction, if necessary, to Belgium and France.[2] After the war, the Cranes' carefully ordered life consisting of the tanning business, farm management, dog breeding and personal interests began to change. Like many Northeasterners of means, the Cranes discovered winter vacationing in Florida, where Francis liked to fish. He extolled the Keys as the only true tropical, frost-free area in the country. From temporary quarters at Marathon they explored the region by car and boat, scouting for property. In 1948, however, Francis had serious heart trouble, from which he recovered slowly, over eight months of bed rest. The illness "crystallized our thoughts," Francis later wrote. "A new dawning came and I knew that instead of the end it was only the beginning of what I am certain will prove to be a life of ever-increasing interest and value."[3]

The Cranes reshaped their lives around independent means and less physically demanding pursuits, living the winter months at Marathon and motoring north in the spring to spend eight months with family in Boston and on the farm. Arriving in Florida ahead of the postwar property boom,

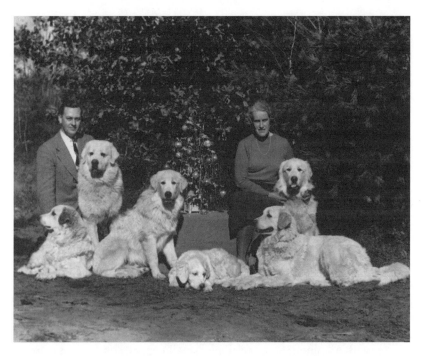

Figure 9.1. Francis and Mary Crane with six Great Pyrenees dogs, on the grounds of their home, Basquaerie Farms and Kennels, near Holliston, Massachusetts, in 1936. "I felt that no group of photographs of us should be complete without at least one dog picture." Mary Crane to Dorothy Dines, December 7, 1975. Denver Museum of Natural History Archives, CR85-006.

when large tracts of virtually unsettled land were still available, they were able in 1949 and 1950 to buy eighty acres in the heart of the Keys on Key Vaca, between the Overseas Highway (U.S. 1) and the Gulf of Mexico (at Mile Marker 50). It was, Francis believed, the finest piece of property throughout the hundred miles of Keys.

As related in "The Cranes of Crane Point: A Memoir," by William B. Bradley, a Marathon realtor and friend, the Cranes realized the significance of their Key Vaca tract as a unique opportunity for both natural and historic-cultural preservation.[4] The tropical hammock extended in a point far into the Gulf and was cut deeply by a contrasting environment of lagoon and mangrove wetland. The property included the Bahama House, a conch-shell-concrete house constructed early in the century by George Adderly, a Bahamian Conch fisherman-farmer settler.

As they opened trails in the dense tropical growth of native shingle-palm

forests and along almost a mile of bayside coral shoreline, the Cranes conceived part of a new personal mission of preservation. In 1950 Francis wrote with passion, "Not until we had macheted thousands of feet of trails did we realize what a priceless purchase we had made. An idea burns ever brighter as we progress deeper into the forest: to preserve against the inroads of advancing civilization this handiwork of nature for all to see. We are calling it 'The Tropical Forest' and are planning to open it to the public in a couple of years."[5] They resisted real estate development of Crane Point (the estate's name after 1954), fenced the property, promoted native vegetation by hand-clearing only, maintained the wetlands, and built trails. They protected the remains of a probable Calusa Indian site and an 1870s Bahamian native settlement.

Practical matters intervened in the Cranes' early 1950s plans as they became preoccupied with selling their Massachusetts property and purchasing a new lakeside retreat in the Maine woods. In 1954, in order to solidify their position in Florida, Francis developed a twenty-acre parcel of Crane Point into an environmentally safeguarded residential subdivision, called Crane Hammock, adjoining Marathon, a small town of about six hundred people. They also built their own distinctive hurricane and site-adapted residence (with adjoining air-conditioned small kennel!) on an inlet near the tip of Crane Point. The Cranes' foresight in purchasing and protecting the Key Vaca land anticipated by many years the national priorities for environmental preservation.[6]

Then the Cranes suddenly turned to a different field of preservation—Native American material culture. They already owned—in fact, *had* owned for up to twenty-five years—the foundation collections, loosely cataloged accumulations of archaeological lithics and ethnographic baskets and textiles passed down from Mary Crane's grandfather, Francis Olney Winslow, and from Francis Crane's parents, Sarah and Walter S. Crane. Focus on these objects and related American prehistory and history had probably been limited to their leisure time, for neither Mary nor Francis mentioned it in their frequent personal news reports to the Wellesley and Harvard alumnae organizations.[7] The Cranes' own active collecting arose full-blown as a retirement activity in 1951 when they took a first warm-season buying trip to New Mexico, Arizona, and California, acquiring 2,864 Indian objects (including many stone artifacts). They quickly incorporated the Crane Foundation, a nonprofit enterprise for the founding and operation of an American Indian museum.

By 1958, after seven years of museum planning and collecting across North America, the Cranes had accumulated 5,500 objects, completed a

new museum building, installed museum exhibits, opened to the public, and at last had a dedicated area for processing and storing the Crane American Indian Collection. During the 1960s, the Cranes' life revolved around the museum and Indian collecting, dogs and dog show judging, bird watching, and seasonal migrations to winter quarters in Florida and to a summer log cabin on Lake Kezar, near Centre Lovell, Maine. They traveled frequently, particularly during summers. For example, in 1965, they spent seven months on the road, traveling to museums, dealers, and collectors in seventeen states and also visited Puerto Rico to see (and reject) a Caribbean Indian collection.

The Southeast Museum of the North American Indian was open to the public for almost ten years, during which the founders continually added objects, to a total of 11,600 objects in 1968. In reaction to poor attendance and the impossibility of insurance because of storm risk, as well as increasing concerns for Francis Crane's health, the Cranes began as early as 1965 to look for locations for donation of the entire collection. They seriously investigated Phoenix-area museums and considered other extant or planned museums, but no suitable alternative arrangement emerged immediately.

In 1967 an Audubon Society program brought Mary Crane together with wildlife lecturer Roy E. Coy, director of the Saint Joseph (Missouri) Museum, who was interested in Indian materials and inspected the Cranes' museum and collection. The following year, when he became assistant director of the Denver Museum of Natural History, he contacted the Cranes about the museum's search for available American Indian collections for a new scientific study collection and American Indian Hall. The museum and the Cranes soon became convinced of a close match between the museum's needs and the available major but little-known Crane Collection. By mid-summer 1968, Denver Museum of Natural History director Alfred M. Bailey announced the donation of the Crane Collection, and by late August the objects had been packed in four moving vans and were on their way to Denver.

In December 1968 Francis Crane died of heart failure. Mary Crane continued her interest in the collection and assumed roles as museum trustee, consultant to the anthropology curator, and selective collector-donor until her death in 1982.

## IMPETUS FOR COLLECTING

The Cranes were always reticent to explain the scale and suddenness of their collecting, yet their biographies, several personal texts, and collection

records do suggest cultural, familial, personal, and other moving forces be-
hind the Crane Collection. These influences produced three main sets of
motivating satisfactions and challenges: the Cranes wanted to make an out-
standing public service educational contribution; they found special inter-
est and value in Native American objects and their preservation; and they
relished the process and achievement of a systematic collecting project.

The sustaining roots lie in family heritage. Francis and, especially, Mary
Crane were raised in the privilege of Massachusetts society—amply prop-
ertied and affluent, yet engaged in professional, financial, or management
occupations. They had the advantages of stable families, economic secu-
rity, property ownership, good education, leisure time, peer companion-
ship, and mobility. They also felt the imperatives of responsibility common
to their class and families—participate actively, use time and money re-
sponsibly, and benefit both self and society.

In both families, accepted outlets for affluence and endeavor were not
only profitable work and investment but also personal activity and prop-
erty. As one friend observed, "[The Cranes] personified the old New En-
gland expectation that a person with such advantages should have at least
one avocation that he does very well. In their case, they did many such
things extraordinarily well."[8] The making and keeping of collections was
included. As Mary Crane pointed out in a 1979 interview, "Most New En-
glanders are collectors, I'm afraid, of all kinds of odds and ends and things.
We had that background."[9] Their collections, in fact, appeared to be
vehicles for expressing and passing down family sentiments and values as
well as "odds and ends and things."

Mary Crane's vivid memories of her knowledgeable naturalist grandfa-
ther, Francis Olney Winslow, are telling. He taught her the enjoyment and
habit of systematic collecting, study, and classification of a broad range of
phenomena:

My first bird list was written when I was eight years old. I have more or less
watched and kept bird lists ever since. My grandfather also . . . started me off as a
little girl making an herbarium. He . . . instilled in me that there was no sense in
doing something and not doing it thoroughly. I'll never forget when he bought me
the sheets and so forth; he had a rubber stamp made that had the family, the Latin
name, the common name, the date the specimen was collected, and where. So, I
grew up feeling that one should have all the data on everything.[10]

The Francis Olney Winslow Collection, inherited by Mary in 1926 to form
the Cranes' first Native American collection, included 1,248 archaeologi-

cal objects (mostly agate bird points from Massachusetts, New York, and Ohio) and four Navajo and Rio Grande blankets from a Southwestern trip.

On Francis Crane's side, both parents enjoyed things Indian and Francis's father actively collected during construction company trips throughout the West. Walter S. Crane revealed a touching affection shared with Francis through collecting, referring in a 1933 note to a stone fleshing tool: "I am sending you a very small remembrance of the day—and it is small—I like such things and think you do too. It was dug up four feet under ground at Lake Odell, Oregon and you will remember it. It can go with your other stone items. My love goes with it."[11]

The Crane Family Collection given to Francis in 1933 included ninety-eight baskets brought home for Walter's wife; sixteen other articles of Indian clothing, jewelry, et cetera; and thirteen stone artifacts, dug personally or purchased. Walter Crane had partially cataloged the objects.

Though valued as family heritage, Indian collecting did not compete with their dogs and country living throughout the Cranes' younger years. It took personal crisis to change their life priorities: Francis's fragile health and need for relaxed, comfortable retirement provided the catalyst. In the 1950 essay that reviewed his life since university graduation and, in a sense, celebrated his recovery from serious illness, Francis Crane eloquently illuminated his evolving philosophy of life: "I can say whole-heartedly that each day has been an interesting one with something new and exciting turning up each morrow. My life at home and at work has been full to overflowing and magnified by an ever-widening circle of friends and territories. Although I was born a dyed-in-the-wool New Englander, I have found that with a zest for living, and a youthful enthusiasm to attempt the unknown, one can be happy, interested, and constructive wherever one may be." He looked forward to "a life of ever-increasing interest and value."[12]

By then they had achieved the all-important setting for a more relaxed life—their Key Vaca property. Pleased with the tropical environment and the fishing, Francis had led in that decision. Mary Crane's naturalist preferences, as well as family ties, remained in New England, and so they compromised by going between two homes. They accepted that the move to Florida precluded continued serious long-haired dog breeding, although a few personal pets always came with them.

But soon Francis and Mary Crane had decided on a new centering of their lives—the quest to discover remnants of Indian life in America. Francis Crane led in selecting the subject field, for he had the deeper interest and enjoyment of Indian objects, by all accounts, and was known as an inveterate

student of American history. Moreover, entering the Indian field became Francis Crane's way "to attempt the unknown," a key need in his post-illness personal philosophy. Mary made Indian collecting a joint enthusiasm as she followed her grandfather's counsel and began to master the field. Furthermore, they decided that the heart of the venture and their goal would be the founding and operation of a museum of the American Indian. In this way, the Cranes kept faith with the social responsibility that Francis had envisioned as a "constructive . . . life of ever-increasing . . . value." Public benefaction to education rather than private enjoyment or gain from the beginning was the overriding purpose of collecting. Mary later neatly explained the personal impulse behind it: "There is no fun in just keeping it to yourself, I mean you want to have it go where it will be seen and appreciated and do some good, create some interest."[13]

The Cranes entered their venture with university educations in liberal arts and business but no formal study in American Indian material culture, archaeology, or ethnology. They made it their business to learn as they collected, by gathering expertise from a multitude of advisors, books, inspections, and records. Realistically, the Cranes' project was too broad, short-lived, and action-oriented for development of real expertise in this huge, complex field. But they progressed to the level of highly experienced, advanced amateurs.

As for deep-collector excitement and engagement with the materials collected, neither Mary nor Francis inclined to such expression, by either personality or heritage. Their enjoyment of special pieces seems to have been demonstrated mostly in quiet contemplation, reserved admiration, and, moreover, practical work devoted to the objects.[14]

Only in one area of collecting did scholarly interest and personal passion come together—in Francis Crane as history bibliophile and romantic on the Old West. Francis's concentration on Plains Indian history resulted in an outstanding collection of peace medals, Plains warrior objects, and many rare books and prints.[15] He researched British, American, and Indian diplomacy and pored over his medals for recreation. Francis also continued his family's predilections for Indian basketry and amateur archaeology, often digging and surface collecting with friends during brief Southwestern trips from Snaketown to Monument Valley. Mary Crane, on the other hand, favored pre-Columbian objects first and then Northwest Coast wood carvings and Hopi kachina dolls, all expressing her love of figurative art. Another particular interest, horse gear, stemmed from her enjoyment of carriage and horseback riding since youth. Although the Cranes did not

surround themselves at home with Indian artworks, they placed a large, fantastic figural Maya covered urn—once used for votive offerings of co-pal—in their living room fireplace (unused in the tropical climate) and in-congruously named it "Sweetie Pie." Neither Francis nor Mary, however, let personal preferences drastically skew the collection, for inclusivity was their agreed-upon priority. Needed object types, whether dear to their hearts or not, stayed on the search list. For example, Mary Crane's last finds in the 1970s included not only her favored Northwest Coast masks and a Chilkat tunic and Francis's long-sought Plains buffalo-hide warrior paint-ing and a horse hood, but also documented Chippewa subsistence and cer-emonial objects.

Beyond the objects, the Cranes relished the pursuit in itself—the trips, the finding and deal-making, the people they met, the doing and completing of a systematic project. One of the most powerful of these motivations was travel, which was integrated with the Cranes' lifestyle and played a part in all their collecting endeavors, from dogs and cattle to bird counts, stamps, and artifacts. The parental families had traveled long distances to collect, and Mary and Francis, too, came to rely on taking themselves by car to most sources, in devious exploration, as Francis called it. Every year they traveled for combined bird watching, dog show judging, and visits to In-dian markets, dealers, and museums.

The couple enjoyed the systematic assembly, identification, and manage-ment of things. Mary Crane concentrated on object registration and cata-loging (via the hand-typed card system), and Francis Crane focused on doc-umentation and planning (via the Crane Collection's remarkable library). They kept tight control over the collections processing and record keeping, assisted only in part by employees whom they taught.

The Cranes savored the mutuality of endeavor and their close compan-ionship during the collecting process, especially on the road. They also en-joyed developing interpersonal relationships beyond business courtesy and exchange of information, particularly with dealing partners who shared in-terests in bird watching, Western history, and archaeology. Personal letters and visits were exchanged with friends as far away as the West Coast and Central America.[16] They had few personal contacts among serious private collectors of the 1950s and 1960s, most of whom outdistanced the Cranes in length, if not in breadth, of experience. They did enjoy exchanging Plains Indian lore with L. Drew Bax, Charles Eberhart, and Charlie Eagle Plume of Colorado and Ralph Hubbard of North Dakota.

In sum, the Cranes found satisfaction in the entire process of collecting—

the objects and learning about them, the places visited, the documentation of their finds, and the interpersonal contacts. Mary Crane put it all together with rare emotion when asked to recall memorable collecting stories. She selected experiences in the upper storage at Harvey's Hopi House at Grand Canyon with Porter Timeche, a Hopi employee of Fred Harvey Company. "That was really great fun because we never had anyone else there and Porter, of course, had a great many stories about things, and we had free scope to go through their collection. . . . [but] I was usually writing down what we liked and what the price was and where it came from and that sort of thing rather than writing stories."[17]

Nearing the end of their active collecting in the mid-1960s, the Cranes reaffirmed their motivation to make a public service educational contribution by seeking a new home for the collection. They rejected sites where their Native American artifacts probably would have functioned primarily as a tourist attraction (i.e., Phoenix and Miami) or as an unexhibited minor resource (i.e., Harvard's Peabody Museum of Archaeology and Ethnology and the Smithsonian's National Museum of Natural History). The Denver Museum of Natural History, however, had a broad scientific-educational mission, substantial donor support, and the immediate availability of new interpretive exhibits in a hall dedicated to the collection. The Cranes decided to bring their grand collection back to Indian Country in Denver. Mary Crane later averred that her favorite activities on Denver visits were the quiet times spent watching children in Crane Hall.

## SOURCES AND STRATEGIES OF COLLECTING

The success of the Cranes in assembling so much prime material so recently is astonishing to today's ethnographers, art historians, and recent collectors of nineteenth-century and earlier objects, who operate in a seller's market of scarcity. The third quarter of the twentieth century was hardly prime for fieldwork and collecting, but with diligence the Cranes were able to tap 335 sources of both primary and secondary collections during their thirty-year collecting span, mostly during seventeen years of intense searching, from 1951 to 1968.

Mary and Francis Crane accomplished their project by blending amateur and entrepreneurial approaches. They started with small, specialized family collections and then scoured the continent, in person and by mail, for a

broad range of objects. They proceeded with businesslike reserve and economy and contacted dealers and galleries, museums, professional and amateur collectors, the descendants of early government workers and travelers, Indian artists and owners, and all manner of interested sellers and donors. They shopped once in Meso- and South America, occasionally in England, and frequently in Canada. They found and acquired from one to 1,319 collectible objects at each of these sources. The collection grew by an average of 650 objects a year during its main accession period.

Underlying their collecting were family patterns of appreciation and active participation, and also assumptions about the strategies for getting things Indian. Indian objects, they knew, were to be found on trips to Indian Country—either by digging them up or by buying them. Primary collecting was the strategy—that is, going to the original sources, to Native Americans on reservations, and to Indians' prehistoric remains found in archaeological digs. Through the process of secondary collecting, artifacts could be obtained from sources removed in time and place from the objects' origins, in a process called secondary collecting. Located in city homes, trading posts, auction rooms, or small museums, secondary collectors and dealers who bought and sold Indian objects represented concentrated bits of Indian Country.

There is no evidence that Mary and Francis Crane added to their family collections until they focused on forming a museum in 1951. But when they did begin to collect intensively, they applied their heritage of amateurism more deliberately and on a vastly larger scale than any of the family had done previously. Established by 1950 in Florida, Mary and Francis Crane began their acquisitions with both primary and secondary collecting strategies, which set a pattern for their next seventeen years of intensive and extensive acquisition. The scale was obviously tipped toward secondary sources by the seventy-five to two hundred years between the collectors and the disruption of North American aboriginal life ways.

First, they gathered leads to available materials and followed up with letters to the dealers, collectors, and owners. Some contacts were made blind to check rumors of old or primary collections, and others were made in response to sale notices. Assemblages originating in the Early Reservation Period could still be located among family descendants, though most nineteenth-century primary collectors had passed on. For example, they secured the Jesse H. Bratley Collection from children of a government schoolteacher who had photographed and collected from the Rosebud Sioux,

Havasupai, Hopi, Oklahoma Indians, and others from 1893 to 1903. Also, the post–World War II boom economy encouraged the liquidation of old personal collections and conversion from hobby to business operations.

Second, they arranged appointments with promising contacts and drove cross-country to view objects and pursue deals. Following their advance itinerary but also inquiring from one stop to the next, they sampled pueblos, reservations, trading posts, and dealers along the way. At motels en route they recorded the purchases and corresponded with staff about the mailed purchases (most items) and future arrangements.

Examples from their first collecting trip in 1951, covering New Mexico, Arizona, and California, show the coverage on a typical buying trip. The most important acquisition was part of the Fred Harvey collections: 287 items housed at the Alvarado Hotel, La Fonda Hotel, Hopi House, and Painted Desert Inn, including primary collections from the Southwest, Southern Plains, Northwest Coast and California, circa 1880 to 1920, with mixed levels of documentation. This was the first of many visits to Harvey Company storerooms, which by 1968 had resulted in 879 objects purchased from the Harvey collection.

In 1951, on the way to Harvey locations, the Cranes stopped at New Mexico and Arizona trading posts and individual sellers and bought some fifty objects. They habitually selected a few recent materials in made-for-sale styles and forms and then inquired about older, unusual pieces. Surprising treasures sometimes turned up; for example, an old Zuni quill-and-horsehair dance anklet was found among undistinguished modern Zuni goods at Kelsey Trading Post.

A bonanza on the 1951 trip, which illustrates the Cranes' seeking out of sources away from the collecting mainstream, was Smith's Museum, a mom-and-pop operation at Clingan's Cross Roads, California. This one-room, everything-shown display was rich in regional prehistoric and ethnographic materials, and George and Ethel Smith wanted to retire. They sold the Cranes 780 objects, many documented to makers and localities of the Yokuts, Monache, and other central California tribes (fig. 9.2).

Elsewhere in California the Cranes established another pattern of purchasing. An exploratory visit to a large, broad-based Indian shop often yielded unexpected materials from all over the country. At the Pony Express Trading Post, for example, they selected 125 objects on the spot in 1951, and the owner subsequently kept in touch with them about new offerings for more than twenty-five years. The Cranes elevated this well-established preferred-buyers pattern to an art.

Figure 9.2. Smith's Museum, Clingan's Cross Roads, California, the first large primary collection acquired by Mary and Francis Crane, in 1951. Yokuts and Monache basketry and central California artifacts. Photograph by Kenneth Beer, Torrance, California. Denver Museum of Natural History Archives, 0093-004.

Following their first and highly productive summer search in 1951, they made major road trips in 1954, 1959, 1963, 1964, 1965, and 1966 (fig. 9.3). The Cranes were quiet, even secretive, about their contacts and activities, and their sources also remained discreet for good business. Not known on the more public sales and auction circuit, the Cranes pursued their collecting with little evidence of discovery by dealers and other collectors. They appeared content to let it remain so, even after the museum opened.[18]

The family habit of purchasing archaeological artifacts continued throughout their years of collecting. For example, when a 1951 purchase of 1,083 Caddoan and Southeastern lithics from private sources proved to hold many fakes, the Cranes began to seek second opinions on authenticity, at least for major pieces. But this lesson in "buyer beware" failed to deter them from buying amateur-excavated materials.

Figure 9.3. Francis and Mary Crane and Walter J. Crawford, at a Hohokam site, Cashion, Arizona, July 1966. Denver Museum of Natural History Archives, 0095-1081.

Realizing that rare objects were mostly long gone from Indian Country, the Cranes began early to seek collections located in more exclusive dealers' hands in major cities. Particularly exceptional Northwest Coast objects, some dating before 1840, were purchased on a trip to London in 1952 from Berkeley Gallery, an auction and sales establishment. They developed long-term trustful client-advisor relationships with several galleries, such as Stendahl Galleries in Los Angeles and New York (pre-Columbian), Rex Arrowsmith in Santa Fe (Southwest and Plains), and Erich Kohlberg in Denver (general). Later, when she was filling in the collections during the more restricted market of the 1970s, an aging and more experienced Mary Crane almost exclusively selected more expensive, exceptional specimens offered by high-end private dealers, perhaps no more than a dozen a year. The Cranes did not, however, buy at auction. In pre-1970 America, Indian auctions tended to be regional, lower-status affairs and much too public for these proper New Englanders. Only in the late 1970s and early 1980s did

Mary Crane acquire a few specially sought objects at auction, but through agents rather than in person.

An openness to small private offers netted scores of purchases every year from people who came to the museum or heard that the Cranes might be interested in a family piece or a "trash-or-treasure" find. Personal friends, particularly in the "old-line" network from Harvard and Wellesley, made several quite remarkable gifts to the museum, including three precious California baskets labeled "Old Mission" and later identified as early-nineteenth-century Chumash, which had probably traveled in Massachusetts sailing ships around the Horn.

The Cranes' criteria and strategies for selectivity also require inspection. Casting their collecting net wide with untrained enthusiasm, the Cranes wanted to gather breadth as well as depth. Writing to a potential source in 1965, Francis Crane stated a case for broad preservation and research-oriented collecting:

> You have said that a number of the items have been damaged and badly treated and that, in some cases like the one legging you showed me, a half of a pair is missing. Nevertheless, where such things may not appear to be either too beautiful or too valuable under the circumstances, they still are important to preserve for the future, not only for exhibition . . . but for study purposes. Some of the least interesting items to the layman . . . have basic value in helping to round out a Museum collection; and we have certain ceremonial pieces that have lost their color and may be cracked or may have damaged feathers, etc., which are still worthy of preservation to the fullest extent possible, and that is one of the real purposes of a good museum. In a great many cases, scientists can learn much more from the ancient artifacts that possibly cannot compete in color or beauty with a modern piece; but much of the modern Indian items are influenced by tastes of White men, whereas the older items are from the true, unaffected life of the Indians prior to the White man's influence.[19]

By 1967, however, the collection's growth had spurred much tighter selectivity, and a letter to a trading post stated: "Unless the items are OLD, RARE, and UNUSUAL we probably won't be interested."[20] Another criterion was exhibit appeal—not only color, pattern, and exotic form, in their judgment, but particularly usefulness for museum teaching. Hence, the Cranes selected a number of now-scarce clothing and equipment ensembles, demonstrations of pottery making or other processes, and sets from particular ceremonies, for example, Western Apache Gaan outfits and replicas of Sun Dance equipment.

Inevitably the collecting offers needed sorting in order for the Cranes to

stay within their budget and to eliminate the new, the freakish, and the false. To achieve a fast learning curve, they relied on existing publications, firsthand experience looking at collections, and the word of their suppliers. They kept an open mind in assessing objects for purchase, and an original decision might be altered by a strong argument from a dealer or authority. In one case, the Cranes rejected a simple striped Zuni blanket primarily on aesthetic grounds ("does not have the spontaneous appeal to the average museum visitor"), yet later heeded the dealer's appalled reaction and advice and bought the blanket, explaining, "We do not pretend to be experts on such rarities."[21]

The Cranes also consulted knowledgeable curators, scholars, appraisers, and other collectors about especially problematic or valuable specimens. Usually Francis Crane spearheaded this research, sending a photograph and voluminous descriptions of the object and its history. For example, he turned to J. O. Brew, director of the Peabody Museum of Archaeology and Ethnology at Harvard University, for information about "an interesting looking pottery bowl" of possible Cliff Dweller origin. Brew showed it to about seven staff members and replied that it was an unusual variation of Pueblo effigy pot dated about A.D. 550–1000. Francis promptly accessioned the piece.[22] In another situation, Francis Crane visited the Museum of the American Indian to authenticate a "Cherokee Cross" that had been offered him for purchase, but found out nothing and turned down the offer.[23]

The collecting net unfortunately snagged trash along with the average and the excellent. A number of fake, nontraditional, replica, and second-rate objects did enter the collection. They ranged from a Boy Scout–style dance shield made from a bushel-basket hoop to beautiful but reconstituted turquoise jewelry and a labeled "Ralph Hubbard original," an eagle feather war bonnet honoring Francis Crane.[24]

## THE BUSINESS OF COLLECTING ECONOMICALLY

The buying-and-selling part of collecting preoccupied the Cranes. Since they had only a small fortune to devote to building the collection and museum, they felt they had to be frugal in spending while expansive in their "shopping lists." Fortunately, although they had missed out on the great buyers' market of the grand collecting years a century earlier, they at least had the advantage of buying for the most part before the major rise in prices

for Indian art in the 1970s. Both Mary and Francis came to collecting well prepared with business experience and high ethical principles. They expected all transactions to reflect efficient procedures, honest full disclosures, good value received, and special consideration for their nonprofit status and educational purposes.

Francis Crane believed in an unfettered market governed by efficient economic influences, whereby the price of goods is set by supply and demand. "After all, who is to say what price is too low, and what too high, and what is just right? There is no standard for Indian goods. It is just a matter of what someone is willing to pay against what someone else is willing to ask. That is the way you buy stocks, and that is the way you buy automobiles, and I am sure we are going to find such is the case with most Indian things."[25] In line with the limited supply of Indian objects and some competition in buying them, the market had gone up during the decade of the 1950s: Francis chafed at buying when even one purchase became "a major financial transaction," "a very serious matter," and "rather grim."

The Cranes often astutely played their "museum card." Because they were buying for preservation and public education with a limited pocketbook, rather than for personal gain or enjoyment with ample funds, they asserted that they should receive advantages in the marketplace. Francis Crane felt justified in always asking for a discount for the Crane Foundation: "As is the case with, I believe, all museums and more particularly with one such as this, the funds are very limited, particularly where a museum is to be erected and buying must be done on a necessarily controlled budget."[26]

"Good value" loomed large. The Cranes' style of shopping—targeting general classes of objects—could be indulged with room for choice and bargaining. Because their way was not the highly selective approach of requiring the best of any class of object, they were freed from having to pay the asking price no matter what it might be. Thus they became accustomed to favored customer relationships and they expected discounts, particularly if they purchased an entire lot. Even when they were not seriously looking for objects, the Cranes often wrote to good sources encouraging offers of rare and unusual materials, "which you feel we should, at least, have a refusal of . . . when such items are priced sufficiently low to make it unwise to pass them up."[27]

Much vigilance went to transaction accuracy and good faith. They were concerned about being "taken in" by replicas, recent objects represented as old, poor-quality objects, nondelivered reserved objects, and other mis-

represented sales. In mail offers, advance photographs were always re-
quested and return rights were reserved. When receiving damaged objects
by mail, air, or railway express, the Cranes carefully documented the cir-
cumstances, had professional repairs done and charged the seller, or simply
returned the object. They learned to stipulate packing and shipping
arrangements. Payment was made only on receipt of goods.

By the time their buying was ending, competition with speculators in the
Indian art market had begun to intensify. In the 1970s Mary Crane began to
hear much more about the changing collector who bought for investment:
"a bloodless HOARDER and speculator who breaks down innocent old Indi-
ans with slick and protracted pressure salesmanship."[28] In comparison
with such purely entrepreneurial buyers, the Cranes took the higher moral
ground.

## COLLECTING FROM NATIVE AMERICANS

Mary Crane's later perception was that "we didn't buy much from the Indi-
ans,"[29] but the collection did benefit considerably from both direct and in-
direct collecting from Indian individuals and groups. The Cranes' enthusi-
asm for travel combined well with personal collecting on reservations and
produced good results in recent documented objects. Yet the paucity of ear-
lier materials still in Indian hands and the couple's non-ethnographic, en-
trepreneurial bent turned them more often toward indirect contacts with
Indian sources.

On their second major collecting trip, from June to October 1954, the
Cranes explored buying in person from Native American artists, individual
sellers, and shops around the West. They stopped at Indian settlements in
the Northern Plains, the Canadian Rockies, British Columbia, and the
Olympic Peninsula. They interrupted the journey with a family visit in Cali-
fornia and continued to the Southwest, including the Hopi Snake Dance,
the Gallup Inter-tribal Ceremonial, and the Santa Fe Indian Market on their
itinerary. In each place the Cranes visited shops or homes that advertised
items for sale, sought local artists, and bought such items as baskets, bows
and arrows, jewelry, and pottery from as many as ten sources. In all, they
collected directly from thirty-four Indian individuals or shops, including
Ottawa, Assiniboine, Sioux, Chippewa-Cree, Blackfeet, Nanaimo, Makah,
Quileute, Quinault, Siletz, Hopi, and ten Rio Grande pueblos.

The Cranes never again attempted such a broad sweep of Indian sources

as the 1954 trip, but they did collect specific needs on return trips to the Southwest and Plains during the next ten years, buying from tribal guilds, stores, and museum shops of the Navajo, Pueblo, Papago, Gila River, and Oglala Sioux. They also made short collecting forays from their homes to nearby Indian-run shops in Miccosukee and Seminole villages in Florida and Mi'kmaq and Penobscot settlements in Maine. They could not resist tourist purchases from Native peoples encountered on birdwatching trips, such as Jivaro feathered materials in Ecuador, Maya textiles at the Chichicastenango market, and ceramic figures and beads from "boys at Tazumal, El Salvador," which proved to be authentically pre-Columbian.

The Cranes' field strategy fell far short of the limited ethnography that might have resulted from even their brief outsider visits. They did not specifically seek items currently in use, and they failed to note systematically the local context, Native object names, techniques, materials, and other information that might have been elicited from original makers or owners. Both Cranes were too shy and formal and too intent on the trading itself to play the ethnographer's role, but they did record places, names, and some descriptive and interpretive notes from Native sources.

From their introductory visits in the mid-1950s, the Cranes did develop long-lasting relationships with several shop owners or managers of Indian heritage, including Porter Timeche (Hopi), Charles Eagle Plume (Blackfoot-Scottish), Woody Crumbo (Potawatomie), and Nellie Menard (Rosebud Sioux). The last two also furnished their own arts. Nellie Menard considered Francis Crane "my kind . . . we both like junk, ha." She wrote, "I bet you two really had fun gathering Indian junk and also met interesting people and [I] wouldn't mind traveling with you."[30] Porter Timeche also became a friend and made prayer feathers for the Cranes during the Soyal-Christmas ceremonial season one year.

At least one extended trading relationship with a Native American family developed from a 1954 contact on an eastern Montana reservation. Over fourteen years, seventy-six well-documented objects were acquired from an Assiniboine-Hunkpapa Sioux man and his wife. Always hoping for heirloom materials, Francis Crane inquired early about peace medals, medicine bags, and metal tomahawks owned by family or friends, but such pieces were so little known by this late date that even extended explanation by Francis led only to information that the sole peace medal had been buried with its owner years ago. The Assiniboine man wrote tersely about having a tomahawk made by his brother in the World War I, his grandma's buffalo horn spoon, a government-issue coffee grinder, and other ordinary

belongings from three generations. The Cranes almost always responded with interest, sent instructions for mailing photographs or the objects, and closed a deal.

Francis Crane commissioned a war bonnet and carefully specified that it include eagle feathers and other authentic materials only. The wife sold one of her wedding-gift dresses, made some excellent beadwork, and embroidered a story quilt about the old ways of life, as dictated by her elderly father-in-law. Two personal dance outfits were sent when the owner felt he would not be dancing much more.

The Cranes recognized in part the ethnographic richness of this source and realized that they were buying remnants of a family's history. They dealt with it only distantly, with customary businesslike courtesy, such as extra-quick response to urgently requested sale and payment, as well as with more personal feeling from time to time, in gifts sent for the children, for example. The longevity of this generally relaxed Native-collector relationship testifies to degrees of satisfaction on both sides.

In another primary collecting emphasis, the Cranes strongly supported contemporary Indian handicrafts production. They turned to the Indian Arts and Crafts Board for merchandising advice, stocked their small gift shop exclusively with inexpensive items bought directly from tribal enterprises, and advertised their authentic Native American arts and crafts. For the collection they purchased replicas of traditional arts, tools, and equipment, such as Arctic and Subarctic weapons and household objects from the Alaskan Native Arts and Crafts Cooperative, and examples of contemporary work, such as baskets from Qualla (Cherokee) Arts and Crafts Cooperative, jewelry from the Navajo Tribal Guild and beadwork from the Northern Plains Arts and Crafts Center. In other cases, they tapped museum shops or trading companies known as sources of regional Indian products, such as Iroqrafts for contemporary Seneca, Mohawk, and Onondaga masks, figurines, and lacrosse equipment.[31]

The Cranes followed collecting norms of the 1950s and 1960s in placing little emphasis on named contemporary artists, although they occasionally purchased a prizewinner from the Gallup Inter-tribal Ceremonial or Museum of Northern Arizona Hopi Show. Rather than seeking the best artists' work, they generally sought good examples of authentic types of objects.

The Cranes also sponsored a primary collector-dealer, Howard Roloff, who visited Indian areas in the United States and adjacent parts of Canada and Mexico seeking objects on Francis Crane's wish list. From 1964 to 1966, he obtained large documented collections from the Seminole,

Miccosukee, Oklahoma Choctaw, Cahuila Kickapoo, Canadian Dakota, Plains Cree, Nootka, and Iroquois of Six Nations Reserve. Later he also purchased many important and rare materials from Northwest Coast people. The Cranes saw this process as the marketplace at work and preservation of the discards of modernizing Indian families in financial need. Apparently, at the time neither buyers nor sellers experienced the ethical quandaries raised by some Native descendants who came to feel disinherited of their cultural and spiritual legacy through the working of this marketplace.

The Cranes also followed prevailing collector ethics regarding American Indian "sacred objects" and "cultural patrimony." When dealers and traders occasionally offered replica, authentic new ceremonial, or possibly community-sanctioned objects, the Cranes readily assumed that the Indian sellers had made or owned and therefore had the right to sell such objects and did purchase some of them. For example, an Arizona trader offered a Shalako Ceremony Kachina Doll set made by a Zuni who had been criticized for carving kachina dolls and forced to leave Zuni. "The last time I talked to him, he had about decided to quit making them, because he wanted to move back. He had promised to make me 2 more of the set. . . . If he ever does, would you like those, too."[32] The Cranes bought the whole set. Later they discovered that the attitudes of Zuni people about the sale of kachina dolls vary. An important Zuni matriarch's grandson, who by chance visited the Marathon museum, readily gave detailed descriptions of the ceremony and all the kachina figures in the set, which were duly recorded in the object records.

Traders also offered previously used ceremonial items: Plains medicine bundles, Midewiwin scrolls, and Pueblo dance clothing and so-called fetish pots. The Cranes bought some such items with the assumptions that the rare and sensitive, but legally sold, materials should be preserved in a research collection. In most cases, as with Zuni war gods purchased from several sources, such known ceremonial objects were withheld from exhibition.[33] Mary and Francis Crane felt that they were forwarding Indian interests as well as their own by fair buying and gathering of traditional knowledge for a public museum. Some of their friends in Indian Country agreed. Nellie Menard, later a winner of the National Folklife Award, noted in 1965 that "all the Reservations are starting to collect Museum things . . . I'm just trying to help you because I'm interested in your museum."[34] She furnished teaching objects, such as a moccasin-making set, three types of tipis in miniature, and two replica painted hide calendar records, all with detailed explanations from herself and elders.

As late as 1970, Ralph Hubbard, a well-known hobbyist and friend of numerous North Dakota Indian people, assured Mary Crane that many old Indians would like to be in touch with buyers like the Cranes: "[They] have much fine family craft of the old types stored [and] are satisfied to sell reasonably when they realize the beautiful things will be placed in dependable museums for all posterity to enjoy."[35]

## THE SOUTHEAST MUSEUM OF THE NORTH AMERICAN INDIAN

The Cranes' museum, operated from 1958 to 1968, was the single artifact that best exemplified its founders' combined educational idealism and ardent amateurism. With the museum as their raison d'être for the seven years of collecting, the Cranes had made sure to study museum and exhibit design across the country. They decided they were ready to follow their own way in building, design, and curation of exhibits, with occasional professional assistance. They also oversaw the entire operation of exhibits, collection, and sales of Indian-made artifacts.[36]

The museum building, 3,150 square feet in size (fig. 9.4), was designed and built by a local construction firm to hurricane-proof specifications rarely seen in Marathon: steel-and-cinder-block construction raised five feet above ground level. The distinguishing architectural feature of the forty-foot-wide front was a five-story windowed tower, which showcased a twenty-five-foot totem pole carved by Watson Williams of Port Alberni, British Columbia, replicating the Tlingit Kian totem at Ketchikan, Alaska.[37] Inside the air-conditioned building were a small admissions area and gift shop, a rear collections management and storage area (with wooden shelving), and a large exhibition hall with nineteen movable exhibit cases (in four- and eight-foot-wide sizes, custom-built of light wood with sliding-glass fronts) (fig. 9.5).

The Cranes rejected the kind of exhibit favored by most Indian enthusiasts of the period—that is, row on row of similar classified objects. Mary explained, "It's hard for me even to go to a museum like that, I get bored to death . . . and that just doesn't stick with you."[38] Instead, the Cranes wanted to use objects interpretively for a broad audience: "You've got to get your story across and there are going to be some that remember it. . . . The older people I don't think much about because . . . they see what they

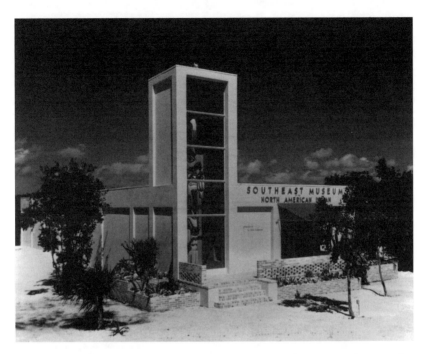

Figure 9.4. Southeast Museum of the North American Indian, 1958. Photograph by Charles H. Anderson, Marathon Shores, Florida. Denver Museum of Natural History Archives, 0098-001.

want to see—design or color or carving or what have you. I think it's all-important to start with the children."[39]

Cases were arranged at the center and at varied angles around the sides of an exhibition area approximately two thousand square feet in size. About 10 percent of the collection was selected and organized to develop themes of Indian life, in a general progression through time and culture areas around the North American continent and sampling Middle American and South American cultures.[40] Several cases changed to highlight new accessions as an incentive for repeat visits by local people as well as to honor collection sources. For example, Francis Crane told their Assiniboine supplier that his family's history quilt would be displayed, along with weapons, tools, and clothing illustrated in the quilt embroidery.

Technical demands of design and production sometimes compromised the Cranes' interpretive intentions—a common problem of small museums

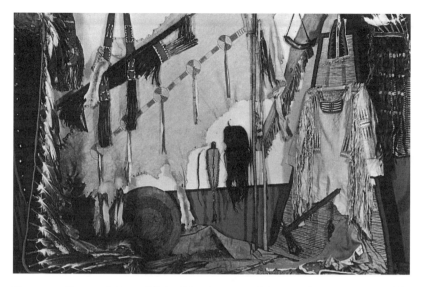

Figure 9.5. Postcard view of Plains Warrior case exhibit, Southeast Museum of the North American Indian, Marathon, Florida, ca. 1960. Photograph by Florida Natural Color, Inc., Miami Beach, Florida. Denver Museum of Natural History Archives, 0098-003.

in this era before widespread availability of exhibit consultants, guide-books, and training. Although labels were "well-thought-out," they were label-typewriter-produced, multiple-paragraphed, and hard to read. Twenty to forty objects crowded many cases, and up to a hundred stone tools and figurines lined archaeology cases. Mounts were somewhat makeshift and placement informal and overlapping. For example, in the Northwest Coast ceremonies case a wooden dance baton lay inside a feast bowl that was placed, along with ten other items, on a Salish finger-woven blanket. Some violence to both interpretation and preservation was inevitable.

Furthermore, the Cranes' lack of depth in Native American ethnology was revealed by the exhibition of some poor selections among the many fine pieces. Judging from photographs and exhibit lists, almost every case contained something with questionable origin, wrong date, nontraditional nature, or erroneous positioning. For instance, four large balsa-wood non-Pueblo figures were displayed as kachina dolls; a Northwest Coast painted dance apron was a recent fake decorated with pig toes in place of deer dew-claws; and a Jicarilla Apache woman's cape was hung sideways.

The Cranes' museum brochures emphasized the authenticity and scope that set the museum apart from most Keys tourist attractions: its sponsorship by a nonprofit, educational, tax-exempt corporation; the status of the collection as "the largest and finest . . . south of the Smithsonian"; and the availability of authentic Indian-made arts and crafts at the gift counter. A one-page article in the *Ford Times* gave the museum its greatest national visibility as a travel destination.[41] But because no professional publications on the collection appeared, researchers and curators remained largely unaware of it.

The Cranes felt acutely that a recreation-focused public misunderstood the museum, and so they installed a highway sign proclaiming "Genuine Indian Museum, not a Tourist Trap." Mary Crane said that visitors to the Keys "come to play and go fishing . . . and do not intend to spend their days in a museum. A rainy day would give us a big day but a sunny day was hard sledding to get anyone to go in. It was just one of those last resorts."[42] Local resident audiences included a few schoolchildren but were mostly retirees interested only in Florida Indians. Regional newspapers paid little attention until the museum closed its doors.

The Denver move helped diminish the Cranes' disappointment in the limited impact of their own museum. Francis Crane said that the main reason for donation of the Crane Foundation collection was "greater exposure where it will do the most good for the most people. We struggle to get 5,000 people a year and they [the Denver Museum of Natural History] have that many in a day."[43]

Particularly satisfying to Mary, as she followed developments after Francis's death, was seeing their original museological hopes paralleled and exceeded in Denver. In the decade after the arrival of the Crane Collection at the Denver Museum, anthropologist-exhibit designer Arminta Neal planned a new American Indian Hall and collection storage area using the entire second floor of a new building wing. A cross-section of materials was installed in innovative environmental-surround settings, miniature and life-size dioramas, and didactic cases. The hall layout followed the culture-area organization favored earlier by the Cranes.[44] As a new core field at the museum, American Indian ethnology received much public and researcher notice, established high public and schools visitation, and pioneered strong outreach to the regional Native American community.

Reviewing her satisfaction with the Crane Collection's ultimate role, Mary Crane put it into a broad educational context, with her usual modesty: "I don't care whether it's conservation of natural resources or creating

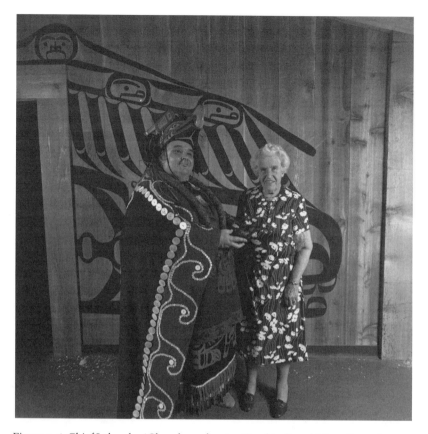

Figure 9.6. Chief Lelooska (Cherokee adoptive Kwakiutl) and Mary Crane in front of the replicated Northwest Coast house in Crane American Indian Hall, Denver Museum of Natural History, 1980. Denver Museum of Natural History Archives, ANT.80013.

an interest in native arts and so forth. I think you've got to start working with the school children. That's the way we always felt, why we wanted it to become something that children saw and grew up with" (fig. 9.6).[45]

## CONCLUSION

A midlife personal crisis propelled Mary and Francis Crane to reach into themselves and their resources to refocus their strong preservationist ideals in a new direction, the collecting of American Indian objects. Motivated to

productive, wide-ranging activity and guided by educational and preservationist goals more than by pecuniary or scholarly interests or connoisseurship, they quietly, determinedly, and joyfully persevered over seventeen years toward an American dream—a museum of their own.

The Cranes balanced ideals of scope and depth, typicality and uniqueness, and ethnographic and artistic interest. Their collecting strategies in the 1950s and 1960s sifted the available Indian materials from both primary and secondary sources. The resulting assemblage included early and fine objects and systematic examples from many periods. The odds were that the Cranes were too late, too modestly financed, and too amateur for what they were attempting. In the end, Francis and Mary Crane did realize their dream of amassing a large and varied collection and placing it in an appropriate home, the Denver Museum of Natural History. Now beginning its fourth decade at the Denver Museum, the Cranes' foundation of grand amateur collecting—and, moreover, of public purpose—continues to enrich enjoyment, research, and education in the American Indian legacy.

### Acknowledgments
The main sources of information for this article were notes, letters, newspaper clippings, other documents, and photographs in archives and collection-object and supplier records and photographs in the department of anthropology of the Denver Museum of Natural History in Denver, Colorado. Particularly important were interviews with Mary Crane by Frances Melrose published in *Rocky Mountain News,* May 18, 1978; and by Rebecca Spangler for the DMNH Archives on August 16, 1979; and records from Arminta P. Neal, former DMNH assistant director and first curator of the Crane American Indian Collection. Access to museum records was provided by Kristine Haglund, DMNH Archives head; Elizabeth Clancy, photoarchivist; Ryntha Johnson, anthropology collections manager; Michelle Zupan, formerly assistant collections manager; and Jim Englehorn, formerly computer records coordinator.

I owe special thanks to anthropology department volunteers who have worked relentlessly and cheerfully over four years, and continue to do so, to assemble, document, validate, file, and enter collector and object records; those people include Retha Bloodworth, Aurora Cuevas, Elizabeth Harvat, Judy Hubbard, Nancy Jones, Ann Moller, Fred Poppe, Jack Ramsey, Malcolm Stevenson, Lydia Toll, Elinor Travis, Peggy Whitehead, and Peggy Zanin.

Alumnae records at Wellesley College and Harvard University provided rich autobiographical and personal information about Mary Crane and Francis Crane. Jean N. Berry, archives assistant, Wellesley College, was particularly helpful in providing copies of documents for deposit in DMNH Archives. For the history of the Cranes' Key Vaca property, I am indebted to William B. Bradley, former Realtor at Marathon, Florida, and Barbara T. Sague, trust administrator, Florida Keys Land

and Sea Trust. Merry Wright at the American Kennel Club Museum of the Dog also assisted with research.

I owe continuing motivation to the late Norman Feder, who, as Denver Art Museum Native Arts curator, taught me much about research. Essential expertise was provided by DMNH staff members Robert Akerley, Dr. Jane S. Day, and Dr. E. James Dixon, and by Howard B. Roloff. Finally, I am grateful for the strong support given to the Crane Collection and my work with it by the Denver Museum of Natural History, Raylene Decatur, president; Dr. Richard Stuckey, chief curator; Dr. Robert Pickering, head, department of anthropology; and, from the beginning, by the late Allan R. Phipps, trustee.

## Notes

1. Francis Crane wrote the breed standard in 1934, and Mary Crane produced three editions of *The Great Pyrenees* (Menasha, Wis.: George Banta Publishing, 1936; Boston: Advance Printing, 1941 and 1949) and twenty-three articles about the breed and its history. Mary Crane judged dog shows across North America and in Europe and South Africa. By 1949 she was eligible to judge twenty-seven breeds of dogs. The Cranes' long-range impact on the field can be seen in the fact that, as Mary Crane judged the 1965 Beverly Hills show, two hundred of the dogs entered in the show traced lines from the Basquaerie Kennel. In 1975 Mary Crane wrote, "You will find far more people today, from coast to coast, who know us for our dogs than for Indian things!" Mary Crane to Dorothy Dines, December 7, 1975, Denver Museum of Natural History (hereafter cited as DMNH) Archives.

2. The feasibility of this project depended on the fact that in his company position Francis was able to purchase canned meat unfit for human consumption from Armour Company. Also, Mary was in charge of recruiting five units of Great Pyrenees—known as excellent watchdogs—for Dogs for Defense. A few Pyrenees served with the military in the Aleutian Islands, Greenland, and Iceland.

3. Francis Crane, 1950, pp. 214–16, in "Francis V. Crane," *25th Anniversary Report, Harvard Class of 1925* (Cambridge: Harvard University, 1950), 210–16.

4. William B. Bradley, "The Cranes of Crane Point—A Memoir," 1994, DMNH Archives.

5. Francis Crane, *25th Anniversary Report,* 214.

6. During the Cranes' ownership, according to William B. Bradley ("Memoir," 9), Crane Point remained accessible only by invitation. Chosen friends, visiting naturalists, the Audubon Society's annual Christmas bird count, and local groups, such as the Marathon Garden Club, visited the trails and gardens near the residence and lunched on the terrace. After the 1968 closing of the museum and her husband's death, Mary Crane maintained Florida winter residency, but in 1972 she sold the 63.5-acre estate to a private owner, who intended to keep the property intact. In 1974 Mary Crane moved to her summer home in Centre Lovell, Maine, where she continued active support of nature causes. Crane Point later passed through two defaulted ownerships by savings

and loan companies, and the property, still undeveloped, passed to the federal Resolution Trust Corporation. In December 1988 the Florida Keys Land Trust, a nonprofit conservation organization, acquired the property for a natural preserve, historic preservation, and recreation use area called Crane Point Hammock. Surveys found 160 native plant species, 10 endangered plant and animal species, and evidence of human habitation to ca. 3,000 B.C. The Adderly House, a remnant of fishing-farming Bahamians who settled the Keys, was dated at 1903 and established as the oldest house in the Keys outside Key West. In 1990 the Museum of Natural History of the Florida Keys was dedicated in the old Crane museum building. Other public attractions include a children's museum, nature trails, and restored Conch house. Few of the 33,000 annual visitors may realize that the "Crane" of Crane Point Hammock stands not for the bird but for the two people who early protected this natural legacy, which has been called "the most environmentally and historically significant piece of land in the Florida Keys," and "the living museum of the American Tropics." Florida Keys Land and Sea Trust, "Rediscover the Florida Keys: The Museum of Natural History of the Florida Keys" (Marathon, Fla.: Florida Keys Land and Sea Trust, 1990).

7. In the Harvard *25th Anniversary Report* in 1950, Francis covered all his business, dog, cattle, and hobby activities, as well as the new property and conservancy ventures in the Keys, but he was silent on any Indian collecting activities or plans. The first published mention of collecting interest did not appear until 1954 in Wellesley alumnae news from Mary, who reported their 1954 motoring trip across country to acquire Indian artifacts for a museum to be built at Marathon, Florida.

8. Bradley, "The Cranes of Crane Point," 7.

9. Mary Winslow Allen Crane interview, August 16, 1979, 2, DMNH Archives.

10. Ibid., 4

11. Walter S. Crane to Francis V. Crane, November 21, 1933, DMNH Archives.

12. Francis Crane, *25th Anniversary Report*, 215–16.

13. Mary Crane interview, 3.

14. A typically muted expression of enjoyment followed their return from a trip to Guatemala: "We look at the various items in the museum each day and enjoy them over and over." Mary Crane to Mr. and Mrs. John V. Smith, Casa de Artes, Antigua, Guatemala, April 27, 1965, DMNH Archives. Parting with the collection in 1968 was an exception, however, according to DMNH staff member Robert Akerley: "As we left, Mr. Crane had tears in his eyes and Mrs. Crane was looking kind of downhearted. The very last thing we packed was the top to an *incensario* that Mrs. Crane had in the fireplace in their home. She hated to part with it and knew when "Sweetie Pie" was gone, that was it—the collection was gone. They certainly had a real attachment for all they brought back, fond memories of collecting these things, and things friends of theirs made. It was a sad time for all of us." Robert Akerley interview, October 31, 1996, 3, DMNH Archives.

15. Goodspeeds, Boston, had a standing order to send newsletters and special offerings monthly.

16. Friends from this period especially remember the dogs in an air-conditioned Florida kennel, Mary braking for land snails on the road and expertly preparing seafood, and Francis expansive and even jovial (as noted by William Bradley), as befitted a member of Harvard's Tuesday Swamp Luncheon Club and the Basquaerie Beer, Bass, and Bath Society for Men.

17. Mary Crane interview, 17.

18. Mary Crane later allowed the Denver Museum to recognize her especially as a trustee but preferred only normal notice of her increasingly important donations to in-fill the Crane Collection. She often reminded the anthropology staff of her primary interest in dogs and nature, not American Indians.

19. Francis Crane to Mr. and Mrs. Frick, March 22, 1963, DMNH Archives.

20. Francis Crane to Gallup Indian Trading Company, July 12, 1967, DMNH Archives.

21. Francis Crane to Erich Kohlberg, April 2, 1962, DMNH Archives.

22. J. O. Brew and Francis Crane correspondence, April 24 to May 22, 1963, DMNH Archives.

23. Francis Crane to Henry A. Jacoby, December 7, 1962, DMNH Archives.

24. In a study of about three hundred Crane Collection objects in a temporary exhibit in 1969, Norman Feder (then curator of Native arts at the Denver Art Museum) found that 10 percent of the objects had errors of authenticity or record. Of these, 4 percent were not authentically Indian-made, 2 percent were not traditional (though they were made by Indians), and 4 percent were misidentified in some respect. From his considerable personal knowledge of most of the recorded suppliers, Feder traced virtually all the errors to the sources' lack of knowledge or documentation and the resulting misinformation given to the Cranes (in several instances due to dishonesty, in Feder's opinion). Norman Feder, Project Report: Primitive Arts and Industries, Fall 1969, DMNH Department of Anthropology.

25. Francis Crane to Erich Kohlberg, May 25, 1962, DMNH Archives.

26. Francis Crane to Mr. and Mrs. E. M. Daniels, July 11, 1954, DMNH Archives.

27. Mary Crane to Erich Kohlberg, September 12, 1958, DMNH Archives.

28. R. Hubbard to Mary Crane, May 28, 1970, DMNH Archives.

29. Mary Crane interview, 18.

30. Nellie Menard to Cranes, March 16 and November 18, 1965, DMNH Archives.

31. In 1968, when the collection was packed for donation to DMNH, several large arrays originally purchased for the gift shop were added to the collection. Thus, unintentionally, some commercial Indian arts of the 1950s and 1960s became well represented, unusual systematic resources, e.g., made-for-sale Iroquois figurines and Rio Grande Pueblo pottery miniatures.

32. Don Hoel to Francis V. Crane, September 12, 1966, DMNH Archives.

33. In 1991, before implementation regulations had been put in place by the federal government for the 1990 Native American Graves Protection and Repatriation Act (NAGPRA), the DMNH Department of Anthropology proposed and the board of trustees approved return of the Crane Collection's six

*Ahayu:da* (war god altar figures) to the Zuni tribe of New Mexico, who had been unaware of their existence. An account of the repatriation is found in Joyce Herold's commentary (pp. 559–60) to William L. Merrill et al., "The Return of the *Ahayu:da:* Lessons for Repatriation from Zuni Pueblo and the Smithsonian Institution," *Current Anthropology* 14, no. 5 (December 1993): 523–67. Concerning other sensitive collection objects, as called for by NAG-PRA the museum has reported fully to American Indian designated representatives, and consultations and repatriations are proceeding.

34. Nellie Menard to Cranes, March 16, 1965, DMNH Archives.

35. Ralph Hubbard to Mary Crane, August 20, 1970, DMNH Archives.

36. In addition to the codirectors, Mary and Francis Crane, the Southeast Museum staff included at most the following positions: a curator, filled irregularly, including Paul Hahn in 1957, Dr. Setzler, a Florida archaeologist, in 1962, and Laurence D. Cone in 1963–65; a secretary-assistant, for letter dictation and general office work; and a registrar–gift shop assistant, filled by Christine Bonney, who continued her meticulous collection numbering, typing of catalog cards, and filing of records in Denver after the collection move.

37. Appropriately, the Kian totem pole—much seen by tourists in Alaska—is surmounted by a crane bird, which is said to signify, "I belong to the Crane Branch of the Raven Phratry." Marius Barbeau, *Totem Poles*, National Museum of Canada Bulletin 119 (1950): 603, 609.

38. Mary Crane interview, 22.

39. Ibid.

40. Exhibit cases were devoted to Northwest Coast wealth and prestige and maritime economies, horse trappings, the buffalo, implements of war, beadwork and quillwork, Plains Indian children, the Hopi, Navajo, Navajo blankets, and the Seminole, the Iroquois, Mexican and Central American Indians, Colima dogs, and the Jivaro. Cross-cultural exhibits were entitled "Baskets from Florida to Alaska," "The Children's Corner," "What's Behind It? The Background of Indian Names," "Masks Are for the Gods," "Man and Stone" and "As Indians Believe."

41. "All About Indians," *Ford Times*, April 1964, 45.

42. Mary Crane interview, 2, 11.

43. Clarence Salee, "American Indian Museum Being Moved to Colorado," *Miami Herald*, Keys edition, August 9, 1968.

44. Joyce Herold, "The Denver Museum of Natural History: Crane Hall," *American Indian Art Magazine* 3, no. 3 (Summer 1978): 74–75.

45. Mary Crane interview, 14, 15, 23.

# CONTRIBUTORS

**Cheri Falkenstien-Doyle** is curator of the Wheelwright Museum of the American Indian in Santa Fe, New Mexico. Previously she worked as curator of collections at the Southwest Museum, Los Angeles, where she developed exhibitions on Central American textiles, California basketry, the history of the Southwest Museum, and the life of Charles F. Lummis. She is trained in art and anthropology, and her interests include historic Native American art of California and the Southwest.

**Barbara A. Hail** is deputy director and curator of the Haffenreffer Museum of Anthropology, Brown University. She trained in history and anthropology, with special interests in historic North American material culture, especially that of the Plains and Subarctic. Her books include *Hau, Kola!* and *Out of the North* (with Kate Duncan), both published by the Haffenreffer Museum of Anthropology, Brown University, Studies in Anthropology and Material Culture, vols. 3 (1980, 1983, 1988) and 4 (1989); and she contributed the essay for *Patterns of Life, Patterns of Art: The Rahr Collection of Native American Art* (Hanover, N.H.: University Press of New England, 1987). She is currently collaborating with descendants of nineteenth-century Kiowa and Comanche cradlemakers on an ethnohistorical study of these cradles, to result in a book and traveling exhibition in 1999, titled *Gifts of Pride and Love.*

**Joyce Herold,** curator of ethnology and a past chief curator of the Denver Museum of Natural History, specializes in historic American Indian material culture, especially of the Southwestern and Plains areas. She has written studies of Havasupai and Jicarilla Apache basketry and, most recently, *A Researchers' Guide to the North American Ethnographic Basket Collection of the Denver Museum of Natural History.* Her current research centers on Jicarilla Apache women's arts, Plains-Plateau horse masking, and Assiniboine-Sioux collections. Herold also has interest

in Southeast Asian cultures and curated a recent award-winning exhibit about Hmong Americans.

**Karl A. Hoerig** is a doctoral candidate in anthropology at the University of Arizona. His dissertation, which will be completed in 1999, is a study of the Native American Vendors Program of the Palace of the Governors in Santa Fe. His research interests include indigenous arts and crafts markets, the relationship between Native Americans and non-Native people and institutions, and the historical and contemporary creation of representations of Native people in markets, the media, and museums.

**Ira Jacknis** is associate research anthropologist at the Phoebe Hearst Museum of Anthropology, University of California at Berkeley. Before coming to Berkeley in 1991, he worked at the Brooklyn Museum, the Field Museum, the Newberry Library, and the Smithsonian Institution. His research interests include the art and culture of the Native peoples of western North America, the history of anthropology, museums, and film and photography. His current research focuses on Alfred Kroeber and the Native Californian collections at the Hearst Museum.

**Clara Sue Kidwell** is currently director of the Native American studies program at the University of Oklahoma in Norman. She received a Ph.D. in the history of science from the University of Oklahoma, then developed a specialization in American Indian history and culture and taught at Haskell Indian Junior College in Lawrence, Kansas, the University of Minnesota, and the University of California at Berkeley. Before joining the faculty of the University of Oklahoma, she was associate director of cultural resources at the National Museum of the American Indian, Smithsonian Institution. She is the author of *Choctaws and Missionaries in Mississippi, 1818– 1918* (Norman: University of Oklahoma Press, 1995).

**Shepard Krech III** is professor of anthropology and director of the Haffenreffer Museum of Anthropology, Brown University. His most recent book is *The Ecological Indian: Myth and History* (New York: Norton, 1999). He is currently working on a historical anthropology of the missionary-Native encounter in the Northern Athapaskan region, and he teaches courses on anthropology and museums at Brown University.

**Molly Lee** is curator of ethnology and history at the University of Alaska Museum and associate professor of anthropology at the University of Alaska, Fairbanks. She has published widely in the fields of Alaska Native art and early-twentieth-century collecting. She is the author of *Baleen Basketry of the North Alaskan Eskimo*, 2nd ed. (Seattle: University of Washington Press, 1998), and is conducting research for a book about Yup'ik Eskimo basketry and also for a publication on the collecting of Native Alaskan artifacts at the turn of the century.

**Moira T. McCaffrey** is director of curatorial and research services at the McCord Museum, Montreal, Quebec. She has conducted archaeological research in Subarctic Quebec and Labrador, and on the Iles-de-la-Madeleine in the Gulf of St.

Lawrence. She has curated numerous traveling exhibitions in collaboration with aboriginal communities, including "Marks of the Mi'kmaq Nation." She is currently project director for an international traveling exhibition titled "Across Borders: Beadwork in Iroquois Life." McCaffrey has published numerous articles and has edited two volumes.

**Nancy J. Parezo,** professor of American Indian studies and anthropology at the University of Arizona and curator of ethnology at the Arizona State Museum, has a Ph.D. in anthropology from the University of Arizona. She has worked extensively in the areas of material culture, especially in the Southwest, the history of anthropology and museums, especially the collecting behavior of anthropologists. She is the editor of *Hidden Scholars: Women Anthropologists of the Native American Southwest* (Albuquerque: University of New Mexico Press, 1993); coauthor (with Barbara Babcock) of *Daughters of the Desert* (Albuquerque: University of New Mexico Press, 1988; and author of *Navajo Sandpaintings: From Religious Act to Commercial Art* (Tucson: University of Arizona Press, 1983). She is currently finishing a book on the Denver Art Museum, titled *The Indian Fashion Show, 1942–1956,* and is beginning a project on anthropology exhibits at the St. Louis World's Fair.

**William C. Sturtevant** has been curator of North American ethnology in the Smithsonian's National Museum of Natural History since 1965, after serving for nine years as ethnologist in the Bureau of American Ethnology, and he is general editor of the twenty-volume *Handbook of North American Indians* (Smithsonian Institution). He has made museum collections during fieldwork among the Florida Seminole and the New York Seneca, and in Michoacán, Guatemala, and Burma. Among his specialties are ethnology, culture history, and material culture of eastern North American Indians, early ethnographic illustrations, and the history of anthropology and anthropological museums.

**Thomas H. Wilson** is director of the Logan Museum of Anthropology and the Wright Museum of Art and director of museum studies at Beloit College in Beloit, Wisconsin. He holds a Ph.D. in anthropology from the University of California, Berkeley. He served as coast archaeologist for the National Museums of Kenya, program officer in the Museums Program of the National Endowment for the Humanities, and deputy director of the Center for African Art in New York before becoming executive director of the Southwest Museum in Los Angeles (1992–95). Wilson earned a J.D. from the University of Maryland and is interested in museum law, art law, and international cultural property law.

# INDEX

Bold page numbers refer to illustrations